IMPRESSIONISTS *in* WINTER
Effets de Neige

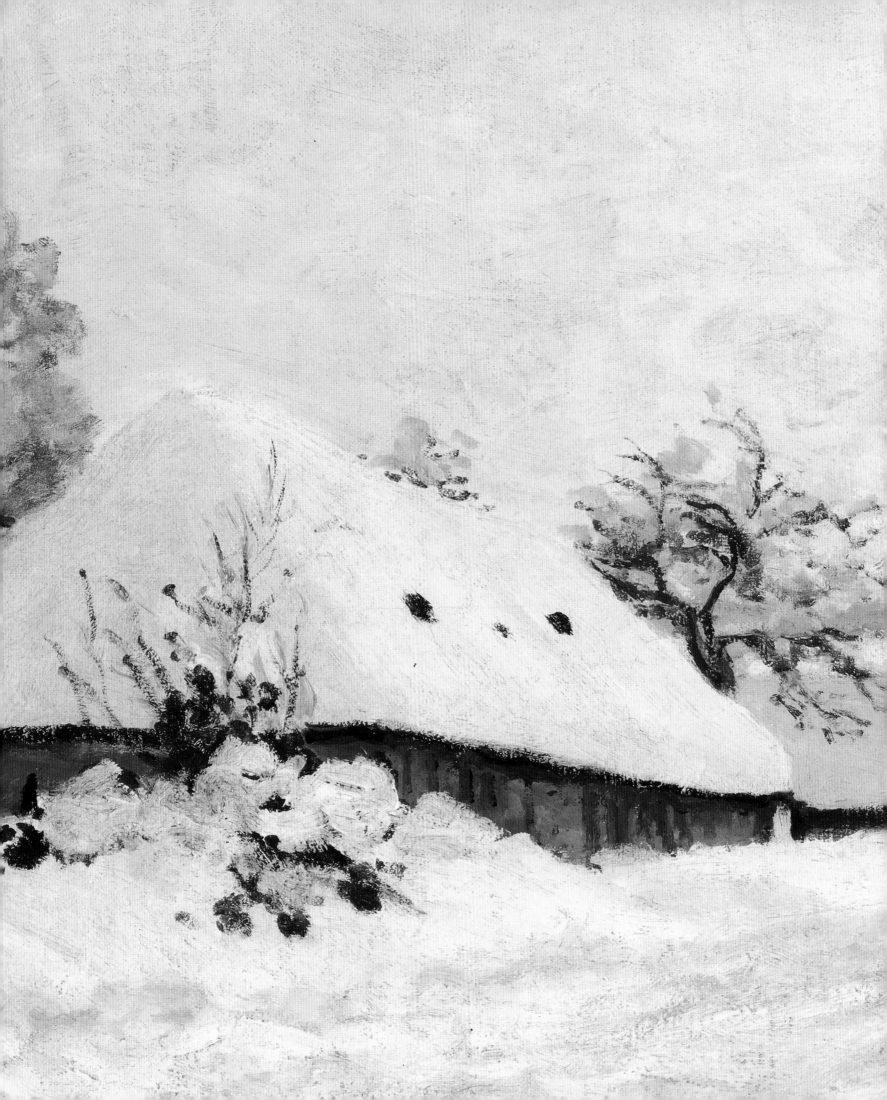

IMPRESSIONISTS *in* WINTER
Effets de Neige

Charles S. Moffett
Eliza E. Rathbone
Katherine Rothkopf
Joel Isaacson

THE PHILLIPS COLLECTION, WASHINGTON, D.C.
in collaboration with
PHILIP WILSON PUBLISHERS

First published in 1998 by Philip Wilson Publishers Limited
143-149 Great Portland Street, London W1N 5FB

Published on the occasion of the exhibition
Impressionists in Winter: Effets de Neige

19 September 1998–3 January 1999
The Phillips Collection
Washington, D.C.

30 January 1999–2 May 1999
The Fine Arts Museums of San Francisco
at the Center for the Arts at Yerba Buena Gardens

Library of Congress Cataloging-in-Publication Data
Impressionists in winter: effets de neige/Charles S. Moffett... [et al.].
 Published on the occasion of an exhibition at the Phillips Collection, Washington, D.C.,
 Sept. 19, 1998–Jan. 3, 1999 and at the Fine Arts Museums of San Francisco at the Center
 for the Arts at Yerba Buena Gardens, Jan. 30–May 2, 1999.
 Includes bibliographical references and index.
 ISBN 0-943044-23-5 (paper)
 1. Impressionism (Art)—France—Exhibitions. 2. Painting, French—Exhibitions. 3. Snow in
art—Exhibitions. 4. Painting, Modern—19th century—France—Exhibitions. I. Moffett, Charles S.
II. Phillips Collection. III. Fine Arts Museums of San Francisco. IV. Center for the Arts at Yerba
Buena Gardens.
ND547.5.I4I495 1998
758'.1'0944074753—dc21 98-8265
 CIP

ISBN 0-85667-495-8 (hardcover)
ISBN 0-943044-23-5 (softcover)

Impressionists in Winter: Effets de Neige was organized by The Phillips Collection, Washington, D.C.
The exhibition is made possible by J.P. Morgan & Co. Incorporated.
Additional support has been provided by the Federal Council on the Arts and the Humanities.

FRONT COVER: (softcover and hardcover jacket): Alfred Sisley, *Snow at Louveciennes* (detail cat. 56),
1878, oil on canvas, 24 x 19⅞ in. (61 x 50.5 cm), Musée d'Orsay, Paris, Bequest of Comte Isaac
de Camondo

BACK COVER: (softcover and hardcover jacket): Claude Monet, *The Red Cape* (cat. 4), 1869-70
or 1871, oil on canvas, 39 x 31½ in. (99 x 79.8 cm), The Cleveland Museum of Art, Bequest of
Leonard C. Hanna, Jr., 1958.39

TITLE PAGE: Claude Monet, *A Cart on the Snowy Road at Honfleur* (detail cat. 1), 1865, oil on
canvas, 25½ x 36½ in. (65 x 92.5 cm), Musée d'Orsay, Paris, Bequest of Comte Isaac de Camondo

Sponsor's Statement

J.P Morgan takes particular pleasure in sponsoring the first major exhibition devoted to the snow scene or *effet de neige* in Impressionist painting.

By dwelling exclusively on snowscapes, *Impressionists in Winter* brings together some of the most serene and subtle works of Monet, Sisley, Pissarro, and others, and enables the viewer to see them in a truly revelatory context.

We at J.P. Morgan are proud to be associated for the first time through this exhibition with Washington's eminent Phillips Collection. Above all we are delighted to be involved in bringing before the public some of the most irresistibly beautiful paintings of the late nineteenth century.

Douglas A. Warner III
Chairman
J.P. Morgan & Co. Incorporated

Contents

Lenders to the Exhibition

The Art Institute of Chicago

The Visitors of the Ashmolean Museum, Oxford

Sterling and Francine Clark Art Institute, Williamstown, Massachusetts

The Cleveland Museum of Art

Fondation Rau pour le Tiers-Monde, Zurich

Göteborg Museum of Art, Göteborg, Sweden

William I. Koch

Le Havre, Musée des Beaux-Arts André Malraux

Mrs. Alex Lewyt

Mr. and Mrs. Herbert L. Lucas

The Metropolitan Museum of Art, New York

Musée d'Orsay, Paris

Museum of Fine Arts, Boston

Museum of Fine Arts, St. Petersburg, Florida, extended anonymous loan

Museum Folkwang Essen

The National Gallery, London

National Gallery of Scotland

The Nelson-Atkins Museum of Art, Kansas City, Missouri

Ordrupgaard, Copenhagen

Philadelphia Museum of Art

The Phillips Collection, Washington, D.C.

Lord and Lady Ridley-Tree

Senator and Mrs. John D. Rockefeller IV

Mr. and Mrs. Stephen A. Schwarzman

Staatsgalerie Stuttgart

Carmen Thyssen-Bornemisza

University of Michigan Museum of Art

Virginia Museum of Fine Arts, Richmond, Virginia

The Walters Art Gallery, Baltimore

Waterhouse Collection

Private collectors

Preface

Impressionists in Winter: Effets de Neige presents the first thorough investigation of the subject of Impressionist winter landscape. No exhibition and no publications in the literature on Impressionism have been devoted to this theme before. While such a thematic approach might seem at first blush a superficial one, the subject of this exhibition goes to the heart of one of the central issues of Impressionism, a dedication to painting specific effects of weather and light that is unprecedented in the history of art. The subject of winter—clearly the most inhospitable season for *plein-air* painting—provides some of the most exceptional and most spellbindingly beautiful paintings in Impressionism.

Inspired by Alfred Sisley's *Snow at Louveciennes* in The Phillips Collection, this exhibition of sixty-three works presents an opportunity to consider the subject of snow in Impressionist painting in an unprecedented way. While anyone might have come across one or several of these exceptional works in various museums in this country or abroad, it comes as a surprise to most to learn that the Impressionists painted hundreds of paintings of snow or *effets de neige*, as they came to be called. Of all the Impressionists, three artists especially were drawn to paint *effets de neige*: Claude Monet, Alfred Sisley, and Camille Pissarro. Their shared fascination with these 'effects' led all three to repeatedly seek out opportunities to paint landscapes in snow. Yet each brought to the subject a highly individual response that we find reflected in the paintings assembled here. In addition to these three artists, Pierre-Auguste Renoir, Gustave Caillebotte, and Paul Gauguin also painted snowscapes, though far fewer. Renoir's characteristic interest in a social gathering of skaters in the Bois de Boulogne, Caillebotte's dramatic elevated views over Paris, and Gauguin's rare Brittany snowscapes add dimension and contrast to the dedicated pursuit of winter landscape just outside Paris of Monet, Sisley, and Pissarro. The result is a wide range of winter scenes from the bucolic French countryside to ice floes on the Seine, from the paths and roads of small villages to the boulevards and rooftops of Paris. Their common ground is an obsession with winter light.

Most of us do not think of Paris—or the surrounding countryside—covered in snow. We do not anticipate a blizzard impeding winter travel to this part of the world nor have we ever seen the Seine frozen solid. A very different weather pattern prevailed during the late nineteenth century. Snowfall, blizzards, and frost were a fairly common winter occurrence. Two of the most severe periods of extended cold since 1840 occurred during the winters of 1879–80 and 1890–91. In order to provide a backdrop of recorded weather conditions of the period, we brought together documentation from numerous sources to describe precisely the winter

weather during the years covered by this exhibition. The weather was at times described as 'wolf-like' or 'Siberian', and once was compared to the North Pole. These vivid accounts not only have helped us to assign dates to certain undated works, but also have provided a context for appreciating the impact of weather conditions on life in France in the late nineteenth century. In this regard, I especially would like to thank Alexandra Ames and Sylvie Péharpré for their diligent and determined research into the archives of the New York Public Library, the Bibliothèque Nationale in Paris, and other sources.

Of course, major support is essential to such a complex and costly enterprise as this exhibition. The Phillips Collection is immensely grateful to our sponsor, J.P. Morgan & Co. Incorporated, whose strong and early commitment made *Impressionists in Winter: Effets de Neige* possible. The exhibition is also supported by an indemnity from the Federal Council on the Arts and the Humanities.

Without generous and supportive lenders, private and public, no exhibition is possible. We are tremendously grateful to all who have generously agreed to send their paintings to our exhibition. In addition, we would like to thank our colleagues at the lending museums, as well as those in galleries, auction houses, archives, and other institutions for all of their invaluable assistance: William Acquavella, Frederick H. S. Allen, Alex Apsis, Martha Asher, Christoph Becker, Jacques de la Béraudière, Robert P. Bergman, Richard R. Brettell, Christopher Brown, Anne Buddle, Nina Buhne, Christopher Burge, Françoise Cachin, Isabelle Cahn, Rosalie Cass, Philippe Cazeau, Michael Clarke, Robert Clémentz, Timothy Clifford, Melanie Clore, Françoise Cohen, Michael P. Conforti, Desmond Corcoran, Diane De Grazia, Ingmari Desaix, Robyn A. Deutscher, Douglas W. Druick, Everett Fahy, Anne Birgitte Fonsmark, Björn Fredlund, Kate Garmeson, Franck Giraud, Caroline Durand-Ruel Godfroy, Gloria Groom, Anne d'Harnoncourt, Colin Harrison, Tokushichi Hasegawa, Alan Hobart, Kathe Hodgson, Christian von Holst, Waring Hopkins, Rory Howard, Ian Kennedy, Georg W. Költzsch, Katharine C. Lee, Ursula Lesiak, Tomás Llorens, Henri Loyrette, Mario-Andreas von Lüttichau, Neil MacGregor, Vera Magyar, Susana Manzanares, Caroline Mathieu, Carol McNamara, Michael Milkovich, Philippe de Montebello, Steven A. Nash, Monique Nonne, Lynn Federle Orr, Michael Pantazzi, Harry S. Parker III, Carmen de Pinies, Joachim Pissarro, G. Rau, Joseph J. Rishel, Malcolm Rogers, Peter Rohowsky, Heidi Römer, Anne Roquebert, James Roundell, Christina Ryan, Manuel Schmit, George T.M. Shackelford, Beverly Smith, Meg Starr, Michel Strauss, Martin Summers, Gary

Tinterow, Gary Vikan, Roger Ward, Alice Whelihan, Christopher White, Marc F. Wilson, Mikael Wivel, James N. Wood, and Eric M. Zafran.

We are very grateful for the support provided by Philip Wilson Publishers Limited, including Anne Jackson. A special word of thanks is due to Andrew Shoolbred for his design of this book, and to Cherry Lewis and Ellen Hirzy, who edited the manuscript.

We are also indebted to the entire staff of The Phillips Collection for their effort to bring this catalogue and exhibition to realization. By fundraising, applying for federal indemnification, negotiating loans and shipping, overseeing conservation reports, handling the works, paying the invoices, planning the installation, organizing special educational programs, and preparing for and serving visitors, the staff of all departments in the museum have helped to present this special exhibition. We would like to offer our special thanks to Michael Bernstein, Jean Briggs, Thora Colot, Franck Cordés, Peter Donovan, Brion Elliot, Faith Flanagan, Sue Frank, Tom Gilleylen, Kelly Gotthardt, Johanna Halford-MacLeod, Joy Hallinan, Joseph Holbach, Bill Koberg, Kristin Krathwohl, Kim Lewis, Fran Marshall, Donna McKee, Marilyn Montgomery, Jake Muirhead, Asa Osborne, Laura Parham, Stephen Bennett Phillips, Malia Salaam, Cynthia W. Savery, Karen Schneider, Mari Lu Shore, Richard Singer, Elsa Mezvinsky Smithgall, Elizabeth Steele, Pamela Steele, Kenneth Thompson, Karen Topping, Elizabeth Hutton Turner, Helene Voron, Alice Whealin, Shelly Wischhusen, Suzanne Wright, and Lisa Zarrow.

I am especially grateful to Charles S. Moffett, former director of The Phillips Collection, for the initial inspiration for this exhibition, for his dedication to obtaining loans of the highest quality, and for the perspective and overview that he brings to the subject in his essay for this catalogue. I acknowledge with gratitude our good fortune in persuading Joel Isaacson to contribute an insightful essay on Impressionist winter landscape with a special emphasis on Sisley. Lisa Portnoy Stein has spent months compiling the provenance, exhibitions, and references of all the works in this exhibition. Her substantial contribution to this book also lies in her many entries on individual paintings, her artist biographies, and her help on the Winter Weather Chronology. Most of all, I would like to thank Katy Rothkopf for her steadfast assistance in every phase of this exhibition and publication and for her enthusiasm and good humor throughout the intensive past two years that we have worked together on this project.

Eliza E. Rathbone
Project Director and Chief Curator

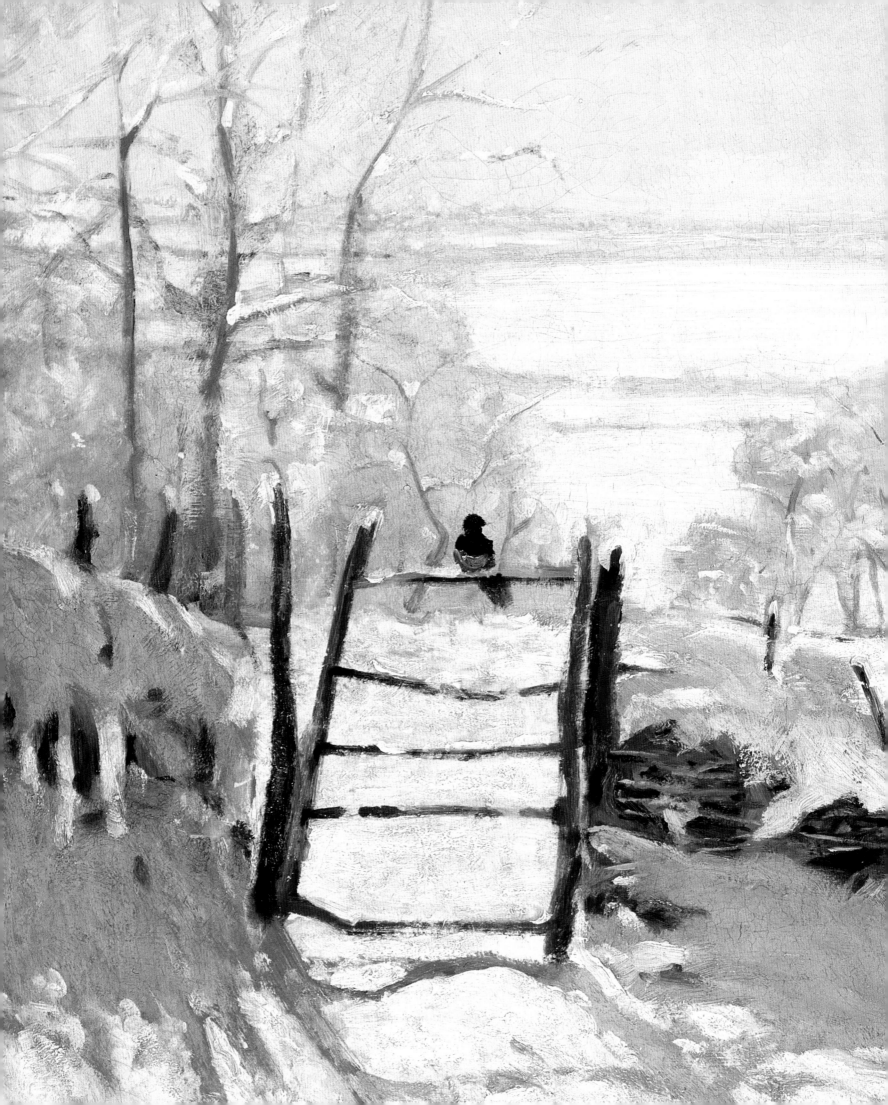

Effet de Neige: 'Claude Monet and a few others…'

Charles S. Moffett

The history of snowscapes in European painting reaches back at least as far as the Limbourg Brothers' *Les Très Riches Heures du duc de Berry* of about 1415 (fig. 1).[1] Of course, winter landscapes with snow often play a part in paintings that depict the cycle of the four seasons, especially in Northern European painting of the seventeenth century. Indeed, as Wolfgang Stechow has observed:

> In many ways the winter landscape is the Dutch seventeenth-century land-scape *par excellence*. Here there is no competition from Italy or France, and little from Flanders, although Flemish *sixteenth*-century antecedents were of decisive importance in its genesis. There is not even much competition in later centuries, with the exception of some works by Caspar David Friedrich, Claude Monet and a few others.[2]

Stechow's subtle nod to the Impressionists is probably the first acknowledgment by a major scholar that the winter landscapes of the Impressionists constitute a significant accomplishment. As this exhibition indicates, Monet and several of his colleagues produced a body of work that is at least the equal of seventeenth-century Dutch winter landscapes.

Other than the often-reproduced image of the page illustrating the month of 'February' in *Les Très Riches Heures du duc de Berry*, the best known early snowscape is Pieter Brueghel's *Hunters in the Snow*, 1565 (fig. 2). With extraordinary accuracy, the painter captured the light, atmosphere, and feeling of a winter landscape not long after a snowfall. The color of the overcast sky, the quiet, the atmosphere, and the sensation of tranquillity that pervades the landscape seem remarkably accurate. Moreover, the land-scape is imbued with an unmistakable beauty that is the result of the snow. As much as the hunting party, the village, and the panoramic view of the valley, the subject of the painting is the transforming effect of the snow.

Most visitors to the Kunsthistorisches Museum, Vienna, who walk into the gallery where the Brueghel landscapes hang are drawn to *Hunters in the Snow*. People linger before it and come back to it. It is an image that visitors do not forget. The same is true of another work that was painted three centuries later, Claude Monet's *The Magpie*, 1869, in the Musée d'Orsay (cat. 3). Visitor surveys and sales of postcards and reproductions indicate that it is the most popular single image in the museum.[3]

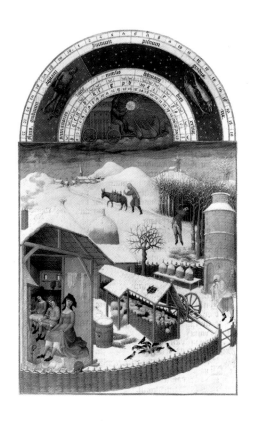

1. The Limbourg Brothers, 'February,' from *Les Très Riches Heures du duc de Berry*, 1413–16, miniature, Musée Condé, Chantilly, Photograph courtesy of Giraudon.

OPPOSITE
Claude Monet, *The Magpie* (detail cat. 3), 1869, oil on canvas, 35 x 51 in. (89 x 130 cm), Musée d'Orsay, Paris.

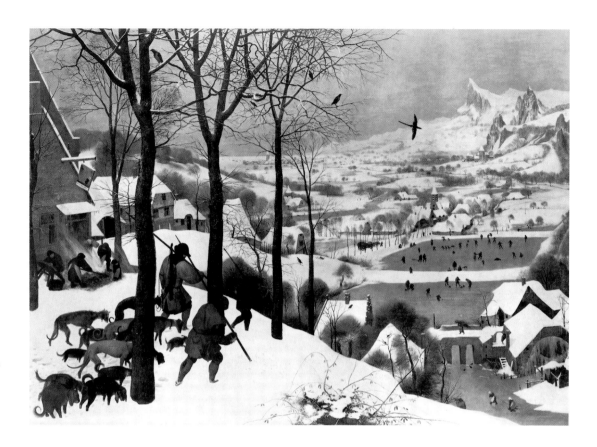

2. Pieter Brueghel the Elder, *Hunters in the Snow,* 1565, oil on panel, 46½ x 63¾ in. (117 x 162 cm), Kunsthistorisches Museum, Vienna.

As one visits museums and collections with Impressionist paintings or peruses books, exhibition catalogues, and catalogues raisonnés, one discovers snowscapes with the words *effet de neige* in the title. The Phillips Collection's Sisley, for example, was originally titled *Jardin à Louveciennes—Effet de neige* (cat. 49).[4] Throughout the Impressionist group shows (1874–86), numerous works were shown with the title or subtitle *effet de neige.* Despite the popularity and appeal of these works, they have never been examined as a discrete category of Impressionist painting. Most collectors, curators, and dealers have always preferred paintings with blue skies, sun, gardens, and fields of flowers, but the snowscapes of the Impressionists— especially those by Monet, Sisley, and Pissarro—are among their greatest accomplishments. These paintings often convey a sense of peace, stillness, and quiet beauty that is unique in the history of modern art.

It is possible that the Impressionists were at least indirectly inspired to paint winter landscapes by the group of snow scenes that Courbet had painted in the late 1850s and early 1860s, but the mood and compositions of Courbet's snowscapes are decidedly different. Most involve the theme of hunting, such as the large painting that was shown in the Salon of 1857, *Downed Doe,* 1857 (Private collection, New York) or *Hunters in the Snow,* 1866 (fig. 3). The importance of the term *effet de neige* to the meaning of these paintings seems marginal, but it is possible that Courbet's interest in winter landscapes may in fact have contributed to that of the emerging Impressionists.

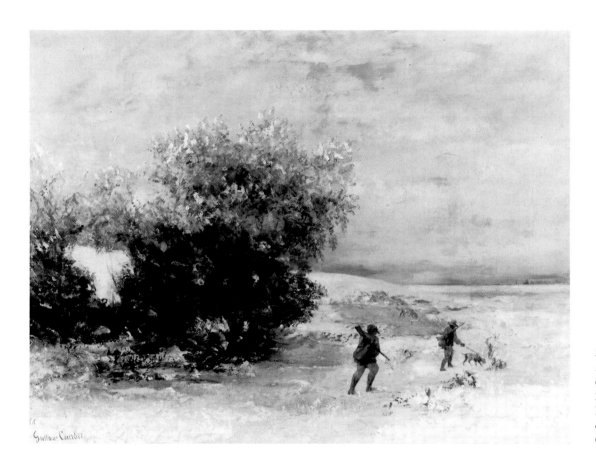

3. Gustave Courbet, *Hunters in the Snow,* 1866, oil on canvas, 18¾ x 25½ in. (48 x 65 cm), Private collection, Courtesy of Salander-O'Reilly Galleries, New York.

More to the point may be photographs of winter landscapes, such as those of the Forest of Fontainebleau by Eugène Cuvelier. The soft, grainy, nearly Impressionist character of Cuvelier's *Road in the Forest in Snow* (fig. 4), probably executed in the late 1850s or early 1860s, seems much closer to the composition, mood, and interpretation of certain winter landscapes by Monet such as *Road to the Farm, Saint-Siméon, Honfleur* of 1867 (fig. 5). The work of Cuvelier, who counted among his friends such painters as Camille Corot and Théodore Rousseau, may well have been known to the Impressionists in the 1860s. In the 1860s Monet and Sisley worked in the Fontainebleau Forest, not far from where Cuvelier lived, and their paths may have crossed. There are other possible connections to photography, too. As Françoise Heilbrun has noted in *Les paysages des Impressionistes,* 'Loydreau's *Effet de Neige* [fig. 6] of 1853, for example, inevitably calls to mind Pissarro's *Gelée Blanche* of 1873 (Musée d'Orsay).'[5]

Monet, Renoir, Pissarro, Sisley, Caillebotte, Gauguin, and others focused on the very particular character of the air, the light, and the appearance of color in landscapes that were blanketed with white. Their snowscapes represent the first sustained interest in the subject since that of the seventeenth-century Dutch landscape painters. With a few notable exceptions, however, most of these earlier paintings are not about the defining characteristics of the snowscape but rather about a wide range of human activities in the context of a landscape

4. Eugène Cuvelier, *Road in the Forest in Snow,* 1850s, salt print from a paper negative, 7¾ x 10⅛ in. (19.6 x 25.7 cm), The Weston Gallery, Carmel, California.

covered with snow. The Impressionists, on the other hand, were drawn to the subject because of its unique visual characteristics. The subtleties of light and color offered an opportunity to work within a range of often muted color that brings to mind Whistler's 'symphonies' in particular colors or combinations of color. The Impressionists concentrated not on ideas about the thing but the thing itself (*pace* Wallace Stevens).[6]

For example, in the painting that inspired this exhibition, The Phillips Collection's *Snow at Louveciennes* of 1874 by Sisley (cat. 49), the overall impression is of a composition of blue-grays, broken whites, and ochres. Wherever Sisley has used stronger color—such as the teal of the gate to the left of the figure—the viewer is acutely aware of the power and pleasure inherent in color. The square, pumpkin-colored section of the outsize gate behind the figure manifests itself very differently in a snowscape than in an autumn landscape of 1873 depicting the same scene (see cat. 49, fig. 1).[7] Indeed, a comparison of the two compositions indicates that in the painting in The Phillips Collection the artist positioned himself somewhat further forward along the lane. The result is a slight exaggeration and simplification of certain forms. In addition, the reduced range of the palette draws special attention to the presence of stronger color wherever it appears. The teal gate and the window casements in the house behind the figure have a presence that is considerably more pronounced than in

the autumn landscape. Of course, in almost any *effet de neige* painting there is considerably less to distract the eye than in an ordinary landscape with its plethora of colors and shapes. The painters tend to focus on subtleties that would otherwise be lost in myriad details, anecdotal content, and complex combinations of strong color. Of course there are notable exceptions, such as Renoir's *Skaters in the Bois de Boulogne* (cat. 31) of 1868, which is very reminiscent of seventeenth-century Dutch skating scenes by such artists as Hendrik Avercamp.

A striking example of the power of certain details in Impressionist winter landscapes is that of the bird in Monet's painting *The Magpie* of 1869 (cat. 3). Normally, the magpie might be incidental and barely noticeable. However, in this case the combination of the black, white, and especially the blue plumage draws the eye because it differs so dramatically from its surroundings. Most of the painting is devoted to the very special character of the light as the sun streams across the recently fallen snow. The rich orchestration of subtle pinks and mauves offers a profound visual experience. Such effects do exist in snowscapes, but usually at the beginning or, more typically, at the end of the day. For a few minutes, the landscape takes on tones of red, pink, purple, and blue, but such effects are very short-lived. Like so many Impressionist paintings, *The Magpie* could not have been painted entirely *sur le motif* and *en plein air*. The complexity of the composition and the care with which Monet painted it

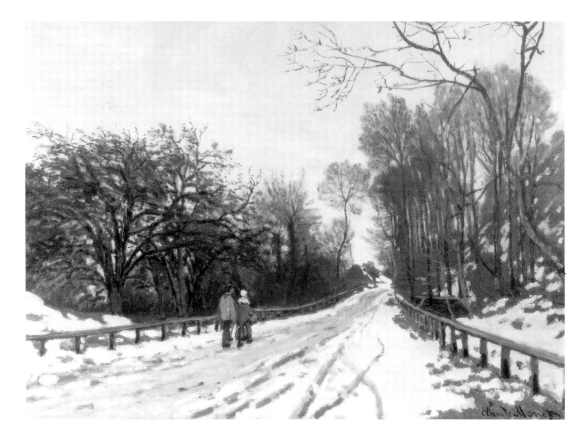

5. Claude Monet, *Road to the Farm, Saint-Siméon, Honfleur,* c. 1867, oil on canvas, 21½ x 31¼ in. (54.6 x 79.4 cm), Courtesy of the Fogg Art Museum, Harvard University Art Museums, Cambridge, Massachusetts, Bequest of Grenville L. Winthrop (1943.260).

6. E. Loydreau, *Effet de Neige*, 1853, salt print from a paper negative, 5⅞ x 8⅝ in. (14.8 x 21.8 cm), © Société Française de Photographie, Paris.

underscore that the painting is, for the most part, a memory of a very fleeting experience. Moreover, the shadows tell us that *The Magpie* depicts a particular moment in time. Within minutes the angle, length, and color of the shadows on the snow will have changed. In addition, the mood projected by the snowscape will have shifted, and the bird will have disappeared. While on one level the image seems to be a precise record of a particular experience, on another we must recognize it as a fiction. Surely the bird did not sit patiently for the artist as he painted, nor did Monet have a camera with fast color film to provide a fairly accurate aide-mémoire.[8]

Regardless of how and where Monet executed *The Magpie*, it is undeniably one of the most appealing images ever produced by an Impressionist painter. It is at once a record of a particular moment and a vision of a landscape that is unspoiled, pristine, and beautiful. Moreover, as is true of most *effet de neige* paintings, this work is unencumbered by messages about the ferocity of nature or the cycle of life. There are no shattered tree trunks or suggestions that winter marks the end of life. On the contrary, *The Magpie* celebrates a moment of transcendent beauty. Although unintended, it offers a polar opposite to Caspar David Friedrich's famous image of snow, ice, and the brute forces of nature, *Sea of Ice (The Wreck of the 'Hope')*, 1824 (fig. 7), the allegorical content of which is Wagnerian in scope. In contrast, Monet's snowscape exists 'in the difficulty of what it is to be' (*pace* Wallace Stevens).[9] Like most Impressionist paintings, it asks nothing of the viewer, which is very likely a reason that it is so appealing to modern audiences. Moreover, *The Magpie* offers an image of unequivocal peace and tranquillity of the kind that has proven particularly elusive in the modern urban and industrial world. It is perhaps not a coincidence that much later in his career, Monet sought to create works that the critic Gustave Geffroy, one of the artist's closest friends, described as paintings intended to appeal to viewers 'in search of distraction from social life, alleviation of fatigue, and love of eternal nature.'[10]

Not all *effet de neige* paintings are as positive as the images created by Monet and Sisley. Gauguin's *The Seine at the Pont d'Iéna, Snowy Weather*, c. 1875 (cat. 61), for example, is strikingly beautiful in its depiction of the lowering sky and winter light, but the scene is uninviting, chilling, and bleak. Nevertheless, Gauguin has captured the appearance and mood of a snowy Parisian day along the Seine with extraordinary accuracy, and he has done so without any apparent commentary. The mood and the meaning are inherent. Likewise, Caillebotte depicts the snowy rooftops of a residential neighborhood in Paris (cat. 59). The atmosphere is heavy, damp, and cold. Soft, blue light permeates the scene, which is punctuated by the rhythms of rooftops, dormers, windows, and chimneys. To the

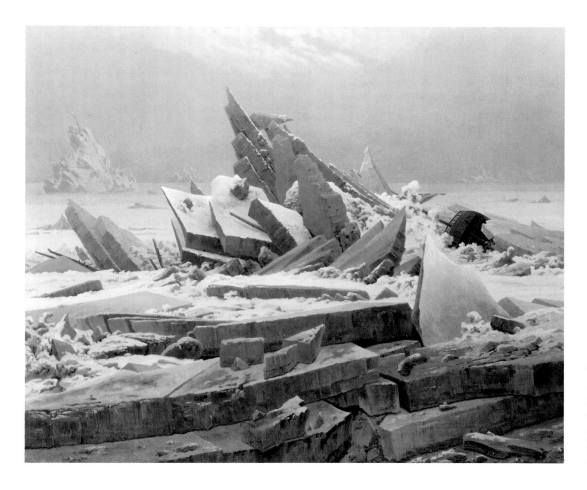

7. Caspar David Friedrich, *Sea of Ice (The Wreck of the 'Hope')*, 1824, oil on canvas, 38½ x 50½ in. (97.7 x 50.3 cm), Hamburger Kunsthalle, Hamburg.

modern eye there will be a hint of *La Bohème* and the romance associated with living in a garret apartment in Paris, but for the most part Caillebotte has done nothing more than record the visually rich appearance of the rooftops of Paris blanketed with snow. The view is as objective as Gauguin's of the Seine at the Pont d'Iéna, but in each case the viewer feels the artist's passionate interest in the mood and feeling of the scene. There is a strong undercurrent of romanticism that is not often associated with 'painters of modern life' and 'the new painting.' In addition, each artist seems driven by the need to express visual truths that previous generations would have found banal and unworthy as the subjects of serious paintings.[11]

As attitudes toward style and subject began to change in the early 1880s, the Impressionists, with the notable exception of Monet, began to lose interest in winter landscapes. Pissarro, Sisley, Caillebotte, and others painted occasional winter scenes, but only Monet continued to produce *effet de neige* paintings with the same level of fascination and determination. In the early 1880s he painted a remarkable series of works that depict ice floes on the Seine (cats. 18–20) and seem to anticipate his later interest in water lilies floating on the water. In 1885 he painted *Frost* (cat. 22), a remarkable performance of virtuoso brushwork despite a very limited palette. The modernity of the image is

8. Paul Cézanne, *Melting Snow, Fontainebleau,* c. 1879–80, oil on canvas, 29 x 39⅝ in. (73.5 x 100.7 cm), The Museum of Modern Art, New York, Gift of André Meyer.

astonishing. Indeed, in 1891 he produced a group of grainstacks in the snow in Giverny that are among the greatest winter landscapes in the history of art (cats. 23–26).

Monet's images of grainstacks in the snow are little concerned with the realism and naturalism of the winter landscapes of the 1870s. Moreover, they stand apart from even the most daring of the winter scenes that he painted in the early 1880s (cats. 21, 22). Their compositions vary, and the range of color in each tends to be decidedly different, although certain works seem to be near variants. Perhaps the greatest importance is that each painting seems to project a particular mood. Exactly how to interpret this feeling is impossible to determine, but at the time of the first exhibition of a group of grainstacks at the Galerie Durand-Ruel in 1891, Gustave Geffroy suggested that the images embody significances above and beyond mere depictions of haystacks in a field during different seasons and at different times of day:

> They first appear during the calm of beautiful afternoons....[A]s evening approaches the light on the downside of the hills has turned blue, the ground is speckled, the day is dappled with purple, their contour is silhouetted with an incandescent line. Then there are the multicolored, sumptuous, and melancholy festive days of autumn....Later still, under an orange and red sky, darkness envelops the haystacks, which have begun to glow like hearth fires.

Veils of tragedy—the red of blood, the violet of mourning—trail around them on the ground and above them in the atmosphere. Finally it is winter, with its threatening sky and the white silence of space; the snow is lit with a rosy light shot through with pure blue shadows.

With all of its faces, this same place emits expressions comparable to smiles, frowns, serious looks, mute amazement; they express force and passion, moments of intoxication. Here nature's mysterious enchantment murmurs incantations of forms and color.[12]

The implication, of course, is that Monet's paintings of grainstacks are expressions of, or correspond to, certain human emotions or interior states of feeling. In other words, they are objectifications of subjective truths.

From the beginning of the Impressionists' fascination with the visual effects of landscapes covered with snow, the tendency to associate *effet de neige* paintings with certain moods must have been very strong. The exaggerated sense of solitude and quiet that is often associated with a snowfall lends itself to interpretation, but authors and critics seldom attempt to attribute meanings to these paintings. There is, after all, no documentary

9. Léon Germain Pelouse, *January: Cernay, near Rambouillet*, c. 1887, oil on canvas, 35⅜ x 46¼ in. (89.8 x 117.4 cm), The Metropolitan Museum of Art, New York, Gift of Mabel Schaus, 1887.

10. Harry Callahan, *Chicago*, c. 1950, gelatin silver print, 7 9/16 x 9 9/16 in. (19.2 x 24.2 cm), Courtesy of PaceWildensteinMacGill, New York.

evidence to suggest that the artists intended anything other than a depiction of visual phenomena. That a snowfall is capable of calming the excitement and urban energies of the city of Paris (cat. 60), or drawing our rapt attention to a wide range of effects of color and light that never linger long in a snow-covered landscape (cats. 23, 24, 26), is perhaps all we need to know. There are no mysteries to unravel and no complex iconographies to decode. Although snowscapes appealed only marginally to artists such as Cézanne (fig. 8), others created images of winter landscapes rivalled by few, if any, painters since the late nineteenth century. Understandably, creating images that are often dominated by a restricted range of muted colors and broken whites did not appeal to all the Impressionists or their academic counterparts (fig. 9). In addition, the commercial possibilities for such pictures were very limited. Perhaps it is not a coincidence that during the twentieth century snow-scapes have been of less interest to painters than to photographers, especially those who have limited themselves to black-and-white film (fig. 10). Nevertheless, as this exhibition makes clear, the Impressionists' *effet de neige* paintings are among their most remarkable images. Within the history of early modern art, these works include some of the most beautiful, daring, and experimental paintings created during the second half of the nineteenth century.

Snow

What silence, shattered by the simple sound of a shovel!…

I awake, greeted by this fresh snow
Which penetrates to the core of my precious warmth.
My eyes open to a day of obdurate whiteness
And my languorous body cringes at its purity.
Oh! how many snowflakes, during my sweet absence,
Must the dark skies have given up during the course of the night!
This pure desert that fell soundlessly from the darkness
Has blanketed the features of the beguiling earth
Beneath this ample whiteness so secretly accumulated
And melds it into a faceless, voiceless place.
Where the eye, disoriented, is drawn to rooftops
Hiding their treasure of ordinary life
Barely offering the promise of a wisp of smoke.

Paul Valéry (1871–1945)[13]

NOTES

1. Erwin Panofsky, *Early Netherlandish Painting, Its Origins and Character*, Cambridge, Massachusetts, 1964, 65: '[T]he February picture [in *Les Très Riches Heures du duc de Berry*] shows a group of peasants huddled in a pitifully inadequate cottage and warming themselves at the fire (the smoke of which is clearly visible against a cold gray sky)....It is in this miniature that we encounter the first snow landscape in the history of painting.'
2. Wolfgang Stechow, *Dutch Landscape Painting of the Seventeenth Century*, London and New York, 1968, 82.
3. Information communicated to the author by the staff of the Musée d'Orsay, October 1997.
4. D146.
5. Françoise Heilbrun, *Les paysages des Impressionnistes*, Paris, 1986, 10. It is also worth noting that the only documented instance of an Impressionist artist using a photograph of a snowscape in connection with the execution of a painting is Cézanne's *Melting Snow, Fontainebleau* (fig. 8); the photograph is reproduced in Rewald, 1996, vol. 1, 273.
6. See Wallace Stevens, 'Not Ideas about the Thing but the Thing Itself,' in *The Collected Poems of Wallace Stevens*, New York, 1964, 534.
7. D95.
8. For a slightly different interpretation, see Gary Tinterow in Tinterow and Loyrette, 1994, 250–51: 'It is unlikely that the masterful *The Magpie* was painted entirely out-of-doors, but it was no doubt begun outside, and the essential aspect of the picture was to reproduce, as faithfully as possible, the experience of being outdoors and watching the play of cool shadows on the snow warmed by raking sun. The fact that Monet brought the surface to a consistent finish, while retaining the sense of fluid and informal brushwork, indicates that he wanted to make this work a proper "tableau."'
9. Wallace Stevens, 'Notes Toward a Supreme Fiction,' in Stevens, *Collected Poems*, 1964, 381.
10. Gustave Geffroy, 'Les Paysages d'eau, ou les nympheas' (1909), in *L'Art et les Artistes*, n.s., no. 11 (November 1920), as quoted in Charles S. Moffett, *Monet's Water Lilies*, New York, 1978, 11.
11. For a different interpretation, see Thomas P. Lee, in J. Kirk T. Varnedoe and Thomas P. Lee, *Gustave Caillebotte: A Retrospective Exhibition*, exh. cat. Houston: Museum of Fine Arts, 1976, 133: 'A specific happenstance in nature such as rain, or in this case snow, is fertile ground for the impressionist. It provides the *modus operandi* for depicting a scene, always lending a desired sense of temporaneity to a canvas. To this impressionist tenet, Caillebotte holds fast. However, he always passes over the temporal, atmospheric effect in favor of a more consuming quality. Just as the rain in the Chicago painting [*Rue de Paris, temps de pluie*, 1877] enables Caillebotte to focus on umbrellas and draw our attention to the pavement, the snow in this painting is the means by which he can accentuate the form of the roofs and gables of the dormer windows.'
12. Gustave Geffroy, 'Claude Monet Exhibition,' in *L'Art dans les Deux Mondes* (9 May 1891), as quoted in Stuckey, 1985, 163–64.
13. The translation of 'Neige' is by Charles S. Moffett and Johanna Halford-MacLeod. Paul Valéry considered including 'Neige' in the book of poems titled *Charmes* (1922). However, it was not actually published until 1939 when it appeared in *Mélange*. The French text is: *Quel silence, battu d'un simple bruit de bêche!… / Je m'éveille, attendu par cette neige fraîche / Qui me saisit au creux de ma chère chaleur. / Mes yeux trouvent un jour d'une dure pâleur / Et ma chair langoureuse a peur de l'innocence. / Oh! combien de flocons, pendant ma douce absence, / Durent les sombres cieux perdre toute la nuit! / Quel pur désert tombe des ténèbres sans bruit / Vint effacer les traits de la terre enchantée / Sous cette ample candeur sourdement augmentée / Et la fondre en un lieu sans visage et sans voix. / Où le regard perdu relève quelques toits / Qui cachent leur trésor de vie accoutumée / A peine offrant le vœu d'une vague fumée.* Copyright estate of Paul Valéry.

Monet, Japonisme, and Effets de Neige

Eliza E. Rathbone

After Corot, Claude Monet is the artist who has made the most inventive and original contribution to landscape painting....Among our landscape painters [he] was the first to have the boldness to go as far as the Japanese in the use of color....Let us now watch Claude Monet as he takes up his brush. To do so we must accompany him into the fields and face being burnt by the blazing sun, or we must stand with him knee-deep in snow—for despite the season he leaves his studio and works outdoors, under the open sky.

Théodore Duret, 1880[1]

Of all Monet's works it is perhaps his *effets de neige* that most immediately and specifically evoke his known admiration for Japanese prints. It may be simply that certain aspects of Japanese Ukiyo-e woodcuts—their striking compositions, simplified contours, vivid color, and the immediacy with which they suggest nature in every aspect of every season of the year—find no counterpart in Western painting before Monet. It may also be that the world described by the Japanese artists is the world of everyday life, not symbolic, anecdotal, or burdened with social or political commentary, but simply observed. In these observations, no season, no time of day, no aspect of human experience or the natural world went unnoticed.

In Western art, despite the precedent of sixteenth- and seventeenth-century Netherlandish painting, the least explored of all nature's manifestations was the subject of snow in its myriad aspects. The Impressionists, and above all Monet, determined to record the complete spectrum: deep snow in brilliant sunshine, creating the bluest of blue shadows; snow under a low, gray winter sky that shrouds nature in a single tonality; landscapes so deep in snow that all details are obscured, evoking a silent world; even snow melting along a country road at sunset; or, perhaps most striking, a sky filled with snow falling. Of all the Impressionists, Monet painted the largest number of snowscapes and the greatest variety of site, time of day, quality of light, and quality of snow itself. He was not only interested in a relatively traditional conception of a snowy landscape, but he found beauty in unexpected phenomena of winter. He brought to his snowscapes his desire to experiment both with new technique and with formal invention. Only in the realm of nineteenth-century Japanese prints could Monet find a variety of compositional approaches to snowscapes and a poetic interpretation of the subject that could be continually relevant and inspiring to his own.

OPPOSITE
Claude Monet, *Boulevard Saint-Denis, Argenteuil, in Winter* (detail cat. 11), 1875, oil on canvas, 24 x 32⅛ in. (60.9 x 81.5 cm), Museum of Fine Arts, Boston, Gift of Richard Saltonstall.

When Monet died, he left behind in his house at Giverny an extraordinary personal collection of Japanese woodcut prints (fig. 1). These are the images that he chose to live with, and they covered virtually every wall in his house. A total of 231 prints constitute the collection he assembled over a period of decades; they hang in bedrooms and hallways, upstairs and down. In his dining room alone he had fifty-six prints, many double- or triple-hung.[2] His embrace of Japanese art and culture extended, of course, to the remarkable garden that he created at Giverny, with its pond, water lilies, and Japanese footbridge, which showed his talent for choosing aspects of Japanese art and culture to incorporate into his creative purpose. Here he could exist in a world of his own invention that combined elements of East and West and provided him with endless motifs for his final years. Although Monet's paintings, like his world, are ultimately more Western than Eastern, they constantly remind us of his delight in the Japanese aesthetic.

While Monet's admiration for Japanese prints is indisputable and widely recognized, the degree to which these prints influenced his own work is variously interpreted by scholars. While some feel that a case for direct, even specific, influence can easily be made, others believe that Monet and his fellow Impressionists only found in these woodcuts reaffirmation of a path they had already taken. When did Monet first discover Japanese prints, and what conclusions can we draw from a study of his art in light of this enthusiasm? We do not know precisely when he first saw them or when he began to collect them. However, his interest in and awareness of Japanese prints came first and could have been sufficient to have some effect on his work. Monet himself recalled that he first encountered them while living in Zaandam, Holland, in 1871.[3] He later revised his

1. Utagawa Kuniyoshi, *Snow at Tsukahara on the Island of Sado*, c. 1835, woodblock, 8 x 13¼ in. (20.3 x 33.6 cm), Claude Monet Foundation, Giverny.

recollection, stating that it had been earlier, but considerable uncertainty surrounds any precise earlier date.[4] It seems likely, however, that he would have been aware of Japanese prints by the mid-1860s and certainly conscious of the first occasion when Japanese art was formally and extensively presented in Paris at the Exposition Universelle of 1867, which established a fashion for things Japanese.

Commodore Matthew Perry's trip in 1854 to Japan reopened its ports to the Western world and in so doing opened the door to travel and cultural exchange that altered the history of Japan's relations with the United States and Europe. After two centuries of isolation, Japan became a subject of enormous fascination, and as Westerners traveled to Japan, so the Japanese left to explore the West. By 1859 they were arriving in increasing numbers in Paris. As early as 1856, Félix Braquemond discovered Hokusai's *Manga* and introduced fellow printmakers to this art. Another source suggests that facsimiles of Japanese woodcuts were made in Paris as early as 1861 by a printer called Caillet in the rue Jacob.[5] By the early 1860s several shops carrying Japanese wares had opened in Paris, including La Porte Chinoise and L'Empire Chinois.[6] According to Ernest Chesneau, writing on 'Le Japon à Paris' for the *Gazette des Beaux-Arts*, it was the artists and men of letters who first embraced Japanese art and who established a taste for Japan in the French capital.[7] Enthusiasm for this newly discovered culture caught on quickly. Having begun in artistic circles, it soon spread to fashionable households.

The excitement over Japanese art began with decorative arts, and by the 1860s a widespread and keen interest in objects from porcelain to screens, kimonos to fans, had taken hold in Paris. The art of the period attests to it in abundance. A famous example, Manet's 1868 *Portrait of Emile Zola* (Musée d'Orsay, Paris) depicts the writer seated at a desk with a Japanese screen behind him and a print of a Japanese wrestler on the wall, and confirms the presence and importance of these works in avant-garde artistic circles. A fascination with Japan informed not only the art of Whistler and Manet, but that of every artist who felt compelled to bring some token of the Japanese *folie* to the studio. Such accoutrements made their way into many a conservative portrait or interior. Chesneau reported that an enthusiasm for things Japanese was sweeping through all the studios.[8] The *Société japonaise du Jinglar*, a group of artists and writers including Philippe Burty, Zacharie Astruc, Félix Braquemond, and Henri Fantin-Latour, gathered monthly to dine *à la japonaise*, off plates with Japanese motifs, and drinking wine like Sake. Hachette's bookstore was filled with books describing voyages to Japan, and Japanese themes infiltrated the theater, the opera, and the ballet. By 1878, describing the Exposition Universelle, Chesneau observed: 'We have seen in a very short time the consignments in the Japanese section on the Champ de Mars carried off by our collectors at fabulously high prices. It's no longer a fashion, it's infatuation, it's madness.'[9]

Japanese mania reached a crescendo in the 1880s and 1890s, and by 1893 there were so many fervent collectors ('les fervents de Japonisme') that according to *Le Figaro Illustré*,

Japanese objects had become more difficult to collect. In the same issue, the situation was described, 'Tout est au Japonisme à present.'[10] Certainly among the intelligentsia, however, the movement was well established by the time Philippe Burty called it 'Japonisme' in 1872.[11] Against this backdrop of intense discovery and delight in the Japanese aesthetic, the art of Monet and the Impressionists emerged.

As early as 1874, so thoroughly had the aesthetic of Japan penetrated the thinking and responses not only of artists but of writers and critics, that when Jules Castagnary reviewed the first Impressionist exhibition on 29 April of that year, he referred to 'the epithet of Japanese, which was applied to them [the Impressionists] at first.' He went on to say that a more appropriate characterization would be 'Impressionist.'[12] It is revealing that these artists' work was labeled Japanese as a way of defining its novelty even before the term 'Impressionist' was thought of. In both cases, it appears to have been Monet's work that Castagnary had specifically in mind. Interestingly enough, in the same article he remarked upon Monet's *Boulevard des Capucines* (cat. 8) and a vantage point from which to view it that he 'couldn't find.' While he may have been commenting upon Monet's exceptionally spontaneous execution of the work and its sketchy appearance, the artist's viewpoint, looking down on the boulevard, was also an element of its novelty. It is precisely such a composition seen from an elevated point of view that owed a good deal to the ideas that had begun to emerge from a familiarity with Japanese prints.

Monet's snowscapes of 1865 (cat. 1) and 1867 (cat. 2) show little evidence of Japanese inspiration. By 1874, however, elements of a Japanese approach seem to have entered his thinking. Since no records exist of the precise dates when Monet acquired his Japanese woodcuts, it is impossible to ascertain at what point he may have seen or owned any specific work. Rather, the prints cited here are to be considered examples of works that he might have seen at any time before he acquired them. Moreover, many aspects of their composition and choice of subject generally characterize Japanese prints, and therefore could have been observed by Monet in other works. For example, the composition of Hiroshige's *Two Ladies Conversing in the Snow* (fig. 2), which looks both down on the river that flows through the center of the image and up the snowy embankment to the side, bears comparison with Monet's *Boulevard Saint-Denis, Argenteuil, in Winter* of 1875 (cat. 11). In both scenes the composition is clearly organized in three sections, the central one establishing spatial recession and leading the eye into depth as the passages on either side return the eye to the surface, bringing the subject to the immediate foreground. In the work by Hiroshige, the third figure that proceeds through the snow on the right is cut off by the frame in a manner that we associate with photography but which is typical of many Impressionist works that owe a great deal to Japanese ideas. The motif of the bridge used to create a bold or dramatic composition, so common in Japanese art, was also embraced enthusiastically by certain Impressionists, especially Monet and Sisley. These artists found many of their subjects on the river Seine, where they had an ideal opportunity to apply the

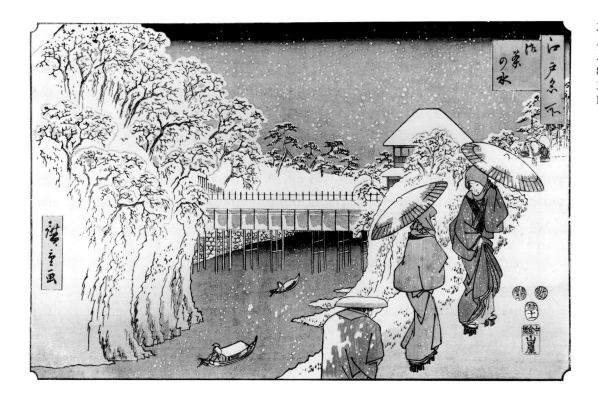

2. Utagawa Hiroshige, *Two Ladies Conversing in the Snow*, 1853, woodblock, 8⁹⁄₁₆ x 13⅜ in. (21.8 x 33.9 cm.), Claude Monet Foundation, Giverny.

Japanese inspiration to the subject of bridges, frequently depicted in Japanese woodcuts.

In the early 1870s, therefore, we see increasing evidence in Monet's painting of his interest in Ukiyo-e composition and subject matter. By this time Monet was presumably building his own collection of prints. In 1878 Chesneau described Monet, along with Edouard Manet and Fantin-Latour, as one of the artists who had formed personal collections of Japanese woodcuts.[13] Monet continued to acquire Ukiyo-e prints, and his collection was formed over many years. From the 1870s until after the turn of the century, Samuel Bing provided an important source of Chinese and Japanese art, and in 1892 Edmond de Goncourt wrote that he encountered Monet 'often at Bing's, in the little attic with the Japanese prints.'[14] Among writers who collected Japanese prints, he noted Edmond and Jules de Goncourt, Champfleury, Burty, Zola, 'l'éditeur Charpentier' (Georges and Marguerite Charpentier, who were also important collectors of Impressionist painting), Henri Cernuschi, Duret, and Emile Guimet. In the same year, 1878, Théodore Duret, who knew many of the Impressionists, described in no uncertain terms the influence of Japanese art on their painting: 'It required the presence of Japanese prints for one of us to dare to sit by the edge of a river and juxtapose a bright red roof, a white fence, a green poplar, a yellow road and blue water on a canvas. Before Japan, this was impossible. The painter always lied.' And he stated that Japanese art 'could not help but impress artists with open minds and it strongly influenced the Impressionists.'[15]

Admittedly, Duret had been an admirer of Japanese art since he first encountered it in London at the International Exhibition of 1862. He made two trips to the Orient,

including Japan, in 1863 and 1871. The latter voyage, with Cernuschi, was a buying trip that formed the nucleus of the Musée Cernuschi in Paris. Duret, author of a book entitled *Voyage en Asie* (1874) as well as a booklet, *Les Peintres français* (1867), was also a collector of Impressionist paintings and Japanese books and prints. A close friend of Manet, he did not meet Monet until 1873, when Pissarro made the introduction. By the time he wrote *Les Peintres impressionistes* in 1878, he had acquired quite a number of Impressionist paintings and greatly admired Monet.[16]

In addition to describing the importance of the Japanese example to the Impressionists, Duret acknowledged Gustave Courbet, Manet, and Camille Corot as fathers of Impressionism for their introduction of 'spontaneous methods of painting' and their 'study of broad daylight.' Of the three, Manet was most engaged by the new Japanese aesthetic, but Courbet and Corot devoted much more of their artistic energies to landscape, and it is revealing to compare their work with Monet's. There is no doubt that Corot and Courbet (especially Courbet), as well as Eugène Boudin and Charles-François Daubigny, were major early influences on Monet's art. Of them all (even Daubigny, who painted a number of winter landscapes), it was Courbet who set the most visible example as a painter of snowscapes.

Courbet painted numerous scenes of snowy landscapes. Between 1856 and 1876, he completed more than eighty-four.[17] By 1867 he had already painted thirty-six 'paysages de neige,' including approximately twenty during the previous winter of 1866–67. About seven of these were included in the one-man show that he mounted on the Place de l'Alma

3. Gustave Courbet, *The Poor Woman of the Village*, 1867, oil on canvas, 34 x 50⅛ in. (86.3 x 127.4 cm), Private collection, Switzerland, courtesy of Galerie Schmit.

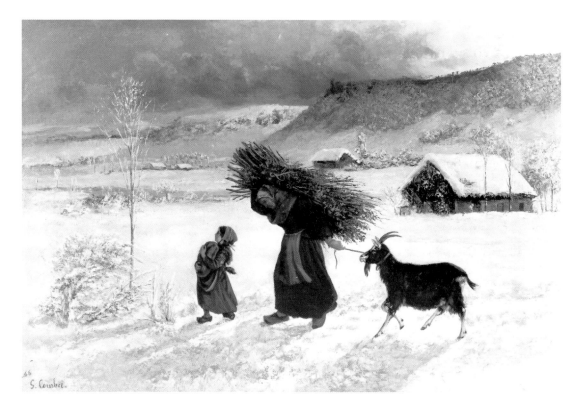

to coincide with the Exposition Universelle. Courbet by this time had an international reputation. His work was collected and on view in Boston as early as the 1860s,[18] and he was well known, even notorious, in France. His winter landscapes often included stags, deer, and fawns in the snow—subject matter that held no special interest for Monet—but they also sometimes had a human subject. Among those works exhibited at the Place de l'Alma in 1867 was *The Poor Woman of the Village* (fig. 3). In this painting a poor woman trudges through a bleak landscape bent forward under the weight of a large bundle of sticks. She leads a goat on a tether, and a small child goes before her. Two small houses are seen in the distance, but no other living thing disturbs the cold winter scene. The painting suggests a narrative beyond the immediate image. The wood will make a fire to ward off the cold for a time as limited as the kindling itself. In a single painting Courbet created a universal image of human survival in winter, a timeless allegory that we can just as easily imagine coming upon in painting or sculpture of several centuries before. Using a picturesque convention that focuses on the simple peasant life, Courbet virtually personifies winter in a traditional way.

How different is the Japanese Kunisada's vision of winter (fig. 4). This print was owned by Monet and also revolves around a female subject. In this case, however, the woman is a well-dressed prostitute who, accompanied by a dog, walks in the falling snow, her head covered by a loose scarf that she tries to secure, in a provocative way, with her teeth.[19] She glances down momentarily at her dog, who appears to look devotedly up at her. This is an informal, fleeting moment that the artist might have glimpsed in daily life. However symbolic or prototypical such an image might be in Japan, from the distance of another culture, it would appear lively, contemporary, a true slice of life rather than an traditional concept of winter. In spite of differences of culture, technique, and context, Monet's innovative work *The Red Cape* (cat. 4), is far closer in spirit to this image than to Courbet's *The Poor Woman of the Village*.

The saleability of Courbet's conception, however, is evidenced in the work of Paulène Bourges (an artist lost to us today), specifically her *Winter* which gained admission to the Salon of 1872 (fig. 5). Bourges depicts a woman and child with an enormous bundle of twigs and branches trailing on the ground behind, marching across the landscape, followed by an old woman (perhaps to suggest three generations), also bearing kindling. Hardly as forceful in imagery or as substantial in technique as Courbet's painting, Bourges' work nevertheless drives home the newness of Monet's vision and the extent of his break with Courbet. While her *Winter* is based entirely on existing convention, in terms of both subject matter and execution, Monet's idea in *The Red Cape* (fig. 6) is startling in its originality and inspired by a unique personal visual experience. For Monet, as for Kunisada, the informality of any given work and the engagement in a moment in time were directly related to the fact that this was one of many aspects of winter to be depicted, not winter symbolized or summed up in a single statement. Monet's interest was in the transitory aspects of experience, a fleeting moment.

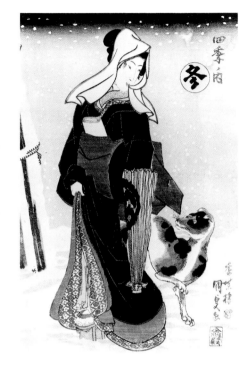

4. Utagawa Kunisada, *Winter*, undated, woodblock, 13¾ x 9⅜ in. (35 x 23.8 cm), Claude Monet Foundation, Giverny.

Monet was a consummate composer of images. To succeed with an art inspired by such transitory phenomena of light, movement, and change, and executed in varied, visible brushstrokes with a commensurate speed, he had to be. Although his work was often painted on site and captured as accurately as possible his visual perception, he altered, edited, and added to his compositions, giving them a structure that was imposed as well as perceived. Over and over again Monet's paintings display a clarity and power of design that speaks to his tendency to structure his vision around vertical, horizontal, and diagonal elements inherent in the subject.

While Monet must have found in Japanese woodcuts innovative compositional structures, he also presumably found in them confirmation of other pictorial ideas, not only in their choice of and approach to subject matter, but also in their use of certain elements. Just as a remarkable print in Monet's collection, Hiroshige's *Asakusa Ricefields during the Cock Festival* (fig. 7), could have prompted him to think of framing his entire subject through a window as he did in *The Red Cape*, so a Japanese approach to winter landscape may have inspired *View of Argenteuil—Snow* (cat. 10). Various aspects of Japanese winter scenes suggest correspondences in Monet's work, specifically the use of the umbrella and, often coincidentally, the depiction of falling snow.

Monet's collection of Ukiyo-e prints included at least twelve snow scenes; half of these show snow falling. Precipitation was rarely shown in Western art, yet in Japanese art it was simply included among the descriptions of weather and the elements. It seems unlikely that the emergence of depictions of rain and snow in Impressionist painting could be a mere coincidence. Pissarro, who painted *effets de pluie* as well as *de neige*, remarked,

5. Paulène Bourges, *Winter*, c. 1872, dimensions and present location unknown, photograph courtesy of Roger-Viollet, Paris.

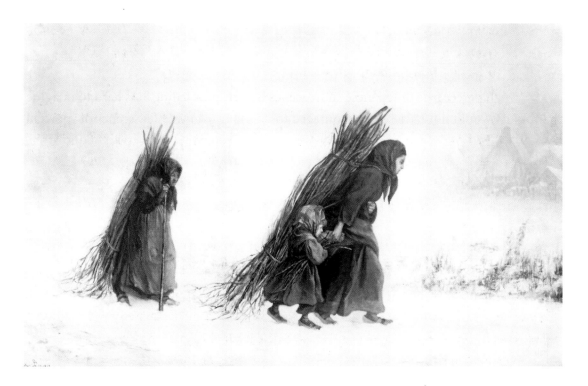

RIGHT
6. Claude Monet, *The Red Cape*, 1869–70 or 1871, oil on canvas, 39 x 31½ in. (99 x 79.3 cm), The Cleveland Museum of Art, Bequest of Leonard C. Hanna Jr., 1958.39 (cat. 4).

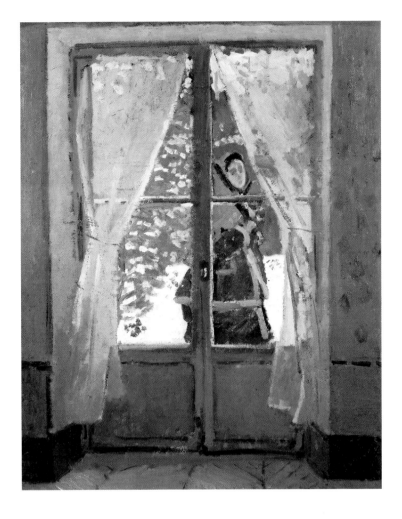

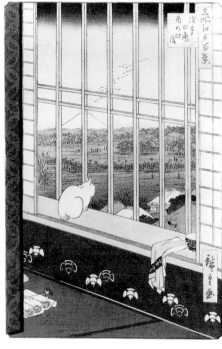

FAR RIGHT
7. Utagawa Hiroshige, *Asakusa Ricefields during the Cock Festival*, 1857, woodblock, 13¼ x 9 in. (33.8 x 22.9 cm), Claude Monet Foundation, Giverny.

'These Japanese confirm my belief in our vision.'[20] Van Gogh declared outright the Japanese example in his famous copy of Hiroshige's *A Sudden Shower over Ohashi and Atake*, an image of people hurrying over a bridge in a downpour.

A high percentage of Japanese snow scenes depict snow falling. It is hard to imagine that Monet would not have been encouraged to paint his own very few scenes of snowfall (cats. 9, 11) without the inspiration of Ukiyo-e prints. He might have known of one of the rare instances in Western art, Pieter Brueghel the Elder's *The Adoration of the Kings in the Snow* (fig. 8), in which large white flakes descend eternally on this Biblical scene transported to the Netherlands.[21] And certainly nineteenth-century popular illustrations included such descriptions of snowfall.[22] In these images, however, a kind of graphic perfection characterizes each falling flake, while Monet's are varied and irregular and exist in a nearly palpable atmosphere of light and air. Even a snowfall itself might be steady and silent (cat. 9) or blustery with swirling flakes, as in *Boulevard Saint-Denis, Argenteuil, in Winter* (cat. 11). Here the various tilts of the umbrellas convey the activity of the scene as pedestrians hurry along the boulevard attempting to shield themselves from the driving, billowing snowflakes. Ukiyo-e prints abound in such representations, including another

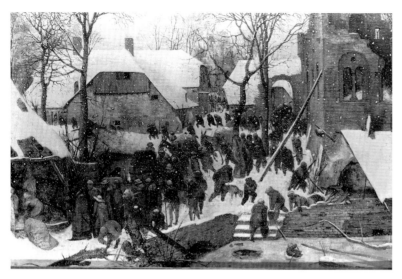

8. Pieter Brueghel the Elder, *The Adoration of the Kings in the Snow*, 1567, oil on canvas, 13¾ x 21⅝ in. (35 x 55 cm), Sammlung Oskar Reinhart 'Am Römerholz', Winterthur.

one in Monet's collection, Kunisada's *Abundant Snowfall at the End of the Year* (fig. 9). Here too the umbrella becomes an expressive artistic element. In Japanese prints, every aspect—the way an umbrella is held, by whom (servant, man, or woman)—can express mood, relationship, or attitude. The tilt or angle of the umbrella suggests the direction and severity of the precipitation (rain or snow) and therefore contributes to the depiction of particular weather as a whole. The contour of the umbrella itself was fully explored as a graphic device in countless Japanese prints, and is often part of the overall pictorial play of shapes.[23]

Monet's approach shares with the Japanese a wide range of mood. While his *Boulevard des Capucines* (cat. 8) is almost festive in its lively depiction of a city street full of people, his *Débâcles* (cats. 18–20) impress upon us an ultimate loneliness and fragility of man in the face of nature. On the one hand, Monet's *The Magpie* (cat. 3) offers a positive, even joyful, view of a winter's day in which the snow-filtered and reflected brilliance of the sunshine is complemented by the stillness of the landscape, reinforced by the foil of a solitary bird. On the other hand, *Lavacourt in Winter* (cat. 13) is a frozen and uninviting landscape, so seemingly inhospitable that we find it hard to imagine the artist at work in such a desolate and chilling setting.

Yet from all accounts, Monet ventured out in precisely such circumstances to capture his 'effects.' Ukiyo-e prints were clearly produced indoors, often based on sketches made in nature. The Japanese artists' uniform and schematic presentation of snow or rain is quite different in character from the Impressionists' evocation of atmosphere itself and their emphasis on perception. Monet's absolute commitment to *plein-air* painting and the many depictions of him painting out of doors constitute a kind of manifesto. He was a leader in this regard and the only one of the Impressionists to be frequently depicted at his easel in a *plein-air* setting—whether on his famous studio boat, which allowed him to study the light on the water wherever he wished to be, or simply in his own garden. As the first of the Impressionists to paint snowscapes, he continued to make exceptional efforts to record his visual perceptions as truly as possible. To achieve this ideal he went to considerable, even extreme, lengths. When a work was not completed in a single session, he often sought to return to a specific view and quality of light, only to find it irretrievably altered by weather. He would complain about the rain changing the color of the river, and in early spring he grumbled, 'this darned rain is going to turn everything green.'[24] In January 1885, he wrote to his dealer Paul Durand-Ruel, 'I am in the snow up to my neck; I have a whole series of paintings in progress; I have only one fear, that the weather may change.'[25] In January of the following winter, he again wrote to him from Giverny, 'I am working in the snow.'[26] Several years later, in 1889, he wrote to Alice Hoschedé, expressing his astonishment and distress

at a sudden snowstorm in late March, 'It's most distressing, it's snowing today....It's snowing just enough to interfere with my work, but not enough to tempt me to represent it...and yet if it goes on snowing after lunch, I will try to make something of it.'[27]

Monet's commitment to *plein-air* painting was aided by a constitution usually hardy enough to sustain it. An account from the 1860s (see cat. 2) describes a vision of the artist, out in temperatures below freezing, bundled into three overcoats, a heater at his feet and standing at his easel in order to capture *en plein air* precisely what his eye observed. In his 1878 *Les Peintres impressionistes*, Duret wrote, 'Winter is here. The impressionist paints snow. He sees that, in the sunlight, the shadows on the snow are blue. Without hesitation, he paints blue shadows. So the public laughs, roars with laughter.'[28] By December 1895, however, when Monet accepted an invitation to Norway to paint its snowy landscape (choosing it over Venice), his reputation was established and he was well known as a painter of snowscapes. As luck would have it, the winter was bitterly cold and snowy. Monet is said to have painted outside in temperatures of minus thirty degrees Celsius (approximately twenty-two degrees below zero Fahrenheit).[29] His letters attest to his humor and hardiness. On 26 February 1896, he wrote from Norway to Gustave Geoffroy, 'Dear friend, a brief note just to assure you of my fate, so that you don't suppose that I have died from the cold....I have never suffered, to the great amazement of the Norwegians, who are more sensitive to the cold than I am!' He concludes his letter, 'Everything is frozen and covered with snow. One should live here for a year in order to accomplish something of value....I painted today, a part of the day, in the snow, which falls endlessly. You would have laughed if you could have seen me completely white, with icicles hanging from my beard like stalactites.'[30]

Half of the paintings Monet made in Norway are of Mount Kolsaas, a site that provided him with the closest comparable subject to Mount Fuji, whose profile is so well

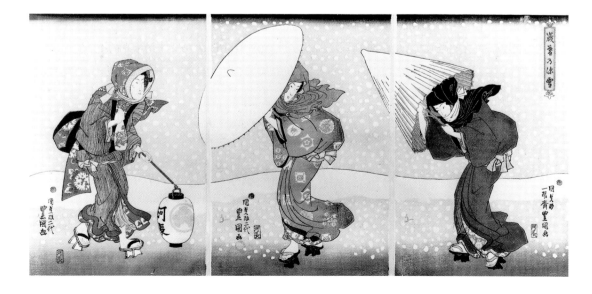

9. Utagawa Kunisada, *Abundant Snowfall at the End of the Year*, n.d., woodblock, 14⅛ x 30¼ in. (35.8 x 76.8 cm), Claude Monet Foundation, Giverny.

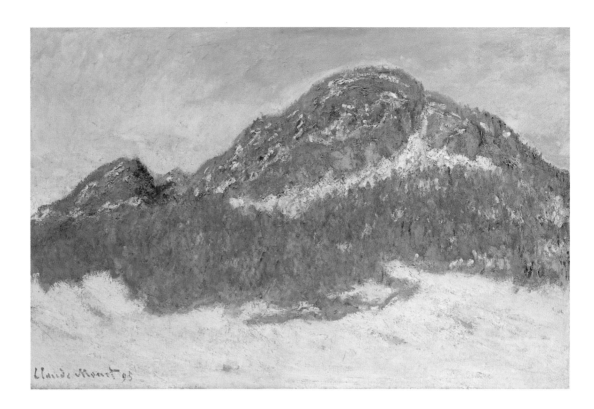

10. Claude Monet, *Mount Kolsaas, Norway*, 1895, oil on canvas, 25½ x 39½ in. (64.8 x 100.3 cm), photograph courtesy of Christie's Images, New York.

known through the woodcuts of Hokusai and Hiroshige.[31] Indeed, Hokusai's series of views of Fuji seem to have been in the back of his mind. He wrote from Norway to Blanche Hoschedé, describing similarities he perceived between the Norwegian landscape and that of Japan, even saying, 'I am working on a view of Sandviken that resembles a Japanese village; then I'm doing a mountain that one sees from everywhere here and which makes me think of Fuji-Yama.'[32]

Yet, once confronted with so close a parallel, we find that Monet's paintings bear little comparison with the Japanese views of their mountain. Monet's works were perceived at the time as 'portraits' of Mount Kolsaas, which invariably occupies most of the composition. The mountain, it was observed, 'looked like a human being. He painted [it] as though it were many different figures.'[33] In Monet's paintings the mass of the mountain towers before us; its physical presence is reinforced by the physicality of the painted surface (fig. 10). In the nearly countless views of Fuji by Hokusai and Hiroshige, the mountain may be the central subject but more often is seen from a seemingly infinite variety of perspectives. The viewer travels through a highly varied landscape, sometimes perceiving Fuji just beyond a cliff and across the sea, and other times from a point much closer. While Fuji is in some views confronted head-on, in others it is included in a broader view, an ever-present feature of the landscape, its jagged volcanic peak crowning its familiar silhouette. In Monet's images of Kolsaas, the very facture of the painting, the artist's impulse and the nature of the medium, distinguishes it, like all Monet's paintings, from the flat, unmodulated colors of the Japanese woodcuts.[34] The variety of brushstroke and the

sensuous, spontaneous quality of the painted surface have a physical presence essential to Monet's art. The paintings evoke specific atmospheric effects not only observed but experienced by the artist *en plein air*. His translation of visual sensation into paint on canvas and the liveliness of the surface itself provide perhaps a Western analog to the vision of life, movement, and change that is intrinsic to the art of Ukiyo-e and that appealed to Monet so much. But Japanese prints and Impressionism shared more than the brilliance and truthfulness of color noted by Duret. Indeed, it may be in part because of the new facture of Impressionist painting—its dabs of pure color, absence of traditional norms of line, shading, and perspective—that the search for a new alternative compositional structure became so important. The art of the 'floating world' of Ukiyo-e woodcuts offered an inventive approach to composition, brilliance of color, and fresh subject matter from everyday life. It had a profound influence, sometimes hidden and sometimes overt, on the paintings of Monet and the Impressionists.

NOTES

1. Théodore Duret, 'Le Peintre Claude Monet', 1880, quoted in Stuckey, 1985, 70–71.
2. Geneviève Aitken and Marianne Delafond, *La Collection d'estampes japonaises de Claude Monet*, Paris, 1983, 175, 176.
3. Ibid., 15.
4. Two years before he died Monet said he had bought his first Japanese print at Le Havre in 1856, ibid., 15.
5. Jacques de Caso, '1861: Hokusai rue Jacob,' in *Burlington Magazine* (September 1969), 564–65.
6. Aitken and Delafond, *La Collection d'estampes japonaises*, 1987, 17, 18.
7. Ernest Chesneau, 'Le Japon à Paris,' in *Gazette des Beaux-Arts* 18 (September 1878), 386. 'C'est par nos peintres en réalité que le goût de l'art japonais a pris racine à Paris.' See also Gabriel P. Weisberg, ed., *Japonisme: Japanese Influence in French Art, 1854–1910*, Cleveland, 1975.
8. Ibid., 387. 'L'enthousiasme gagna tous les ateliers avec la rapidité d'une flamme courant sur une piste de poudre.'
9. Ibid., 388.
10. *Le Figaro Illustré* 37 (April 1893), xv.
11. Philippe Burty, 'Japonisme,' in *La Renaissance artistique et littéraire* (May 1872–February 1873).
12. Jules Castagnary, 'The Exhibition on the Boulevard des Capucines,' in *Le Siècle* (29 April 1874), quoted in Stuckey, 1985, 58.
13. Chesneau, "Le Japon à Paris," 1878, 387.
14. Edmond and Jules de Goncourt, *Journal. Mémoire de la vie littéraire, 1851–1896*, quoted in Aitken and Delafond, *La Collection d'estampes japonaises*, 1983, 18. Edmond de Goncourt met Monet 'souvent chez Bing, dans le petit grenier aux estampes japonaises.'
15. Théodore Duret, 'Les Peintres impressionistes', Paris, 1878, quoted in Stuckey, 1985, 65–67.
16. Distel, 1990, 59–60, 66.
17. Robert Fernier, *Gustave Courbet, catalogue raisonné*, Lausanne and Paris, 1978. There are eighty-four snowscapes recorded in the catalogue raisonné and four additional works 'completed in collaboration.' I am grateful to Alexandra Ames for her research.
18. See Perry T. Rathbone, preface to *Gustave Courbet 1819–1877*, Philadelphia and Boston, 1960, 11–12.
19. Aitken and Delafond, *La Collection d'estampes japonaises*, 1983, 92.
20. Camille Pissarro, letter to his son Lucien, dated 1893, quoted in Colta Ives, *The Great Wave: The Influence of Japanese Woodcuts on French Prints*, exh. cat. New York: The Metropolitan Museum of Art, 1974, 19.

21. The precise whereabouts of this painting in the nineteenth century is not known. It was acquired by Dr. Oskar Reinhart from Paul Cassirer in Berlin in 1930. Before Cassirer it was in the collection of Count Saurna in Schleswig, Germany. Its prior provenance is unknown except for its presence in the Paris collection of Count Jahrbach, who died 6 March 1695. It was inventory number 243. Some of Count Jahrbach's paintings are in the Louvre. Peter Brueghel the Younger made at least thirty copies of this painting. Although I have been unable to determine if any of the copies show snow falling, further research is required to determine more precisely how they were done and where they were in the nineteenth century. My thanks to Dr. Peter Wegmann, Director of the Museum Oskar Reinhart am Stadtgarten, Winterthur, for his assistance.
22. See 'Winter Weather Chronology.'
23. See Julia Meech, *Rain and Snow: The Umbrella in Japanese Art*, exh. cat. New York: Japan Society, 1993.
24. Letter to Alice Hoschedé, 21 March 1889, quoted in Wildenstein, 1979, vol. 3, ltr. 923: 'Cette maudite pluie va tout verdir....La Creuse se grossit de nouveau et redevient jaune.'
25. Letter to Paul Durand-Ruel, 20 January 1885, quoted in Venturi, 1939, 298.
26. Letter to Paul Durand-Ruel, 24 January 1886, quoted in Venturi, 1939, 307: 'Je travaille dans la neige…'
27. Letter to Alice Hoschedé, 22 March 1889, quoted in Wildenstein, 1979, vol. 3, ltr. 924: 'J'étais plein d'espoir pour aujourd'hui mais que faire avec cette neige… si elle persiste après le déjeuner, je tenterai quelque chose.'
28. Duret, 1878, quoted in Stuckey, 1985, 66.
29. Reuterswärd, 1948, quoted in Stuckey, 1985, 168.
30. Letter to Gustave Geffroy, 26 February 1895, quoted in Stuckey, 1985, 169.
31. According to Joel Isaacson, 'Geffroy found the results [Monet's paintings of Mount Kolsaas] aesthetically satisfying and suggested a parallel to Japanese prints in terms of a freedom from the conventions of linear perspective. He was probably thinking primarily of these views of Mount Kolsaas, which seem to present a Western equivalent to Hokusai's close-up views of Mount Fuji, and, perhaps, some of Hiroshige's scenes of mountains in the snow.' Isaacson, 1978, 224.
32. See Tucker, 1989, 172–74.
33. Hermann Bang (1857–1912), Danish journalist and novelist, quoted in Stuckey, 1985, p. 170.
34. It is interesting in this regard to note that Monet did not make prints, unlike his colleagues Manet and Pissarro, whose interest in Japanese prints is more clearly revealed in this medium.

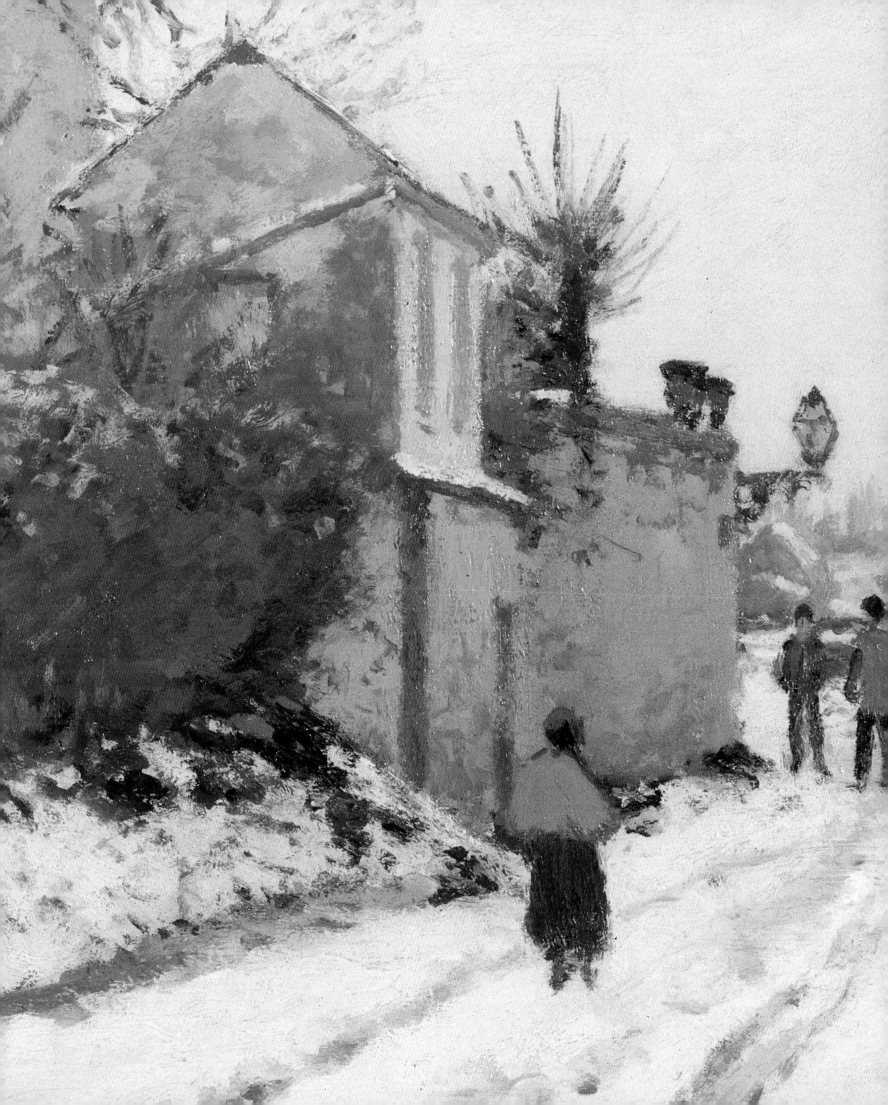

Camille Pissarro:
A Dedicated Painter of Winter

Katherine Rothkopf

There is nothing more cold than the sun at its height in the summer, contrary to what the colorists believe. Nature is colored in winter and cold in the summer.

Camille Pissarro, 2 May 1873[1]

Throughout his career as a landscape painter, Camille Pissarro produced just over one hundred canvases during winter in which snow, or a variant of snow such as hoarfrost, white frost, or ice, plays a major role in the composition. Some of these works depict quiet village roads with townspeople on their way to or from their homes, while others concentrate on the heavy, peaceful quality of a large snowfall on an isolated farm. These views were painted in a variety of locations, including Louveciennes, London, Pontoise, Montfoucault, Osny, Eragny, and Paris, and include suburban, rural, and city images of life in the late nineteenth century. Pissarro began this long series of works during the winter of 1868–69, and he continued to address the many complex issues of representing snow on canvas with oil paint for over thirty years, until the end of his life in 1903. Despite the wide variety of content and composition, these winterscapes have in common Pissarro's enduring love of nature, his great fascination with light and shadow, and his interest in humanity; in virtually every painting he includes a reference to human-kind— a house, a fence, or a small figure.

The Impressionists are, of course, best known for their landscapes of late spring and summer, full of lush foliage and fragrant flowers. However, this group of modern painters also explored these landscapes on less pleasant days of the year, when weather conditions were cold and uncomfortable. Claude Monet, Alfred Sisley, and Pissarro were the three Impressionist artists who produced the most snowscapes. Despite the relatively large number of winter paintings in Pissarro's œuvre (approximately eight percent of his entire output), he is not best known for his snowscapes, and little has been written about them. He was, however, extremely proud of his *effet de neige* compositions and exhibited at least nine views of winter at the eight Impressionist exhibitions held periodically from 1874 to 1886.[2] With relatively few breaks over the course of his career, probably caused by warmer weather conditions (1880–81, 1883, 1896) or by changes in painting style (1886–88), Pissarro painted at least one canvas each year that celebrated the quiet and serene quality of a frosty winter day, and therefore he can be considered the most dedicated winter painter of the Impressionists. These views vary from true *effets de neige*,

OPPOSITE
Camille Pissarro, *Street in Pontoise (Winter)* (detail cat. 37), 1873, oil on canvas 21¼ x 29 in. (53.9 x 73.6 cm), Private collection.

with substantial amounts of snow on the ground, to lighter forms of winter precipitation, such as frost.[3]

Pissarro's first winter landscape was *The Banks of the Marne in Winter* (fig. 1) of 1866. It is not an *effet de neige* painting, as there is no snow on the ground, but it is the first example of his interest in depicting the coldest season of the year. Pissarro was still under the influence of the Barbizon painters in terms of style and general subject matter, but he had shed the anecdotal and narrative quality of their landscapes for a more honest view of the natural world.[4] The painting was accepted into the Salon of 1866, and the critic Emile Zola had a positive reaction to this new style:

> M. Pissarro is an unknown and probably no one will talk about him….Thank you, Monsieur, your winter landscape refreshed me for a good half hour, during my trip through the great desert of the Salon. I know that you were admitted only with great difficulty and I congratulate you on that. Besides which, you ought to know that you please nobody and that your painting is thought to be too bare, too black. So why the devil do you have the arrant awkwardness to paint solidly and study nature so honestly?
>
> Look, you chose wintertime, you have there a simple bit of road, then a hillside in the background and open fields to the horizon. Not the least delectation for the eye. A grave and austere kind of painting, an extreme care for truth and rightness, an iron will. You are a clumsy blunderer, sir—you are an artist that I like.[5]

1. Camille Pissarro, *The Banks of the Marne in Winter*, 1866, oil on canvas, 35¾ x 58¾ in. (91.8 x 150.2 cm), The Art Institute of Chicago, Mr. and Mrs. Lewis Larned Coburn Memorial Fund, 1957.306.

Louveciennes and London

Pissarro became immersed in painting snowscapes three years later. He and his family had moved from Pontoise to Louveciennes, a close suburb of Paris that was easily accessible by train. Monet and Renoir lived nearby, and Pissarro probably settled there to be close to his colleagues.[6] Although he may have painted his first snowscape during the winter of 1868–69 in the forest in Marly,[7] it was near his home on the route de Versailles in Louveciennes during the following winter that he became inspired by the infinite range of possibilities winter subjects offered. Much like Monet and Renoir, who had formed a close relationship during the previous summer when painting together at La Grenouillère, Pissarro and Monet worked together on a series of canvases that depict the route de Versailles, which runs through the center of Louveciennes. Pissarro and his family lived at 22, route de Versailles, and after a large snowstorm in December 1869, when Monet stayed with the Pissarro family, the two painters produced a remarkable collection of views of this street (see cats. 5, 6, 32, 33). In all of Pissarro's versions of this street blanketed with snow,[8] he included at least one figure walking on the road, making his or her way through town. This adds a narrative element to his works that one of Monet's two versions (cat. 6) does not have, as Monet left his canvas unpeopled and concentrated more on the drama of the sunset on the wintry landscape. Pissarro went on to produce several more views of the route to Versailles in different types of weather. This group of works by Pissarro and Monet looks forward to the series paintings that both men did as mature artists in the 1890s.[9]

Unlike Monet, who occasionally traveled to distant and exotic places for inspiration for his landscapes, Pissarro did not enjoy being away from home. He kept his painting trips to relatively close destinations in France (Rouen, Le Havre, Dieppe, Paris) or combined them with family or social visits (Montfoucault, London). When the Franco-Prussian War began during the summer of 1870, Pissarro and his family first escaped to Montfoucault, located in the Mayenne region on the border between Brittany and Normandy. There they were welcomed by Ludovic Piette, a fellow artist and intimate friend of Pissarro who owned a large farm. After several months, the family traveled to London, where they stayed for the remainder of the war.

While living in London, Pissarro was again inspired by the effects of winter weather. His colleague Monet had also fled to London during the war, but the two artists did not rekindle their creative collaboration of the previous winter. Instead they often met at museums in London and were impressed by paintings by Turner and Constable.[10] Pissarro later described their separate painting interests in London to Wynford Dewhurst, an English landscape painter: 'Monet worked in the parks, whilst I, living in Lower Norwood, at that time a charming suburb, studied the effects of fog, snow, and springtime.'[11] Pissarro painted at least four canvases of London under a blanket of snow; they vary from perspectival road views with figures walking in the road and with horse-drawn carts[12] to two views of a quieter part of suburban London without the hustle and bustle of a busy

2. Camille Pissarro, *Winter Scene*, 1879, gouache on paper, fan shape, 11 x 23 in. (27.9 x 58.4 cm), Museum of Fine Arts, Springfield, Massachusetts, The Robert J. Freedman Memorial Collection.

street.[13] Pissarro's great inspiration from his time working in London remained with him when he returned to France, as can be seen in the fan he painted eight years later (fig. 2), which includes portions of the landscape that he had painted in Upper and Lower Norwood.

Pissarro returned from London during the summer of 1871, only to find that his house on the route de Versailles had been ransacked and countless paintings had been destroyed. Estimates of how many works were lost range greatly, but it certainly is possible that some snowscapes, which may not have been as marketable as some of his other works for a general audience and therefore were not yet sold, may have been lost. Pissarro was able to rekindle some motifs from before the war, and he produced a record number of snowscapes during the winter of 1871–72 in Louveciennes. He returned to depicting the route de Versailles and other roads leading in and out of the town. In these works, Pissarro experimented with different types of perspective, varying the angle of the road to the picture plane in several examples.[14] During the early part of 1872, Pissarro produced *Louveciennes*, a painting that indicated a new and dramatic direction for his snowscapes (cat. 36). Rather than using the traditional composition of a road view, he limited his visual field to focus on a large tree and its dark, dominant shadows below. During his period in Louveciennes before and after the Franco-Prussian War, Pissarro was fascinated with the play of light and shadow, and he often included shadows of objects that did not appear in the painting itself. In fact, he was chastised two years later during the first Impressionist exhibition by the critic Castagnary for his seemingly arbitrary use of shadows: 'Pissarro is sober and strong. His synthesizing eye embraces at a glance the whole scene. He commits the grave error of painting fields…with shadows cast by trees placed outside the frame. As a result the viewer is left to suppose they exist, as he cannot see them.'[15] In *Louveciennes*, Pissarro also includes two buildings on the left side of the painting as a human reference in the landscape.

During the same productive winter of 1871–72, Pissarro painted *Chestnut Trees at Louveciennes*, now in the Musée d'Orsay, Paris (fig. 3). Here he addresses the increasing

popularity of towns along the Seine and the constant influx of the bourgeoisie into this formerly rural area in the Ile de France. In the painting, a woman and child, both well dressed, stand stiffly in the snow before a bright red country home with a well-tended garden and yard and are framed by chestnut trees.[16] This use of recognizable bourgeois figures and expensive houses rarely occurs in Pissarro's snowscapes, as he tended to focus on peasant figures.

In 1872, Pissarro received a commission from Achille Arosa, a wealthy collector, for a series of four large horizontal paintings of the four seasons to be placed above the doors in his home.[17] The first canvas, *Winter*, was painted in early 1872 in Louveciennes, and the three remaining canvases were completed in Pontoise. *Winter* (fig. 4), (see also cat. 54, fig. 1), Pissarro's quintessential view of the season, is a remarkably modern painting in which he has created a spare, panoramic view of the landscape near his home. It appears to have been painted from above, perhaps from a window on an upper floor of a house, and the viewer looks down on an enclosed garden and the landscape beyond. He has limited his palette to a few colors—brown, ochre, gray, blue, white, and a few highlights of red—that give a real feeling for the intense cold that occurs in winter. In a letter written to his son Lucien nearly twenty years later, when all four works were offered at auction for the first time, Pissarro cited *Winter* as the most successful of the group, perhaps revealing his preference for this season of the year.[18]

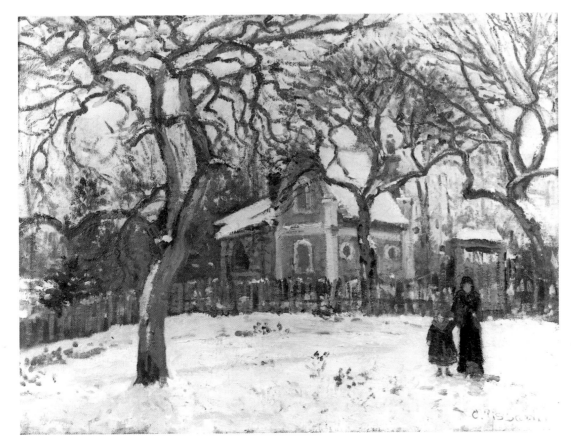

3. Camille Pissarro, *Chestnut Trees at Louveciennes*, c. 1872, oil on canvas, 15¾ x 21¼ in. (40 x 54 cm), Musée d'Orsay, Paris.

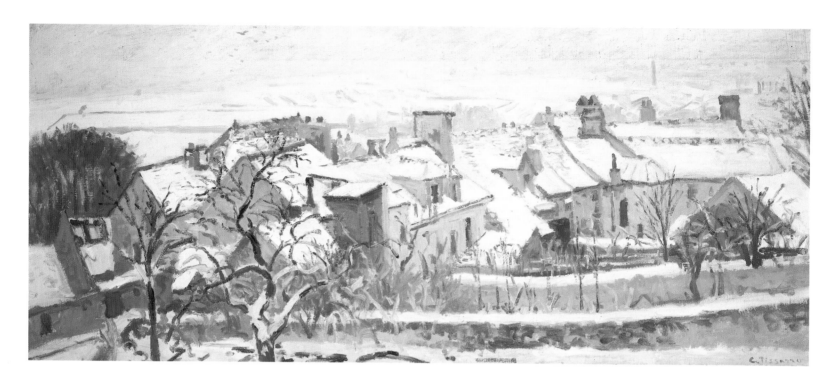

4. Camille Pissarro, *Winter*, 1872, oil on canvas, 21⅞ x 51⅞ in. (55.5 x 131.6 cm), Private collection, photograph courtesy Christie's Images, New York.

Pontoise

In August 1872, Pissarro and his family returned to the Pontoise area for the second time. There he explored the landscape extensively, focusing most of his attention on the small hamlet of l'Hermitage on the outskirts of Pontoise where he and his family lived for most of their ten years in the area.[19] Although Paris was the artistic center of France, Pissarro did not spend a great deal of time there until the end of his career. It was much more expensive to live in Paris, and Pissarro did not earn financial stability until the 1890s when he was settled in Eragny. For Pissarro, life in Paris was too hectic and uncomfortable, and after the Franco-Prussian War he was interested in painting life in suburban or rural France. His landscapes were created close to home, and he was focused on painting views of village streets (fig. 5), country meadows, and deserted lanes. Unlike some of his colleagues, who often did not include figures in their landscapes or did so as an afterthought, Pissarro continued to populate his snowscapes with figures that seem at home in his paintings and are performing a task or providing a service as they walk through town, do their chores, or tend to their gardens.[20]

His political interests may also have played a role in this conscious decision to live on the outskirts of Paris. As an anarchist, he may have wanted to live a simple, quiet life, away from the extreme stratification of society in Paris. He later wrote that he did not have to be a peasant in order to paint an honest landscape,[21] but he also seemed to have felt that he could not paint peasant life without living near them. Although Pontoise was not a utopian society—both bourgeois and peasant classes lived there—it provided the perfect solution for Pissarro. He could easily commute to Paris to sell his works and

visit his colleagues, but he lived more comfortably with those who worked the soil for a living.

Soon after Pissarro went to live in Pontoise, his colleague Paul Cézanne moved nearby to work with him. Cézanne was considerably younger than Pissarro, and looked up to the artist who was considered the 'dean of Impressionist painters.'[22] Many years after the two artists had worked closely together, Cézanne still considered Pissarro his teacher and commented, 'Until the [Franco-Prussian] War…I was a mess, I wasted my whole life. When I think about it, it was only at l'Estaque that I came to fully understand Pissarro—a painter like myself—a workaholic. An obsessive love of work took hold of me.'[23]

Pissarro urged Cézanne to abandon the savage and violent motifs of his early paintings and to invest all his pent-up energy in producing powerful landscapes out of doors. Soon after Cézanne's arrival in Pontoise, Pissarro wrote to Antoine Guillemet regarding his younger colleague's progress: 'Our friend, Cézanne, raises our expectations, and I have seen and have at home a painting of remarkable vigor and power. If, as I hope, he stays some time in Auvers, where he is going to live, he will astonish a lot of the artists who were too hasty in condemning him.'[24]

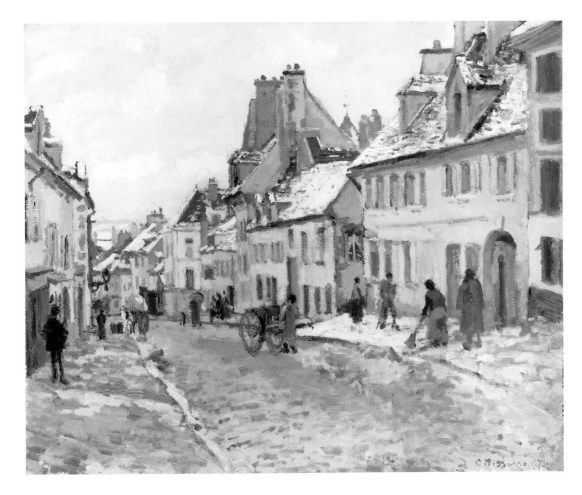

5. Camille Pissarro, *Pontoise, The Road to Gisors in Winter*, 1873, oil on canvas, 23½ x 29 in. (59.8 x 73.8 cm), Museum of Fine Arts, Boston, Bequest of John T. Spaulding.

Despite Pissarro's continued interest in *effet de neige* paintings in 1873, 1874, and 1875, Cézanne only produced one snowscape with his friend during his two-year stay in Auvers. Pissarro's *Street in Pontoise, Winter* (cat. 37) and Cézanne's *Snow Effect—Road to the Citadel at Pontoise* [25] feature the same street from slightly different points of view. Pissarro set up his easel behind Cézanne's vantage point and gives a longer view of the street and the large stone wall by the octagonally shaped citadel. Although the Cézanne version was stolen during World War II and its present location is unknown, a surviving black and white photograph (see cat. 37, fig. 1) shows that he included the wall on the right side of the road. In addition, Cézanne chose to leave out figures in his composition, whereas Pissarro added a touch of narrative with the figures of two men in conversation and a woman walking toward them.

Pissarro's interest in figures, as well as his general subject matter and techniques, changed when he began traveling to Montfoucault to visit his friend Piette. From the late summer of 1874 to the fall of 1876, Pissarro made three extended trips to Piette's house where, for the first time, he was really able to study rural nature. This shift in focus from suburban landscapes to true countryside motifs may have been stimulated in part by a letter from his friend and supporter Théodore Duret, who tried to advise the artist on a new direction:

> I maintain my opinion that rustic nature, with animals, is what suits your talent best. You haven't Sisley's decorative feeling nor Monet's fantastic eye, but you have what they have not, an intuitive and profound feeling for nature and a powerful brush, with the result that a beautiful picture by you is something absolutely definitive. If I had a piece of advice to give you, I would say: don't think of Monet or Sisley, don't pay attention to what they are doing, go your own way, your path of rustic nature, you will be going along a new road, as far and as high as any master. [26]

In response, Pissarro wrote:

> Thank you for your advice; surely, you must know that I have been thinking for some time about what you have been saying. What has stopped me from doing nature from life has simply been the lack of available models, not only to do pictures, but even to study the subjects seriously. Yet, it will not be long until I attempt to do some of it again; it will not be easy as you know that these pictures cannot always be done after nature, i.e. outdoors. This will be difficult. [27]

Pissarro played an integral role in the organization of the first Impressionist exhibition in the spring of 1874. Unfortunately, it was both a financial and a critical disappointment for the artists, who had hoped to attract new collectors and patrons. Pissarro's economic situation began to worsen, and after the death of his daughter Jeanne, Montfoucault

provided the perfect escape. He was able to experiment with new subject matter and techniques and to concentrate on painting the figure, as Duret had suggested, in a new way. It was much easier for him to find models there who would pose for him, and his financial worries were somewhat lessened while he and his family were living with Piette. In regard to his snowscapes, he was certainly not able to paint large figure paintings in the cold outdoors, but the nature of his small figures in the landscape changed. As Joachim Pissarro has noted:

> In contrast to his Pontoise figures, who always seem represented in movement on a path, either on their way from somewhere or toward somewhere else, Pissarro's Montfoucault figures are static; they stay where they are. Unlike Pontoise, a cross-road of paths, roads, walks, bridges, and railways, Montfoucault appears to be a place from which there is virtually nowhere else to go.[28]

The isolation in Montfoucault was a great inspiration for Pissarro's winter paintings. He did not paint with his friend and colleague Piette as he had with Monet and Cézanne, but instead chose to work alone. During the winter of 1874 in Montfoucault, Pissarro produced at least six *effet de neige* compositions and at least three more during the winter of 1875, a time when his interest in painting winter views was at an apex.[29] Unlike his snowscapes of Pontoise, these works do have 'rustic' images, including farm animals. Pissarro chose to feature aspects of the rough, hard conditions of winter life in this isolated rural village. His color scheme became more limited, with shades of gray, black, gold, sienna, and slate blue.[30]

As Pissarro had been living in the more rural hamlet of l'Hermitage since October 1873, he continued to follow Duret's advice during and after his Montfoucault period.[31] In at least one example from l'Hermitage, his figures are moved into the foreground, revealing his greater interest in incorporating them into the landscape (cat. 41). There he produced winter paintings in which peasants played an important role, as he concentrated on pre-modern agricultural images. During the latter part of the 1870s, probably due to a series of somewhat warmer winters, Pissarro's output of snowscapes decreased to only a few examples.

During the winter of 1879, he resumed painting *effets de neige* with vigor, and his motifs ranged greatly. For the first time, he painted a view of the busy outer boulevards in Paris filled with pedestrians and horse carts (fig. 6), a subject that recalled Monet's remarkably modern *Boulevard des Capucines* from six years earlier (cat. 8). In 1880, Pissarro returned to the city as inspiration in a beautiful pastel drawing, *Boulevard de Clichy, Winter, Sunlight Effect* (fig. 7), in which he depicts the emerging social and economic classes of Paris.[32] Both winter cityscapes prefigure the large and impressive series of Parisian views that Pissarro would paint in the late 1890s and early 1900s. At the same time, he continued to depict suburban themes of Pontoise in winter, as his favorite

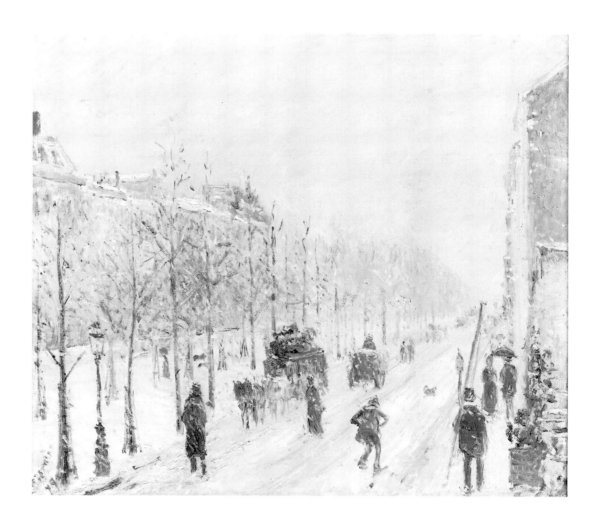

6. Camille Pissarro, *The Outer Boulevards: Snow Effect*, 1879, oil on canvas, 21¼ x 25⅝ in. (54 x 65 cm), Musée Marmottan-Claude Monet, Paris.

perspectival road views with figures and horse carts making their way through the snow, or as views of l'Hermitage, where he contrasts the cramped architecture of the buildings with the organic quality of the snow (cat. 44). In the early 1880s, Pissarro began to concentrate less on landscapes, and focused his attention on producing figure paintings with peasants in a landscape. Subsequently, his production of snowscapes temporarily decreased.

Osny and Eragny

After living and working in Pontoise for more than a decade, in late 1882 Pissarro decided that he and his family needed a change of scenery. He had created over three hundred views of Pontoise and its environs, and he sought new stimuli for his motifs. They moved to the nearby town of Osny, where they remained until early 1884. There Pissarro was again inspired by inclement weather, and he produced at least three *effet de neige* compositions of the local farms, trees, and the washhouse on the river.[33] In April 1884, the Pissarro family moved for the last time to the small town of Eragny, a tiny village sixty miles from Paris on the banks of the Epte River. Eragny is three kilometers from the market town of Gisors and fairly close to Giverny, where Monet lived.

During the winter of 1884–85, Pissarro produced snowscapes of his new home that range from village road scenes to panoramic views of the neighboring town, Bazincourt, painted from a second-floor window.[34] One of these paintings, *Snow Effect at Eragny, Road to Gisors* (cat. 45), depicts a road in Eragny covered in snow after a significant storm. Much as he had done at the start of his interest in painting snowscapes, Pissarro painted another version of the same composition that differs only in size and with the addition of figures in the road.[35]

In 1885, Pissarro, who had experimented with new techniques and subject matter throughout his career, met the younger artist Paul Signac. Signac later introduced Pissarro to Georges Seurat, who was experimenting in painting with complementary colors in a dot-like style. Pissarro was impressed with Seurat's technique and his interest in color theory, and he soon modified his own painting style to reflect that of his new colleagues, known as Neo-Impressionists or Pointillists. At the eighth and final Impressionist exhibition, he chose to exhibit with the Neo-Impressionists in a separate gallery from his former Impressionist colleagues.

This major change in philosophy and doctrine had a significant effect on the number of paintings that Pissarro was able to produce. Working in a Neo-Impressionist style, he

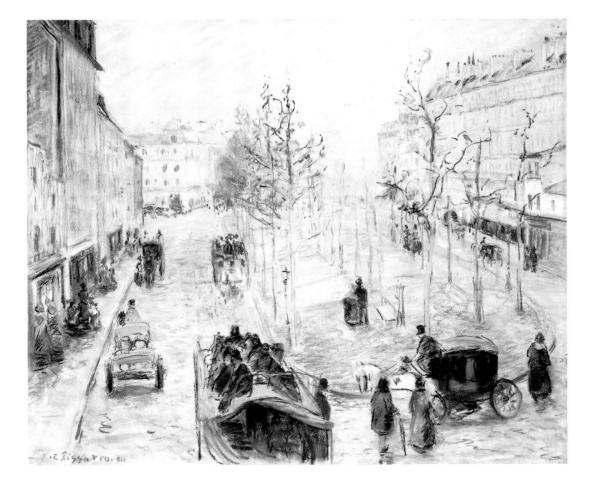

7. Camille Pissarro, *Boulevard de Clichy, Winter, Sunlight Effect*, 1880, pastel on paper, 23⅝ x 29⅛ in. (59.9 x 73.9 cm), Sterling and Francine Clark Art Institute, Williamstown, Massachusetts.

8. Camille Pissarro, *Morning Sunlight on the Snow, Eragny-sur-Epte*, 1895, oil on canvas, 32⅜ x 24¼ in. (82.3 x 61.5 cm), Museum of Fine Arts, Boston, John Pickering Lyman Collection.

was no longer interested in painting *en plein air*; instead, these new works were produced in the studio with much less influence from nature. As a result, his commitment to painting *effets de neige* was temporarily suspended for several years while he allied himself with the Neo-Impressionists. Another issue that changed Pissarro's attitude toward painting or sketching out of doors was his health. In September 1888 he was treated for an eye infection. This condition continued to affect him for the rest of his life, forcing him to limit his painting outdoors and to paint his landscapes from either a window in his home or in his studio.[36]

Pissarro returned to views of winter in 1890, and he slowly started to reintegrate them into his chosen motifs. By 1891, he began to reject the theories of Neo-Impressionism and reevaluate his Impressionist roots. In 1892, Pissarro's commitment to painting winter landscapes returned in force, as he produced at least six canvases that year that investigate the differing effects of frost, hoarfrost, and snow on the Eragny landscape outside of his home. This shift coincided with a very successful retrospective in 1892 at Galerie Durand-Ruel, which enabled Pissarro to free himself from the financial stresses of twenty-five years as an artist. With the help of a loan from Monet, Pissarro also purchased the home in Eragny where he and his family had lived for the past eight years.

In the early 1890s, Pissarro began to eliminate figures from his snowscapes of Eragny[37] and instead limited the ever-present human element in his paintings to the surrounding architecture or fences. He was particularly taken with painting the towns of Eragny and Bazincourt from the upper floors of his house. During this period he concentrated on the atmospheric effects of winter weather on this familiar landscape (cat. 46). He described his interest in the motif in two letters from the early 1890s: 'The weather's been very good recently…dry cold, hoarfrost and radiant sunshine, so I've begun a series of studies from my window;…at the moment the countryside's covered in snow, all three of us are busy at the windows on the unique and beautiful motif of Bazincourt.'[38] By 1895, however, Pissarro began to reintroduce the figure into his snowscapes in Eragny, and he continued to include them for the remainder of his career in both rural and urban views. *Morning, Sunlight on the Snow, Eragny-sur-Epte* (fig. 8) is an atmospheric tour de force, with a small female figure walking near a screen of trees and bushes after a light snowfall. In this painting, the figure seems absorbed into the enveloping winter *effet* and becomes one with nature.

Paris

During the last decade of his life, Pissarro dramatically changed the subject matter of his paintings. While he had spent almost his entire career producing images of rural and suburban life in small towns, in 1893 he began to paint views of cities—Paris, Rouen, Le Havre, and Dieppe—creating more than three hundred works in a ten-year period. In this remarkable collection of paintings, which can be grouped into eleven series, Pissarro returned to his lifelong interest in depicting the figure in his landscapes, as people walk, ride, labor, and promenade in his city views.[39] Unlike the people in earlier cityscapes by Monet and Caillebotte, those in Pissarro's works are not anonymous figures created by a few strokes of paint. In most cases, Pissarro makes them specific individuals from identifiable classes: bourgeois men, workers, soldiers, wealthy women, and working women.[40]

Of the four cities that Pissarro painted from 1893 to 1903, Paris was the location he favored most; he completed series paintings there in 1892–93, 1897, 1898, 1899, and 1900–1903.[41] On 15 December 1897 Pissarro wrote to his son Lucien regarding his upcoming trip to Paris and his inspiration for painting the city:

> I forgot to mention that I found a room in the Grand Hôtel du Louvre with a superb view of the Avenue de l'Opéra and the corner of the Place du Palais-Royal! It is very beautiful to paint! Perhaps it is not aesthetic, but I am delighted to be able to paint these Paris streets that people have come to call ugly, but which are so silvery, so luminous and so vital. They are so different from the boulevards. This is completely modern![42]

Pissarro stayed in Paris from 2 January to 28 April 1898 and produced fifteen paintings of three motifs for his Avenue de l'Opéra series.

Unlike his friend Monet, Pissarro did not have in mind an exhibition devoted to a series when he began painting these canvases. During his lifetime, only two of his series were exhibited as a group; a selection of the Avenue de l'Opéra works were shown at Pissarro's one-man exhibition at Durand-Ruel in June 1898, and his first series of Rouen paintings were exhibited in the New York galleries of Durand-Ruel in 1896.[43]

Snowscapes were an important part of his series paintings of Paris. For his Avenue de l'Opéra series, Pissarro did two snowscapes in early 1898,[44] both featuring the bustling large street filled with pedestrians and horse-drawn carriages. Of the two paintings, *Avenue de l'Opéra: Snow Effect* is a much more wintry composition. The people and carts on the avenue have already made numerous tracks in the snow that turn the fugitive white substance various shades of peach, mauve, and gray.

In late 1898, Pissarro made plans to return to Paris for another winter of painting, and he rented an apartment on the rue de Rivoli with views of the Tuileries Gardens:

> We have engaged an apartment at 204 rue de Rivoli, facing the Tuileries, with a superb view of the Park, the Louvre to the left, in the background the houses

9. Camille Pissarro, *The Pont-Neuf: Snow*, 1902, oil on canvas, 21¼ x 25⅝ in. (54 x 65 cm), National Museum of Wales, Cardiff.

on the quays behind the trees, to the right the Dôme des Invalides, the steeples of Ste. Clothilde behind the solid mass of chestnut trees. It is very beautiful. I shall paint a fine series.[45]

Pissarro produced twenty-eight paintings in his Tuileries series, fourteen in 1899 and fourteen in 1900. Because he had rented an apartment for an extended period, Pissarro had more time to concentrate on his series, and the larger space provided more windows and different views to use for his paintings. He produced four works that include winter precipitation, three paintings with snow, and one with frost.[46] His snowscapes from this series feature views of the Tuileries with the Louvre beyond, providing a new contrast between the nature of the gardens and the architecture of the buildings.[47]

On 14 November 1900 Pissarro moved to another location in Paris, the Place Dauphine on the Ile de la Cité, where he worked on two more groups of paintings, the Square du Vert-Galant and the Pont-Neuf series. He remained there through 22 April 1901 and completed what he called his 'série d'hiver,' which contained three snowscapes: one view of the Louvre and two views that included the Pont-Neuf.[48] After spending the summer in Dieppe, Pissarro returned to the Place Dauphine from 27 September 1901 to

21 January 1902 to paint more views of the Square du Vert-Galant and the Pont-Neuf (fig. 9). In his series depicting the bridge, Pissarro looked back to the early 1870s when his two friends and colleagues, Monet and Renoir, also painted this landmark after the Franco-Prussian War when the Impressionist style was still developing.

The Galerie Bernheim-Jeune held an exhibition of Pissarro's late work entitled 'Série des tableaux de C. Pissarro, 1901,' which opened on 15 February 1902, and Pissarro continued to paint views of these same subjects throughout that year. In early 1903, he produced his last snowscape, *The Louvre, Morning: Snow Effect*, a beautiful view in his series of paintings of the Louvre seen from across the river from his window on the Place Dauphine.[49] In these paintings of Paris, Pissarro alternated between depicting the transient, momentary, fast-paced world of the small figures that move through his cityscapes and the permanence of the city's architectural landmarks, the Louvre, the Tuileries Gardens, and the Pont-Neuf. He died on 13 November 1903 while working on another Parisian series, views of the Quai Voltaire.

Pissarro was an observer of both nature and human nature, and in his snowscapes one can see his fascination with both. His career was neatly divided into two parts: the rural scenes of Pontoise, Louveciennes, Montfoucault, and Eragny, and the urban views of Rouen, Dieppe, Le Havre, and Paris. As Gustave Geffroy wrote about Pissarro in his biography of Monet:

> There is a division within Pissarro's work, like a counterpoint where the painter of vegetable gardens, meadows, pathways, apple trees neatly planted in rows in grassy orchards, harvesters, haymakers, and stubble burners confronts this serene existence with the restlessness of the towns and with the somewhat mysterious beauty of capitals….He was the portraitist of the town, just as he had been of the village.[50]

Camille Pissarro's snowscapes changed dramatically in subject from their genesis during the winter of 1868–69 in Marly to their powerful conclusion in Paris in 1903. As with his other landscapes, he began in the suburbs of Paris, concentrating on the delicate balance between the rural past of the Ile de France and the encroaching industry that threatened to take it over. He chose to depict the subtle order of small French villages, with their quiet streets, well-kept homes, and allées of trees along the roads into and out of town. After moving to Pontoise and working closely with Cézanne, his compositions and technique became more inventive, and he created a wide variety of images that included snow. His experimentation with Neo-Impressionism sidelined him from painting from nature during winter, but in the early 1890s he returned to create some of his most subtle and sublime depictions of the coldest season of the year from his window in Eragny. In the late 1890s and early 1900s he traveled back to the city where he first met his Impressionist colleagues, and there he created more views of Paris than any other Impressionist painter, including many beautiful snowscapes.

Despite all of the changes in his œuvre, both geographic and stylistic, the one constant in all these winterscapes is Pissarro's commitment to painting man's relationship to nature. His colleague Monet, who painted more *effet de neige* compositions than Pissarro, produced numerous paintings of pure snowscapes that contain no references to the human experience. Monet's *Ice Floes* paintings of the winter of 1893–94 (cats. 27–30), which depict the Seine after a significant freeze followed by a thaw, and his series of views of Mount Kolsaas from a trip to Norway in 1895, are images of pure beauty that display the overwhelming power of nature, and of nature alone. Moreover, in more than half his earlier series of frozen riverscapes, the *Débâcle* paintings of the winter of 1880 (cats. 19, 20), Monet again celebrated both the beauty and the strength of the river in pure landscape form. Pissarro never created pure winterscapes like Monet, choosing instead to celebrate the relationship between nature and humankind in his snow paintings by always adding a human element—a house, a barn, a solitary figure, a fence, or a recognizable landmark. Over the course of thirty-five years as a painter of winter, Pissarro produced these images of city and village, field and forest, when conditions were the most difficult. For him, however, nature was at its most inspiring and colorful during the coldest time of the year, as can be seen in more than one hundred canvases. It is his lifelong dedication to exploring all the motifs of winter that distinguishes him among his fellow painters of *effets de neige.*

NOTES

1. Letter to Théodore Duret, 2 May 1873, quoted in P&V225.
2. In 1874, Pissarro exhibited *Hoarfrost, Ancienne Route d'Ennery, Pontoise* (P&V203). In 1876, he exhibited *Haze* and *Snow Effect at l'Hermitage, Pontoise* (P&V246, 238) and two unidentified works, *Snow Effect at Pontoise* and *Snow Effect, Osny Hill*. In 1879, he exhibited two unidentified paintings, *Snow Effect (Hill of Palais Royal)* and *Snow and Ice Effect (Sun Effect)*, and two snowscapes painted on fans, *Winter, Return from Market* (P&V1626) and *Winter Scene* (Museum of Fine Arts Springfield, Massachusetts, see fig. 2). For more information, see Berson, 1996.
3. His colleague Monet painted the largest number of winter scenes (more than 140) and is the best known Impressionist painter of *effets de neige*. As Monet took advantage of most significant snowfalls, his output of winter landscapes was often more sporadic, with occasional bursts of activity followed by periods without production. Monet lived longer and also produced more canvases during his lifetime, so his overall percentage of snowscapes is slightly less than Pissarro's (approximately seven percent). Sisley produced the fewest number of snowscapes of these three founding Impressionists (more than fifty, or about five percent of his total output).
4. Pissarro, 1993, 48–50.
5. Emile Zola, 'Mon Salon,' in *l'Evénement* (26 April–20 May 1866), quoted in Shikes and Harper, 1980, 70.
6. Lloyd, 1981, 40.
7. *Entering the Forest of Marly (Snow Effect)*, c. 1868–1869, B. and R. Rappaport Collection (P&V68).
8. Pissarro produced five views of the route de Versailles in the snow: P&V71–73; cats. 32, 33 (previously thought to have been produced in the winter of 1871–72; see cat. 33). Monet produced two views that have been identified as the route de Versailles in the snow: W147, 148 (cats. 5, 6).
9. Pissarro, 1993, 72.
10. Brettell, 1990, 150.
11. See Dewhurst, 1904, 31.
12. See P&V105 (cat. 34) and 108.
13. P&V106 and *Landscape Under Snow, Upper Norwood*, 1871, illus. in Pissarro, 1993, fig. 78.
14. See P&V130, 131, 142, 149.
15. Jules-Antoine Castagnary, 'L'Exposition du Boulevard des Capucines, Les Impressionistes,' in *Le Siècle* (29 April 1874), quoted in Moffett et al., 1986, 138.
16. Brettell, 1990, 103.
17. Christie's, New York, auction catalogue for Camille Pissarro's *The Four Seasons*, 5 November 1991, 24.
18. Letter to Lucien Pissarro, 9 May 1891, quoted in Rewald, 1981, 212.
19. Between 1866 and 1883, Pissarro produced at least three hundred paintings of Pontoise and its immediate surroundings. See Brettell, 1990, 1.
20. Ibid., 133.
21. Letter to Octave Mirbeau, 21 April 1892, quoted in Bailly-Herzberg, 1980–91, vol. 3, 217.
22. John Rewald, *Pissarro*, New York, 1963, 9–10.
23. P. Michael Doran, ed., *Conversations avec Cézanne*, Paris, 1978, 148.
24. Letter to Guillemet, 3 September 1872, in Bailly-Herzberg, 1980–91, vol. 1, 77, quoted in Shikes and Harper, 1980, 117.
25. Rewald, 1996, no. 195.
26. Letter from Théodore Duret, 6 December 1873, quoted in P&V, vol. 1, 26.
27. Letter to Théodore Duret, 8 December 1873, ibid., 27.
28. Pissarro, 1993, 139.
29. In 1874 he painted P&V281, 283–287; it is believed that P&V283 was begun in 1874 although it was signed and dated in 1876 (see cat. 40). In 1875 he painted P&V324, 326, 328.
30. Pissarro, 1993, 136.
31. Lloyd, 1986, 27.
32. Ibid., 261.
33. See P&V555, 622, 623.
34. See P&V631, 632, 656.
35. See P&V656.
36. Joachim Pissarro and Stephanie Rachum, *Impressionist Innovator*, exh. cat. Jerusalem: Israel Museum, 1994, 51.
37. This contrasts greatly with other paintings from this period without snow, in which Pissarro included figures in views of peasants in harvest scenes and at work in the fields.
38. Letter to Lucien Pissarro, 28 December 1891; letter to Esther Isaacson, 9 December 1892, quoted in Bailly-Herzberg, 1980–91, vol. 3, 175, 285.
39. For a fascinating survey of Pissarro's late series paintings, see Richard R. Brettell and Joachim Pissarro, *The Impressionist and the City: Pissarro's Series Paintings*, exh. cat. Dallas: Dallas Museum of Art, 1992.
40. Ibid., xxvi.
41. Ibid., 1.
42. Quoted in Rewald, 1981, 405.
43. Brettell and Pissarro, *Impressionist and the City*, 1992, xviii.
44. P&V1022 (Private collection), 1029 (Pushkin State Museum of Fine Arts, Moscow). For color reproductions, see Brettell and Pissarro, *Impressionist and the City*, 1992, cats. 66, 67.
45. Letter to Lucien Pissarro, 4 December 1898, quoted in Rewald, 1981, 431.
46. See P&V1103, 1124, 1128, 1130.
47. For color reproductions of two snowscapes from this series, see Brettell and Pissarro, *Impressionist and the City*, 1992, cats. 80, 82.
48. P&V1161, 1162, 1178; Brettell and Pissarro, *Impressionist and the City*, 1992, 125.
49. P&V1279; for a color reproduction, see ibid., cat. 101.
50. Geffroy, 1922, 265–66, quoted in Lloyd, 1981, 133.

Sisley, Snow, Structure

Joel Isaacson

Impressionism has a deciduous character. Nature may forfeit its coloristic splendor in winter, but for the Impressionist painter, committed to working outdoors, winter proved to be no deterrent; in fact, it had its advantages. Gone were the immature, seductive greens—gray, yellow, pistachio—of spring; gone the deep, plump greens of summer; gone the dazzle of autumn's variegated hues. What remained was white, gray, brown, black, icy blue—the orphans of the spectrum. But what was revealed was structure, nature's skeleton—the architecture of trees, of hedges; the outlines of things—houses, fences, posts, doors, windows, roofs. They take on new definition in winter's poverty; they feed the eye and the imagination in ways not possible in the more favored seasons. They appeal to the *structural* imagination of the painter and often serve as guide posts for the development of the composition. The vertical trunk of a tree, the ridge line of a roof, the edge of a road directed into space provide directions for the painter to follow. The diagonal edge of the road becomes an orthogonal, a line that establishes recession and can be made a key element of a perspective construction. A tree or a horizontal roof line may serve, along with other lines or forms parallel to them, to establish a horizontal-vertical grid that can be made to bring order and discipline to a painted composition.

Impressionist painters organized their paintings in just such traditional ways, but we, dazzled by their depictions of nature's abundance, by the gloriously colored and complexly interwoven surfaces of their paintings, have failed to see or adequately acknowledge the structures of Impressionist paintings. Winter's spareness may have, in this respect, a salutary effect; it may help to reveal the presence—and the strength and intelligence—of Impressionist approaches to composition.

Recognition of the deliberative underpinning of Impressionist landscape painting has been hampered by a number of factors. One reason is that, despite the ingenuity, and even occasionally the daring, with which the Impressionists composed their pictures, their basic methods were relatively traditional. The 1860s, the decade before their emergence as a group, had been a period of searching formal experimentation. Manet, in particular, had discovered ways to reinterpret some of the cardinal precepts of Western painting. He, and some of the future Impressionists in their more adventurous efforts, had sought to create what Emile Zola termed 'a new manner of painting,' and one of their principal targets was the orthodoxy of the perspective system as the basis for producing the illusion of space in painting. By the 1870s, however, the Impressionists' concern to explore issues of color and

OPPOSITE
Alfred Sisley, *Snow at Louveciennes* (detail cat. 49), 1874, oil on canvas, 22 x 18 in. (55.9 x 45.7 cm), The Phillips Collection, Washington, D.C.

notation—a more complex system of hue relationships and efforts to develop a flexible, fine-grained but texturally rich facture—came to overshadow other, perhaps more innovatory aspects of picture construction.[1] In addition, the early critical response to the movement very soon came to emphasize anti- or non-structural concerns, citing the element of spontaneity, for example, the painters' attempts, as it was seen, to capture the instant of perception, a momentary vision.[2] Moreover, by the 1880s, with shifts in direction by some of the Impressionists themselves, notably Renoir and Pissarro, and with the arrival of Neo-Impressionism, some critics came to see Impressionist painting as formless or even mindless (a concern for drawing and structure being traditionally associated with the intellect).[3] Still another reason would be the emphasis placed, in studies of modernism, on the opticality of Impressionism—its concentration on microstructure, the small scale and complex distribution of hues relatively close in value (neither too dark nor too light), and the consequent loss of the more bodily sense of three-dimensional form effected in traditional painting by chiaroscuro modeling and the perspective structuring of space.[4]

During the 1870s, then, in the work of the landscape painters, color experimentation came to take precedence over efforts to reinterpret the space of painting. Traditional perspective schemes, which had been actively questioned during the 1860s, reappeared (they had never actually been abandoned) along with other compositional devices that governed the order and disposition of forms within the composition. The principal organizing device was the grid, involving the coordination of horizontal and vertical lines and directions that referred to or repeated the basic orientation of the edges of the canvas. In developing a grid construction the painters tended to orient planes within the picture parallel to the plane of the canvas; in that way both the picture surface and its edges played an implied role in the organization of the painting. This was a traditional device that had been deployed to establish compositional coherence since the Renaissance, and it continued to be used for the same purpose by the Impressionists. Often the painters would, in line with traditional practice, try to interlock the grid system of surface reference with the spatial system of perspective (see the discussion of Monet's *The Seine at Bougival*, fig. 2, below). In other instances, perspective might be used almost as an expressive device, to add an element of dynamism to a composition (as in Sisley's *Footbridge at Argenteuil*, fig. 7). These efforts are discernible in the work of all the Impressionist painters, but are especially well represented in the paintings of Alfred Sisley, Claude Monet, and Camille Pissarro, whose works are featured in this exhibition.

The results of their structural concerns are there to be read in paintings from all seasons, but those results are especially well revealed in winter landscapes. I will start with winter, and then turn to works done throughout the year. Along with Monet, I will concentrate on Sisley, whom I find to be one of the most astute and refined but also one of the most adventurous formalists in the Impressionist camp. Sisley's sensitivity to ordonnance and compositional harmony is demonstrated beautifully in The Phillips

Collection's *Snow at Louveciennes* of 1874. *Snow at Louveciennes* (cat. 49) is a quiet picture. One can easily feel winter's silence in this small corner of nature; perhaps no greater sound is registered than a dull crunch underfoot as the village woman makes her slow advance along the snow-covered path. The picture's simplicity, its ability, somehow, to capture both the look and the feel, the very temperature of the setting encourages us to accept it as if it were nature itself—as if it just happened that way.

But of course it did not. Sisley, as any artist inevitably will do, interpreted nature through his temperament—his sensitivity, his taste, his predilections—as well as through his sense of form. Once reminded of this we can begin to discern some of the things Sisley found attractive in the subject and what he did to exercise control of it. We see the clear foreshortening of the garden path as it recedes beneath the woman's feet and the angled wedge of snow and fallen leaves in the garden at left. We can notice how the low garden fence—composed of rough twigs and branches, raggedy uprights of browns, grays, and copper—is developed in unspoken contrast to the high stone wall that borders the path at the right, with its light, broad strokes of peach and coral. As the path turns the corner sharply to the left, fence and wall assume a new orientation parallel to the picture plane;

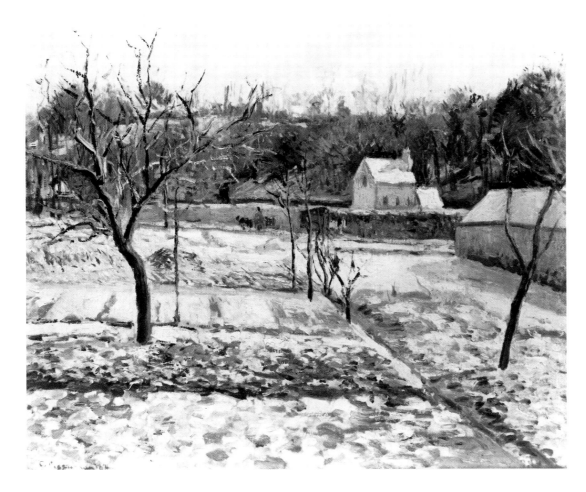

1. Camille Pissarro, *L'Hermitage, Effect of Snow*, 1874, oil on canvas, 21¼ x 25½ in. (53.9 x 64.7 cm), Courtesy of the Fogg Art Museum, Harvard University Art Museums, Gift of Mr. and Mrs. Joseph Pulitzer Jr.

together, they form a single unit, a horizontal rectangle with a smoothly painted upper register (now more dusty rose in hue) and a dry-brushed, striated lower zone.

Sisley pursues a play of contrasts and variations on the theme of the rectangle. Consider the two rectangular forms that mark the turning of the path: the heavily pigmented garden gate, an open rectangle articulated by diagonal crossing bars, and the broad, unbroken square of the carriage gate, whose coral hue presents a muted complement to the gray-blue-green of its garden counterpart. Open and closed, regular and irregular, textured and smooth, dark and light—Sisley seems to delight in such contrasts. We see evidence of that in the multiple and varied rectangular shapes of gables and dormers: from left to right, the black window framed in salmon; an elongated rectangle with russet framing pink; a splotch of black on the pink field; a near-square of Indian red bordering black; and high above, in the gable of the furthest house, an echo of black flanked by two dabs of coral.

Along with the distribution of rectilinear forms we find a play of minor triangles and diagonals. Different in function from the assertive, space-defining forms of the foreground—the canted garden triangle and the foreshortened path—they help to give definition to the descriptive forms of the houses beyond the stone wall: the angles of the pitched roofs; the inverted triangle, filled with the gray-brown scumble of snow-covered branches, between the two main houses; the inverted V-shapes of the gables; the triangles formed where the dormers meet the pitched roof at right. Stone wall, wood fence, garden gate, carriage gate, gables, dormers, rectangles, triangles—a blend of forms and functions, each unit different in shape and size, color and weight; forms that, despite their descriptive role, might seem to float free were it not for the scaffold of horizontals and verticals that pull it all together—the horizontals of ridge lines and eaves, the tops of fences; the vertical edges of houses, gates, tree trunks, fence posts, the curious vertical form dabbed with earthen red on the stone wall at right. Sisley paints a recognizable corner of nature, and the forms he paints have their origin in the observable. But they take on a new sense as elements in a newly determined whole when they are recast within the rectangle of the canvas.

The relationship of the painted world to the observed is perhaps made clearer if we look at Sisley's rendering of the same scene at an earlier date, in summer 1873, *Garden at Louveciennes* (see cat. 49, fig. 1).[5] Sighted from a slightly different angle, perhaps only a few feet to the right, he paints the same objects and gives them a somewhat sharper definition, in response to the greater brilliance of the light. Structure and order are no less a concern here, but it is a less severe order than in the winter version; in the summer scene full foliage obscures the houses at the left and the turn of the path is drawn as a lazy curve. Winter's spareness seems to stiffen the painter's spine; it helps reveal the strength and clarity of the painting's skeleton.

In Pissarro's *L'Hermitage, Effect of Snow*, 1874 (fig. 1), winter seems even more chilling, with orderly rows of garden plots laid bare by snow and frost. Pissarro depicts this frigid scene according to a traditional scheme of perspective. Although he does not adhere

2. Claude Monet, *The Seine at Bougival*, 1869, oil on canvas, 25¾ x 36⅜ in. (65.4 x 92.3 cm), The Currier Gallery of Art, Manchester, New Hampshire, Currier Funds (1949.1).

to a strict construction with a clear vanishing point—at best we locate a vanishing 'area' to left of center, above the stone wall and just to the right of the large tree—he does establish a clear sense of recession, effected by the strong orthogonals that angle in from the right and by the large, irregular checkerboard divisions of the garden floor. We can read back easily to the long rectangular plane of the stone wall before the house and the low-lying range of hills that closes the space of the picture. Pissarro, as Sisley, engages in the play of varying weights and emphases: the strong, uninterrupted swath of the diagonal directed in from the bottom left corner and the short, regular furrows of the third plot in; the contrast between the latter, ordered rectangle and the irregular stabs and curls of the brush, as well as the earthen tones, of the adjacent plot closer to us, where the large tree is located; the strength of horizontal lines within the picture in contrast to the frail uprights of the saplings and the sharp but undeveloped vertical edges of the buildings; the angle of the tree at right, which leans toward the framing edge, helping to open up the entry into depth in the right foreground. The middle ground is stabilized by the stone wall, which divides the composition into two nearly equal parts, and by the solid bulk of the chimneyed house behind the wall. Note, too, the open rectangle just to the left of center (with a furrow as its base and the snow-covered ridge of the stone wall as its top, its vertical framing edges supplied by the two thin, straight saplings); it serves to frame a small picture within the picture in which the one indicator of human activity is located. Despite its delicacy, this

internal frame serves as the stabilizing core of a composition in which perspective construction and grid are harmoniously interrelated.

In the early winter of 1873, Monet, too, had painted a similar subject of gardens in the snow, *Thaw in Argenteuil* (cat. 7). Not unlike Pissarro, Monet opens up a strong foreground space, establishing a rapid recession marked by the repetition of snow-dotted diagonal rows and the looping curve of the stone wall at right. But whereas Pissarro arranged his garden plots in a foreshortened rectangular grid or checkerboard, Monet emphasizes a play of diagonals and triangles. In the bottom left corner is a triangular wedge of earth, beyond which are a snow-covered triangle (in which the twisted tree is rooted) and an oblique rectangular field that angles across to the center, 'causing' the central path to curve to the right as it makes its way back to a farmhouse gate. This play of foreshortened forms is activated by the zig-zag swath that moves sharply from bottom center, to the left edge, then back to the right, to the place where the central path begins its curved passage. The houses at right present several discrete triangular forms that Monet utilizes in a kind of playful commentary upon some of the larger perspectival movements within the garden. The forked branch, for example, that stretches across the sloped roof at right divides that canted plane into three parts that idly mimic the sharply foreshortened shapes of the garden plots at left.

In terms of structure—composition, organization, ordonnance—each of these paintings presents a clear, more or less traditional opening into space, governed by the spirit if not the strict letter of perspective. The bareness of winter helps to make their structures clearer than might be the case in summer, when the abundant flora tend to obscure the skeleton of form. A concern for a clear formal underpinning, however, is not by any means rare in Impressionist painting; it appears in works of all seasons and before a wide variety of motifs. Not that without such underpinning Impressionist paintings would 'fall apart'; in many instances, perhaps even for the most part, the revetment of color and texture, the 'over all' activity of brushstroke and complex interaction of moderated hues, serve to hold the painting together. Indeed, it is just such activity, just such a demonstration of 'optical' values, of surface unity, that is so frequently cited as the formal hallmark of Impressionist painting. In that respect we can point to the color patch and broken brushwork, the move away from the value system toward the array of spectrum hues, a new world of color where warm and cool come to replace light and dark; to the creation of an overall unity of color and texture, where objects and intervals are given a comparable materiality, where the resultant effect seems often to be a filling and flattening of space. By these means Impressionism moved to close the Renaissance 'window on the world' in favor of the exploration of the window surface itself, now (re)constituted as an opaque surface, a field of resistance to touch.

To emphasize these things—however accurate and potent they have been in the creation of Impressionism's place in the history of modernism—is nevertheless to affirm

only part of the story. For Impressionist painting does not depart from the tradition of realism inaugurated in the late middle ages and early Renaissance. Moreover, realism, representation, the imaging of the observable world, were central to its 'mission.' If we are to arrive at a core understanding of Impressionist painting, we must take both illusion and surface, both realism and style (form, artifice) fully into account. The Impressionist devotion to *plein-air* painting can tell us much of the story. In the open air, directly before the motif, painters come to realize, in a more direct, existential way than they might otherwise, the contradictions between realism and style, the vast difference between nature and medium. That contradiction, in the case of Impressionism, did not lead to a plunge into abstraction. Rather, Impressionist painters emphasized fidelity to appearances more insistently than painters before them had done. But that commitment was joined to the synchronous realization that the goal of a transparent realism was an impossible one, that the painter's material means was no match for nature's evanescence, that the painter's signs were at best metaphors for nature's appearances.[6] From this realization came much of their strength and innovatory power. It was the dynamic interplay between nature and (the means of) representation that constituted Impressionism's life blood.[7]

Monet and Sisley

In the early winter of 1869, Monet painted a major snow picture, *The Magpie* (cat. 3), which he submitted unsuccessfully to the Salon of that year. Done on a relatively large scale, as befits a Salon entry, *The Magpie* provides a brilliant display of compositional control and the record of a delicate sensitivity to the reduced palette of winter. The white snow and sky provide a clean ground for drawing—dark against light, blue-violet on white, white on gray, gray on white, white on white. If we permit our eyes to follow the contours formed by the crowns of trees to right and left—describing an eccentric V-shape whose base is located behind the tip of the gatepost—then we have a hint of convergence, of a tree-lined road, perhaps, beyond the wattle fence, its vanishing point identical with the base of the V.[8] That subtle recession is an anomaly, however, in this painting devoted to the governance of a strict horizontal-vertical grid and the orientation of forms parallel to the picture plane. Consider the framing uprights of tree trunks, posts, and gate at left and the repeated short verticals of the thin trunks behind the fence, silhouetted (like the rungs of a sideways ladder) against the pinkish horizontal rectangle of the house; the subtle gray-on-white strata of clouds in the sky; the long horizontal planes of the house, filling the right half of the picture; the longer horizontal of the snow-topped fence; and the rungs of the ladder-like gate. Only the diagonal shadows of trees cast on the snow this side of the fence would seem to open up a space in the foreground, although the plastering of blue-violet along its base serves to blunt that opening.

The grid structure of *The Magpie* represents a basic compositional mode, one that Monet did not abandon during the course of his life. A second primary schema was

3. Claude Monet, *Zaandam*, 1871, oil on canvas, 18½ x 29 in. (47 x 73.6 cm), Musée d'Orsay, Paris.

4. Claude Monet, *Houses by the Zaan in Zaandam*, 1871, oil on canvas, 18¾ x 29 in. (47.5 x 73.5), Städelsches Kunstinstitut und Städtische Galerie, Frankfurt-am-Main, Germany.

a more or less traditional perspective structure, which he retained through the 1890s, in his Japanese bridge paintings, for example, done at Giverny. The fusion of the two modes provides the formal basis of his 'paysages d'eau' series, his easel-size water lilies paintings of the first decade of this century. Efforts toward that integration may be seen early on, in 1869–70, notably in the perspective road paintings done in the Paris suburbs, such as *Road at Louveciennes—Snow Effect* (cat. 5). Here, however, the power of the foreshortened road dominates any reference to the surface or to a restraining grid formation provided by the coulisse-like placement of the houses and the repetition of vertical tree trunks.

Perhaps the finest, most mature, and—in terms of its ordered clarity—most classical of Monet's early paintings is *The Seine at Bougival* (fig. 2), painted probably in the early fall of 1869. In this he develops a double perspective—looking across the bridge to the town of Bougival to the right and down to the Seine at left. The bridge road is framed by trees, vertical accents that are set in right-angled contrast to the prominent tree-lined embankment on the far shore and to the less affirmative horizontals of houses and roofs and the near and far shore lines. The central cluster of tall trees divides the composition into two rectangular sections of unequal size. In the narrower rectangle, to the left he creates his secondary perspective—the short dirt path that leads down to the river and looks across to the farther shore, where the embankment closes off farther penetration. By contrast, the firmly articulated recession of the bridge road rises to a crest at mid-river, then descends back to the village, the line of its descent carried forth by the diminishing retreat of the bridge railing at right. *The Seine at Bougival* provides a complex integration of perspective and grid structures, based upon the data of the observed scene but brought by the painter to an assured and balanced resolution.[9]

After 1869, as Monet approached new and unfamiliar sites, he frequently sought to bring them under control by utilizing the basic compositional structures with which he had become familiar: once again, he alternated between the frontal grid and perspective systems. Having left France with his family to avoid conscription during the Franco-Prussian War, he lived in London from fall 1870 to spring 1871 and then spent the summer and early fall in Holland, where he produced a considerable body of work. Two paintings done in Zaandam during his stay in Holland exemplify his compositional approach: *Zaandam* (fig. 3) and *Houses by the Zaan in Zaandam* (fig. 4). In the latter painting he establishes the horizontal of the river bank, painting the houses in frontal orientation above it. Below the river bank, he depicts with a marvelously flexible brush touch the intermixed colors of sky and houses as reflected in the water, producing a neatly arranged grid composition. In *Zaandam*, Monet develops the area of the water as a foreground apron within a carefully controlled perspective scheme; the assurance of structure and the delicacy of palette—mostly pale blue and orange-ochre—give the painting a classical order similar to that produced in *The Seine at Bougival* two years earlier.

5. Claude Monet, *Argenteuil, the Bridge under Repair*, 1871–72, oil on canvas, 23⅝ x 31¾ in. (60 x 80.5 cm), Fitzwilliam Museum, University of Cambridge.

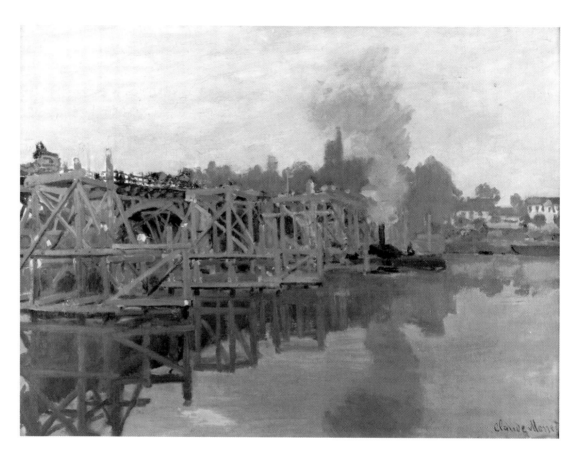

6. Claude Monet, *The Wooden Bridge*, 1871–72, oil on canvas, 21¼ x 28¾ in. (54 x 73 cm), Fondation Rau pour le Tiers-Monde, Zurich.

Shortly after his return to France, in December 1871 Monet settled in Argenteuil, a town on the Seine west of Paris. Among his earliest paintings at Argenteuil were two views of the highway bridge over the Seine being rebuilt following its destruction during the war the year before. The two paintings demonstrate, in effect, a pairing or comparison of perspective and frontal compositional schemes. In *Argenteuil, the Bridge under Repair* (fig. 5), the bridge is partly masked by extensive scaffolding that tends to slow up and provide a degree of measure to its recession across to the far bank. In *The Wooden Bridge* (fig. 6), a section of the bridge near the Petit-Gennevilliers bank across from Argenteuil is stretched across the picture surface, its shape silhouetted against the sky and doubled by its reflection in the river. Monet sets the total form, bridge plus reflection, carefully within the canvas rectangle, allowing equal space for the strip of sky above and below (as seen in the reflection). He balances the solid pier at the left edge against the articulated structure of the scaffolding at the right. The open space between, formed by the bridge and its reflection, may be read as a picture within the painting, framing the down-river scene where we see the floating boathouse, smoking steamboat, and distant shoreline.[10] This interior image by itself presents a convincing composition, but it totally disrupts the illusionistic effect of the painting as a whole. In the interior picture one can read the receding surface of the water with relative ease, but the reflection of the bridge road in the lower portion of the composition negates that possibility for the painting itself (try to picture a seamlessly foreshortened river plane receding from the bottom edge of the canvas back to the distant shore line; I find it almost impossible to do so). As Virginia Spate has observed, 'It is as if Monet were testing the relationship between descriptive marks and structural ones by *forcing* a disjunction between them, and forcing attention on ways in which abstract matter can signify external reality.'[11] In one sense, then, the painting within the painting plays a disruptive role, in another, a positive one; it may destroy the illusion, but it takes its place as an integral unit within the surface architecture of the painted composition.

Monet's return to France brought him renewed contact with his old friends, and during the next few years a number of them—Sisley, Pissarro, Renoir, Manet—joined him to work at Argenteuil. Sisley was the first to do so; during 1872 he spent several months with Monet, and the artists frequently painted together, occasionally rendering the same sites. From an examination of their works it is clear that they shared a keen interest in formal experimentation. Sisley, too, tested variations on frontal grid and perspective constructions.

Sisley was also attracted to the highway bridge undergoing reconstruction. His *Footbridge at Argenteuil* (fig. 7) was started sometime after Monet's *The Wooden Bridge* and *Argenteuil, the Bridge under Repair*, as seems evident from the

7. Alfred Sisley, *Footbridge at Argenteuil*, 1872, oil on canvas, 15⅜ x 23⅝ in. (39 x 60 cm), Musée d'Orsay, Paris.

8. Alfred Sisley, *The Ferry of the Ile de la Loge: Flood*, 1872, oil on canvas, 18⅛ x 24 in. (46 x 61 cm), Ny Carlsberg Glyptotek, Copenhagen.

absence of the scaffolding, although signs of continuing construction remain. Unlike Monet, however, Sisley chose a vantage point high up at road level as he looked across to the Argenteuil shore. Although the *Footbridge* contains elements that impart stability to the composition—the bridge piers set parallel to the picture plane, the top of the second pier made to align with the farther bank, the toll houses at the far end of the bridge that serve as a visual anchor, a desired weight at the center—the overwhelming sense is of the speed of the bridge railing as it shoots out from the bottom right corner in a straight path back to the Argenteuil bank. The wooden rail posts, with temporary buttresses set at a supporting angle, fail to slow the swift recession, nor do the pedestrians—slow moving or still—serve that function; precisely, they help to set the contrast of reserve and energy that characterizes the picture. Monet provided nothing like it during the course of his career.[12]

Sisley proved equally adept at exploiting to the full the characteristics of the frontal grid composition. *The Ferry of the Ile de la Loge: Flood* (fig. 8) was painted later in the year near his new home in Louveciennes, during the floods of December 1872. In the foreground we see a tree and wooden stanchion perched on a sliver of land of the Ile de la Loge that just managed to stay above flood level. Across the Seine is a group of buildings on the Louveciennes-Marly bank; a ferry, guided by an overhead cable, makes its way across the swollen river. Sisley takes what must have been a rough and ragged scene and converts it

into an entirely artful design, creating a neat arrangement of rectangles and triangles and aligning all parts of the setting in parallel with the picture surface. He divides the canvas roughly in half by means of the tree trunk and its reflection; then, making use of the stanchion and its reflection, and the distant horizon and near strip of island, he divides and subdivides the right section of the canvas into several smaller rectangular and triangular units, establishing each one as if drawn on the picture plane (the one element that restores awareness of the foreshortened plane of the river is the scumbled horizontal strokes that suggest ripples and reflections). Even the ferry cable, which loops back to the farther bank, Sisley coaxes toward the picture plane; the two triangular shapes formed as the line of the cable angles behind the foreground tree may be read as surface figures, as paler echoes of the prominent triangles formed by the stanchion and its reflection. In traditional composition, the tree and stanchion might act as a repoussoir, serving to open up the space of the landscape; in Sisley's hands every unit is so locked into the plane geometric grid that foreground and background seem to meet as one.[13]

The previous year, in London and Zaandam, Monet had produced two river views in which he used open geometric structures as repoussoir elements: the foreground mooring posts that loom above the horizon in the low-angle view of *The Port of Zaandam;*[14] and the brilliantly orchestrated horizontal-vertical forms of pier and reflection, neatly organized parallel to the picture plane and set dark against the misty grays of the Thames and Houses of Parliament in *The Thames below Westminster* (fig. 9). In both paintings the foreground repoussoir is contained *within* the space of the painting. Sisley's *The*

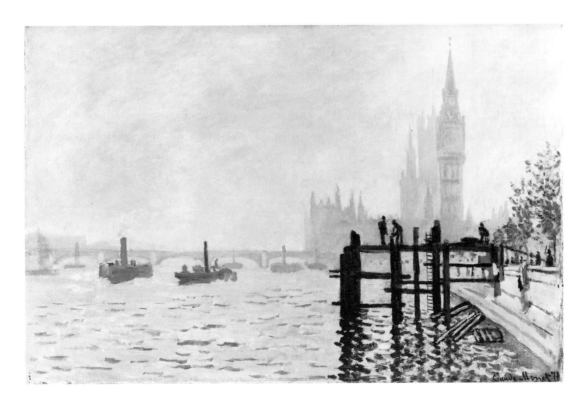

9. Claude Monet, *The Thames below Westminster*, 1871, oil on canvas, 18½ x 28¾ in. (47 x 73 cm), National Gallery, London.

Ferry of the Ile de la Loge: Flood, however, in which the foreground structures fill the frame at the same time that they reaffirm it by their frontal orientation, alters the sense of the equation, implying that nature has been made to conform to the painting rather than that the painting mirrors nature. Sisley was a witness to Monet's painting of *The Wooden Bridge* (fig. 6), with its problematic play between illusion and artifice, and he may well have built upon what he saw there. Monet's complicated painting may remain, perhaps, more question than solution; Sisley, by means of a logical leap, arrives at a lucid declarative statement.

The relationship between Monet and Sisley continued to be an interesting one during the next several years. Sisley's *Bridge at Villeneuve-la-Garenne* (fig. 10), for example, seems to build upon Monet's Holland pictures in brushwork, palette, and composition (see, for example, *Zaandam*, fig. 3). In this scene along the Seine, Sisley directs the bridge back across the river from the left edge, just as Monet did in *Argenteuil: The Bridge under Repair* (fig. 5). But Sisley's bridge, unencumbered by scaffolding, is set at a much more dramatic angle, penetrating the space of the picture with impressive velocity.

When, two years later, Monet returned to this motif in *Bridge at Argenteuil* (fig. 11), he produced one of the most serene paintings of his long career, and he did it precisely through the coordination of grid and perspective constructions. The foreshortening of the river's surface is unerring; the bridge piers, at right, stepped back and arranged like wing flats,

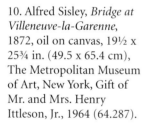

10. Alfred Sisley, *Bridge at Villeneuve-la-Garenne,* 1872, oil on canvas, 19½ x 25¾ in. (49.5 x 65.4 cm), The Metropolitan Museum of Art, New York, Gift of Mr. and Mrs. Henry Ittleson, Jr., 1964 (64.287).

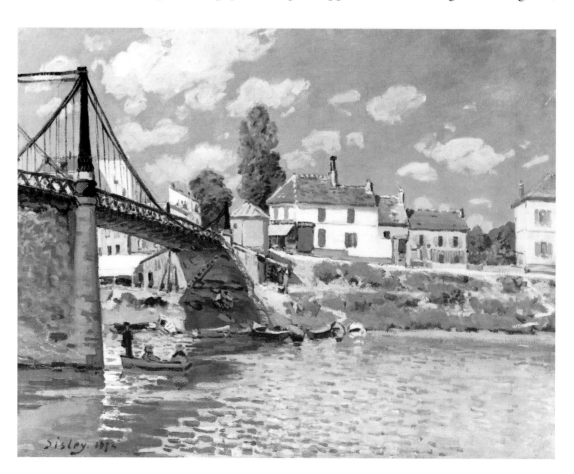

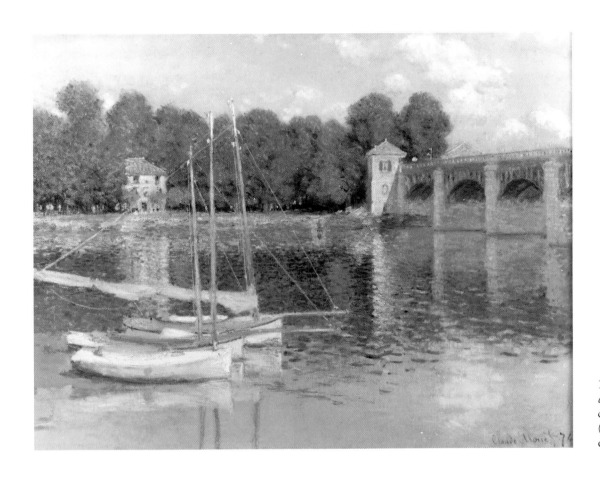

11. Claude Monet, *Bridge at Argenteuil,* 1874, oil on canvas, 23¾ x 31½ in. (60.5 x 80 cm), Musée d'Orsay, Paris.

slowly pace off the recession to the far shore. The piers are elongated by their reflection in the water, as are the houses on the Argenteuil bank. These solid forms, all oriented parallel to the picture plane, serve as principal elements of the grid-like organization of the surface, surface and recession are each articulated with great clarity and intermeshed with assured finesse. This painting may be taken as the *summa* of Monet's classicism, classicism understood in the universalizing terms of order, measure, clarity, and rational control. Although Monet reaches such equilibrium only rarely—other examples would be The Metropolitan Museum's *La Grenouillère* of 1869, *The Seine at Bougival* (fig. 2), *Zaandam* (fig. 3), and *Saint-Lazare Station* of 1877 in the Musée d'Orsay—a vein of classical order emerges and reemerges, with varying intensity, through all the phases of his career.

Sisley

While Monet was producing his classical painting of the bridge at Argenteuil, during the summer of 1874 Sisley was in England, painting in and around Hampton Court on the Thames, west of London. Away from immediate awareness of what his colleagues were doing, he produced a number of paintings that further attest to his interest in exploring the possibilities of novel pictorial schemata. Evidently stimulated by the Hampton Court environment, Sisley produced several unusual and challenging paintings, including the

extremely sketchy *The Regatta at Molesey, near Hampton Court*[15] and the vigorous *Hampton Court Bridge: the Mitre Inn,*[16] the latter comparable to *Bridge at Villeneuve-la-Garenne* (fig. 10) of two years earlier but much sketchier in execution, the brushwork in the area of the river treated in a slashing, staccato manner.

Two paintings in particular are worth singling out. In *Molesey Weir, Hampton Court: Morning* (fig. 12), the structure of the weir and the vigorous action of the water generate a highly dynamic composition, marked by the complex deployment of angular forms and an especially vigorous, even exaggerated, brushwork. Developing the composition from a low viewpoint close to the weir, Sisley exploits the power of the unleashed water as it streams forward in one straight-lined blue surge in the immediate foreground or gushes through the teeth of the weir itself. That complicated structure, with its dark-light piers, the similarly painted warning posts (a recessional row of inverted Vs), and the broad steps of the embankment at the bottom edge, gives this painting a strength and immediacy, an angular aggressiveness rarely associated with Impressionist painting.

For another depiction of the bridge he departed from all convention, setting himself below the bridge and sighting along the length of its underside. *Under Hampton Court Bridge* (fig. 13) is a work of blunt power. The recession of the underside of the bridge—ranged like overhead railroad tracks—is rapid, more like a contraction than a

12. Alfred Sisley, *Molesey Weir, Hampton Court: Morning,* 1874, oil on canvas, 19¾ x 29½ in. (50 x 75 cm), National Gallery, Scotland.

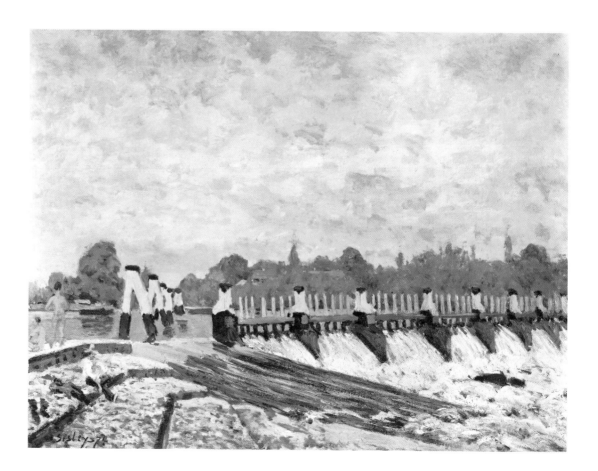

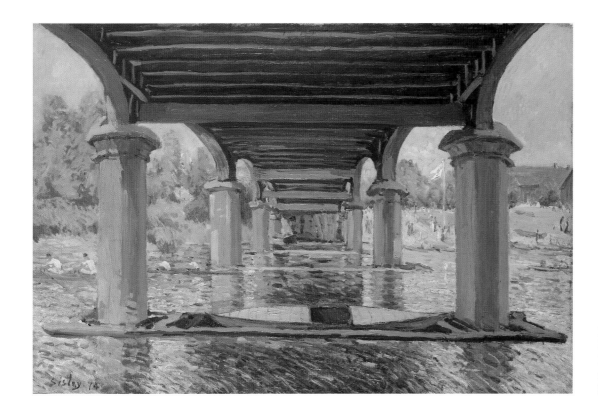

13. Alfred Sisley, *Under Hampton Court Bridge*, 1874, oil on canvas, 19⅝ x 30 in. (50 x 76 cm), Kunstmuseum Winterthur.

smooth convergence. That effect is reinforced by the striking reduction in size and spacing of each pair of supporting piers. Along with a powerful effect of spatial penetration, however, Sisley contrived to establish a tight grid construction: the horizontal pads at water level that connect the piers (beginning with the foreground platform with kayak); the 'railroad ties' of the underside of the bridge surface; the heavy vertical forms of the octagonal piers; even the implied plane between each pier, oriented parallel to the picture plane. These elements establish the grid, which seems to possess a strength and presence equal to the effect of the perspectival recession. And yet, although it is weight and mass that produce the power of both depth and surface readings, we should acknowledge as well the role of transparency. The rectangle formed by the foreground pair of piers and the horizontal units that link them may be read as a transparent plane, a window through which we look to the next 'window,' and the next—five in all, if we include, as we should, the picture plane itself. When we reach the furthest of these ever-diminishing rectangular planes at the far shore, we can no longer speak of transparency, however; we find enframed a small area made up of thick orange-ochre brushstrokes, a reminder of the materiality, rather than the transparency, of the stretched canvas upon which the effects of both materiality and transparency were produced.

Sisley did not stand out among the Impressionist painters. Neither the critics at the time nor critics and historians since have singled him out for special attention. Only in recent years, as Impressionism and exhibitions of Impressionist painting have continued

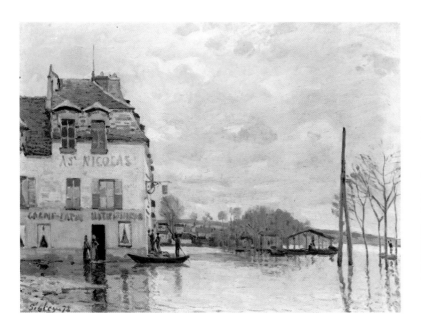

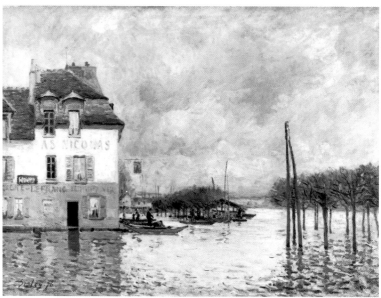

to increase in popularity, have a large-scale retrospective exhibition and monograph devoted to Sisley been produced.[17] There are certainly reasons for this relative neglect. One may be the lack of an adequate base for his career—a dearth of work surviving from his formative period during the 1860s, possibly due to the destruction of paintings during the Franco-Prussian War. At the other end, we can point to a falling off in quality after 1880, as has occasionally been noted. Another reason may be the thinness of his biography, the lack of documentation, and, to the extent we know it, the relative uneventfulness of his life. Still another may derive from his almost exclusive concentration on landscape painting, which may have restricted his appeal. And yet Sisley's paintings of the 1870s offer some extraordinary riches: bold, inventive compositions that were not matched by his colleagues, save Caillebotte, who may have learned from Sisley;[18] numerous paintings, in landscape settings, of rural labor and occupations;[19] and a feeling for delicate and often artificial color combinations—plays of complements (mainly orange and blue), a preference for blues and pinks and subtly varied grays—that often seem to depart from the coloration offered by nature.[20] Occasionally his work achieved significant distinction and attained a level comparable to the very best pictures of his close colleagues.

If I were to choose Sisley's masterpiece—and it might win the popular vote as well—it would have to be his group of paintings of the floods at Port-Marly, which he first essayed in 1872 and then returned to in a series of canvases in 1876. The 1872 picture was done at the same time as *The Ferry of the Ile de la Loge: Flood* (fig. 8), in response to the floods of December that year. *Flood at Port-Marly* (fig. 14) displays much of the assurance, if not the experimental play, of the *Ile de la Loge*. Sisley divided the composition laterally into three parts: the building with its reflection at left; the view downstream, across the center; and the tall, narrow rectangle at right, containing the telegraph pole and bare trees.

Two of the paintings done in 1876 (fig. 15)[21] assume the same vantage point, Sisley moving only slightly to his left so as to present a cleaner edge of the building, the inn 'A St Nicolas.' Sisley's effort, compositionally, in all three paintings of this site is to create a pristine, grid-like construction that emphasizes orientation to the picture plane; indeed, so insistent is the vertical 'paneling,' especially in the rendering of the inn's reflection at left, that it is necessary to remind oneself that one is looking at a foreshortened plane of water that flows continuously away from the bottom edge and off into the distance.

As in The Phillips Collection's *Snow at Louveciennes* (cat. 49), Sisley delights in the play of those parts that are given in the setting, the varied rectangular shapes—doors, windows, shutters, chimneys, a hanging sign—that provide him with the opportunity to develop vertical against horizontal (including the horizontal blocks of lettering), black against blue against gray, some areas solid, some striated, some paneled. In the earliest version, of 1872, of *Flood at Port-Marly* (fig. 14), he altered the tone and hue in each pane of the windows on the second level. Throughout each composition he demonstrates his feeling for subtle color harmonies, exploiting a range of warm and cool grays, subdued blues and browns, and what Christopher Lloyd calls the 'peach-ochre' of the lower half of the building[22]—these hues set in close correlation with the expanding grays, blues, browns, pinks, and creams of the dour landscape setting. These are paintings that present the verso of Impressionism's typical coin; the brilliance and coloristic extravagance of spring, summer, autumn—the staples of Impressionism in its most familiar form—are missing here. They are pictures that have been stripped bare, down to the skeleton that underlies Impressionism's more radiant garment. These are, after all, winter paintings.

My aim in this essay has been to underline and feature an aspect of Impressionist landscape painting that has been frequently ignored or overrridden. I have called winter to my aid, for winter's spareness may reveal what the abundance of the other seasons often conceals. Forms and structures stand out more clearly; nature's 'drawing,' in effect, is offered for the painters' appropriation. That spareness serves their efforts to construct a composition, to establish and control the illusion of space and bring into coherence the organization of forms across the canvas. And that, as I have stressed, applies to work in all seasons.

It is important to acknowledge the structure—the bones and sinews—of Impressionist landscape paintings, for that may lead us to a more comprehensive understanding of what Impressionism was and what it offers. To emphasize the optical character of Impressionist painting—its brilliant use of color, the virtuoso play of the brush, the decorative emphasis upon the canvas surface—is to privilege the eye over the other senses. To do that is to mask the full range of sensory responses to these paintings. Impressionism appeals not only to the eye, but to the sense of touch and to the kinesthetic responses of the body (after all, its textured, impastoed surfaces appeal directly to the tactile sense). Historically, the notion of 'tactile values,' of a kind of bodily empathy with a

painting or elements depicted within it, has been keyed to the deployment of the chiaroscuro technique and linked to the illusion of three-dimensional extension in a picture, of solid bodies inhabiting a believable space.[23] Traditional perspective, according to which such a space can be constructed, tends to still the action of the body—at least theoretically—by positing a single vanishing point, a fixed spot opposite which the rooted spectator would be positioned. Impressionist painting, as was recognized from the first, had a different 'mission.' It engages viewers to move, to go back and forth, to savor the evidences of the brush, of the textured surface when up close and to (re)discover the illusion when they step back to a suitable distance. The most complete and effective viewing of Impressionist paintings is a matter of stalking, of moving the body and the eyes in a play of discovery and recovery. The eye is only a part of the game.

NOTES

1. Zola's reference derives from the title of his article on Manet of 1867: 'Une nouvelle manière en peinture: Edouard Manet,' in *L'Artiste: Revue du XIXe siècle* (1 January 1867). The present essay, in its concentration on the landscape of the Impressionists, necessarily overlooks the work of Degas and Caillebotte and to a lesser extent Renoir, who, during the 1870s, explored a number of innovative approaches to composition, utilizing unusual vantage points, intimate close-ups, and exaggerated, often oblique perspectives, formal experiments not usually found in the work of the landscapists.

2. A critic of the first Impressionist exhibition in 1874, Ernest Chesneau, wrote of Monet's ability to capture 'the fugitive, the instantaneous quality of movement'; and Philippe Burty thought that the paintings in the exhibition shared a feeling for 'the purity (*netteté*) of the first sensation.' Chesneau, 'A côté du Salon: II—Le plein air: Exposition du boulevard des Capucines,' in *Paris-Journal* (7 May 1874), repr. in Berson, 1996, vol. 1, 18; Burty, 'Chronique du jour,' in *La République française* (16 April 1874), repr. in Berson, 1996, 36. For a discussion of critical views associated with the subjects of spontaneity and instantaneity, see Richard Shiff, 'Impressionist Criticism, Impressionist Color, and Cézanne,' Ph.D. diss., Yale University, 1973, 38–51.

3. See, for example, the views of Félix Fénéon, the critic and leading advocate of Neo-Impressionism, writing in 1887 (my trans.): '...the works of the impressionists have an improvisatory character: they are summary, brutal, and approximative,' 'Le Néo-impressionnisme,' in *L'Art moderne* (1 May 1887), repr. in Fénéon, *Au-delà de l'impressionnisme*, ed. Françoise Cachin, Paris, 1966, 91. For convenient reference to a sampling of Fénéon's views, see Martha Ward, *Pissarro, Neo-Impressionism, and the Spaces of the Avant-garde*, Chicago, 1996, chap. 4. See also the survey of Impressionist criticism in Oscar Reuterswärd, 'The Accentuated Brush Stroke of the Impressionists,' in *Journal of Aesthetics and Art Criticism* 10 (March 1952), 273–78.

4. See n. 7 for a discussion of opticality and related issues raised in the study of modernism.

5. D95.

6. Here I am in effect paralleling the view of one of the most percipient of the early critics of Impressionism, the poet Stéphane Mallarmé, as presented in the last paragraph of his essay 'The Impressionists and Edouard Manet,' in *Art Monthly Review* 1 no. 9 (30 September 1876), 117–22; repr. in Moffett et al., 1986, 27–35.

7. The preceding discussion and that which follows works in good part against some key aspects of modernist theory, especially that of Clement Greenberg, whose views have dominated debate on the subject. Greenberg focuses his theory of modernist painting on three defining characteristics: the purity and self-defining function of *medium*; the phenomenon of *opticality*; and *flatness*, isolated as the property that distinguishes painting from all the other arts. (Greenberg's definitive discussion of modernism appears in 'Modernist Painting' [1960], cited here as repr. in *Modern Art and Modernism*, ed. Francis Frascina and Charles Harrison [New York, 1980], 5–10. In the remarks that follow I will also draw upon the following texts: Greenberg, *The Collected Essays and Criticism*, 4 vols. [Chicago, 1986, 1993]; idem, *Art and Culture* [Boston, 1961]. For a recent discussion of Greenberg's modernism and his notion of opticality and an excellent bibliographical guide to selected commentators and issues, see Michael Fried, *Manet's Modernism or the Face of Painting in the 1860s* [Chicago, 1996], 13–19, including the extensive endnotes.) It should be clear from the foregoing discussion in the text that, at least for Impressionism, I wish to qualify Greenberg's emphasis upon the internal, self-critical examination of medium as a defining element in the constitution of modernist painting. (As early as 1940, in 'Towards a Newer Laocoon,' Greenberg presented in lucid and dramatic fashion his views on the internal development of each art form: 'The history of avant-garde painting is that of a progressive surrender to the resistance of its medium...'; *Collected Essays and Criticism*, vol. 1, 34.) Whereas I agree with Greenberg that a recognition and exploration of the medium of painting were fundamental to the changes that began to appear in the 1860s, for Impressionist painting I want to keep the concern for medium in a more flexible and responsive relationship to the appearances of nature than his formulation tends to allow. I also disagree with aspects of Greenberg's other key propositions for modernist painting, his views on opticality and flatness.
 Opticality. Greenberg sets the optical over and against the bodily and tactile associated traditionally with the Renaissance model: 'Where the Old Masters created an illusion of space into which one could imagine oneself walking, the illusion created by a Modernist painting is one into which one can only look, can travel through only with the eye' ('Modernist Painting', 8). That last notion is itself difficult to understand, but it has to do with chromatic variety, the textural microstructure of activated pigment upon the surface, the 'inadvertent silting up of pictorial depth,' as Greenberg puts it, in Impressionist painting ('Cézanne,' in *Art and Culture*, 50); the body is closed out, the eye responds to a vibrational play of color and texture across the plane of the painting. But as Greenberg acknowledged elsewhere, a 'full blown Impressionism' that would meet his description appeared 'only after 1880,' and even then, he added, 'the balance between the illusion in depth and the design on the surface [was] precarious' ('The Later Monet,' in *Art and Culture*, 43). In work of the 1870s by Monet, Sisley, and Pissarro, the presentation of traditional pictorial structures is for the most part fully in evidence.

Flatness. Greenberg's emphasis upon flatness as the unique characteristic of painting as a medium is both enlightening and overdrawn. I have no disagreement that flatness—in the sense of an acknowledgment of the canvas surface as a defining, resistant field upon which painters manipulate their tools—was a principal area of investigation for painters beginning in the 1860s; it was part of a concerted, if groping, effort to find 'a new manner of painting' at a dynamic historical juncture in the course of the nineteenth century. But in preference to his privileging of flatness as such, I look to some of his qualifications of that thesis as he spells them out in 'Modernist Painting.' In an important paragraph Greenberg acknowledges that 'the flatness towards which Modernist painting orients itself can never be an absolute flatness,' and observes that 'the first mark made on a canvas destroys its literal and utter flatness....' ('Modernist Painting', 8). In my view Greenberg's first modification provides a necessary dose of realism; and his second goes much further: it overrides his main thesis. I prefer to bring that last qualification to the fore and say that the core characteristic of painting is not flatness, but precisely its opposite, illusion. If, indeed, any mark upon a surface 'destroys' (or alters or opens up) its flatness, then flatness is no more than a material condition (although an essential one) of painting. Painting's true nature is brought out only when the painter begins to paint, when the first (and subsequent) marks are made. Painting has illusion at its heart; it cannot escape it. But it can struggle with it, attempt to overcome it, explore different ways to construe it, to elicit it, to circumscribe it. Greenberg is right to say that with Manet in the 1860s flatness came to the fore; it was in effect discovered then. After something of a *relâche* in the 1870s it returned as a governing concern in the later 1880s and 1890s, but by the end of the century it was almost exhausted as a primary formal goal. Beginning with early Cubism, advanced painting in the twentieth century has largely been given over to the 'precarious' balance between the two, between flatness and illusion. In formal terms, its primary effort has been the exploration of new forms of space, new kinds of illusion.

8. See the excellent, brief discussion of *The Magpie* in Seitz, 1960, 76.

9. The interweaving of perspective and grid systems in *The Seine at Bougival* may be compared with Monet's earlier handling of an equally brilliant painting, *The Terrace at Sainte-Adresse* of 1867 in The Metropolitan Museum of Art, New York, W95. In the earlier painting the foreshortened stage of the garden terrace is suddenly transformed, halfway up the canvas, into the grid-like backdrop of sea and sky; in this instance, however, the strong organizing verticals of the flagpoles and prominent horizontals of garden fence and horizon fail to overcome the disparity between the two compositional systems.

10. The observation of the bridge and its reflection as providing a frame for the downriver scene has been made by Tucker, 1982, 62, and Spate, 1992, 83.

11. Spate, 1992, 84.

12. Sisley may have known two paintings by Monet, done prior to 1872, that demonstrate Monet's interest in developing a dynamic perspective: *The Blue House at Zaandam* (1871, W184), with its sharp and rapid foreshortening of the fence at the right; and *Road at Louveciennes—Snow Effect*, 1869 (cat. 5), with its strong, almost abstract treatment of the central converging road.

13. Monet, too, responded to the floods of December 1872 with two paintings (W251, 252). Although freer in execution than Sisley's *The Ferry of the Ile de la Loge: Flood* (fig. 8), Monet's paintings also reveal a rather abstract composition in which elements of grid and perspective systems are conjoined.

14. W188.

15. D126.

16. D123.

17. Stevens, 1992; and Shone, 1992.

18. Stevens has suggested that Caillebotte may have been aware of Sisley's more challenging works and learned from some of them, e.g., Sisley's *Under Hampton Court Bridge* (fig. 13); Stevens, 1992, 134.

19. I can list more than two dozen paintings from the years 1872–79, mostly devoted to scenes along the Seine (by date and number from Daulte, 1959): *1872*—27; *1874*—135; *1875*—159,160, 176–178, 183 (a unique interior of a blacksmith's shop at Argenteuil); *1876*—230; *1877*—266, 268, 271–276; *1878*—289–292; *1879*—315, 316, 331, 343–348. Sisley would play an important role in an exhibition on the subject of Impressionism and work, along with Caillebotte, Degas, Guillaumin, Pissarro, and perhaps the young Signac.

20. I have in mind paintings such as: *Bridge at Villeneuve-la-Garenne* (fig. 10) and *Ile Saint-Denis* (D47, Musée d'Orsay), both 1872; *Wheatfields—The Slopes of Argenteuil* (D79, Kunsthalle, Hamburg) and *The Machine de Marly* (D67, Ny Carlsberg Glyptotek, Copenhagen), both 1873; *Corner of the Village of Voisins* of 1874 (D142, Musée d'Orsay), with its delicate play of pinks and blues; and from 1876, *Flood at Port-Marly* (D241, Fitzwilliam Museum, Cambridge) and *Waterworks at Marly* (D216, Museum of Fine Arts, Boston), with its autumn selection of deep orange and russet tones along with a range of pale blues.

21. The other is D237, Musées des Beaux-Arts, Rouen.

22. Christopher Lloyd, in Stevens, 1992, 64.

23. The term 'tactile values' was coined at the beginning of the twentieth century by Bernard Berenson in his study of Florentine painting *The Italian Painters of the Renaissance*, book 2, 'The Florentine Painters', London, 1952, esp. 40–43. Berenson used the term in reference to the Italian development of perspective and light-dark modeling beginning with Giotto, by means of which the painter could give 'tactile values to retinal impressions.' The idea of opticality, of a painting that could appeal exclusively to the eyes, posits an historical development that parts with the Renaissance model. My intention is not, of course, to return to Berenson's essentially nineteenth-century empirical model of perception, but to claim that Impressionist painting provides and demands a fuller experience than the exclusive notion of opticality allows.

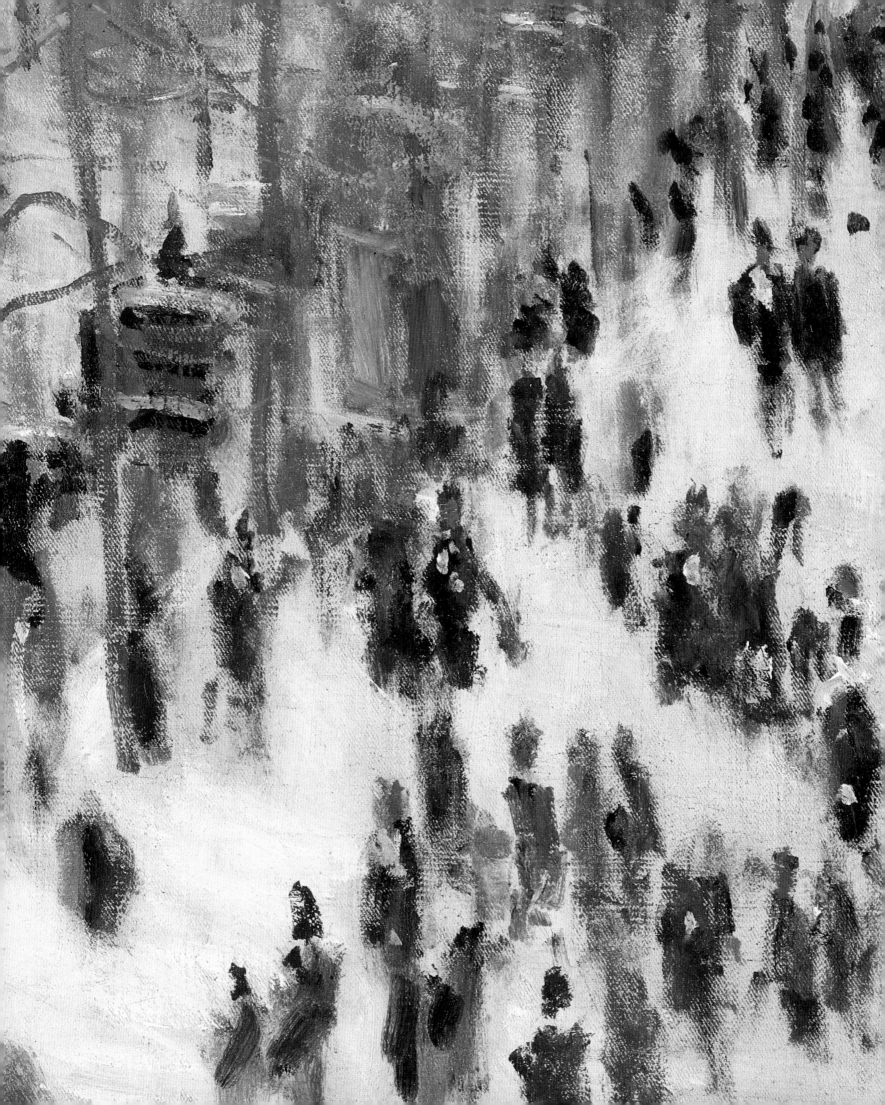

Monet

Claude Monet was born in Paris on 14 November 1840 to Adolphe Monet, a wholesale grocer, and his wife Louise-Justine Aubrée. About five years later the family moved north to Le Havre. There, as a teenager, Monet exhibited caricatures in a local shop and painted seascapes along the Normandy coast. He also became familiar with the works of two local landscape painters, Eugène Boudin and Johann Bartold Jongkind, whose eventual friendships Monet later recognized as critical to his development as an artist.[1]

From 1859 to 1860 Monet studied in Paris at the Académie Suisse, where he met Pissarro. In 1862, after brief military service, he returned to Paris and studied with Charles Gleyre. In Gleyre's atelier he met Renoir, Sisley, and Bazille, with whom he developed close friendships.

Monet painted his first *effet de neige* in 1865, the same year that he first exhibited at the Salon.[2] His two seascapes received positive reviews, and he was again successful at the Salon of 1867. In the following years, the Salon jury frequently rejected Monet's works, including *The Magpie* (cat. 3), and he did not again attempt to exhibit at the Salon until 1880. He instead contributed to five of the Impressionist exhibitions, where at least nine of his exhibited works were *effets de neige*, including *Boulevard des Capucines* (cat. 8), which hung in the first exhibition.

During the summer of 1869 Monet moved to Saint-Michel near Bougival, and one year later married Camille Doncieux, three years after the birth of their first child, Jean. That autumn they fled to England to escape the advancing Prussian army. Monet returned to France via Holland in 1871 and later that year settled in Argenteuil, where he would remain until 1878. During this time he developed a close friendship with the family of Ernest Hoschedé, a wealthy businessman and art collector.

In 1878 Monet moved to Paris. After six months the family, including the newborn Michel, moved once more, this time to Vétheuil, where they were joined by the recently bankrupt Hoschedés. Although Monet maintained a studio-apartment in Paris until 1882, he preferred painting the beauty of nature and did not return to the capital often.

Camille died on 5 September 1879 after suffering from cancer for nearly a year. She died on the eve of a bitterly cold and severely snowy winter during which Monet painted his series of *Débâcles* along the frozen Seine. At about the same time, Ernest Hoschedé began to break his ties with his wife Alice and their six children, and in 1881 Monet and Alice moved their families to Poissy. Two years later they settled in Giverny.

For nearly a year, from the summer of 1889 to the spring of 1890, Monet did not complete a single canvas. When he returned to his easel, he painted in the fields of Giverny, creating his series of paintings dedicated to the subject of grainstacks, twelve of which depict winter scenes (see cats. 23–26). In 1891 Ernest Hoschedé died, giving Monet and Alice Hoschedé the freedom to marry in 1892. The following winter, after a prolonged cold spell, Monet painted ice floes along the Seine.

Monet's visits to Paris became less and less frequent, though he continued to travel abroad. He spent his final years cultivating and painting in his garden at Giverny. In 1912, two years after Alice's death, he first experienced problems with his vision, though he continued to paint. In 1923 he underwent surgery to correct his near-complete blindness, and three years later, on 5 December 1926, Monet died of pulmonary sclerosis at the age of eighty-six.

1. In 1900 Monet recalled that through Boudin 'my eyes, finally were opened, and I really understood nature.' See Stuckey, 1985, 206. He had met Boudin as a student in Le Havre. In 1862, he met Jongkind and later credited him as his 'real master, and it was to him that I owed the final education of my eye.' See François Thiébault-Sissons, 'Claude Monet: An Interview', in *Le Temps*, 27 November 1900, quoted in Stuckey, 1985, 217.
2. See cat. 1.

Claude Monet, *Boulevard des Capucines* (detail cat. 8), 1873–74, oil on canvas, 31⅝ x 23¾ in. (80.4 x 60.3 cm), The Nelson-Atkins Museum of Art, Kansas City, Missouri (Purchase: the Kenneth A. and Helen F. Spencer Foundation Acquisition Fund).

1 *A Cart on the Snowy Road at Honfleur*

1865
Musée d'Orsay, Paris
Bequest of Comte Isaac de Camondo

The first landscape under snow that Monet painted, *A Cart on the Snowy Road at Honfleur* offers early testimony to the artist's dedication to capturing the subtle, transient effects of light and atmosphere that characterize each season of the year. It is the first manifestation of his interest in winter, especially snow, a subject that he would continue to pursue for decades. Although Monet did not date the painting at the time, many years later he recalled that the year he had painted it was 1865.[1]

Monet depicts the stretch of road that passes by the Saint-Siméon Farm, visible in the painting in the buildings to the left of the road. This establishment, consisting of a cottage and farm buildings, was beautifully situated at the mouth of the Seine near Honfleur on the road to Trouville. From a bluff to the north side of the farm one could look across the Seine to Le Havre. Little wonder, therefore, that it became a favorite destination for many artists, musicians, poets, and writers, especially from about 1855 to 1875, when a certain Mme. Toutain provided good meals. A regular clientele of landscape painters frequented this rustic and welcoming spot to take advantage of the beauty of the surroundings. Among those who came were Diaz, Troyon, Daubigny, Corot, Courbet, Bazille, Boudin, Jongkind, and Monet.[2]

The site of *A Cart on the Snowy Road at Honfleur* was familiar to Monet, who had painted the view of the same road from either side of the Saint-Siméon Farm in the summer and early fall of 1864. He spent some months there, occasionally painting in the company of Boudin and Jongkind.[3] By January 1865 he was sharing a studio in Paris with Bazille and working on two landscapes of the region around the Seine estuary. It seems possible that he returned during January or February to the Saint-Siméon Farm to finish these works and, perhaps while there, seized the opportunity after the snowfall of 3 January[4] to paint his first snowscape.

Monet painted *A Cart on the Snowy Road at Honfleur* with the reduced palette typical of many of his winter landscapes. Pink and yellow tints in a pale gray sky give the limited warmth of winter light to this snowy scene, which is otherwise strongly characterized by blue, in the shadows and even the trees. Presumably Monet began the painting on the site. Subsequent changes were probably made indoors.[5] An X-radiograph of the painting suggests that the cart was added later, and infrared reflectography, as well as pentimenti in the painting itself, shows that Monet decided to eliminate trees and branches in the upper left corner of the composition that were originally included but painted over by the artist. In spite of his dedication to *plein-air* painting and his desire to record the landscape before him, Monet often made minor alterations and refinements for the sake of his composition. Here the inclusion of the tree may have closed in the left side of the composition and limited the spatial expanse he felt was needed to balance the snowy bank in the lower right portion of the canvas. His later addition of the figures in the cart provided scale and focus for the recession into depth already suggested by the passage of blue that describes melted snow in the ditch to the right of the road. Reminiscent of the ruts in the road that lead the eye into depth in his painting *Le Pavé de Chailly* of 1864,[6] the composition reflects the importance to Monet of the Dutch landscape tradition epitomized by Jacob Van Ruisdael as well as the inspiration of his Dutch friend Jongkind, whom he had met in 1862 and who provided significant encouragement and direction to Monet's painting out-of-doors. As Monet later remarked, 'it was to him that I owed the final education of my eye.'[7]

Although some scholars believe the work was painted later, a date of 1865 can be supported stylistically. The reworking of the surface, the broad description of the light on the snow, and the pronounced horizontality of the format all suggest a date of 1865. The signature with the rounded 'M,' which Monet used until about 1866 when it became more pointed, also helps to confirm a date of 1865.[8]

EER

1. Letter from Monet, 19 October 1913, Archives du Louvre, Paris: 'L'effet de neige avec charrette a été fait a Honfleur en 1865.'
2. Charles Gehore Cunningham, *Jongkind and the Pre-Impressionists*, Williamstown, 1977, 16.
3. Wildenstein, 1996, vol. 1, 52–53.
4. See 'Winter Weather Chronology.'
5. I am grateful to Anne Roquebert for showing me these studies at the Musée du Louvre, Laboratoire des Musées de France.
6. W19.
7. François Thiebault-Sisson, 'Claude Monet: An Interview', in *Le Temps*, 27 November 1900, quoted in Stuckey, 1985, 217.
8. I am grateful to Joel Isaacson for pointing out to me the change in Monet's signature and for guiding me toward the date given by Wildenstein and Monet himself, in spite of a number of scholars who date the work to 1867.

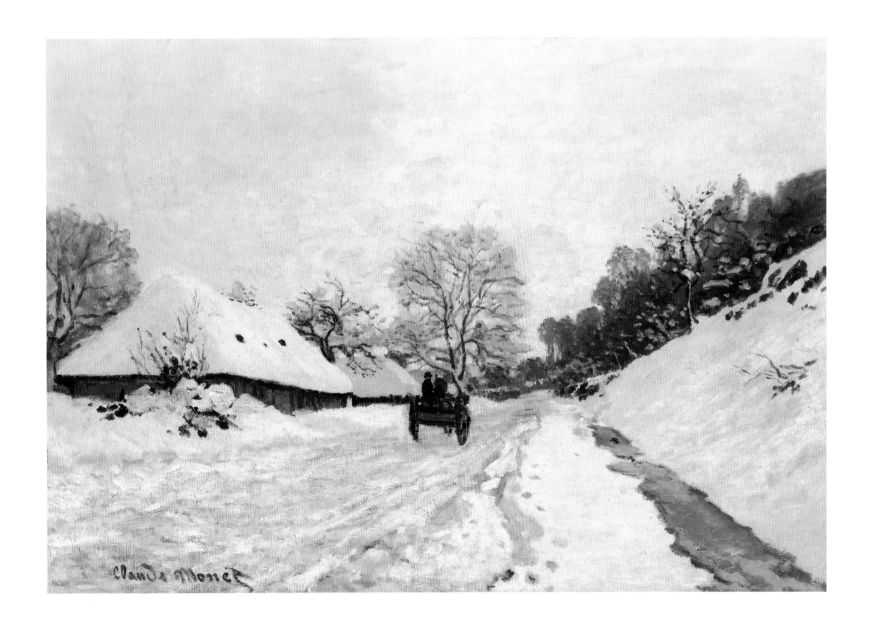

2 *Road by Saint-Siméon Farm in Winter*

1867
Mrs. Alex Lewyt

Among Monet's earliest landscapes with snow, *Road by Saint-Siméon Farm in Winter* is one of several paintings that Monet made after a substantial snowfall had blanketed the region of Honfleur. It was probably painted in January of 1867 when Monet was known to have been working on *effets de neige*.[1] All the snowscapes that he painted at this time were done on the stretch of road that passes by the Saint-Siméon Farm, the main buildings of which are visible in this painting to the left of the road. Here the artist's view is from slightly farther away from the farm than it had been in his painting of two years earlier, *A Cart on the Snowy Road at Honfleur* (cat. 1).

These snowy landscapes of 1867 are thought to constitute the artist's first 'series' of closely related works. In this regard, they anticipate many such series by Monet, including *effets de neige* in his *Débâcles* of 1880 (see cats. 18–20) and his grainstack paintings of 1891 (see cats. 23–26).[2] Four paintings constitute this early group of snowscapes: *The Road in front of Saint-Siméon Farm in Winter* (fig. 1), *Road by Saint-Siméon Farm, Snow Effect,*[3] the present picture, and *The Snowy Road at Honfleur.*[4] The first of these certainly seems to represent the deepest and most untouched snowfall of the group and was probably followed by this landscape. Here the snow appears to have melted a little, inviting a few pedestrians to venture out into the bleak winter weather. The recession into depth so effectively conveyed by a stream of melted snow on the right of *A Cart on the Snowy Road at Honfleur* (cat. 1) is clearly marked here by the fence bordering the property of the farm on the left. On the right Monet offsets the snowy road and pale wintry sky with the stark silhouettes of the trees, nearly barren of leaves, that dwarf the figures on the road, reinforcing the sense

of man's fragility and helplessness before the forces of nature. Close examination of the brushwork around the feet of the pedestrians suggests that Monet may have altered this part of the painting. The birds circling above animate the stillness of the gray sky that is only slightly relieved by a pale peachy glow in the center distance.

Of all the artists who offered an example to Monet, it was Courbet who had most frequently painted the landscape under snow. By the end of 1867, he had painted some thirty-six 'paysages de neiges'.[5] Seven of these he included in his large one-man show on the Place de l'Alma in April 1867 at the time of the Paris World Exhibition. Monet, well aware of Courbet's work, had probably seen the artist the previous fall in Deauville.[6] By February 1867, however, they were both at work independently on snowscapes, Courbet in the Franche-Comté near Ornans and Monet near his own childhood home of Le Havre.

The following year an account of Monet painting out-of-doors in the snow gives vivid proof of the artist's dedication to capturing the true effects of light on snow:

> It was during winter, after several snowy days, when communications had almost been interrupted. The desire to see the countryside beneath its white shroud had led us across the fields. It was cold enough to split rocks. We glimpsed a little heater, then an easel, then a gentleman swathed in three overcoats, with gloved hands, his face half-frozen. It was M. Monet studying an aspect of the snow.[7]

This painting, however, does not appear to have been entirely painted in one session. In some areas the paint has been more thickly applied than others. This is particularly noticeable in the dark browns and greens used to accentuate the trees and slope to the right of the road. Reminiscent of Courbet's palette, even in his many snowscapes, these somber touches bring an earthy solidity to the scene.

EER

1. Claude Monet, *The Road in front of Saint-Siméon Farm in Winter,* 1867, oil on canvas, 31⅞ x 39⅜ in. (81 x 100 cm), Musée d'Orsay, Paris.

1. *Revue du Louvre,* 1978, 398: Dubourg, letter to Boudin, 2 February 1867.
2. Champa, 1973, 15.
3. W80, Harvard University Art Museums. See fig. 5, p. 17.
4. W82, Private collection.
5. See Eliza E. Rathbone, 'Monet, *Japonisme,* and *Effets de Neige,*' n. 17.
6. Stuckey, 1985, 191.
7. Léon Billot, 'Exposition des Beaux-arts,' in *Journal du Havre,* 9 October 1868, quoted in Stuckey, 1985, 192.

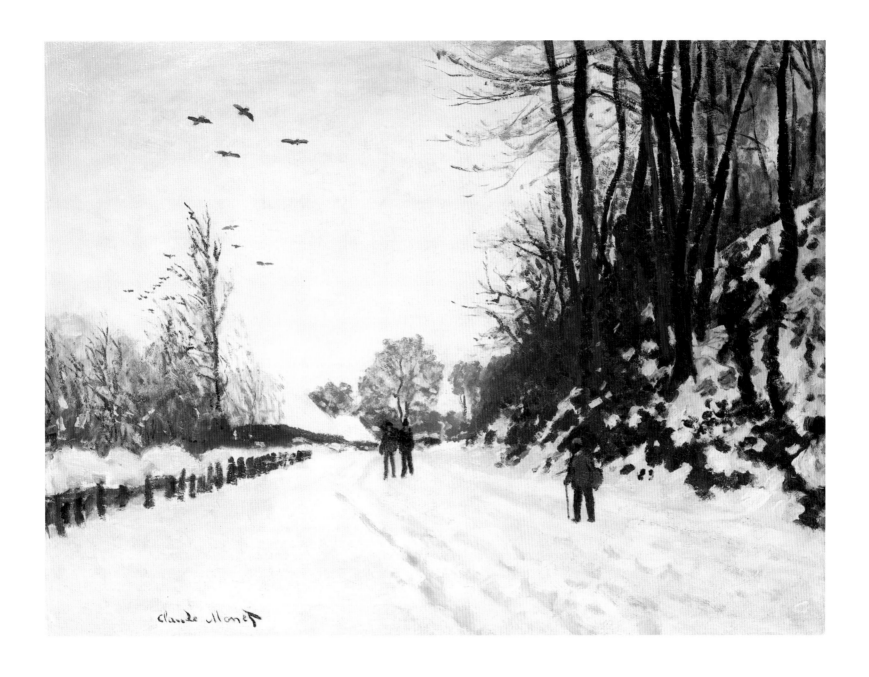

Claude Monet

3 *The Magpie*

1869
Musée d'Orsay, Paris

In the fall of 1868, Monet and his family, including Camille and their young son Jean, moved from a rented home in nearby Fécamp to Etretat on the Normandy coast, where he soon found great inspiration for both figure paintings and landscapes. Soon thereafter he wrote to his friend and colleague, Frédéric Bazille, 'I go out into the country which is so beautiful here that I find the winter perhaps more agreeable than the summer, and naturally I am working all the time, and I believe that this year I am going to do some serious things.'[1] Monet probably painted this dazzling composition in Etretat in either January or February 1869, after a large and heavy snowfall. He later submitted *The Magpie* to the Salon of 1869, where it was rejected.

Monet's interest in painting *effet de neige* compositions had begun four winters earlier (see cat. 1), but this painting was his largest and most ambitious effort to capture the unique, luminous atmosphere and quality of light in a snowy landscape, and is probably one of the 'serious things' that he told Bazille that he would produce that winter. It has been suggested that this painting might have been painted over a portrait of Bazille or a floral still life,[2] which may account for its rather large size. However, an X-radiograph of the painting does not appear to support that claim.[3] Instead, the most noticeable change that can be seen here is in the group of trees on the left side of the composition. The evidence suggests that there was originally a denser group of trees, but in the end Monet decided to pare down the grouping to three sparse trees. He may have chosen to modify the final composition in this way in order to carry the viewer's eye back to the distant horizon.

By utilizing the snow-covered fence and ladder in his composition, Monet is able to display his virtuoso skill in depicting light and shadow. In addition, his use of horizontals, verticals, and diagonals provide a balance to the organic and undefined texture of the dense snow. Monet has painted this work with a muted palette of blues, purples, and grays to depict the heavy snow in shadow, accented with the small dashes of red from the chimneys in the background on the right. Despite what appear to be footprints in the foreground of the painting, the overwhelming silence and calm following this snow storm seems undisturbed by humankind. The magpie is the only sign of life, and with it Monet reveals his artifice in this composition that depicts a fleeting moment—with the bird's shadow in the snow painted in reverse.

KR

1. Letter to Bazille, December 1868, quoted in Isaacson, 1978, 200.
2. See W133.
3. This X-radiograph is located at the Laboratoire des Musées de France at the Musée du Louvre, Paris.

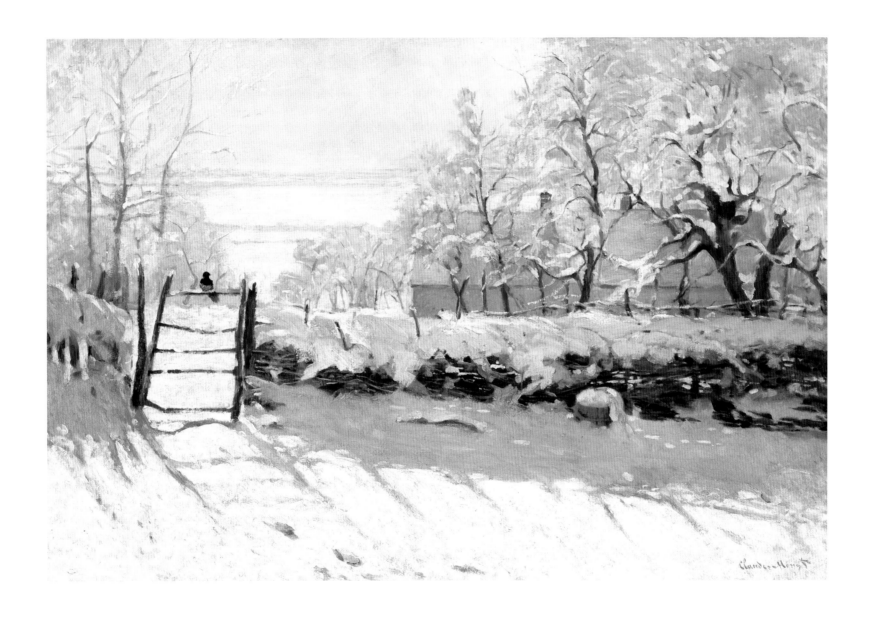

4 *The Red Cape*

1869–70 or 1871
The Cleveland Museum of Art
Bequest of Leonard C. Hanna, Jr.

Although Monet painted Camille many times both before and after their marriage in 1870, this is the only known painting he made of her outdoors in the winter.[1] In this exceptional work, the interior space has been minimally described. Nevertheless, the geometry of the window, a frame within the frame, focused on a view of Camille out-of-doors, entirely defines the structure of the composition. The figure of Camille is primarily visible through the right half of the large window, giving the impression of her movement past it, soon to be out of our view. Monet has captured a magical moment when Camille turns to look in from the cold without. The framing of her head by her brilliant kerchief is echoed in the parted curtains in the window which in turn echo the fall of her skirt. Because the window also functions as a door, the viewer has an additional sense of closeness to the figure, knowing that a single gesture could open the door inviting her in. Perhaps no other painting of a view through a window equals Monet's in its suggestion of intimacy.

With a modicum of means Monet implies a contrast of sensory experience: the cold without and warmth within.

1. Vincent van Gogh, *View of a Pork Butcher's Shop*, 1888, oil on canvas on pasteboard, 15½ x 12¾ in. (39.5 x 32.5 cm), Van Gogh Museum, Amsterdam (Vincent van Gogh Foundation).

Bold flat brushstrokes in subtle tones of gray and gray-green describe the interior walls and window, providing a foil to the green foliage and red of Camille's scarf. She looks through the window at us, and therefore, by implication, at the artist himself. Her wistful expression suggests a fleeting unselfconscious moment reminiscent of the immediate spontaneity of expression on a woman's face captured in paintings by Vermeer, which Monet might have seen in Holland. Yet art historically the painting looks forward as much as back. Although a general precedent for painting a view through a window was established especially in the Netherlands in work from Rogier van der Weyden to Pieter de Hooch, Monet's painting brings the genre into the modern world and sets the stage for Vuillard, Bonnard, and van Gogh (fig. 1), and the twentieth century.

The date of this work remains problematic. Left undated by the artist, it was retained in the family until well into this century. Dates given to the painting range from spring 1868 to as late as 1875.[2] Monet was out of France because of the Franco-Prussian War from September 1870 until late October of 1871. Since there is no record of snowfall in 1872, the painting must have been done either during the winter of 1869–70 when a big snowstorm covered the Ile de France and Monet did a number of snowscapes, or possibly late December of 1871, after he settled in Argenteuil. It is less likely, though conceivable, that he painted it in February of 1873 when snow fell during the first half of that month.[3]

Monet later returned, in 1873, to the subject of his wife seen through a window in a markedly different and smaller work called *Camille Monet at the Window*.[4] This time, however, the artist has chosen a view from the outside looking in, on a summer day at their house in Argenteuil.

EER

1. Another painting by Monet, '*La Femme à la cape rouge (Madame Monet et son chien)*'—now lost—was exhibited with *The Red Cape* at the Orangerie in 1931 (cats. 6, 7). Neither work was illustrated.
2. Stuckey, 1985, gives a date of 1873; Hélène Adhémar et al., in *Hommage à Claude Monet*, exh. cat. Paris: Grand Palais, 1980, 96, give a date of 'not later than 1870'; Seitz, 1960, gives a date of about 1872; John House, *Monet*, Oxford, 1977, 8, gives 'about 1868–1869'; and so on.
3. See 'Winter Weather Chronology.' John House notes that the style of this painting 'still echoes Manet's handling' and contrasts it with a work of 1875. See House, ibid.
4. W287, Virginia Museum of Fine Arts.

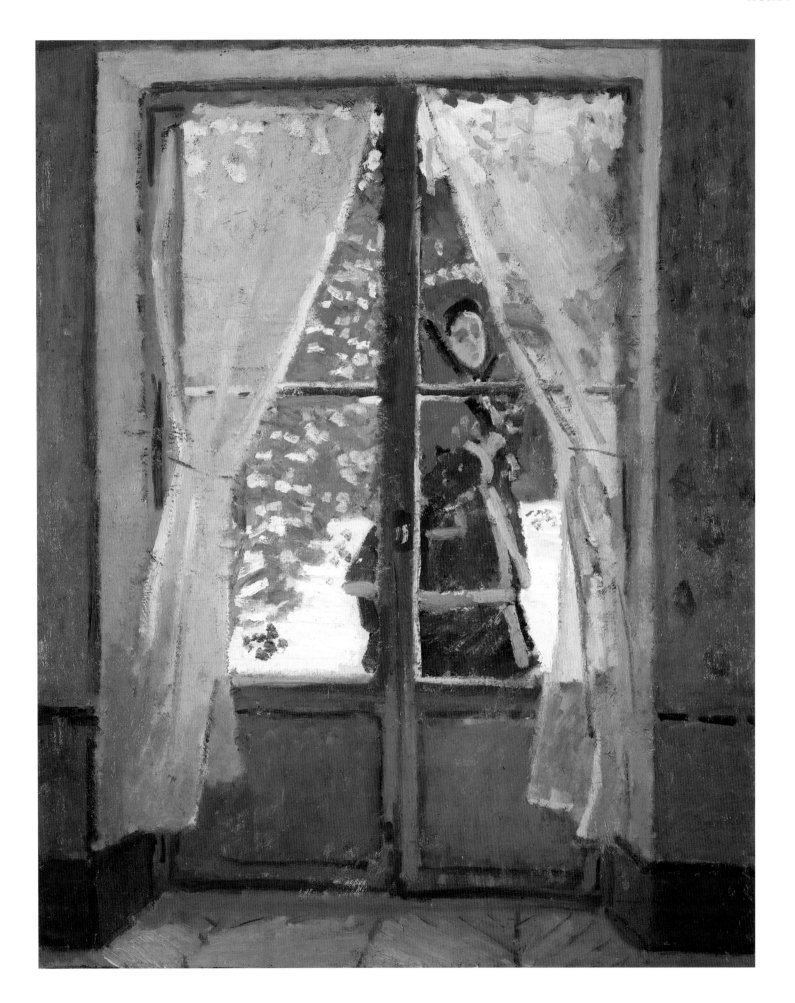

5 *Road at Louveciennes—Snow Effect*

1869–70
Private collection, Chicago, Illinois

In the spring of 1869 Monet and his family moved to the village of Saint-Michel, near the town of Bougival on the banks of the Seine, where they remained for over a year. Monet and Renoir painted side-by-side at La Grenouillère during the summer of 1869, where they experimented for the first time with broken brushstrokes and a bright, vibrant palette. The following winter Monet stayed with Pissarro and his family when there was a heavy snowstorm in the region, and the two artists each painted views of Louveciennes.

This work depicts the route de Versailles in Louveciennes, where Pissarro lived during this period at number 22 on the left hand side of the road. It has been noted that the Marly Aqueduct appears in the background of this work.[1] Both artists painted perspective views of this road during the winter of 1869–70 (see also cats. 6, 32), and Pissarro produced two works in the rain and the snow of the same site seen in this work by Monet.[2] This suggests that the two artists may have

worked quite closely together on this group of paintings. When compared to the version painted in the rain by Pissarro from the Clark Art Institute (fig. 1), one can see the differences between the two artists at this early point in their careers. The Pissarro painting is considerably smaller, and the perspective axes are slightly off-center, with the artist painting from the left-side of the road. Monet, on the other hand, uses a X-type of composition where the axes meet in the center. In these works, the artists use the traditional compositional device originally used by the Dutch in the seventeenth century of a road leading into a painting.

This was not the first time that Monet had painted this type of composition. He had initially produced views of country roads receding into the distance while painting in the Forest of Fontainebleau in 1864,[3] and he continued to be inspired by the subject at the Saint-Siméon Farm in Honfleur in 1865 (cat. 1). This work contains his most precise effort of perspective—recession toward a central vanishing point—in this group of works. Monet has set up his easel in the middle of the road, as he paints the villagers emerging from their homes and walking to and from town. The sun has already melted a portion of the snow on the left side of the street, but there is still an abundant amount of snow in the road and on the right side, where Monet is able to use shades of yellow, gray, and pink to depict the fugitive white substance.

KR

1. Camille Pissarro, *The Road: Rain Effect*, 1870, oil on canvas, 15¹³⁄₁₆ x 22³⁄₁₆ in. (40.2 x 56.3 cm), Sterling and Francine Clark Art Institute, Williamstown, Massachusetts.

1. See W147.
2. See P&V71, 76.
3. See W17, 19.

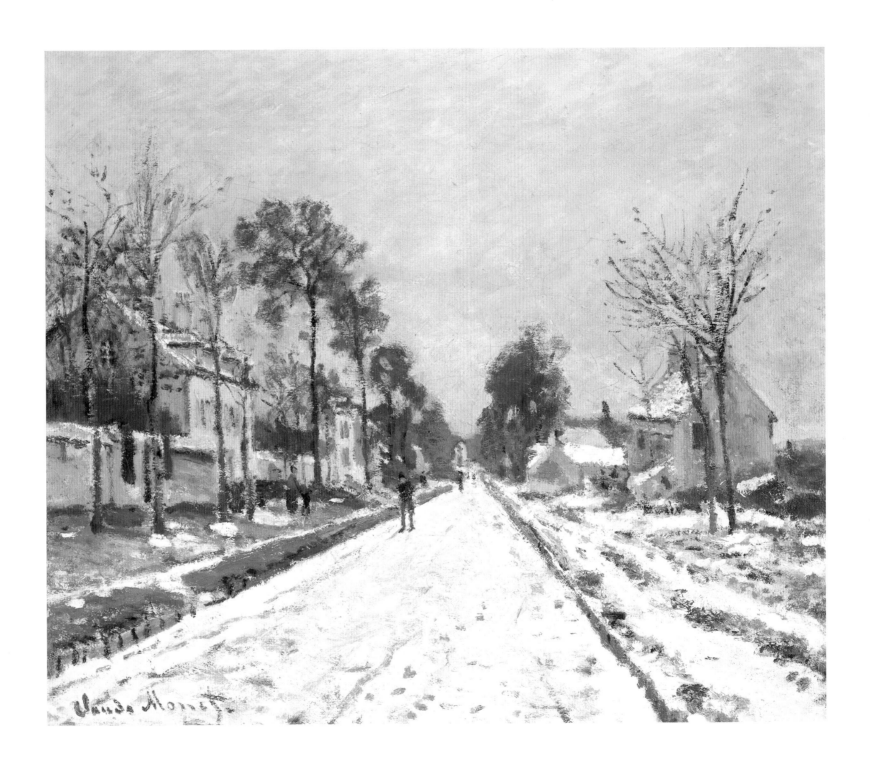

6 *Road to Louveciennes, Melting Snow, Sunset*

1869–70
Collection of Mr. and Mrs. Herbert L. Lucas

In December of 1869, Monet came to stay with his friend and colleague Pissarro when a substantial snowstorm blanketed the area. Pissarro and his family were living in a large house, the Maison Retrou, at 22, route de Versailles, where they had moved in early 1869. Much like Monet and Renoir had done during the previous summer at La Grenouillère, Monet and Pissarro soon began investigating motifs together. Monet had been creating *effet de neige* compositions since 1865, often incorporating views of village roads into his paintings. After the impressive storm had ended, the two artists

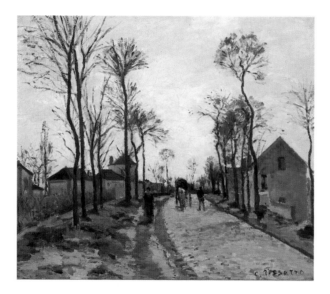

1. Camille Pissarro, *The Road to Saint-Cyr at Louveciennes*, c. 1870, oil on canvas, 18 x 21½ in. (46 x 55 cm), Collection of Mr. and Mrs. Herbert L. Lucas.

painted views of the road where Pissarro lived, as well as other roads in Louveciennes (fig. 1). This painting by Monet contains a view of the route de Versailles looking toward the south, and is one of only two views of the road that he produced that winter.[1] Pissarro painted this exact site in the rain, as both artists apparently were working closely together at this time.[2]

Painted after the significant snowfall has begun to melt, this dramatic composition has the freshness and spontaneity of a sketch completed *en plein air*. Unlike several of his other perspective road views, Monet has not included any figures along the village lane. Instead, he has added the drama of the sunset, with its shades of pink, yellow, and intense orange at the horizon line, which reflect against the slush that is melting in the roadway. Underneath these colorful clouds, hints of a blue sky are evident. The vibrant color of the sky and the road contrasts greatly with the shades of white and gray that depict the melting snow on the dark ground in the foreground on the left and scattered along the roadway, leading the viewer's eye toward the horizon line in the far distance.

KR

1. W148; the other snowscape is cat. 5 (W147), which shows a view of the route de Versailles looking toward the north.
2. See *French Paintings from the Collections of Mr. and Mrs. Paul Mellon and Mrs. Mellon Bruce*, exh. cat. Washington, D.C.: National Gallery of Art, 1966, no. 25.

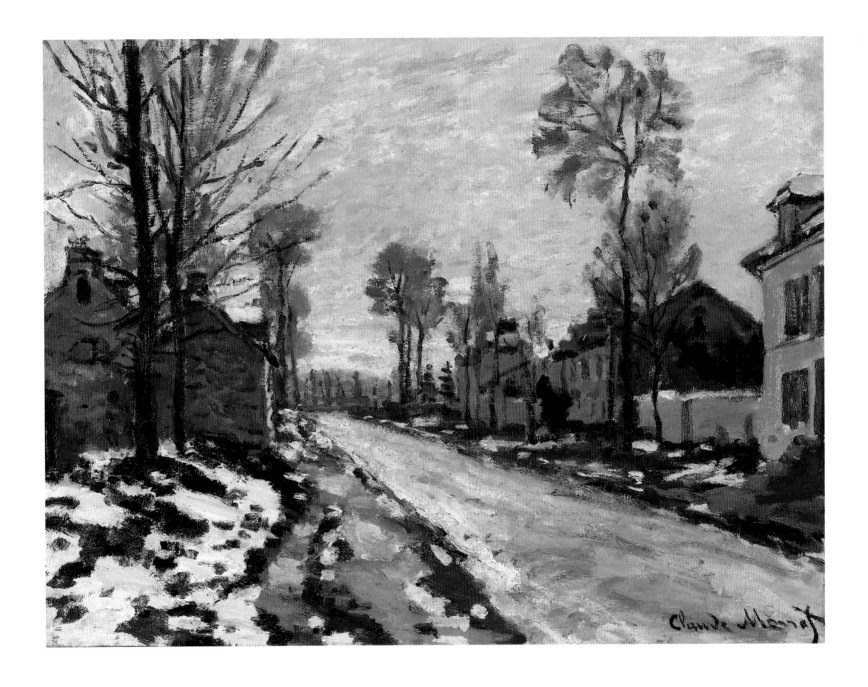

7 *Thaw in Argenteuil*

1873

Senator and Mrs. John D. Rockefeller IV

After moving to Argenteuil in December of 1871, Monet contentedly painted views of his new home town and its surroundings for the next seven years. Known as a center for leisure activities on the banks of the Seine, Argenteuil continually inspired Monet throughout his time there. During his first years living in Argenteuil, Monet celebrated in his paintings the coexistence between the spread of industrialization in the region and the beauty of the landscape. However, as time went on, he became less interested in showing the reality of modernization in the bustling suburb of Paris, and instead concentrated on the quieter aspects of life in Argenteuil.

This rare view of a garden under snow was probably painted by Monet during the early months of 1873. In this well-ordered, meticulous garden, Monet has depicted nature and man living together harmoniously. The light snow has already fallen, and its remnants slowly melt in neat rows on the ground. Monet has used a restrained palette, with an almost equal balance between warm and cool colors. The rich, earthy tones of cocoa and tan on the ground and the wall combine with the cool icy colors of the snow and the sky. The hint of spring (or the last days of fall) can be seen in the green grass in the left foreground and on the edges of the plot of land next to the garden wall.

The use of vertical and horizontal lines throughout this composition provide a sense of calm and order on the well-tended garden, particularly with the use of the large wall on the right side of the composition. Before the industrialization of Argenteuil, this garden was probably part of a larger farm, but the land had since been subdivided into smaller plots. The inhabitants of modern Argenteuil tend to their gardens rather than to their crops.[1] Monet was, of course, a great gardener himself, and at various times throughout his career he painted flower gardens in full bloom. This is a fairly unique example by Monet, however, of a garden depicted in winter, with the snow serving as the only decoration.

KR

1. Tucker, 1982, 38–40.

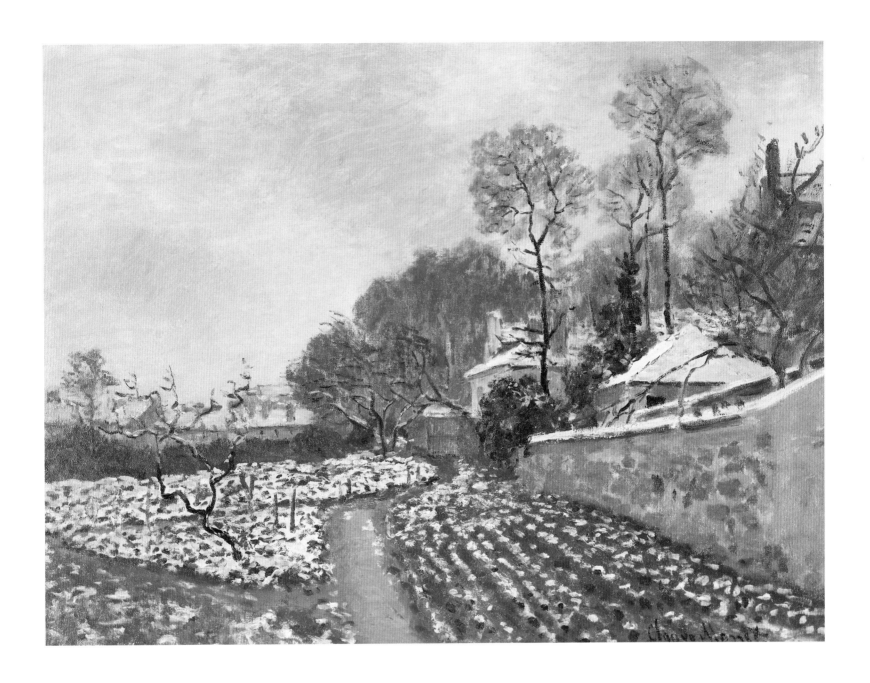

8 *Boulevard des Capucines*

1873–74
The Nelson-Atkins Museum of Art, Kansas City, Missouri
(Purchase: The Kenneth A. and Helen F. Spencer Foundation Acquisition Fund)

Painted from the balcony of his friend Nadar's studio at 35, boulevard des Capucines, Monet produced two versions of this composition of the boulevard looking toward the Place de l'Opéra.[1] Monet later exhibited one of these works in 1874 at the first exhibition of the Société anonyme des artistes peintres, sculpteurs, graveurs, etc. that was held in the same studio of the famed photographer. Both works have similar dimensions but depict different types of lighting and weather, with the horizontal, sunny view from the Pushkin Museum and the white, wintry, vertical *effet de neige* composition from The Nelson-Atkins Museum.

The response to the first Impressionist exhibition was quite mixed, with critics responding both positively and negatively to this revolutionary effort. *Boulevard des Capucines* was directly mentioned in several texts as an example of the 'new painting' of these artists. Ernest Chesneau exuberantly described the painting in his review of the exhibition in the *Paris-Journal* on 7 May 1874 and his comments are applicable to both versions of the scene:

> The extraordinary animation of the public street, the crowd swarming on the sidewalks, the carriages on the pavement, and the boulevard's waving in the dust and light—never has movement's elusive, fugitive, instantaneous quality been captured and fixed in all its tremendous fluidity as it has in this extraordinary, marvelous sketch that Monet has listed as *Boulevard des Capucines*. At a distance, one hails a masterpiece in this stream of life, this trembling of great shadow and light, sparkling with even darker shadows and brighter lights. But come closer, and it all vanishes. There remains only an indecipherable chaos of palette scrapings. Obviously, this is not the last word in art, nor even of this art. It is necessary to go on and to transform the sketch into a finished work. But what a bugle call for those who listen carefully, how it resounds far into the future![2]

Louis Leroy, in his famous, sarcastic review in *Le Charivari* on 25 April 1874 in which he gave the Impressionists their name, had a more visceral reaction to the *Boulevard des Capucines*. He found the new style of painting to be 'appalling' and lambasted Monet's painting technique in his essay, which he wrote in a conversational form with the fictitious M. Vincent:

> Unfortunately, I was imprudent enough to leave him too long in front of the Boulevard des Capucines, by the same painter. 'Ah-ha!' he sneered in Mephistophelian manner. 'Is that brilliant enough, now! There's impression, or I don't know what it means. Only, be so good as to tell me what those innumerable black tongue-lickings in the lower part of the picture represent?' 'Why, those are people walking along,' I replied. 'Then do I look like that when I walk along the boulevard des Capucines? Blood and thunder! So you're making fun of me at last?'
> 'I assure you, M. Vincent....'
> 'But those spots were obtained by the same method as that used to imitate marble: a bit here, a bit there, slap-dash, any old way. It's unheard-of, appalling! I'll get a stroke from it, for sure.[3]

Although this extremely modern composition is not immediately obvious as a winter scene, Monet does include several subtle clues to the season in which the painting was created. There is a thin layer of snow on all the black carriages located on the left part of the composition. The group of trees in the center of the boulevard have lost their leaves, and the ground also appears to have a dusting of snow. Despite the light precipitation, the boulevard is filled with people who are enjoying a beautiful winter day in the city. With his spontaneous brushwork and quick execution, Monet accurately expresses the instantaneous movement of the pedestrians and carriages and provides a real sense of life in the modern city of Paris in the late nineteenth century. In the far right side of the composition, Monet has included a group of top-hatted gentlemen on a balcony who look down at the crowd below, mirroring the artist who also looks down at his subject below.

KR

1. The other version is in the Pushkin Museum, Moscow, W292.
2. Ernest Chesneau, *Paris-Journal,* 7 May 1874, quoted in Moffett et al., 1986, 130.
3. Louis Leroy, *Le Charivari,* 25 April 1874, quoted in ibid.

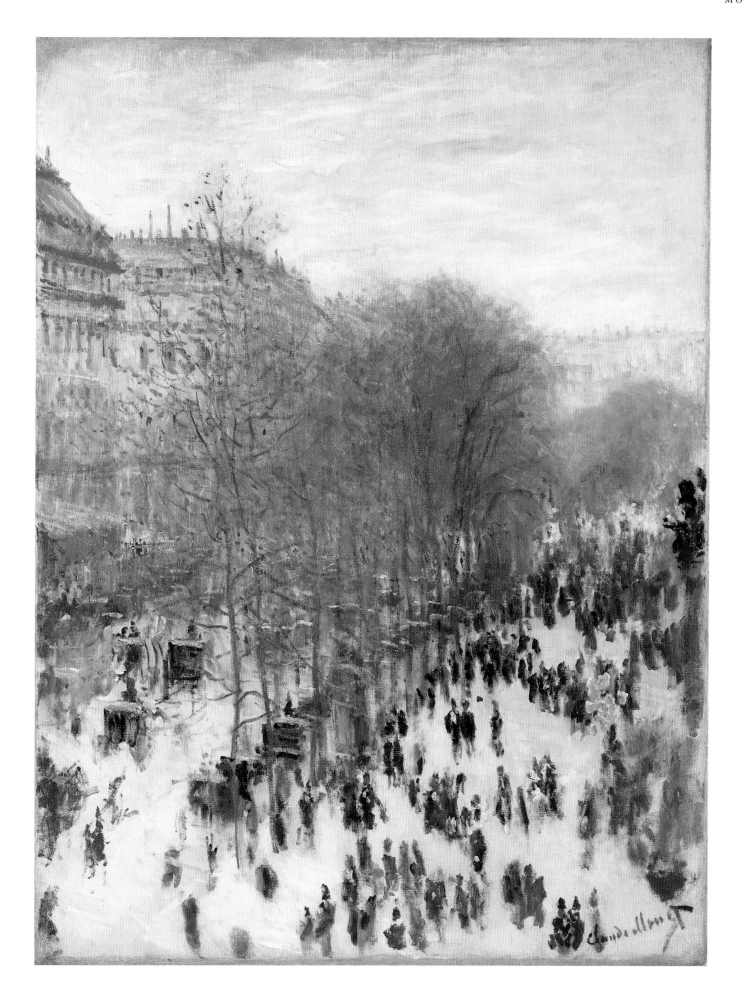

9 Snow at Argenteuil

c. 1874
Museum of Fine Arts, Boston
Bequest of Anne Perkins Rogers

In this painting, Monet selected a view of the town that provided a harmonious balance of nature and the hand of man. The open expanse of the meadow in the right foreground is counteracted by a high wall on the left that gives the composition a line of recession into depth. The path that runs along the wall leads to the center of town and is taken by a few pedestrians in spite of the snowy weather. This is one of very few works by Monet that shows snow falling. Painted not far from Monet's house, the work demonstrates his dedication to all effects of light and weather. Very thinly painted on a warm gray ground, the sky is scumbled in and the trees give the appearance of being quickly done, allowing the ground to show through in places. Monet's commitment to painting out-of-doors could make precipitation of any kind an obstacle that caused him considerable irritation which he expressed in his letters. Here, he probably began the work on the site and the rapidity of execution would help to confirm this. The primary areas of the

work are expressed in quick strokes of green, gray-blue and shades of gray and beige. The church spire rises in the center of the composition and the trees to either side give a stability and symmetry to the whole. Dabs of white appear throughout the sky and elsewhere, and are especially visible against the darker background of the trees and the wall.

The painting could well have been inspired by the snow of 19 December 1874, which fell all day long in large flakes, and was described in the daily news as 'crystalline and immaculate…one thousand times more white than the white of ermine and the tie of a perfect notary', and as being as beautiful and as pure as the snow in the Alps.[1]

This work is closely related to a slightly smaller painting of the same view of Argenteuil that Monet might have used as a study or *pochade* (fig. 1).[2] More loosely painted in some areas with rapid brushstrokes, the smaller work is more colorful overall and evokes a bright winter day. Here, in contrast to the larger painting, the clear light makes the church and buildings in the distance more visible. A little snow covers the ground. Lively brushstrokes of white and pale blue, indicating snow on the roofs behind the wall to the left, suggest reflected sunlight. Not a single figure disturbs this peaceful scene. Bordering the expanse of green on the right is a high fence that is almost completely obscured by the falling snow in the subsequent view.

EER

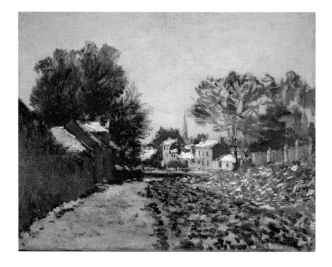

1. Claude Monet, *Snow at Argenteuil*, 1874–75, oil on canvas, 19⅞ x 25½ in. (50.5 x 65 cm), Marion and Henry Bloch.

1. See 'Winter Weather Chronology.'
2. See House, 1986, 167, 168.

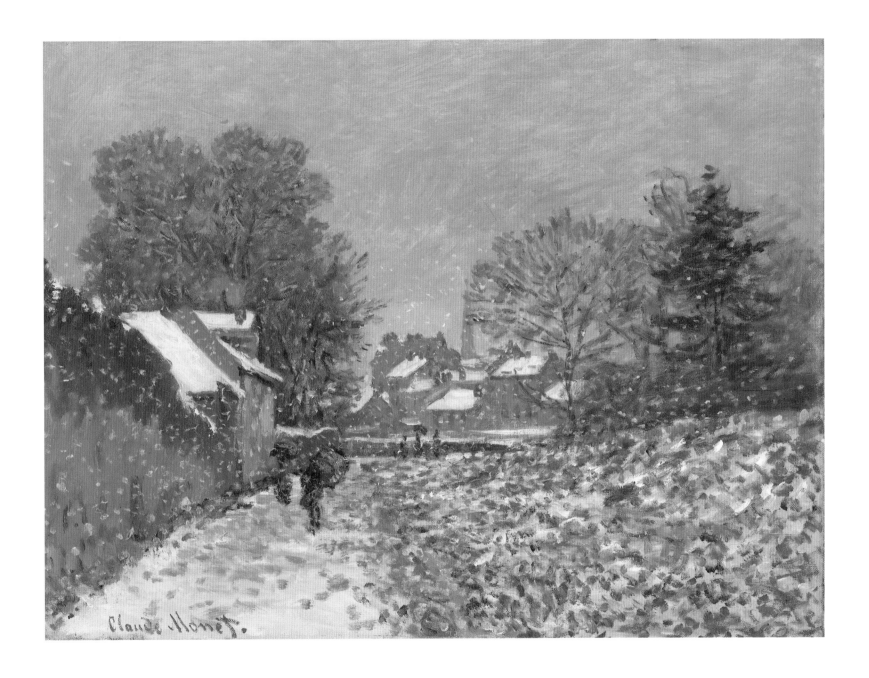

Claude Monet.

10 View of Argenteuil—Snow

c. 1874
The Nelson-Atkins Museum of Art, Kansas City, Missouri
(Gift of the Laura Nelson Kirkwood Residual Trust)

By the time he painted this view of Argenteuil under the snow, Monet had lived in the town for three years and had painted many aspects of Argenteuil and its riverside location. In this view, however, he introduced a new composition and depicted the town from an unusual vantage point. This work was probably painted late in December of 1874, following the considerable snowfall of that month in the region around Paris. This snowfall offered the first opportunity in some time for Monet to paint *effets de neige*. The press wrote on the 19th of December: 'Finally, the snow is here, real snow, that we haven't seen for many years.'[1] And: 'Rarely does as much snow fall in this region as between the 16th and 25th of December 1874.'[2]

Taking full advantage of this opportunity, Monet painted sixteen views of Argenteuil in the snow that winter. Living on the boulevard Saint-Denis, near the train station, Monet was able to choose not far from home a variety of views of the town, some of particular houses and gardens or the banks of the river, and others, though fewer, that show the town from a distance, thereby offering a more open survey of the landscape in which Argenteuil was situated. In this case Monet describes the view looking east toward the hill of Sannois from the embankment of the railroad tracks that afforded him an unusually high vantage point.[3]

Since the advent of the railroad, Argenteuil had become an increasingly industrial suburb of Paris with a growing population. Although this painting includes a smokestack and some factory buildings, Monet describes the softening and beautifying effect of a fresh snowfall that covers the ground and roofs of buildings. The smoke wafting into the sky mingles naturally with the clouds, reminding us of Monet's fascination with atmospheric effects and his ability to harmonize nature with industry. His palette of pale yellow, blue, and white is punctuated by the brilliant red of the building in the foreground on the right. Most of all, our attention is focused on the figures, some with umbrellas, who walk like a procession along the snow-packed road marked by a picket fence that curves around toward the town and leads the eye through the pictorial space.

It is tempting to think that Monet may have already seen—or owned by this year—the woodblock print by Hokusai that he acquired for his collection of the *Reconstruction of the Ponto de Sano in the Province of Kozuke* (fig. 1). We do know that by 1878 he had a collection of Japanese prints.[4] The two works make a striking comparison in composition: the abrupt juxtaposition of near and far is marked in Monet's painting by the branches in the center foreground and to the left that contribute to the suggestion of an elevated viewpoint; likewise in the work by Hokusai, a lone tree and building on the right and a snow-laden bush to the left offer a dramatic spatial recession to the view of the valley below. In Monet's painting the road populated by figures of diminishing size leads the eye into the distance just as the evenly-spaced figures by Hokusai grow smaller as they approach the hills and high horizon that characterize both works.

EER

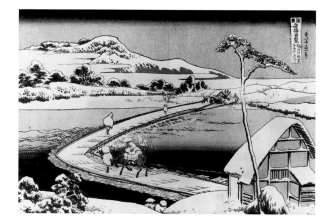

1. Katsushika Hokusai, *Reconstruction of the Ponto de Sano in the Province of Kozuke*, from the series 'The Astonishing Views of Famous Bridges in All the Provinces,' 1831–32, color woodcut, 9⅝ x 14⅝ in. (24.5 x 37 cm), Claude Monet Foundation, Giverny.

1. See 'Winter Weather Chronology.'
2. *La Nature*, no. 84, 9 January 1875.
3. See W358.
4. See Eliza E. Rathbone, 'Monet, *Japonisme*, and *Effets de Neige*.'

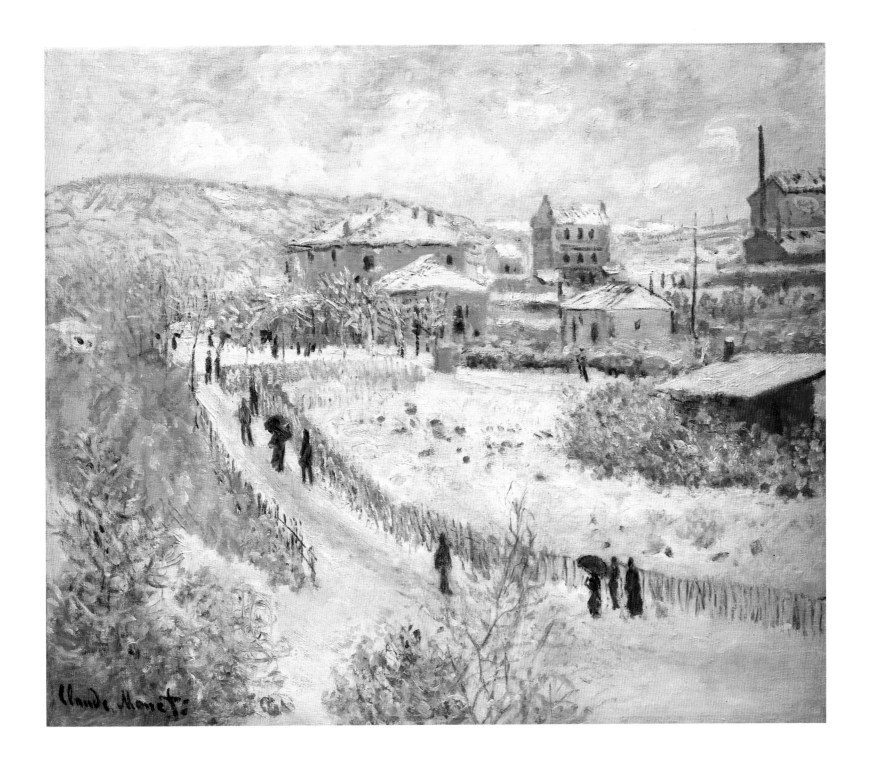

Claude Monet

11 *Boulevard Saint-Denis, Argenteuil, in Winter*

1875
Museum of Fine Arts, Boston
Gift of Richard Saltonstall

This view of Argenteuil painted from a location on the path between the railway embankment and the boulevard Saint-Denis reflects Monet's readiness to describe a momentary aspect of highly changeable weather.[1] In this work, the sun is breaking through the midst of a snowstorm. Snowflakes are blowing in all directions. An atmosphere of turbulent and blustery wind is reinforced by the figures in the foreground who tilt their umbrellas to fend off the billowing snowflakes.

The composition is an unusual and dynamic one. The strong diagonals of the fences on either side of the path that leads the eye into depth do not meet at a far horizon; rather the boulevard veers off to the left and sharply recedes to the right, giving the entire work a sense of many directions and the composition a kind of centrifugal force that furthers the dynamism and energy of the subject. Some inspiration for the composition of this work may derive from Japanese prints that Monet was collecting at this time.[2]

The combination of pink, yellow, and blue in the upper portion of the painting, colors that are only occasionally used by the artist to describe a winter sky, is carried through in the prevailing hues of the entire work in which the rosy tones of the houses are complemented by blue and blue-green roofs and shutters. Trees and shrubs are also conveyed in tones of pink and blue, while the white of the snow is accented by blue highlights. The green fence to either side of the path plays a crucial compositional role in the work. Strongly contrasting with the surrounding delicate tonalities, the dark green pickets of the fence are flecked with the white of the snowflakes.

This painting, executed near the artist's house, is one of very few by Monet that describe snowfall. It reminds us of the variety of composition and the tremendous creative energy and imagination that characterizes the artist's work of the 1870s. This work was acquired by a Boston collector in 1890 and was owned by the Saltonstall family for over fifty years before it was given to the Museum of Fine Arts, Boston, in 1978.

EER

1. The location of this work is given in W148.
2. See Eliza E. Rathbone, 'Monet, *Japonisme*, and *Effets de Neige*.'

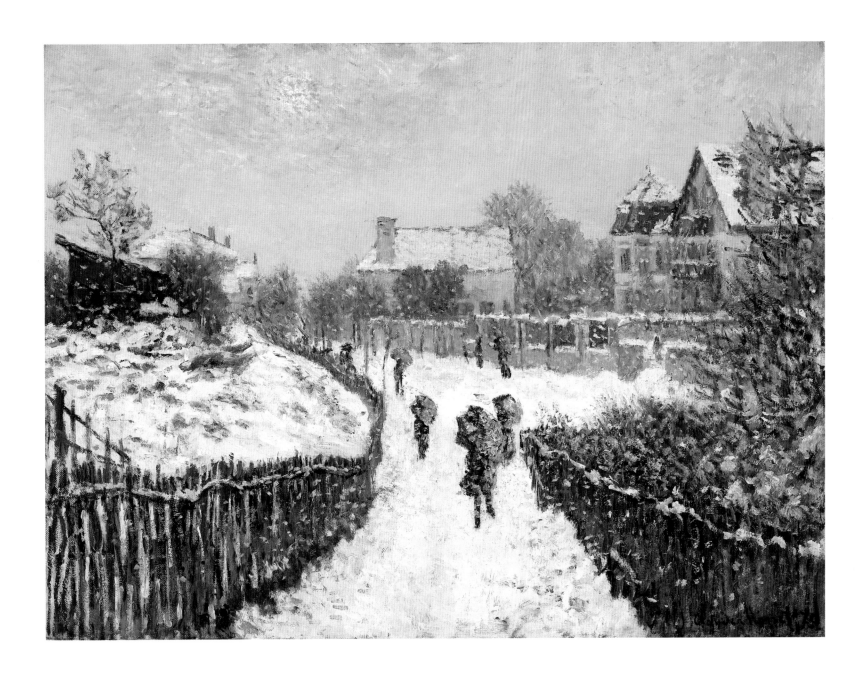

12 *Train in the Snow at Argenteuil*

1875
Mr. and Mrs. Stephen A. Schwarzman

During the snowy winter of 1874–75, Monet produced sixteen *effet de neige* compositions that depict many different aspects of the landscape in and around the town of Argenteuil where he and his family had lived since 1871.[1] These paintings range from a rare scene of snow falling on a village road as the townspeople struggle against the elements (cat. 9) to a view from above that overlooks Argenteuil after a significant storm (cat. 10.) Monet's interest in painting snowscapes during this winter was not limited to these more suburban or rural views that include villagers on their way to and from their homes. He also painted two scenes during the winter of 1874–75 that feature trains, the method of transport used by most townspeople and visitors to Argenteuil. For Monet, trains served as a reminder of the progressive industrialization of this formerly agrarian region of France, and he included a train moving across the railroad bridge in two landscapes of Argenteuil from the previous year.[2]

Train in the Snow at Argenteuil features a train making its way into town. It is very sparingly painted, with a great deal of the brown preparatory ground evident throughout the composition. Monet has used a very limited palette, consisting mainly of shades of brown, rust, black, white, and gray, with subtle accents of blue in the Sannois hills in the distance. He also includes a vibrant touch of red at the back of the train, which may be a type of signal, as it speeds toward town with great billows of smoke rising above the locomotive. The train's path curves away from the viewer, and is mirrored both by the rust and black fence on the left and the hills in the background. Unlike some of Monet's *effets de neige* that were begun *sur la motif* and were later finished in the studio, the sketchy quality and the immediacy of this work suggest that it was begun and completed outdoors. This work was purchased almost twenty years after its completion by the American painter Mary Cassatt for her brother Alexander, who formed an impressive collection of Impressionist paintings.[3]

Monet produced another train painting during the same winter that is similar in size but very different in composition. *The Train Engine in the Snow* (fig. 1) features a train in the Argenteuil station, awaiting its next departure as people exit and enter. The brightly-colored locomotive dominates the composition, with its dense, gray smoke rising into the cloudy sky that threatens more precipitation. Monet and his family were living in a house across the street from the train station at this time, and his proximity to the trains may have inspired him to produce these paintings.[4] These works look forward to his great series of canvases depicting trains in the Gare Saint-Lazare station in Paris in 1877.

KR

1. Claude Monet, *The Train Engine in the Snow*, 1875, oil on canvas, 23¼ x 30¾ in. (59 x 78 cm), Musée Marmottan-Claude Monet, Paris.

1. See W348–360, 362. He also produced two views of frost during the same period that are not included in the group of sixteen, W361, 363.
2. See W318, 319.
3. See W360.
4. See W356.

13 *Lavacourt in Winter*

1879
Private collection

In August of 1878, Monet relocated to the small village of Vétheuil, located approximately sixty kilometers north of Paris. Although he was very productive and content during the previous seven years when he lived in Argenteuil, he found the undeveloped and unchanged landscape in Vétheuil—without major industry or tourist attractions— immensely satisfying. Despite the rural nature of the area, its relative proximity to Paris also allowed him access to his studio and to the galleries in the capital.

During the three years that he lived in Vétheuil, Monet painted almost three hundred works, significantly more than the approximately 175 paintings he produced during seven years in Argenteuil.[1] The subject of these paintings had also changed from those in Argenteuil, as in Vétheuil Monet often chose landscapes with undisturbed views of nature with little evidence of human presence. His interest in depicting the impact of industry and leisure activities on the banks of the Seine in and around Argenteuil waned in Vétheuil. Instead, he concentrated on the quiet beauty of the town and its surrounding areas.

Monet often painted the small village of Lavacourt during this period. Located on the banks of the Seine near Vétheuil, Lavacourt appealed to Monet for its location and rural quaintness. He painted at least sixteen views of the town during the fall and winter of 1878–79, and was particularly drawn to the group of buildings in the village that were located next to the towpath along the river. Throughout this series of river views, Monet painted the town from looking both upstream and downstream, and often included a view of the opposite bank. He investigated this motif in both fair and inclement weather during this period.[2]

With its energetic brushwork and subtle, cool palette, *Lavacourt in Winter* showcases Monet's interest in painting the dense atmosphere and quality of light after a small snowstorm. This type of a perspective view of a road, where the walkway recedes back towards a single point along the horizon, was a familiar type of composition for Monet that he had been incorporating into his paintings for over fourteen years. He also produced a variant of this painting that appears to have been painted on a somewhat brighter day.[3] *Lavacourt in Winter* is one of many Impressionist pictures that went through the Parisian art dealer Boussod, Valadon & Cie., where Vincent van Gogh's brother, Theo, worked and championed the paintings of these modern artists.[4]

KR

1. Tucker, 1995, 101.
2. W475, 476, 495–501, 511–13, 515–17.
3. W513.
4. Rewald, 1986, 94.

14 *Road to Vétheuil, Snow Effect*

1879
Museum of Fine Arts, St. Petersburg, Florida, extended anonymous loan

Having spent most of the decade of the 1870s in Argenteuil, Monet moved in August 1878 to Vétheuil, where he would live for just over three years, until 1881. By October he and his family were settled in a house on the outskirts of town situated right on the road to La Roche-Guyon. The house had a garden on the opposite side of the road that led down to the Seine, making this property ideal for Monet's painting interests. In this view of the *Road to Vétheuil*, the house that Monet lived in is visible as the last of the group on the left overshadowed by the Villa 'Les Tourelles.'[1]

This painting is one of five of the view of the town from the direction of La Roche-Guyon that Monet painted between 1878 and 1880 under different weather conditions. Since he signed and dated it 1879, he probably painted it in December when, unlike January and February of that year, there was a considerable snowfall.

The month of December 1879 was described as, 'one of the coldest we have had in a long time….Snow fell during the first ten days of the month, but particularly from the third to the fifth; at this time nearly everywhere there were frightful snowstorms and communications

remained suspended almost everywhere for two to three days.'[2]

Compositionally, the *Road to Vétheuil, Snow Effect* echoes an earlier series of snowscapes that Monet made during the winter of 1869–70 of the Versailles road entering the village of Louveciennes. Here, however, because of the physical surroundings of Vétheuil, the recession into depth established by the road itself is counteracted by the hillside rising in the distance. Monet's chosen position on the road allows for an expansive view of the village and its setting. The trees and shrubbery in the immediate foreground to the left act as a repoussoir for the spatial illusion of the painting. Using a limited palette of white, blue, and red-ochre, Monet painted his landscape with a white sky suggesting an atmosphere thick with the promise of more snow. The work is painted primarily in white, flecked with strokes of blue that describe the blanketing effect of a recent snowfall that nearly obscures the village itself. A figure boldly suggested in the middle ground trudges along the beaten track in the snow indicated by the painting's only warm tonalities. The other work in this series painted from approximately the same vantage point, though showing less snow, is *Entering the Village of Vétheuil in Winter* (fig. 1).

The early history of this painting is uncertain. It is possible that it was one of the two snowscapes that Monet exhibited at the seventh Impressionist exhibition in 1882. Having declined to participate in the previous two Impressionist group shows, he returned in 1882 with thirty-five works, five of which were *effets de neige*. The painting was largely in the hands of his dealer Durand-Ruel until it was acquired early in this century by an American collector.

EER

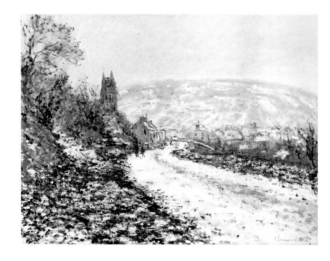

1. Claude Monet, *Entering the Village of Vétheuil in Winter*, 1879, oil on canvas, 23⅞ x 31⅞ in. (60.6 x 81 cm), Museum of Fine Arts, Boston. Gift of Julia C. Prendergast in Memory of her brother, James Maurice Prendergast.

1. Wildenstein, 1974, vol. 1, 102.
2. See 'Winter Weather Chronology.'

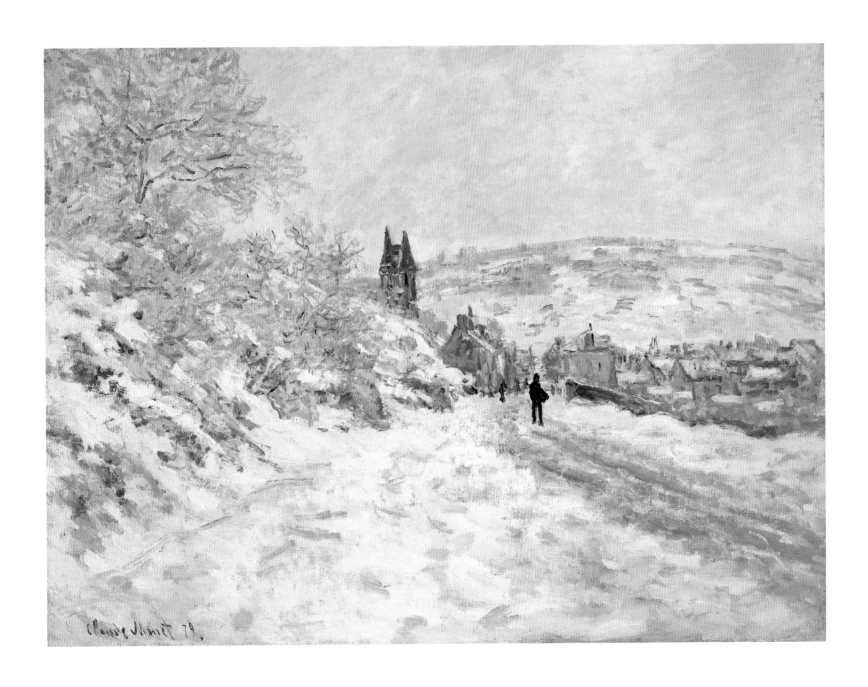

15 *Road into Vétheuil in Winter*

1879
Göteborg Museum of Art, Göteborg, Sweden

Within a relatively short time, Monet painted three closely related views of the road on the edge of the town of Vétheuil where he lived from 1878 to 1881. Further from Paris than Argenteuil, where he had stayed for seven years, Vétheuil offered quite a different setting for painting.

In this work Monet takes a vantage point closer to the village itself than he had in the two other views of this road painted the same winter (cat. 14). The hill to the left of the road rises steeply, giving an effective repoussoir to the composition as a whole and accentuating the rapid recession into depth of the road and the contrast of near and far. This is further heightened by the tumultuous and highly charged diagonal brushwork using the same palette that accents the dirt road—red, green, blue, black, and white—describing the still snowy bank in contrast to the melted slush and mud along the road.

The pale gray walls of the buildings and their darker blue-gray roofs emphasize the monochrome quality of the sky which is thinly painted in fairly broad brushstrokes. This cool palette is only relieved and off-set by the red of the chimneys and the red and green strokes in the foreground painted with a smaller brush. The mountain beyond rises, a snowy craggy mass, as if to impede all travel beyond the end of the village street, and indeed the only movement suggested in the work is in the few pedestrians, two in the foreground and several more minimally indicated by dabs of blue in the distance. Although the snow has begun to melt, Monet suggests the continuation of winter cold that has settled over the town. Smoke rises from one of the chimneys and only a few local people are out.

Although this painting is not signed, the closely related *Road to Vétheuil, Snow Effect* (cat. 14) bears a date of 1879. Presumably both works were painted within days or weeks of each other, perhaps in November 1879 which marked the early beginning of one of the fiercest winters of this period. Monet could well have begun these works after the snowfall of 20–22 November or the abundant snowfall of 29 November.[1]

Yet the two works present entirely different moods. As opposed to the obscuring effects of a heavy snowfall conveyed in *Road to Vétheuil, Snow Effect* (cat. 14), here the solidity of the buildings and walls of Vétheuil itself offer architectural structure and density to the subject. The stony edifices are matched by the overcast sky that suggests an unrelieved episode of cold and damp winter weather.

EER

1. See 'Winter Weather Chronology.'

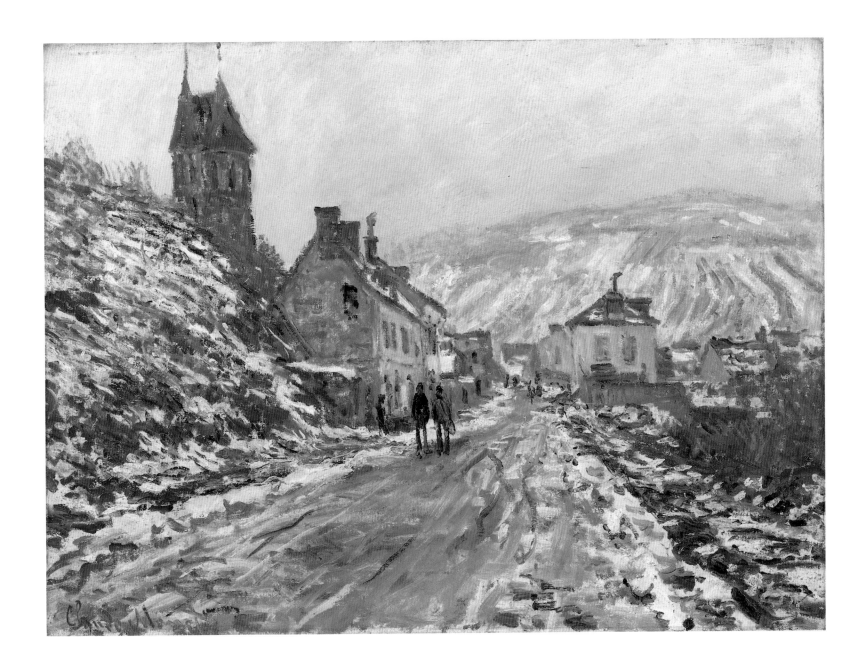

16 *Winter on the Seine, Lavacourt*

1879–80
Private collection

17 *Winter Sun, Lavacourt*

1879–80
Le Havre, Musée des Beaux-Arts André Malraux

With these two paintings of the view of Lavacourt across the Seine from Vétheuil, Monet began to develop the most intensive engagement with winter views of the river of his entire career. Starting in December 1879 with three paintings of frost on the Seine, he continued to study the river, frozen and under snow, at different times of day. These paintings of the Seine, mostly very horizontal in format and tending to be quite large, culminated in an extraordinary series of seventeen paintings of the breaking up of the ice on the Seine that occurred in January of 1880 (see cats. 18–20).[1]

The winter of 1879–80 was an unusually cold and snowy one for the entire region. Beginning early with snow in November, the winter weather intensified in December with exceptional and unrelieved cold and constant snowfall, which was particularly abundant between 3 and 5 December. The weather, which virtually paralyzed Paris, where it was described by journalists as 'Siberian', had an equally transforming effect on the surrounding countryside, where the river was frozen to a stand-still and the snow grew deep on its surface.

Once again, as he had at the Saint-Siméon Farm in 1867, Monet returned to a spot that he had come to know in more clement weather, for he had painted various views of Lavacourt across the Seine from Vétheuil the previous summer. The works present a dramatic contrast of color and mood. In both December views of the river, the extremely limited palette offered by the austerity of the winter landscape is accentuated by the evening light which silhouettes the village of Lavacourt in icy tones of blue. The reduced palette of the foreground, however, is enlivened by the orb of the setting sun and by the resulting streaks of red across a sky of chilly green and blue.

Though viewed from the bank of the river at Vétheuil, these compositions exclude any description of the near bank where Monet was standing that he had included in at least four other views of frost on the river at this time.[2] Here he created a greater sense of isolation and absence of human presence. The nearest habitation

appears far off on the distant shore of Lavacourt, the sky is low and the orange ball of the sun gives light but no warmth to the frozen stillness. Bushy outcroppings from the banks to the right of the composition are the closest vegetation and appear transfixed by ice and snow.

Although both works appear to have been quickly executed, the somewhat larger *Winter on the Seine, Lavacourt*, might well have been completed in a subsequent session. The sun, which hovers low in the sky over Lavacourt, was originally higher in the composition and is still faintly visible in the pink passages above its present location. While Monet consistently began his paintings on the site, often he did not complete them in one session. He typically had many works in progress at any given time. His letters attest to his frustration in trying to resume work on a painting in circumstances identical to the first session. This was not always achievable, and may be one of the reasons for his subsequent revision of this work.

Other changes have occurred in *Winter Sun, Lavacourt*. According to Wildenstein, 'two small figures centre left were visible in 1905, but were subsequently covered over.'[3] Instead a boat, immobilized by the frozen river, is suggested in the middle distance by a horizontal passage of paint to the left of the bushes in the foreground. In *Winter on the Seine, Lavacourt*, two figures are possibly suggested by a few dabs of blue paint, again establishing a middle ground and a sense of scale for the artist's recession into depth.

At this time, Monet was presumably still recovering from the death of his wife Camille just a few months earlier, on 5 September 1879. It may be that he found a personal resonance in the stillness of winter, when much of the world seems to sleep.

EER

1. W559–572.
2. W553–556.
3. See W557.

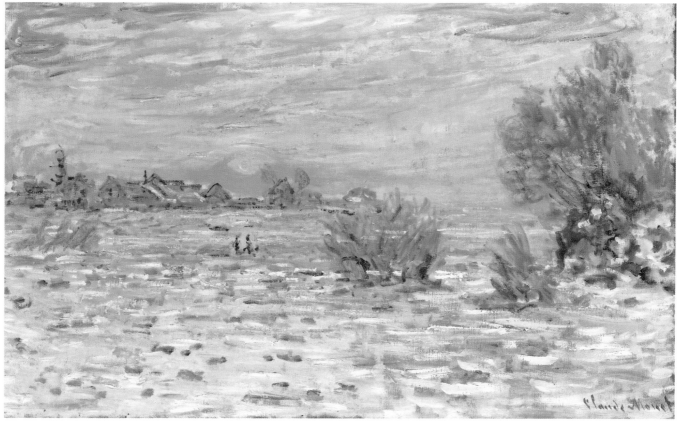

16

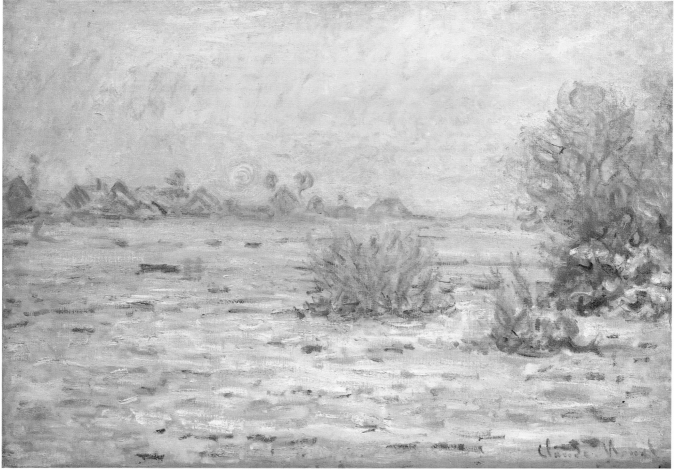

17

18 *The Breakup of the Ice at Lavacourt*

1880
Private collection

19 *The Breakup of the Ice*

1880
University of Michigan Museum of Art
Acquired through the generosity of Mr. Russell B. Stearns (LSA 1916) and his wife,
Andrée B. Stearns, Dedham, Massachusetts

20 *The Breakup of the Ice*

1880–81
Private collection

21 *Sunset on the Seine in Winter*

1880
Private collection, Japan

Painted during Monet's years in Vétheuil, the 1880 *Débâcle* series of paintings of the Seine reflect an unusually sustained effort on his part to capture a single subject in all its moods and from various vantage points. No other series before his years in Giverny exceeds in number this group of seventeen paintings of ice floes on the Seine. Escaping a large household including eight children (his own two and six of Ernest and Alice Hoschedé), Monet pursued these works over a period of many weeks in January and February 1880. In spite of the fact that he had lost his wife Camille the previous September, he seems to have attacked his painting with renewed vigor and determination.

Although during 1879 Monet felt discouraged about his work, which had been criticized for its lack of finish, he produced among his *Débâcles* several very large paintings including one he felt worthy of submitting to

1. Claude Monet, *The Ice Floes*, 1880, oil on canvas, 38⅛ x 59⅛ in. (97 x 150 cm), Shelburne Museum, Shelburne, Vermont.

the Salon.[1] *The Ice Floes* (fig. 1), which is over three feet high by nearly five feet wide, was refused by the Salon but was exhibited in the seventh Impressionist exhibition in 1882 where it was praised by Armand Silvestre, Philippe Burty, and Joris-Karl Huysmans. Where Burty noted the 'originality' of the work, Huysmans found it 'intensely melancholic.'[2]

These four paintings of *La Débâcle* depict the breakup of ice on the Seine, following the thaw that began 3 January 1880 and that continued for some weeks afterward. The sudden rise in temperature after weeks below freezing wreaked havoc on city and countryside alike with the Seine flooding its banks and huge islands of ice floating uncontrollably down the river. The destruction of boats and trees was considerable as was the damage to riverside suburbs and roads. Reporters in Paris described an avalanche of snow and ice as well as forty-two boats utterly destroyed.[3] Alice Hoschedé described the drama of the initial effects of the thaw upon ice and snow:

> Monday, at 5 in the morning. I was awakened by a frightful noise like the rumbling of thunder…to the frightening roar were added cries coming from Lavacourt; quickly, I went to the window, and despite the great darkness we could see the masses of white rushing by; this time it was the *débâcle*, the real thing.[4]

In spite of the calamity of the event, Monet found the subject of the ice on the river one of enormous fascination and beauty. Although some paintings from the series depict snapped tree trunks and branches that

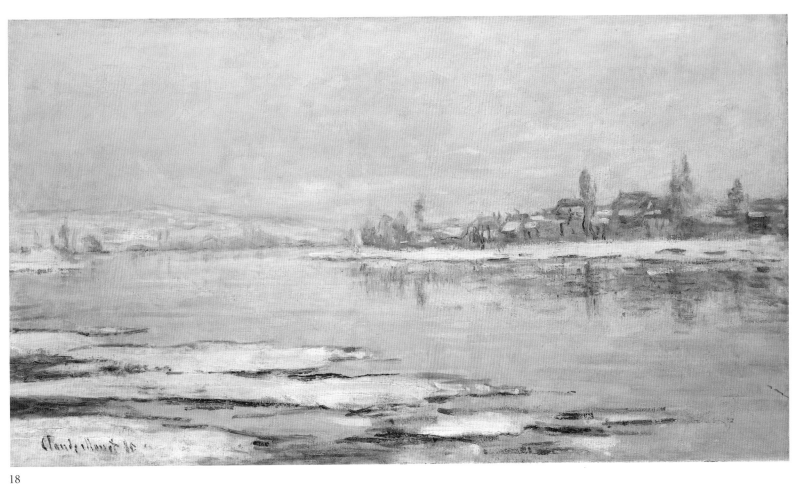

18

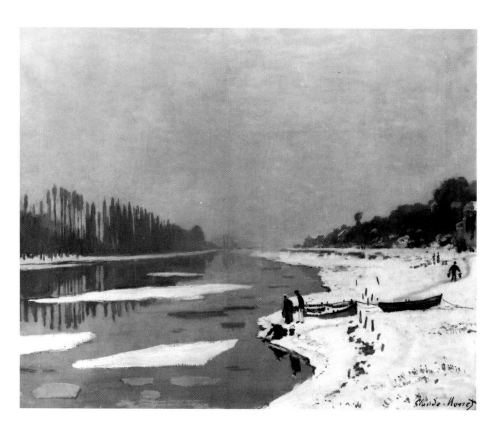

2. Claude Monet, *Ice Floes on the Seine at Bougival*, 1868, oil on canvas, 24 x 31⅞ in. (61 x 81 cm), Musée d'Orsay, Paris.

Monet's passion for painting the river itself, even in its bleakest moment, is anticipated by his earliest paintings of the Seine, *Ice Floes on the Seine at Bougival* (fig. 2) and *Snow on the River*, both probably dating from the winter of 1867–68.[5] Although these works depict a different location and were painted before Monet began to live by the Seine, these first paintings of the river nevertheless anticipate both in subject and season this major series in the artist's œuvre. Marked by shifts in viewpoint and time of day, variations in palette and composition, the seventeen *Débâcle* works find Monet exploring the quality of winter light on water in an unprecedented way.

In *The Breakup of the Ice* (cat. 20), the largest, and most classical in composition of these four paintings of the *Débâcle*, Monet depicts a view of the Seine providing banks on either side with trees. The steady progression of vertical trees is off-set by the evenly-spaced horizontals of the floating ice that seem to measure the intervals of distance to the far horizon. The trees and shrubs by the banks of the river are painted in lively strokes of red, violet, and blue-green; in some cases their vigorous vertical energy suggests new life and hope for spring against a gentle, pale blue sky. More than any paintings before them, these works with their complex study of intermittent reflections in the water anticipate the numerous paintings Monet would do of water lilies floating on the pond in his garden at Giverny.

One of the last versions of *La Débâcle*, this painting (cat. 20) is closely related to two other works in the series. Dated 1881, it is the larger of two paintings that appear to be inspired by an earlier version of the subject, and as such constitutes a commanding summation of his paintings on this theme. Although this work might have been begun early in 1880, it was presumably not completed until early 1881 when the artist signed and dated the work.

Altogether different in mood and palette, *Sunset on the Seine in Winter* (cat. 21), was also probably painted in January or February 1880. A fiery red sun presents its final burst of brilliance before sinking below the horizon. It illuminates the sky and its pink and golden hues are perfectly reflected in the surface of the Seine, off-set by the blues of the floating ice and the distant shore. The broad brushstrokes reflect a rapid execution and the work as a whole brings to mind Monet's renowned *Impression, Sunrise* of 1873 which gave the movement its name. Here the view across the Seine to Lavacourt echoes Monet's paintings of December 1879 (cats. 16, 17) and anticipates another larger painting, *Sunset at Lavacourt, Winter* (fig. 3) that Monet sent to the seventh

tell of the devastation, others offer a more serene view of the river. Throughout the series, Monet vacillates between works freely and sketchily executed and others more finished and descriptive. The smallest and most impressionistic of the works included here (cat. 18) is the delicate and serene view of Lavacourt from across the river in which the immediate foreground is occupied by large floating pieces of ice, while the water further out is melted but still, offering a perfect reflection of the village on the opposite bank. It rises almost like a mirage out of the nearly monochrome atmosphere of winter.

In another view (cat. 19), Monet has positioned himself on the opposite side of the river, painting the view from Lavacourt, which gave him the opportunity to paint the islands of Moisson in the middle distance with the hills of Chantemesle rising behind them on the far bank. Here, it is the reflection of the trees in the river interrupted by the ice floating on the surface that gives the water its quality of reflected light and the artist the opportunity to express the expanse and depth of the river in a majestic way. Primarily painted in shades of blue-green, white, and blue, this work is full of the still, cold atmosphere of winter. No sign of human life or habitation disturbs the scene. The nature Monet describes is beautiful but forbidding.

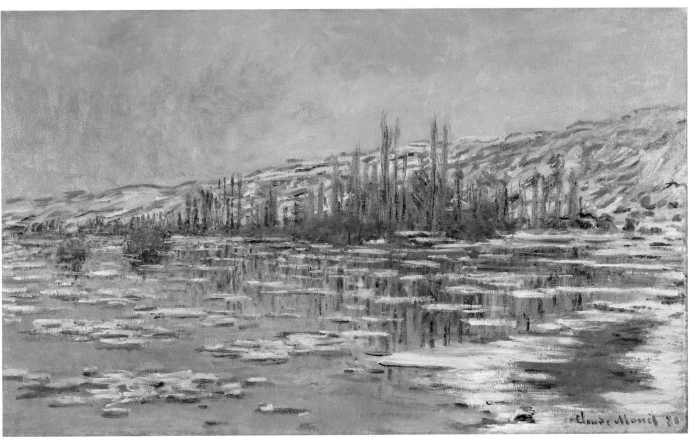

19

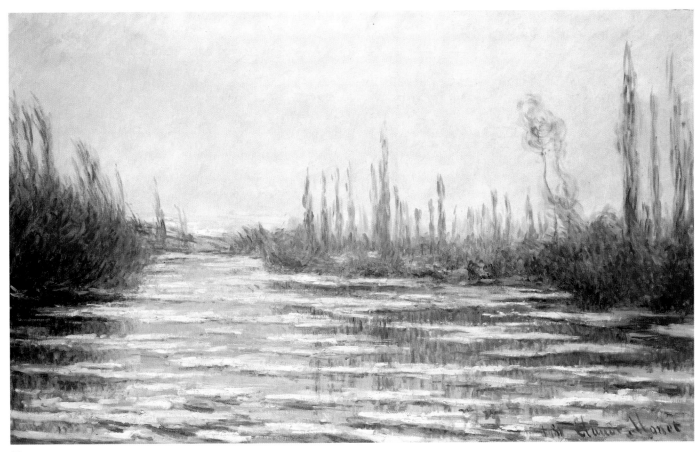

20

3. Claude Monet, *Sunset at Lavacourt, Winter*, 1880, oil on canvas, 39⅜ x 59⅞ in. (100 x 152 cm), Musée du Petit Palais, Paris.

Impressionist exhibition in 1882. The radical nature of the work brought strongly divergent responses from the critics, one of whom noted: 'As for the *Soleil couchant sur la Seine*, one thinks simply of a slice of tomato stuck onto the sky and is quite astonished by the violet light it casts on the water and the riverbanks.'[6] On the other hand, J.-K. Huysmans wrote for *L'art moderne*:

> Yes, the painter who put brush to these canvases is a great landscapist. His eye, now healed, seizes every phenomenon of light with astonishing fidelity. How true the foam on the waves when struck by a ray of sunlight; how his rivers flow, dappled by the swarming colors of everything they reflect; how, in his paintings, the cold little breath of the water rises in the foliage to the tips of the grass.[7]

EER

1. See Joel Isaacson, '*La Débâcle* by Claude Monet,' in *Bulletin*, Museum of Arts and Architecture, University of Michigan, 1978, v. 1, 1–15.
2. Philippe Burty, *La République Française*, 8 March, 1882. J.-K. Huysmans, *L'art moderne*, 1883, quoted in Moffett et al., 1986, 402.
3. See 'Winter Weather Chronology.'
4. Wildenstein, 1974, vol. 1, 106.
5. W105 and W106, Private collection, Switzerland.
6. Jean de Nivelle [Charles Canivet], *Le Soleil*, 4 March, 1882, quoted in Moffett et al., 1986, 403.
7. Joris-Karl Huysmans, 1883, quoted in Moffett et al., 1986, 403.

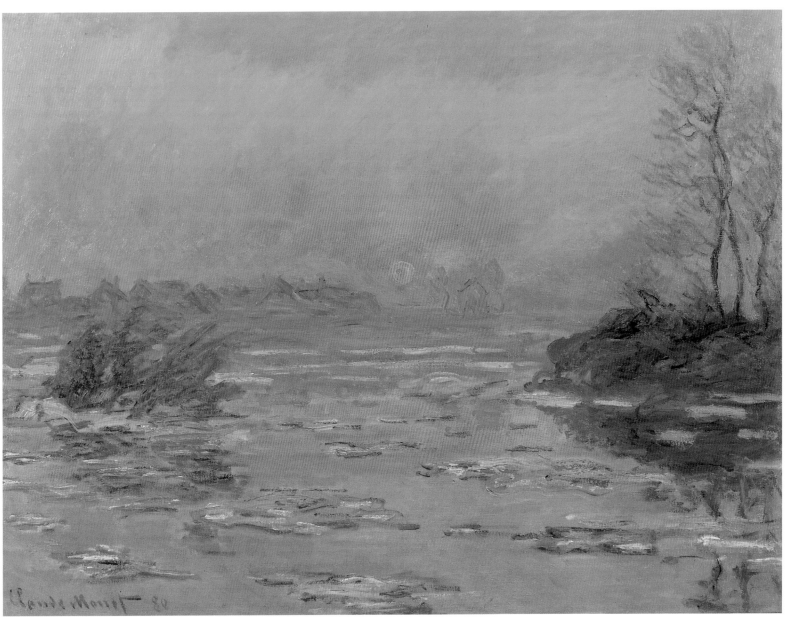

21

22 *Frost*

1885
Private collection, Dallas, Texas

This remarkable painting was probably painted in 1885 near Monet's home in Giverny.[1] He and his family had moved from Poissy to Giverny in April 1883, and he remained there until his death in 1926. Giverny was a small farming village located to the west of Poissy on the Seine. Monet was continually fascinated by the landscape near his home there, and he explored it passionately throughout all seasons of the year.

Monet continued to travel at various times during the 1880s, and one of the most important experiences in his evolution as a painter was his three-month painting trip to Bordighera on the Italian Riviera in early 1884. On his return in April 1884, Monet was newly inspired by the motifs available in Giverny, and produced almost eighty paintings of the region in the following two years. These works are remarkably diverse in composition and technique, and *Frost* is a wonderful example of his exploration and innovation during this period.

With its close-up view of a grove of trees and bushes after a deep frost and its aggressive brushwork, Monet looks forward to the twentieth century in this painting as he moves toward abstraction. The overall palette is quite pale, with the cold whiteness of the snow and frost, but

Monet has also included large dashes of color—green, blue, red, brown—to add accent to the windy, frigid conditions. Unlike his more typical snowscapes that include views of the landscape at a respectful distance, here Monet has severely cropped the composition in order to fully concentrate on the effect of snow and wind on this group of bushes and trees. With the incredibly energetic painting technique and dramatic composition, at first glance the painting appears to be a pure landscape without any evidence of man. Upon closer inspection, however, one can see some type of man-made object, perhaps an animal trap or a discarded piece of metal, in the foreground underneath the foliage.

KR

1. In his catalogue raisonné of the paintings of Claude Monet, Daniel Wildenstein has supplied the date of 1885 to this painting based on the stylistic qualities of the work. He does, however, suggest that the picture could have been painted during the cold winter of 1879–80. See W964.

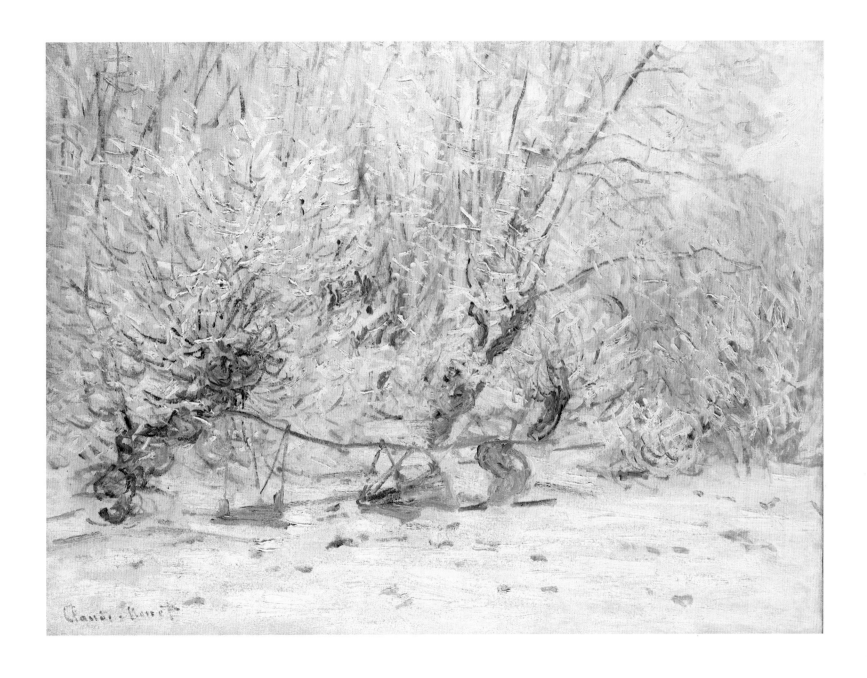

23 *Stack of Wheat (Snow Effect, Overcast Day)*

1891
The Art Institute of Chicago
Mr. and Mrs. Martin A. Ryerson Collection

24 *Stack of Wheat*

1891
The Art Institute of Chicago
Restricted gift of the Searle Family Trust; Major Acquisitions Centennial Endowment;
through prior acquisitions of the Mr. and Mrs. Martin A. Ryerson and Potter Palmer
Collections; through prior bequest of Jerome Friedman

25 *Grainstacks: Snow Effect*

1891
National Gallery of Scotland

26 *Stacks of Wheat (Sunset, Snow Effect)*

1891
The Art Institute of Chicago
Mr. and Mrs. Potter Palmer Collection

Monet probably began working on his series of grain-stack paintings in the fall of 1890 when the local farmers had started harvesting their grain and had begun to make stacks in the field near his home in Giverny, and he continued painting the motif until January or February of the following year.[1] Although these paintings were originally referred to in English as the Haystack series, they have since taken on various titles, including Wheatstacks, Stacks of Wheat, and Grainstacks. The motif that is depicted in Monet's paintings are, in fact, stacks of wheat that have been thatched with straw to protect the grain from inclement weather.[2] This was not Monet's first attempt to paint grainstacks in Giverny; in 1884 and 1885 he had produced six paintings of grainstacks and from 1888 to 1889 he had also produced several views of stacks.[3] However, Monet became truly inspired by the simple shape and iconic beauty of these stacks of grain during the fall of 1890, and devoted the next four or five months to chronicling their subtle changes during different times of day and season.

On 7 October 1890, Monet wrote to his close friend and future biographer, Gustave Geffroy, and provided the first reference to his important series of painting:

I am hard at it; I am adamant about doing a series of different effects (the stacks), but at this time of year the sun sets so quickly that I can't follow it....I am becoming so slow in my work that it exasperates me, but the further I go, the more I see that it is

necessary to work a great deal in order to achieve what I am looking for: 'instantaniety,' especially the external appearance (*l'enveloppe*), the same light diffused everywhere; and more than ever, things that come all at once disgust me. I am, finally, more and more excited by the need to realize what I experience [feel].[4]

With great enthusiasm, Monet continued to paint this series throughout the fall and winter of 1890. In an interview almost thirty years later with the duc de Trévise in 1920, Monet described his creative process during this time:

When I began, I was like the others; I thought that two canvases were sufficient, one for overcast conditions and one for sunny days. I then painted two stacks which impressed me and made a lovely group, two steps from here; one day, I saw that the light [had] changed; I said to my stepdaughter, 'Go to the house, if you would be so kind, and bring me another canvas.' She brought it, but a little later things were different again. Another! and yet another! And I worked on each only when the effect was right, and that's all there is to it. It's not very difficult to understand.[5]

His apparent pleasure and inspiration with this series of paintings may have been caused in part by the purchase of the home in Giverny that he had been renting for himself and his family since 1883.[6] With the help of

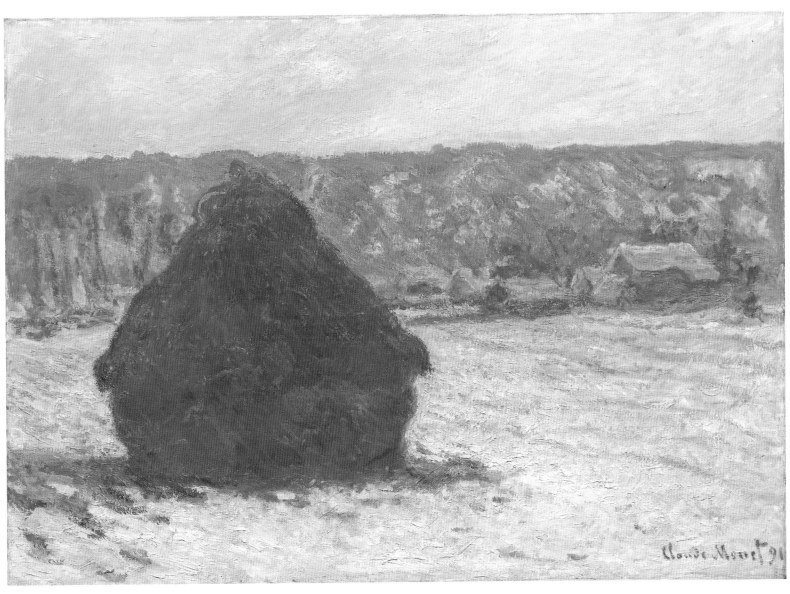

23

his dealer Durand-Ruel, Monet bought the house and surrounding land for 22,000 French francs.[7] Monet lived in this house for the rest of his life, and its gardens and its surrounding landscape continually inspired him.

The weather during the winter of 1890–91 seems to have been perfect for painting out-of-doors. Although the average temperature was quite cold, there were very few days with unbearable conditions. In addition, the modest amount of snowfall that occurred that winter, combined with the cold temperatures, kept the ground covered with a thin layer of frost and snow that can be seen clearly in the paintings included in this exhibition. According to his friend Geffroy, Monet's neighboring haystacks stayed in the fields longer than usual during this period: 'The haystacks were not removed so he could continue, throughout the year as the seasons returned, to concentrate on the infinite changes of atmospheric effects on the eternal face of nature.'[8] With almost twenty-five years experience painting *en plein air* in the coldest months of the year, these relatively stable weather conditions allowed Monet to paint outdoors consistently throughout the winter of 1890–91 and to produce some of his most sublime expressions of *effets de neige*. From September 1890 to February 1891, Monet produced twenty-five paintings of grainstacks, with twelve created during the winter.[9] For him, this was a rare and inspired period of production of winter landscapes.

Approximately six months after he began the series, Monet exhibited fifteen of his grainstack paintings at Galerie Durand-Ruel in Paris. Although the exhibition did not only feature works from this remarkable series (there were seven other paintings in the show), it was the first time that Monet was able to install such a large group of works with the same subject and title together in one gallery. The exhibition was a great success with critics and collectors, and Monet had already sold many of the paintings before the show opened.

Unfortunately, not all of Monet's colleagues were receiving the same accolades and positive responses from collectors and critics. Fellow Impressionist Camille Pissarro, for example, was not particularly pleased with the great success of Monet's series. As he wrote to his son Lucien on 3 April 1891, before Monet's exhibition had opened, 'For the moment, people want nothing but Monets; it seems he can't paint enough pictures to satisfy the demand. The worst of it is, they all want "Wheatstacks at Sunset"! Always the same old story; everything that he does goes to America for prices of four, five, six thousand francs....Life is hard.' Six days later, Pissarro continued, 'It defeats me why Monet doesn't find it annoying to confine himself to repeating the same subject; such are the terrible consequences of success.'[10]

During the run of the exhibition, the Dutch essayist Willem Geertrud Byvanck met and interviewed Monet and later described Monet's thoughts about the series:

Above all I wanted to be truthful and exact. For me a landscape hardly exists at all as a landscape, because its appearance is constantly changing; but it lives by virtue of its surroundings—the air and light—which vary continually. Did you notice the two portraits of a woman above my Haystacks? It's the same woman, but painted in a different atmosphere. I could have done fifteen portraits of her, just like with the haystack. To me, only the surroundings give true value to the subject. When you want to be very accurate, you suffer terrible disappointments in your work. You have to know how to seize just the right moment in a landscape instantaneously, because that particular moment will never come again, and you're always wondering if the impression you got was truthful.[11]

Although he did begin all his Grainstack paintings *en plein air*, he did eventually take the canvases into his studio to finish the compositions. Several of the works from the series were re-worked in the studio by Monet, and the stacks themselves were often moved or changed after coming indoors.[12] Throughout the series, Monet continuously varied the composition and palette for each work. The painting from the National Gallery of Scotland (cat. 25) is a wonderful example of his use of a subtle and restrained palette. It features a rather large haystack in front of a secondary, smaller one. The buildings and trees behind the two stacks are quite indistinct, as they seem to merge into the hills in the distance.

Stacks of Wheat (Sunset, Snow Effect) from The Art Institute of Chicago (cat. 26) contains a similar composition to the version from Scotland, but has a brilliant palette with great energy and intensity. The composition is dominated by the searing orange-yellow of the setting sun. Also from The Art Institute of Chicago is *Stack of Wheat (Snow Effect, Overcast Day)* (cat. 23). This painting features a single stack atop a snowy ground. The group of poplar trees that can be seen in the series of grainstack paintings from 1888 to 1889[13] can be seen to the left of the grainstack. Although the composition appears similar to the previous painting (cat. 23), in *Stack of Wheat* (cat. 24), one can see that Monet has slightly changed his position, since the screen of poplar trees is more visible in this painting. In the two latter paintings in the exhibition, the skies are overcast, and the shadows on the ground are of less interest.

KR

1. Tucker, 1989, 71.
2. Charles S. Moffett, 'Monet's Haystacks,' in Rewald and Weitzenhoffer, 1984, cat. 143.
3. See W900–902, 993–995,1213–1217.
4. Quoted in Moffett, in Rewald and Weitzenhoffer, 1984, 157–58, n. 19.
5. Ibid., 158, n. 21.
6. Tucker, 1989, 76.
7. Stuckey, 1995, 220.
8. Moffett, in Rewald and Weitzenhoffer, 1984, 157, n. 1.
9. The twelve winter grainstack paintings are W1274–1284, 1287; Tucker, 1989, 75–76.
10. Bailly-Herzberg, vol. III, 1980–91, 55, quoted in Koja, 1996, 114.
11. Quoted in Stuckey, 1985, 165.
12. Tucker, 1989, 81–82.
13. W1216, 1217, 1279.

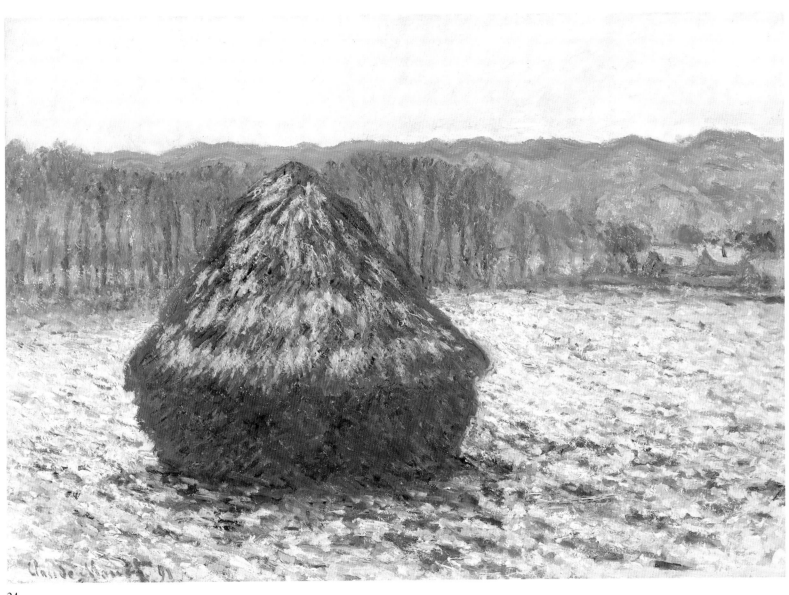

24

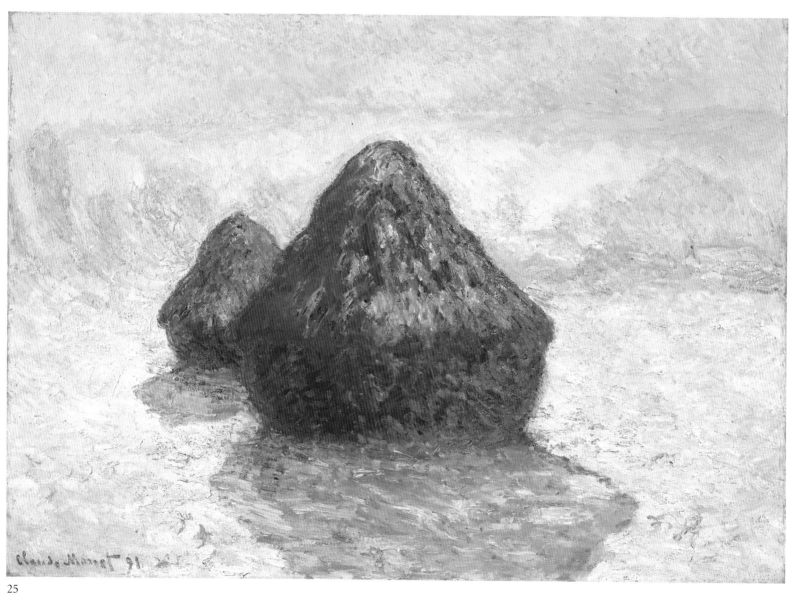

25

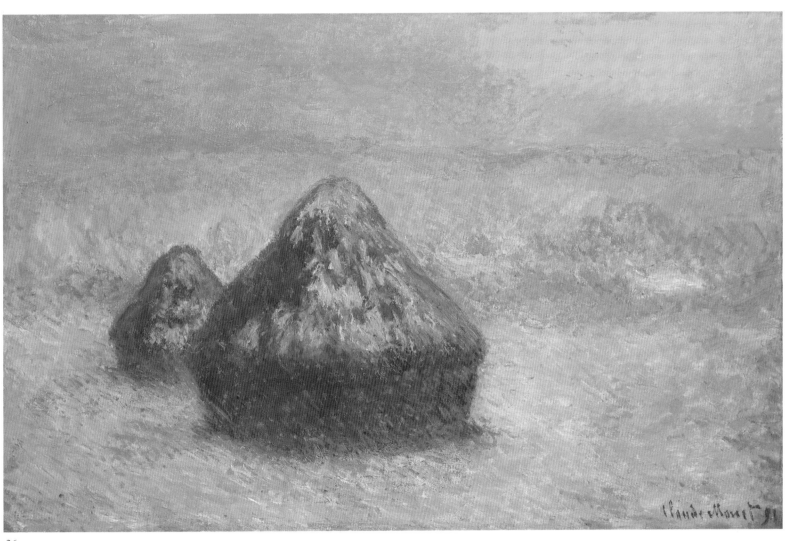

26

27 *Ice Floes*

1893
The Metropolitan Museum of Art, New York
Bequest of Mrs. H.O. Havemeyer, 1929, The H.O. Havemeyer Collection

28 *Floating Ice at Bennecourt*

1893
Waterhouse Collection

29 *Morning Haze*

1894[1]
Philadelphia Museum of Art
Bequest of Mrs. Frank Graham Thomson

30 *Ice Floes on the Seine near Bennecourt*

1893
Private collection
Courtesy James Roundell Ltd.

In July 1892 Monet married his second wife, Alice Hoschedé, one year after the death of her estranged husband. This event, combined with the marriage of his stepdaughter Suzanne Hoschedé to Theodore Butler, seems to have disrupted Monet's painting schedule during the fall of 1892, as he spent most of his time reworking paintings that he had already begun in his studio. Monet wrote to Durand-Ruel about this period of relative inactivity in late January of 1893: 'Not having worked in so long, I only painted things that I had to destroy.' He persevered, and reported to his dealer that 'I succeeded in finding myself again. The results—just four or five canvases and they are far from complete.... But, I do not despair about being able to take them up again if the cold weather returns.'[2]

During this period of renewed enthusiasm, Monet produced thirteen views of ice floes on the Seine that are remarkable for their delicate atmospheric effects and energetic brushwork.[3] Monet, as he had since 1865, braved the elements and produced these extraordinary studies of weather in rather frigid conditions. These paintings are reminiscent of his previous series of ice floes from the winter of 1879–80 when the extremely cold conditions also caused the river to freeze over (see cats. 18–20).

For over two weeks in January of 1893, the Seine went through a period of freezing and thawing that produced dramatic ice floes. These pieces of ice floated for several days, and inspired Monet to produce these subtle atmospheric studies. Painted on the Bennecourt bank of the river, across from Giverny, Monet executed nine examples that face towards the hills on the left bank with subtle changes of site, time of day, and atmosphere. In the center of the works from The Metropolitan

Museum of Art, the Waterhouse Collection, and the Philadelphia Museum of Art (cats. 27, 28, and 29), Monet has included the islet of Forée, which was at that time situated between the Grand-Ile and the Ile de la Flotte.[4] In a variant from a private collection (cat. 30), Monet has moved his position to the right, and places the islet of Forée on the left of the composition with the Ile de la Flotte and the islet de la Motte (which no longer exists) in the background on the right.[5]

In these paintings, the river is filled with snow-capped ice floes, and provides a fascinating combination of ice, water, and cold mist. These works are a triumph of atmosphere. Despite the similar compositions of this series, they are each distinguished by their delicate palettes which vary individually from ice-blue, mauve, and pink of a frigid day on the river to warmer tones of yellow and blue when the sun attempts to melt the thick ice that floats on the water. In the three works with the similar composition (cats. 27, 28, and 29), the cold river provides the perfect reflection of the islet, the trees, and the sky, and adds to the tranquil and harmonious mood of this series. In the variant (cat. 30), however, there is no reflection of the islet, and instead Monet concentrates more attention on the water and the presence of the floating pieces of ice, which are painted with a luminous palette of light blue, green, pink, and white.

KR

1. Although this painting is dated 1894, it seems likely that it was begun in 1893 at the same time as cats. 27, 28, and 30, but the artist may not have finished it until the following year when he signed and dated it.
2. Letters to Durand-Ruel, 12 and 19 December 1892 and 24 January 1893, in Wildenstein, W1172, W1173, quoted in Tucker, 1989, 156.
3. See W1333–1344.
4. See W1333.
5. See W1339.

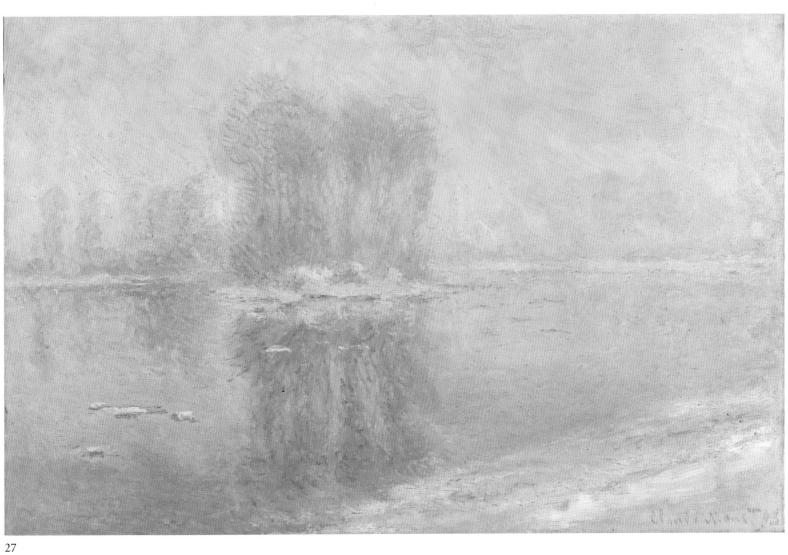

27

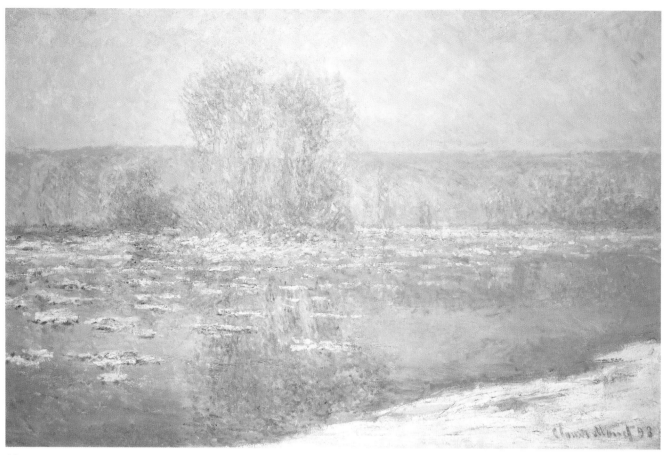

28

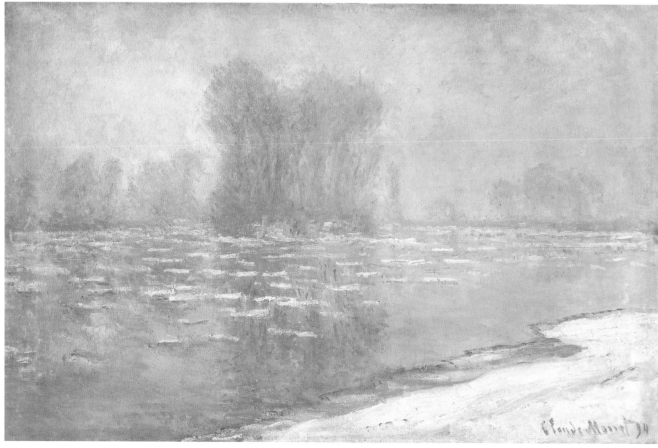

29

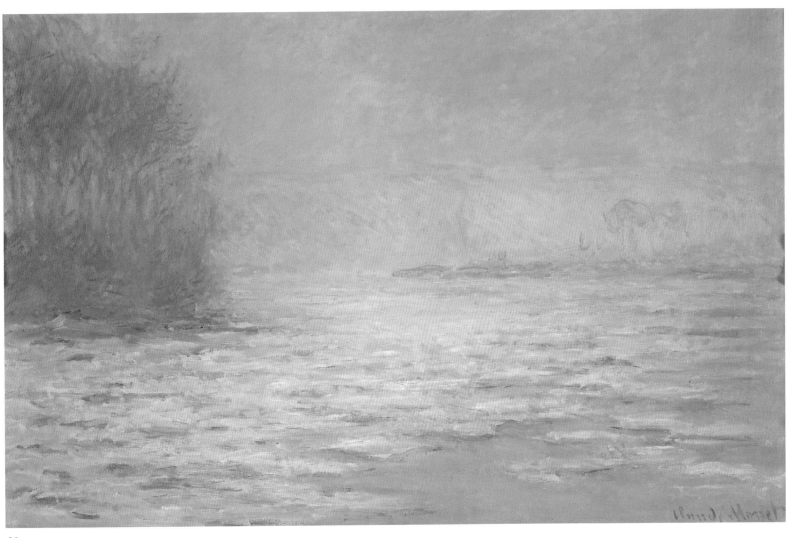

30

Renoir

Pierre-Auguste Renoir was born on 25 February 1841 in Limoges, to Léonard and Marguerite Renoir, a tailor and dressmaker who moved their family to Paris in 1844. Ten years later Renoir became apprenticed to the porcelain painter M. Levy and began studying drawing with the sculptor Callouette. After working briefly as a decorator for a manufacturer of blinds, in 1861 he began attending the atelier of Charles Gleyre, where he met Sisley and Monet. The following year he was admitted to the Ecole des Beaux-Arts.

Renoir first exhibited at the Salon in 1864.[1] In the years leading up to the following decade, the Salon jury accepted his works sporadically. It was during this time, in 1868, that he painted his first snowscapes, virtual rarities in his œuvre. Firm in his conviction that snow 'is one of nature's illnesses,' Renoir painted only two or three *effets de neige*.[2]

During the Franco-Prussian War, Renoir was posted in Libourne. Upon completion of his service, he returned to Paris and immediately resumed painting. During the Commune, he began commuting between Paris and Louveciennes, where his parents were living.

In 1872 he again attempted to exhibit at the Salon. By this time his palette had lightened and his brushwork had become more animated, and his work was rejected, as it would be again the following year. That summer he visited Monet in Argenteuil and later that year they began discussing plans for what would become the first Impressionist exhibition, in which Renoir showed six paintings and one pastel.[3]

Although a founding member of the Impressionist exhibitions, Renoir never failed to recognize the importance of exhibiting at the Salon. In 1878, rather than exhibit with his colleagues, he re-entered the official art world by exhibiting at the Salon. His works met with success, and by 1879 he had gained the support of influential, wealthy art-lovers whose commissions essentially provided him with a means of living. Durand-Ruel, who began to purchase Renoir's paintings with great frequency in 1881 and who in 1883 held Renoir's first solo exhibition, provided further financial support.

In February 1881 Renoir left for Algeria in search of light and exotic subjects. He then traveled to Italy, where he developed a profound respect for ancient and Renaissance artists. Hereafter he attempted to reconcile mythological themes with his penchant for painting scenes of everyday life, in an attempt to create images which emulated the 'simplicity and grandeur of the ancient masters'.[4]

Upon his return to France in 1882, Renoir painted with Cézanne at l'Estaque, and in 1883 he painted alongside Monet on the Riviera. Following this trip south, Renoir primarily worked in Paris, where he met regularly with his Impressionist colleagues and a group of naturalist writers for monthly dinners at the Café Riche. In 1887, as he had in 1871, he began dividing his time between Paris and Louveciennes.

In April 1890 he married Aline Charigot, his longtime companion and the mother of his five-year old son, Pierre.[5] One month later he exhibited at the Salon for the last time. That same year the French government awarded him with the medal of the Legion of Honor, which he initially refused. He accepted the award ten years later, in 1900, by which date he had begun dividing his time between the Mediterranean coast and Essoyes, his wife's birthplace. By now he had experienced his first attacks of rheumatism, which worsened in intensity in the early years of the century. He continued painting within his physical limitations, however, and in the last years of his life experimented with sculpture, pottery, and designing tapestries. On 3 December 1919, Renoir died in Cagnes, of congestion of the lungs.

1. Renoir first attempted to exhibit at the Salon in 1863, with *A Nymph with a Faun*, which he apparently later destroyed. See Arsène Alexandre, *Exposition A. Renoir*, Paris, 1892, 12.
2. Ambroise Vollard, *Les Tableaux, Pastels et Dessins de Pierre-Auguste Renoir*, Paris, 1918, vol. 1, no. 18, 5.
3. He chose not to participate in the fourth, fifth, sixth, and eighth exhibitions. Durand-Ruel, however, entered twenty-five of his paintings in the sixth show.
4. Venturi, 1939, vol. 1, 117.
5. Pierre Renoir was born in Paris, 21 March 1885. On 15 September 1896 Aline Charigot (1859–1915) gave birth to the couple's second son, Jean, in Paris. Their third son, Claude, was born 4 August 1901, when Renoir was sixty years old.

Pierre-Auguste Renoir, *Skaters in the Bois de Boulogne* (detail cat. 31), 1868, oil on canvas, 28⅜ x 35⅜ in. (72.1 x 89.9 cm), From the collection of William I. Koch.

31 *Skaters in the Bois de Boulogne*

1868

From the collection of William I. Koch

Renoir likely painted *Skaters in the Bois de Boulogne* during the early weeks of 1868, when chilling temperatures permitted daring pedestrians to walk across the frozen Seine and ice skaters were observed as far south as the Midi.[1] As rare an event as this was, equally unusual was Renoir's painting of a winter snow scene. Several years after he painted *Skaters in the Bois de Boulogne,* Ambroise Vollard, the work's original owner, asked Renoir about it. The artist responded:

> Yes, the *Bois de Boulogne*—the one with skaters and
> pedestrians in it. I have never been able to stand the
> cold; it is the only winter landscape I ever did….Oh,
> no, there were two or three other studies, too. But
> then, even if you can stand the cold, why paint snow?
> It is a blight on the face of Nature.[2]

Renoir painted *Skaters in the Bois de Boulogne* from a high vantage point, placing the horizon line two-thirds of the way up the canvas. He gradually reduced the scale of the figures who, even in the nearest foreground, are so small that they are essentially faceless. Those in the distant background have been reduced to one or two cursory dashes of gray. Rendered in short, sketchy brushstrokes, they appear warmly clad in dark winter coats and hats, brightened by occasional dabs of red and bluish-purple.

As a result of their small scale, it is the silhouettes of the figures in *Skaters in the Bois de Boulogne* which suggest their obvious delight in this casual winter-time treat. They assume a remarkable variety of poses, ranging from chatting onlookers who appear to have randomly formed a loose circle around the skaters, to singles and couples gliding effortlessly across the ice. Anecdotal elements, such as a top-hatted man just below the center of the painting who, having slipped, sits upon the ice with his knees bent; a man diagonally to his left who, having more recently fallen, is caught with his legs in the air; a pair of tentatively treading children; men sweeping fresh snow off of the ice; and a gray dog, just to the right of center, who stands alert to another gold-colored dog, all contribute to the sense of spontaneity and vitality of the scene.

Renoir's technique further animates this winter landscape. Shadowy silhouettes of iron gas-lamp posts which illuminated the park's ponds repeat the arabesques of skating figures. Thickly painted patches of white snow alternate with areas of equally built-up strokes of bluish-grays that suggest the smooth icy surface of the pond. Their density contrasts with the thinly painted row of brownish-gray trees in the distance. The foliage which frames the left side of the composition, including an unexpectedly large tree that extends beyond the picture frame, reveals diverse brushwork, from wispy strokes of green and brown at the top, to shorter, broken touches of white, olive, and burnt ochre in the foliage along the ground.

As Robert Herbert discusses, Renoir painted this work along the *lac de patinage* in the western section of the Bois de Boulogne, although as recently as 1866 a skating rink had been constructed with electric lights to accommodate the new Cercle de Patineurs.[3] The skating pond, like the numerous other streams and lakes in the Bois, had been artificially constructed during Napoleon III's renovation of the park, which was a major component in his campaign to redesign the capital city. From 1852 to 1858, this once royal preserve had been completely transformed to become one of Paris' most fashionable sites for gathering, strolling, and being seen, specifically for members of the upper- and middle-classes. The nearby racetrack at Longchamp, which Degas frequently painted, as well as a zoo, botanical garden, and an amusement park, provided additional forms of entertainment for the park's visitors.

The elevated point of view and the expansive city setting populated by small, hastily-painted figures in *Skaters in the Bois de Boulogne* reflect elements characteristic of a series of paintings that both Renoir and Monet executed in Paris the previous year.[4] In works such as *The Champs Elysées during the Paris Fair of 1867* and *The Pont des Arts,* Renoir painted Parisians enjoying the city's attractions from a high vantage point, though in summer's full sunlight.[5] These two paintings, as well as *Skaters in the Bois de Boulogne,* are among his earliest depictions of modern Paris and prefigure a theme that would dominate Renoir's œuvre—social leisure—which he and Monet would cultivate while again painting side-by-side, this time in the suburbs at La Grenouillère, during the summer of 1869.

LPS

1. See 'Winter Weather Chronology.'
2. Ambroise Vollard, *Renoir: An Intimate Record*, trans. Harold L. Van Doren and Randolph T. Weaver, New York, 1925, 51–52.
3. Robert L. Herbert, *Impressionism: Art, Leisure, and Parisian Society*, New Haven and London, 1988, 147.
4. For Monet's related paintings, see *Quai du Louvre* and *Garden of the Princess*, W83, 85.
5. *The Champs-Elysées during the Paris Fair of 1867*, 1867, Private Collection, and *The Pont des Arts,* 1867, Norton Simon Foundation. See Herbert, ibid., 1988, figs. 8, 9.

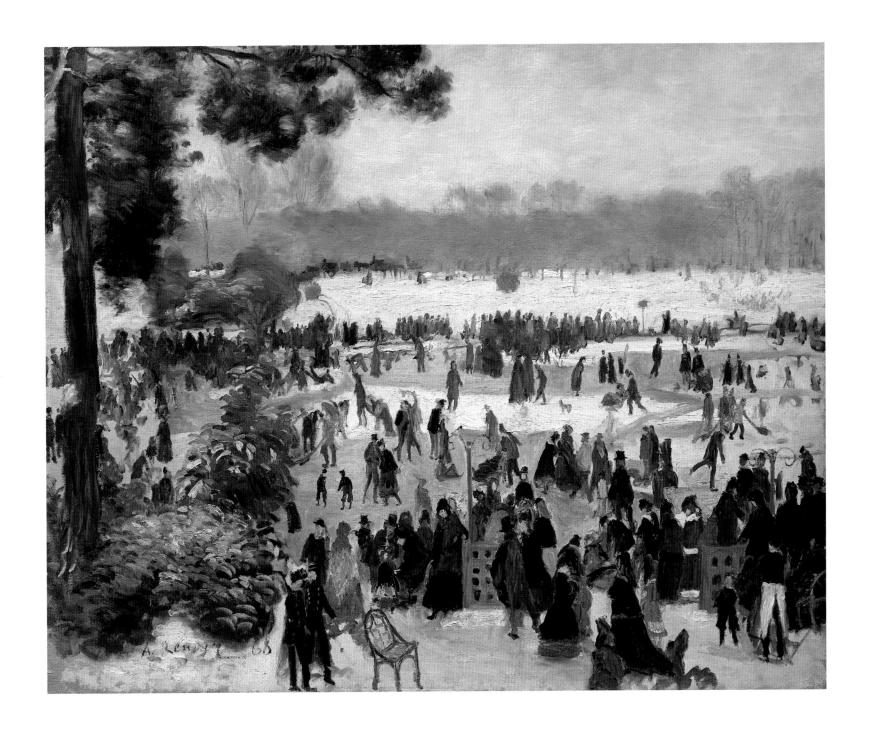

Pissarro

On 10 July 1830 Camille Pissarro was born in Charlotte-Amalie, St. Thomas. The son of a prosperous businessman, at the age of twelve he was sent to study in the Parisian suburb of Passy, where he quickly developed a deep appreciation for the arts. In 1847 he returned to St. Thomas and joined the family business. His four and a half years in Paris, however, had left him determined to become a painter, and in 1852 he left for Venezuela, where he spent two years painting and sketching the landscape and ordinary people of Caracas with the Danish painter Fritz Melbye (1826-1869).

Pissarro returned to St. Thomas in 1854, only to set sail for France one year later, where, for a short time, he attended classes at the Ecole des Beaux-Arts. In 1859, as a student in Paris at the Académie Suisse, he met Monet, who would subsequently introduce him to Renoir and Sisley. 1859 also marks the year that Pissarro first exhibited at the Salon. His now-lost *Landscape at Montmorency*, which hung in that Salon, is typical of his earliest Parisian works, which reflect the accepted genres of landscape and scenes of rural life. Although he exhibited at the Salon regularly throughout the 1860s, Pissarro grew frustrated by its principles and politics. At the same time he came to distrust organized authority and sympathize with anarchist values, and after 1870 he refused to submit works to the Salon jury.

In 1866 he retreated from the city and settled in Pontoise with his mistress Julie Vellay and their two children.[1] From Pontoise he could readily commute to Paris, though from this date onward he never again established a permanent residence in the city. He did, however, maintain contact with his colleagues there and in 1869 moved to Louveciennes to paint with Renoir and Monet. At about this time Pissarro painted his first *effets de neige*, a theme to which he returned up until the final year of his life.

During the Franco-Prussian War Pissarro and his family sought refuge in London. They returned to Louveciennes in the summer of 1871 to find their home, including a vast number of Pissarro's early paintings, had been pillaged by the Prussian army. One year later the Pissarros re-settled in the Pontoise area, where they remained until 1882. Pissarro's primary subjects during these years were the streets, fields, and rural areas of the neighboring villages of Auvers, l'Hermitage, and the town of Pontoise itself.

In 1874 he was instrumental in planning the first of eight group exhibitions by the artists eventually known as the Impressionists. In addition to his role as a founding member of the group, Pissarro was the only artist to participate in each of the exhibitions from 1874 to 1886. *Snow at l'Hermitage, Pontoise* (cat. 42) which he included in the second Impressionist exhibition, was the first *effet de neige* he exhibited in the shows.

From 1879 to 1880, he collaborated with Edgar Degas, exploring the process of printmaking for their proposed periodically-issued print journal titled *Le Jour et la Nuit*. Although the journal never came to fruition, Pissarro continued to experiment with printmaking and created nearly two hundred prints by the time of his death. During these highly experimental years, he also invited younger artists to contribute to the Impressionist exhibitions, at the risk of severing ties with dear friends such as Degas and Monet.

In 1882 Pissarro left Pontoise for the nearby town of Osny. In 1884 the family settled in Eragny, situated on the banks of the Epte in Normandy and Pissarro's primary residence for the rest of his life. Four years later, at the age of fifty-eight, he began to suffer from an eye condition that had first affected him ten years earlier, and which eventually required him to work behind a protective window or indoors, though it did not lead to a decrease in his artistic productivity. He continued to commute to Paris frequently and visited his eldest son Lucien in London in 1890, 1892, and 1897. At the age of seventy-three, on 13 November 1903, Pissarro died in Paris.

1. Pissarro eventually married Julie Vellay (1839–1926), formerly his mother's maid, while in England on 14 June 1871. The couple had eight children.

Camille Pissarro, *Road, Winter Sun and Snow* (detail cat. 33), c.1869–70, oil on canvas, 18 x 21¾ in. (46 x 55.3 cm), Carmen Thyssen-Bornemisza Collection.

32 *The Versailles Road at Louveciennes (Snow)*

1869
The Walters Art Gallery, Baltimore

In December 1869 the Pissarro family hosted Monet at their home on the route de Versailles. Working side-by-side, Monet, who had painted his first *effet de neige* during the winter of 1865 (cat. 1), completed two paintings of the snow-covered route, and Pissarro three. These, among Pissarro's earliest *effets de neige*, were thus likely inspired by Monet, whose influence was further bolstered by the particularly heavy snowfall which descended upon Paris and its environs during his month-long stay in Louveciennes.[1]

A thickly painted white sky, highlighted by streaks of pale yellow and orange, and ominously marred by small passages of dark gray, hovers above the quiet road. In the distance, a horse-drawn carriage has begun to leave its tracks upon the newly-fallen snow blanketing the route. As it advances, a woman, flanked by two children and followed by a third, approaches the curb. Donning a bright red cap and walking stick, another woman stands to the left of the road, just in front of the yellow house with dormer windows that several scholars have presumed to be the Maison Retrou, Pissarro's Louveciennes home.[2]

1. Camille Pissarro, *The Road to Versailles at Louveciennes,* 1870, oil on canvas, 15¹⁵⁄₁₆ x 22³⁄₁₆ in. (40.16 x 56.36 cm), Sterling and Francine Clark Art Institute, Williamstown, Massachusetts.

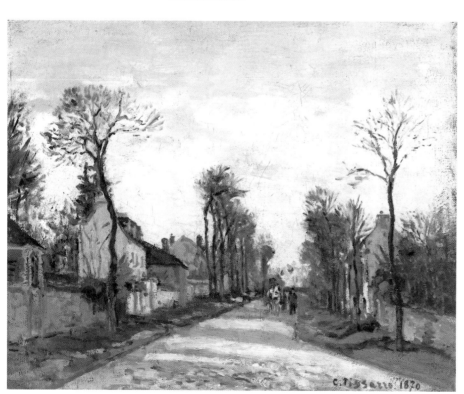

Pissarro placed his easel to the right of the route, where it is intersected at the right by another street, creating a gentle bend in the road. He would again employ this point of view for *The Road to Versailles at Louveciennes* (fig. 1), a painting of a brighter day later that winter, when the chestnut trees had not yet replenished their leaves but the green grass had begun to surface. Having situated himself slightly further to the left in the later painting, the bend in the road has become more subtle and the bordering stone wall extending to the south of Pissarro's home has achieved greater length. In this timeless village, the chestnut trees have maintained their awkward shapes and the horse-drawn carriage entering the composition headed south also appears, this time approaching a male figure walking in the same direction.

Pissarro's paintings from the winter of 1869–70 reflect Monet's paint handling during this period. As did Monet in his contemporaneous view of the route de Versailles in *Road at Louveciennes—Snow Effect* (cat. 5), Pissarro used more fluid brushstrokes to render the solid, stone buildings and thinner, coarser brushwork for the bare trees. Monet continued with a more scumbled approach in the rendering of the thawing ground, as if his technique were determined by an inherently rougher image of brown earth emerging from beneath melting snow, in much the same manner as Pissarro's gloomy sky in the current work. The more fluid handling of paint in Pissarro's snowy road and sidewalks may likewise be compared to Monet's similar approach in his rendering of the clearing blue sky.

The Versailles Road at Louveciennes (Snow) is unique in its most probable date of 1869, a year to which few other Pissarros may be definitively dated. Like most of his early works, Pissarro did not date this painting, but it was purchased just weeks after its completion, when Pissarro sold it to one of his first dealers, 'Père' Martin. Martin, in turn, sold it for 20 francs to the American collector George A. Lucas, on 7 January 1870, making it one of the first works by Pissarro to enter an American collection.[3]

LPS

1. See 'Winter Weather Chronology.'
2. See Tinterow and Loyrette, 1994, 447.
3. Distel, 1990, 41.

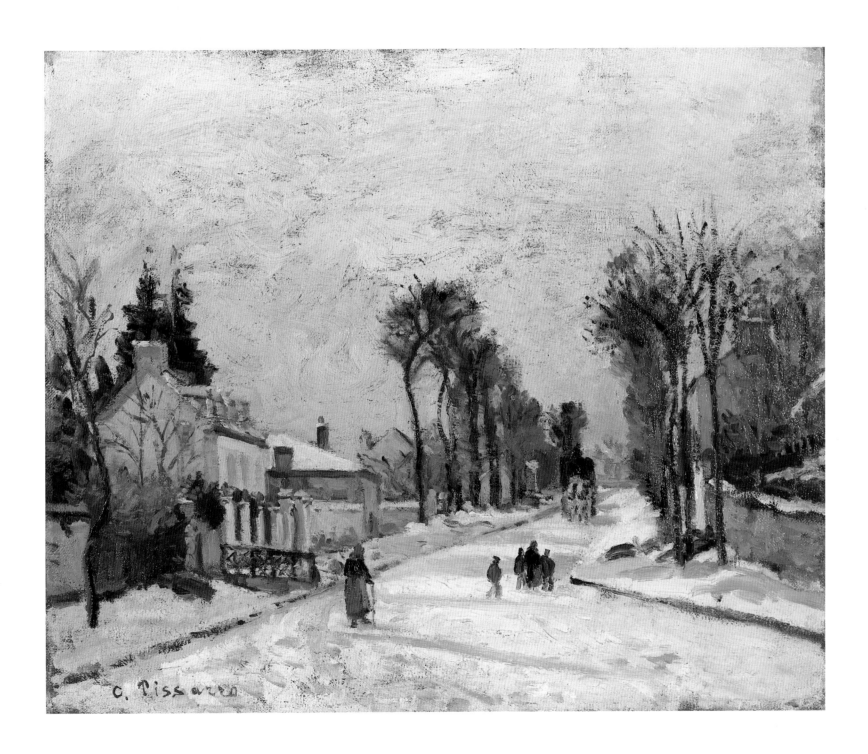

33 Road, Winter Sun and Snow

c. 1869–70
Carmen Thyssen-Bornemisza Collection

The Pissarro family lived in Louveciennes from 1869 to 1872, a brief period further abbreviated by the interruption of the family's flight to London during the Franco-Prussian War. While in Louveciennes, Pissarro resided at 22, route de Versailles, on the upper part of the road, just steps away from the home of Renoir's grandmother.[1] The route de Versailles became the subject of at least eight paintings, including the present work, in which Pissarro fully explored the effects of the changing weather and light, and concentrated on depicting one site from different angles.

In *Road, Winter Sun and Snow*, a bright and sunny winter day threatens to thaw the remaining patches of snow lining the road and dotting the grassy areas to its right and left. A pattern of horizontal lines created by the trees' shadows establish a rhythm along the brightly-lit dirt road. Along the left side of the road a woman and man with his horse have paused in their travels to talk. A carriage, having just continued past them, travels toward the Parc de Marly.

Pissarro's palette is essentially composed of browns, yellows, greens, and light blues with dabs of opaque whites. Small areas of red punctuate the composition and lead the eye into the distance. A square patch of red to the right in the immediate foreground resounds in the male figure's bright red scarf which leads the eye toward the small red structure just behind him. These larger areas of red are accented by smaller dashes along the road.

Road, Winter Sun and Snow is a signed but undated work that has typically been considered to date from the winter of 1872, following Pissarro's return to Louveciennes. Today, however, there remain questions as to whether some of Pissarro's Louveciennes paintings were executed before or after the artist's self-imposed exile in London. Following the Prussian army's siege of Pissarro's studio and home, the artist reported the loss of more than 1400 paintings, presumably including recent works from 1869 to 1870. While there exist works definitively painted in 1870, there are, in fact, no known works dating from 1869. Quite possibly then, some paintings which have been attributed to later dates, including the present work, may have indeed been painted as early as 1869.

The imagery, subject matter, and technique of *Road, Winter Sun and Snow* suggest a date of winter 1869–70, before the Prussian invasion. Ronald Pickvance has noted that before the war, the road was lined with trees which the Prussian army chopped down.[2] In a letter she wrote to her brother-in-law, Julie Vellay's sister offered eyewitness testimony to the destruction in Louveciennes. She wrote, '…the [main] road is in a pitiful state. The road is unmanageable for cars, the houses are burned, windows, shutters, doors, staircases and floors, all are gone. I arrived in Louveciennes and didn't even recognize your house….[It] is uninhabitable.'[3]

Silhouetted against the luminous blue sky, the tall chestnut trees in the present work have clearly matured, and bear no evidence of devastation, much like the trees in the more firmly dated Baltimore painting, *The Versailles Road at Louveciennes (Snow)* (cat. 32). Its composition, palette, and facture are also shared by the Baltimore work, and reflect the influence of Monet, with whom Pissarro painted during the winter of 1869–70. Furthermore, although the route de Versailles figured prominently among Pissarro's subjects while he resided in Louveciennes, among his dated works following his return from London, the route does not seem to have held the same interest. Pissarro did, however, depict the route in snow on at least two occasions when once resettled in Louveciennes. These two later paintings,[4] both signed and dated 1872, vary quite drastically from *Road, Winter Sun and Snow*, most notably, in their compositions. In both, the road, the defining compositional element in Pissarro's earlier Louveciennes works, no longer provides the structure of the painting and, consequently, the perspectival thrust into the composition is lost. All these characteristics, when considered together, along with the painting's small size which is typical of Pissarro's paintings from his early period in Louveciennes, suggest an earlier rather than a later date.

LPS

1. Renoir's grandmother owned a home at 18 route de Versailles in Louveciennes.
2. Ronald Pickvance, in *Masterworks from the Carmen Thyssen-Bornemisza Collection*, exh. cat. Madrid: Thyssen-Bornemisza Museum, 1996, 160.
3. Bailly-Herzberg, 1980–91, vol. 1, 69–70.
4. P&V 130, 131.

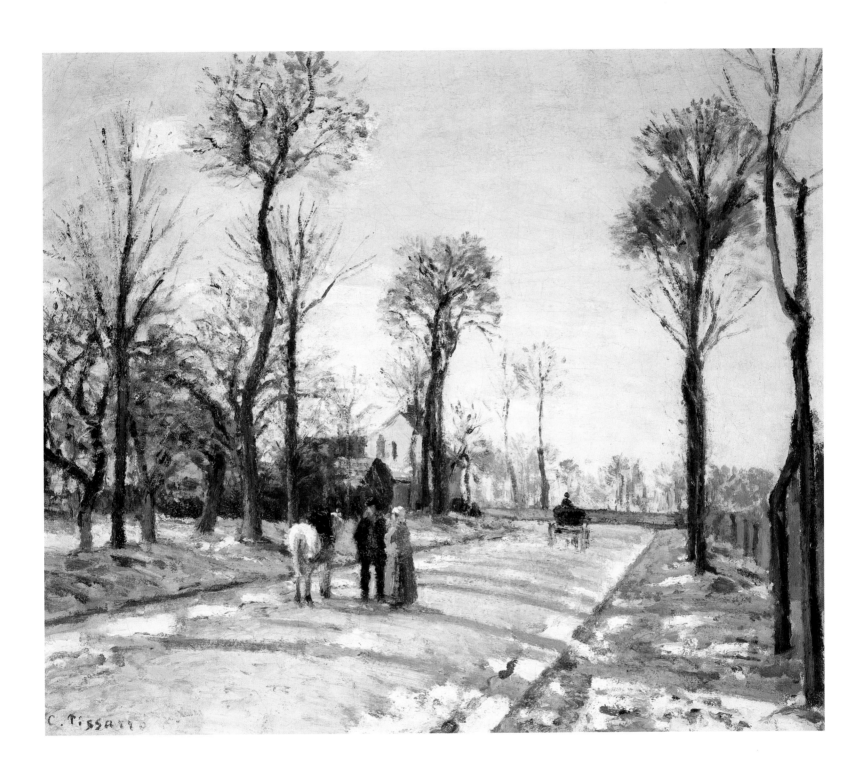

34 *Fox Hill, Upper Norwood*

c. 1870
The National Gallery, London

During the Franco-Prussian War and the Paris Commune of 1870–71, the Pissarro family fled to England and resided in the London suburb of Upper Norwood. As Pissarro later described, here he 'studied the effects of mist, snow and springtime,' and created some thirteen oil paintings.[1] In London's galleries Pissarro studied the paintings of English masters he admired such as Constable, Turner, Lawrence, Reynolds, and Gainsborough. He was also welcomed at the French quarter between Soho and Leicester Square, where he met with fellow French exiles. Among this set, Pissarro met Paul Durand-Ruel, the art dealer and gallery owner whose patronage would prove essential to Pissarro's career.

The winter of 1870–71 was exceptionally cold in London, offering Pissarro the opportunity to continue painting *effets de neige*, which he had begun to paint during the winter of 1868–69.[2] For the current work, he set up his easel in the center of the road, which gently undulates and winds, leading upward and looking westward, toward Fox Hill. Older and newer houses stand side-by-side, sharing the roadside with winter brown shrubbery and bare trees. Puffs of smoke emerge from chimneys and merge with the cloudy, winter blue sky. The blue, in turn, is reflected in blue-colored patches of snow on the road and roofs. Three strolling figures, a set of two women and one top-hatted man, will imminently pass each other in the road. Dressed predominantly in shades of brown, gray, and black, they harmonize with the landscape. Highlights of red in the women's clothing reappear in the rooftop of the nearest home and a small area of foliage along the right side of the road.

Although living amid the English and their art history, Pissarro's subject matter during his London period reflects themes which he had begun painting in France. *Fox Hill, Upper Norwood* is no exception, illustrating a familiar type of scene in Pissarro's œuvre—indeed if not for the painting's title, one might easily imagine this road in Louveciennes. The painting's original title, in fact, may have been simply and generically *Effet de neige*.[3]

Pissarro's association with Durand-Ruel led to his participation in the first London exhibition of the Society of French Artists, in which one of the paintings exhibited, perhaps this work, was a snow scene, titled *Effet de neige*.[4] Unlike his Pontoise paintings, which Richard Brettell has noted for their 'uncanny locative precision' the original title of this painting may not have indicated a specific English location.[5] This may have been the result of an artist whose interests lay more in the scene's light and weather conditions than its situation, or perhaps Pissarro did not wish to specify the precise location, which may have conflicted with his socialist beliefs.

The village of Upper Norwood, where Pissarro lived, was a place whose name connoted both geographical and social associations. Originally distinguished by its location on the higher ground of the village of Norwood, it eventually became a wealthier neighborhood than its geographically lower cohort.[6] The meaning of the two names would have been clearly apparent to the painting's contemporary English viewers, and in fact, in 1885 the village's name was changed from Lower Norwood to West Norwood as a result of social pressure.

Pissarro's stay in London in 1870–71 would not be his last. Although he waited impatiently to return to 'beautiful, great, and hospitable' France, he retained an appreciation for some of England's customs, most specifically those associated with Christmas, which he would have enjoyed that winter.[7] He crossed the Channel three times in the 1890s to paint and to visit his eldest son Lucien, who settled there in 1883.

LPS

1. Letter to Wynford Dewhurst, November 1902. See Dewhurst, 1904, 31. For the paintings executed in London, see P&V105–116, and Pissarro, 1993, fig. 78.
2. Four of the works he painted in England include scenes of wintry weather. He also began work on a number of fans, which are attributed to later dates. These were based on drawings made in London but painted once Pissarro had resettled in France.
3. Malcolm Warner, ed., *The Image of London: Views by Travellers and Emigrés 1550–1920*, exh. cat. London: Barbican Gallery, 1987, 160.
4. On 10 December 1870 Paul Durand-Ruel opened the first exhibition in London of the Society of French Artists. Although a February review of the show does not mention Pissarro, a second hanging opened on 6 March 1870 which included *A Snow Effect* (entry 38) and *Upper Norwood* (entry 41). The two paintings have not been definitively identified, but they were the first works by Pissarro to be shown outside France. See Katherine Rothkopf, 'Camille Pissarro: A Dedicated Painter of Winter.'
5. Brettell, 1990, 4.
6. For a discussion on Lower and Upper Norwood, see Martin Reid, 'The Pissarro Family in the Norwood Area of London, 1870–71: Where Did They Live?', in Lloyd, 1986, 62–63.
7. For Pissarro's desire to return to France, see Bailly-Herzberg, 1980–91, vol. 1, 64. Regarding Pissarro's recollections of England, see Shikes and Harper, 1980, 90.

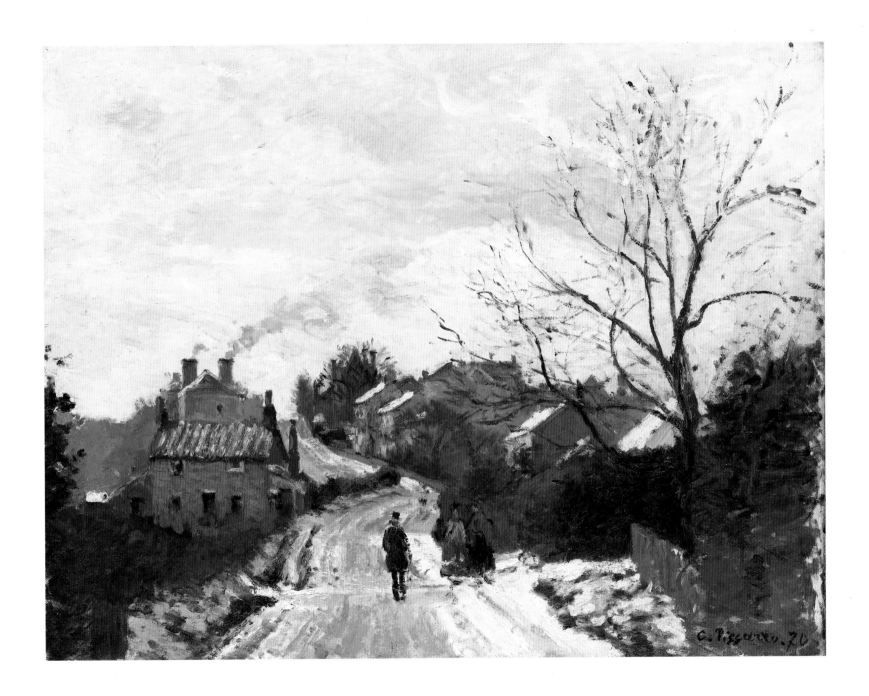

35 *Snow at Louveciennes*

c. 1871–72
The Art Institute of Chicago
Mr. and Mrs. Lewis Larned Coburn Memorial Endowment

Although this work is not dated, it was probably painted during the winter of 1871–72 when Pissarro had returned from London to his home in Louveciennes after the Franco-Prussian War. Pissarro and his family arrived in Louveciennes in the summer of 1871, only to discover that their house had been used by the Prussians during the war, and that a substantial part of Pissarro's œuvre had been destroyed.

Despite the devastating loss, Pissarro quickly resumed working, and the first winter after the war proved to be his most productive period for painting snowscapes. During the winter of 1871–72, Pissarro produced a large group of at least eleven[1] *effet de neige* paintings ranging from several views of the route de Versailles and other major lanes in Louveciennes peopled with villagers walking through town, to more contemplative views of simple fields, trees, and houses in the snow.

Snow at Louveciennes obviously falls in the latter category, as Pissarro has caught the fleeting period following a fresh snowfall with gray skies threatening to produce more precipitation. This relatively small painting has the spontaneity and freshness of a work created *en plein air*. In the foreground, there is a gently sloping hill beneath a thick blanket of snow, behind which stands a bordering stone wall that cuts across the composition. A group of several bare trees spreads across the entire width of the painting, with generous amounts of snow on their branches. A solitary figure walks below the screen of trees, on his way, perhaps, to the house in the distance. Pissarro has used a limited palette in this simple, intimate work, relying on shades of white, brown, blue, tan, gray, and green to evoke the deep cold of this stormy day. He has added a small amount of orange-red on the figure and the trees that surround him to provide an accent of vibrant color to this relatively somber palette.

KR

1. The eleven paintings are: P&V130–132, 142–144, 146, 149, 186, and also include this painting and *Louveciennes* from the Museum Folkwang Essen (cat. 36). P&V136 (cat. 33), previously thought to have been produced in the winter of 1871–72, may instead date to the winter of 1869–70.

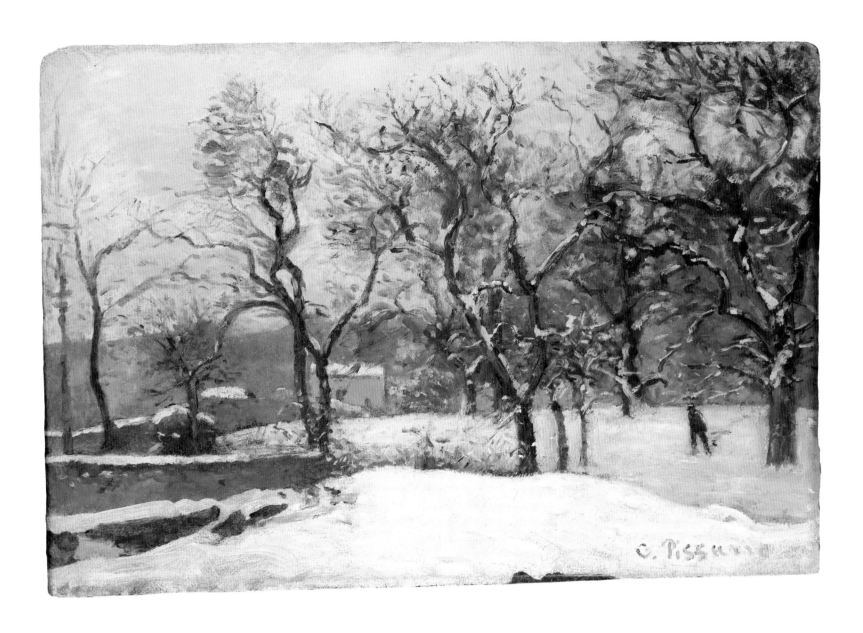

36 *Louveciennes*

1872
Museum Folkwang Essen

Louveciennes is a signed and dated work, completed during Pissarro's second stay in Louveciennes following the Franco-Prussian War. Devoid of human presence, it is purely a study of the effects of winter light and snow on a tranquil landscape made more serene by snow. Houses along the left margin, however, imply a human presence as do fresh footprints which have created a central path in the composition. The footprints, though, do not reveal brown earth beneath them, but have created an icy path, which suggests both the snow's significant depth and a path not frequently traveled.

Shadows of seen and unseen trees provide the structure of the foreground. The shadows cast by the trees along the right of the canvas, in particular, create a pattern of blue diagonals which alternate with areas of thickly painted whites. Joachim Pissarro has noted that Pissarro's Louveciennes period may be characterized by the painter's intense interest in shadow and structure.[1] Pissarro's early critics, as well, readily noticed the important role of shadow in his compositions. Jules-Antoine Castagnary, in his review of the first Impressionist exhibition, remarked:'He commits the grave error of painting fields with shadows cast by trees placed outside the frame. As a result the viewer is left to suppose they exist, as he cannot see them.'[2] Although the critic was quick to criticize Pissarro for his use of shadow, the artist continued to embrace this unusual technique.

The diagonal shadows of the trees and surrounding bushes suggest the presence of the sun to the lower right of the composition. Its morning light has created streaks of muted pinks and lavenders which enliven the light blue sky, and which are reflected on to the thick layer of snow covering the ground and rooftops. The painting is further animated by the varied angles of tree branches silhouetted against the clear blue sky, creating a web-like pattern in the upper portions of the canvas.

LPS

1. Pissarro, 1993, 66.
2. Jules-Antoine Castagnary, 'L'Exposition du Boulevard des Capucines. Les Impressionistes,' in *Le Siècle*, 29 April 1874, reproduced in Anne Dayez et al., *Centenaire de l'Impressionisme*, exh. cat. Paris: Grand Palais, 1974, 265.

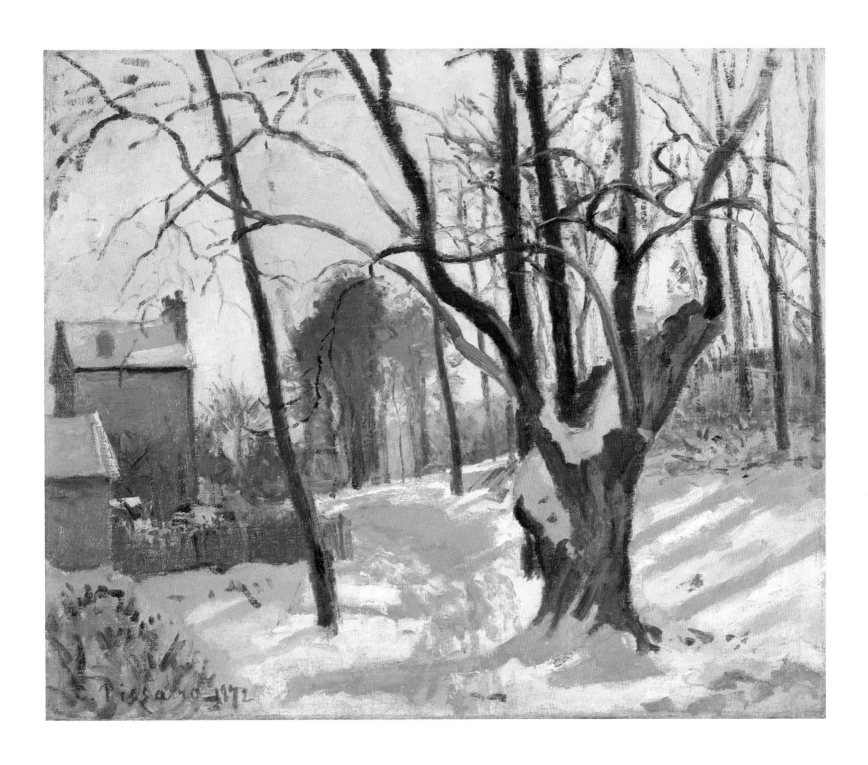

37 *Street in Pontoise, Winter*

1873
Private collection

After their time abroad during the Franco-Prussian War and a brief stay in Louveciennes, Pissarro and his family relocated in 1872 to Pontoise, a town twenty-five miles north of Paris, where they remained for more than ten years. His younger colleague Paul Cézanne soon moved nearby, and the two artists formed a close working relationship.

In a letter to his son Lucien from 22 November 1895, after having seen Cézanne's one-man show at Vollard's gallery, Pissarro recalled the happy period when the two artists worked together in close harmony in Pontoise and Auvers:

> Curiously enough, in Cézanne's show at Vollard's there are certain landscapes of Auvers and Pontoise [painted in 1871–74] that are similar to mine. Naturally, we were always together! But what cannot be denied is that each of us kept the only thing that counts, the unique 'sensation'!—This can be easily shown.[1]

Although Cézanne moved back to Aix in 1874, he

1. Paul Cézanne, *Snow Effect—Road to the Citadel at Pontoise*, 1873, oil on canvas, 15 x 18 in. (38 x 46 cm), whereabouts unknown.

continued to visit Pissarro in Pontoise on a regular basis. Both artists learned a great deal from each other during this period. In particular, Cézanne's relationship with Pissarro forced him to focus on landscape painting for the first time in his career. During this period, they often painted side-by-side, much like their colleagues Renoir and Monet had already done at La Grenouillère. There are ten known pairs by both artists,[2] and this view of a street in Pontoise was probably the first time that the artists painted the same site together.[3] Unfortunately, the version by Cézanne, which had been in the collection of Josse Bernheim-Jeune in Paris, was stolen by the Germans during World War II and its current location is unknown.

This composition features a motif that was quite typical for Pissarro in the early 1870s—a perspectival view of a village road after a snowstorm. When compared to the extant black and white photograph of the Cézanne painting of the same subject (fig. 1), it is fascinating to see the differences in composition and handling. Pissarro includes a significant portion of the rue de la Citadelle, with the octagonally-shaped old citadel in a prominent position on the left. Two men, who are engaged in conversation, stand in the road underneath a lamp post, while a woman walks toward them. Cézanne, on the other hand, set his easel up much farther down the path, and included the wall on the right side of the road as well. His buildings have a greater solidity and weight than those included in Pissarro's version, which has a greater emphasis on the atmosphere and light on a wintry day.

KR

1. Quoted in Rewald, 1981, 352.
2. White, 1996, 118.
3. Rewald, 1996, no. 195, 149.

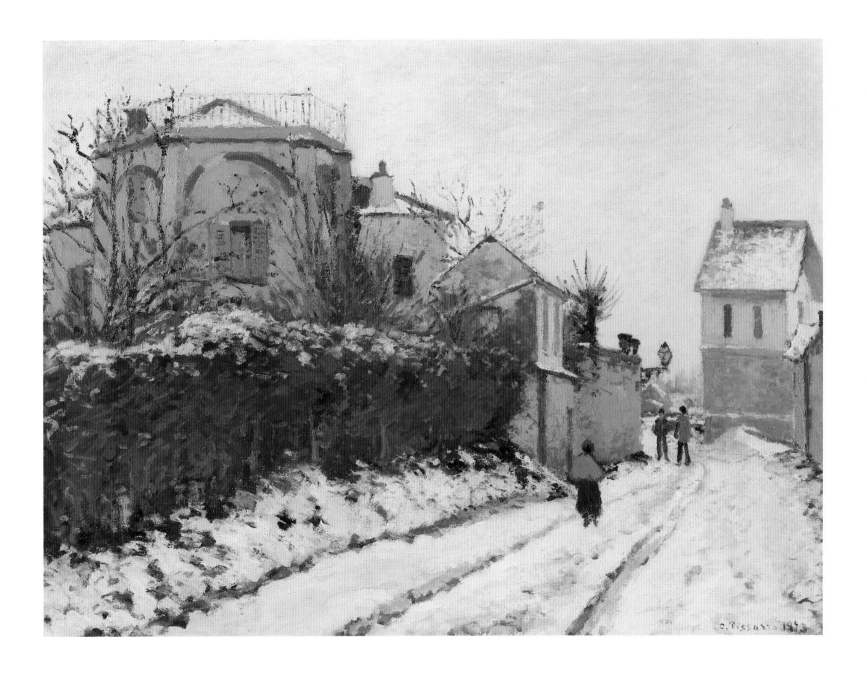

38 *Piette's House at Montfoucault*

1874
Sterling and Francine Clark Art Institute, Williamstown, Massachusetts

Ludovic Piette was a wealthy landowner and painter with whom Pissarro developed a dear friendship after their initial meeting in 1860, when both were students at the Académie Suisse. Like Pissarro, Piette was profoundly concerned with social and political affairs, and loved to paint. He was a constant source of support for Pissarro, whose work he deeply admired. In 1877 he joined Pissarro in exhibiting with the Impressionists and in 1879 his work was shown posthumously with the group.[1]

Piette, who owned a family farm in Montfoucault, was himself inspired by the area's isolated landscape. In 1871 he wrote to Pissarro:

Ah! If only it were just the two of us where I come from! What splendid things to do, and in these places, one could think that one is thrown 1,000 or 2,000 years back: no traces of man left, it is just as wild as after a century or two of flood; trees and rocks of such color![2]

Two years later Piette again exalted upon his surroundings, particularly their beauty in winter. He wrote:

When I am by myself in a wood, contemplating nature, I regain all the strengths that worldly events take away from me; I would like to paint all that is beautiful that I see around me, and you know better than I that winter is full of exhilaration for a painter.[3]

Tempted by Piette's letters, Pissarro brought his family to Montfoucault for an extended stay during the winter of 1874–75. He did not need to look far to find the isolation and solitude of which Piette wrote. He focused on Piette's house as well as the outbuildings and farmyard of his friend's property in a number of works, seven of which depict the effect of snow on its environs. According to Shikes and Harper, and as evidenced by his relatively large number of *effets de neige*, Pissarro was fascinated 'by the challenge of capturing the reflection of color in the snow, [and] particularly liked to paint winter scenes, sometimes until his fingers could no longer wield the brush.'[4]

As Joachim Pissarro has noted, Montfoucault's physical isolation is manifested in the works Pissarro painted there.[5] This may be due, as well, to the lay of the land in Montfoucault, where the fields were typically enclosed and the horizon line was often obstructed. *Piette's House at Montfoucault*, like the contemporary *Snow at Montfoucault* and *Farm at Montfoucault, Snow Effect* (cats. 39 and 40), reveals such characteristics. The composition, framed by nature, is enclosed on all sides. It is nearly symmetrical, with both the right and left of the canvas laden with bushes and tree branches sagging beneath the weight of deep snow. A central path leads not into the distance, as it might in Pontoise, but to a closed iron gate, which prevents further access to the farmhouse just behind. The farmyard appears enclosed from above as well, blanketed by a densely painted white sky.

Along the snow-covered path, a man and woman each carry bundles of wood. In this, an early effort to study 'figures and animals of the real countryside,' the workers are small and painted in the same tonalities as the surrounding landscape.[6] Although they are not prominent, they are integral to the composition. Facing one another as if engaged in conversation, they are centrally placed and perform distinct tasks.

LPS

1. Pissarro made his final journey to Montfoucault in 1876, two years before Piette's death from cancer in April 1878.
2. Ludovic Piette, *Mon cher Pissarro. Lettres de Ludovic Piette à Camille Pissarro*, ed. Janine Bailly-Herzberg, Paris, 1985, 67–68.
3. Ibid., 96.
4. Shikes and Harper, 1980, 127.
5. Pissarro, 1993, 139.
6. Letter to Théodore Duret, 20 October 1874, quoted in Bailly-Herzberg, 1980–91, vol. 1, 95.

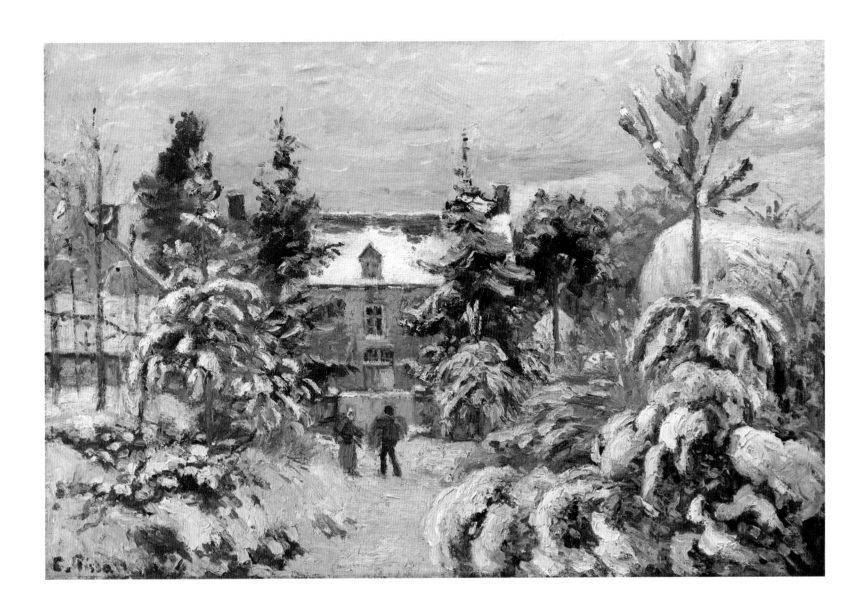

39 *Snow at Montfoucault*

1874
Lord and Lady Ridley-Tree

Today, as it was some one hundred and twenty-five years ago, Montfoucault is a barely inhabited hamlet in eastern Brittany which lies approximately fifteen miles from the nearest town. Located about 225 kilometers (approximately 140 miles) west of Paris, in Pissarro's lifetime nearly one full day was required to reach the capital. A letter from 1874, in which Piette provides Pissarro with instructions on how to reach his farm, reveals the complexities of reaching the remote village:

> Decide upon your definite date of departure at least two days in advance. Then go to the Montparnasse or the Saint-Lazare stations; then book a family omnibus to come and fetch you….The train to aim for is the seven o' clock or the express at 8:55….Book your seats in Paris for Céancé….Once in Céancé, we will send for you, providing that you have warned two days in advance of your arrival, in order to leave us time to find horses….You should arrive in Céancé at 3:55; in two hours maximum, you should reach Montfoucault, i.e., 5:55.[1]

In addition to the rigors of the one-day journey to Montfoucault, originating in Pontoise rather than in Paris, the Pissarros would have been required to stay overnight in the capital before departing early in the morning from Paris.

The hamlet's physical isolation is readily conveyed in Pissarro's Montfoucault paintings. In contrast to his contemporary paintings of Pontoise, Pissarro does not offer glimpses of towns in the vistas beyond, for in the immediate vicinity of Piette's property, his chosen subject while in Montfoucault, lofty trees provide the backdrops of these agrarian scenes and prohibit any views into the distance. Although *Snow at Montfoucault* offers a more expansive view of the environs of Piette's farm than do *Piette's House at Montfoucault* (cat. 38) or *Farm at Montfoucault, Snow Effect* (cat. 40), a sense of isolation and serenity permeates the painting, which is enhanced by the lack of an obvious human presence.

Beneath a heavy winter sky tinged with rays of pink, snow-capped trees provide a natural frame for the quiet farmyard in the present work. A dirt path extends diagonally across the painting and is divided into two by a row of roughly painted snow-covered bushes, thus creating one path which leads to the barn and another to the slightly larger stone building. The latter, marked by its bright green shutters, does not appear in any of Pissarro's other Montfoucault paintings. Six geese approach the path at the left, and behind them a brown horse saunters toward the barn. In the foreground, patches of snow veil the hard brown earth. A gently undulating tree trunk, with roots exposed, extends beyond the edges of the painting on the right.

The monochromatic, earth-toned palette in *Snow at Montfoucault* is characteristic of Pissarro's works from this Montfoucault period. Blues, greens, ochres, and opaque whites are thickly applied and roughly handled. Both palette and technique are thus appropriate for the rural imagery and the burdensome weather conditions they convey.

LPS

1. Ludovic Piette, *Mon cher Pissarro. Lettres de Ludovic Piette à Camille Pissarro*, ed. Janine Bailly-Herzberg, Paris, 1985, 116.

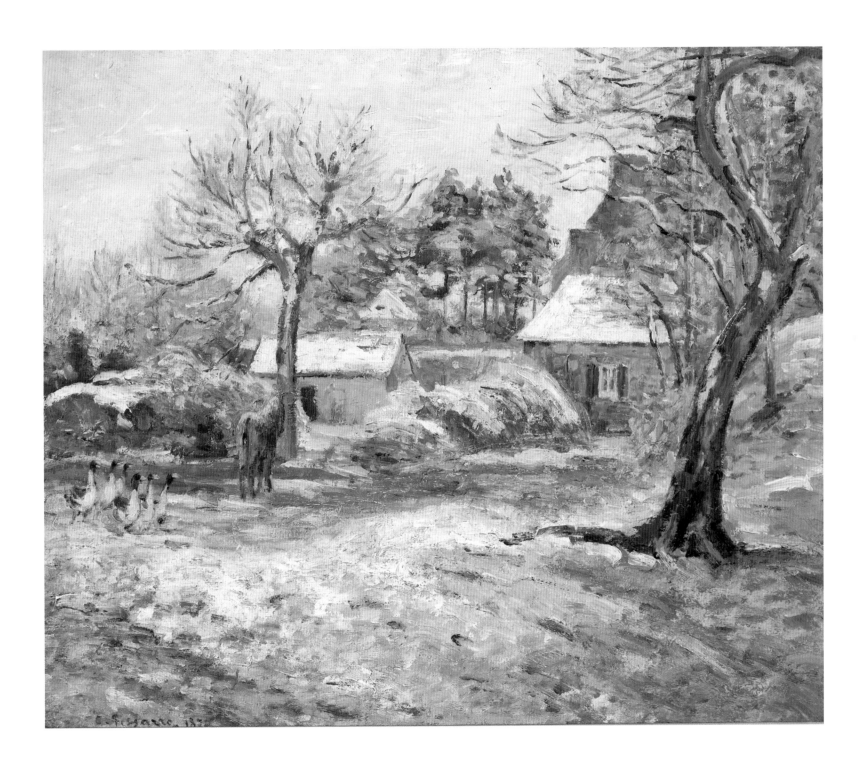

40 *Farm at Montfoucault, Snow Effect*

1876 [1]
The Visitors of the Ashmolean Museum, Oxford

Pissarro first painted with his close friend Ludovic Piette in Montfoucault in 1864, and he often returned there throughout the following decade. In 1870, as the Prussian army advanced toward Paris, Pissarro and his family retreated to Montfoucault before setting sail for England. Once more Pissarro sought refuge with the Piettes, following the highly criticized and disappointing first Impressionist exhibition. Throughout the 1870s, Montfoucault provided Pissarro not only with a comforting place of retreat, but also with an alternative landscape to that of the rapidly modernizing Pontoise. Here, in 1874, he was first inspired to take up the subject of peasants at work in the landscape, a theme which would occupy him for the rest of his career.

In December 1873 one of the Impressionists' greatest defenders, the critic and art collector Théodore Duret, wrote to Pissarro, encouraging him to paint 'rustic nature, with its fields and animals.'[2] Pissarro may have begun to consider studying the subject the following summer, while he and his family were visiting the Piettes. They returned to Montfoucault that October, and just before his departure, Pissarro wrote to Duret, 'I am going there to study the figures and animals of the real countryside.'[3] Two months later, in another letter, he informed Duret:

> I am not working too badly here. I am doing figures and animals. I have several genre paintings, but I throw myself timidly into this branch of art, so well illustrated by artists of the highest order, this is so bold, I fear that it may be a complete flop.[4]

In referring to artists of the 'highest order,' Pissarro may have been alluding to Courbet or Millet, painters with whom he may have feared comparison but who may have concurrently inspired him to paint animals in the countryside or peasants tending the fields.[5] Millet's works, in particular, which portrayed rural workers with sincerity, but with neither saccharine sentimentality nor harsh social commentary, had in recent years gained wide appeal. By 1872 Durand-Ruel had become his primary dealer and his paintings were fetching prices of 15,000 to 20,000 francs at auction. Courbet, admired by Pissarro for his art and politics, had also gained notoriety with his images of peasants. In addition to his subject matter, Pissarro embraced Courbet's coarse brushwork and tactile surfaces which are not only evident in his Montfoucault paintings, but in his earlier works as well.

Farm at Montfoucault, Snow Effect, which Pissarro likely began to paint in 1874, illustrates his early attempt to fully integrate the presence of figures and animals into the landscape. In the foreground, a peasant carrying a bundle of hay passes through a wooden gate. A single sheep follows behind him, and to their right two crows hobble along the snow-covered ground. The worker and animals are rendered in the same earth-toned palette of blues, greens, browns, and opaque whites as their surroundings. Employing such a technique, Pissarro enhanced the notion of man's unity with nature, already inherently implied in the figure's role and his placement.

With few exceptions, the workers and animals in Pissarro's Montfoucault paintings are imbued with greater prominence than are their ancestors who stroll along the roads of Pontoise and Louveciennes. They are larger in scale and stand in the immediate foreground. The men and women of Montfoucault are indeed more solidly composed than Pissarro's earlier figures and, tending animals or carrying bundles of wood, their tasks reflect the tradition of Millet and Courbet. The figures in this grouping of paintings, however, are less conspicuous than those portrayed by Pissarro's predecessors, and would remain so for another five years.

LPS

1. Although Pissarro signed and dated this painting 1876, it has traditionally been considered to date to 1874, with Pissarro and Venturi noting that it was signed and dated in that year (see P&V283). Based on its similarity to cats. 38 and 39 (P&V287, 284) and the fact that the only time Pissarro is known to have spent at Montfoucault in 1876 was during the autumn, Pissarro may have begun this composition during the winter of 1874 and completed it upon his return to Montfoucault two years later. During his 1876 stay in Montfoucault, Pissarro does not seem to have painted any additional *effets de neige*.
2. Letter to Pissarro, 6 December 1873: 'Je persiste à penser que la nature agreste, rustique avec animaux est ce qui correspond le mieux à votre talent,' P&V, 1939, vol. 1, 26.
3. Letter to Duret, 20 October 1874, quoted in Bailly-Herzberg, 1980–91, vol. 1, 95.
4. Ibid., 96.
5. Critics were quick to compare Pissarro and J.-F. Millet (1814-1875). Pissarro, however, resented such comparisons and expressed his frustration on several occasions. See Pissarro, 1993, 147.

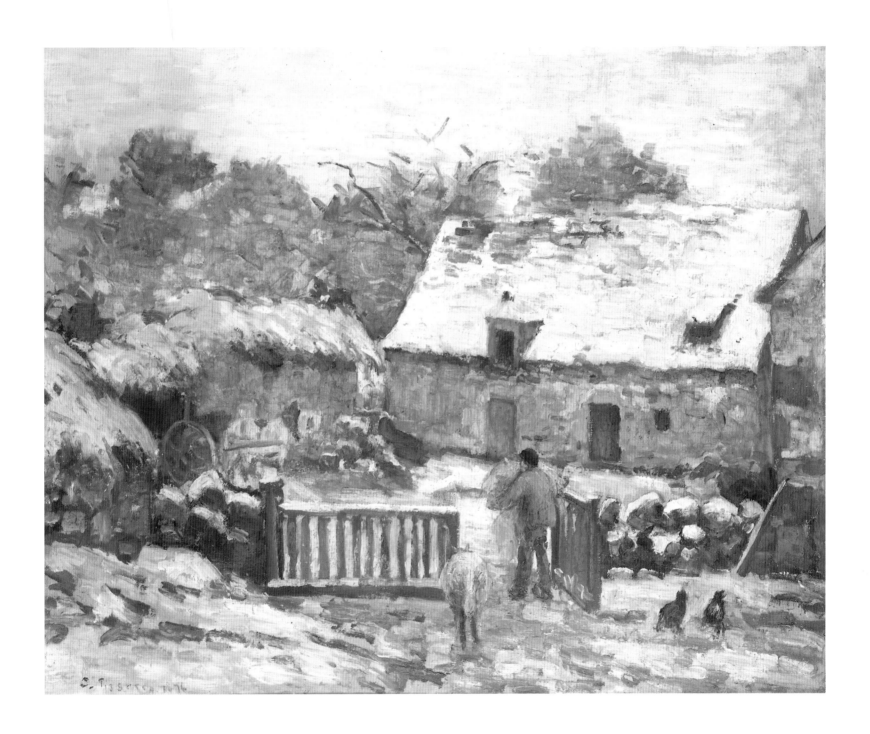

41 *The Road to l'Hermitage in the Snow*

c. 1874
Private collection, Cambridge, Massachusetts

Pissarro probably painted this view of two houses on a country path in l'Hermitage, a hamlet just to the north of Pontoise that bordered the Oise River, in the winter of 1874–75. He and his family chose to live in l'Hermitage for almost the entire length of their stay in the Pontoise area from 1872-1882. Pissarro was inspired by the intimate nature of life in l'Hermitage, where houses were built very close to each other, and he painted more views of l'Hermitage than any other part of Pontoise.

Although Pissarro painted this site on at least four occasions in 1874 and 1875,[1] this is the only example executed in winter. His great friend and colleague, Paul Cézanne, also painted a view of the house on the right of this painting, with the bare walnut tree in the prominent position in the center of the composition.[2] Despite the lack of leaves on the tree, Cézanne's canvas was probably painted during the early part of spring, as the fields in the distance and the grass in the front of the house have already begun to turn green. As is typical in several of the paintings by both artists of similar sites in and around Pontoise and Auvers, Cézanne has chosen not to include any figures in his composition.

The Road to l'Hermitage in the Snow is the only painting by Pissarro or Cézanne that features the two houses bordering the path that runs through the hamlet. The other examples previously mentioned only include the house on the right with the mauve-colored shutters and the walnut tree in the front yard. As with many of his compositions of the Pontoise period, Pissarro has included figures in the course of their everyday errands.

A couple walk together toward the viewer in the snow, perhaps holding onto each other to keep from slipping. The woman carries a bag on her arm that may contain the makings of the evening meal. Behind them, a solitary man, carrying a large bundle under his arm, walks in the same direction. Pissarro has created a true image of life in the close quarters of l'Hermitage. Instead of producing a more typically picturesque view of a farm house with the expanse of land in the distance, he has instead focused on the cramped yet seemingly cosy living arrangements in this small village.

Pissarro has also chosen a dramatic and varied palette, with some of his most inventive use of color to depict snow. The vivid green that appears in the snow on the right side of the foreground also appears on the front of the house on the right, and on the door of the garden gate on the house on the right. It is a late winter day, and although the sky is blue-gray and seems somewhat bleak, the sun has managed to break through, and has produced a wonderful yellow-peach light on the side of the house on the right. Pissarro has managed to produce a composition that successfully recreates the quiet hush of a cold day after a significant snowfall.

KR

1. See P&V265, 272, 315.
2. See Rewald, 1996, no. 222.

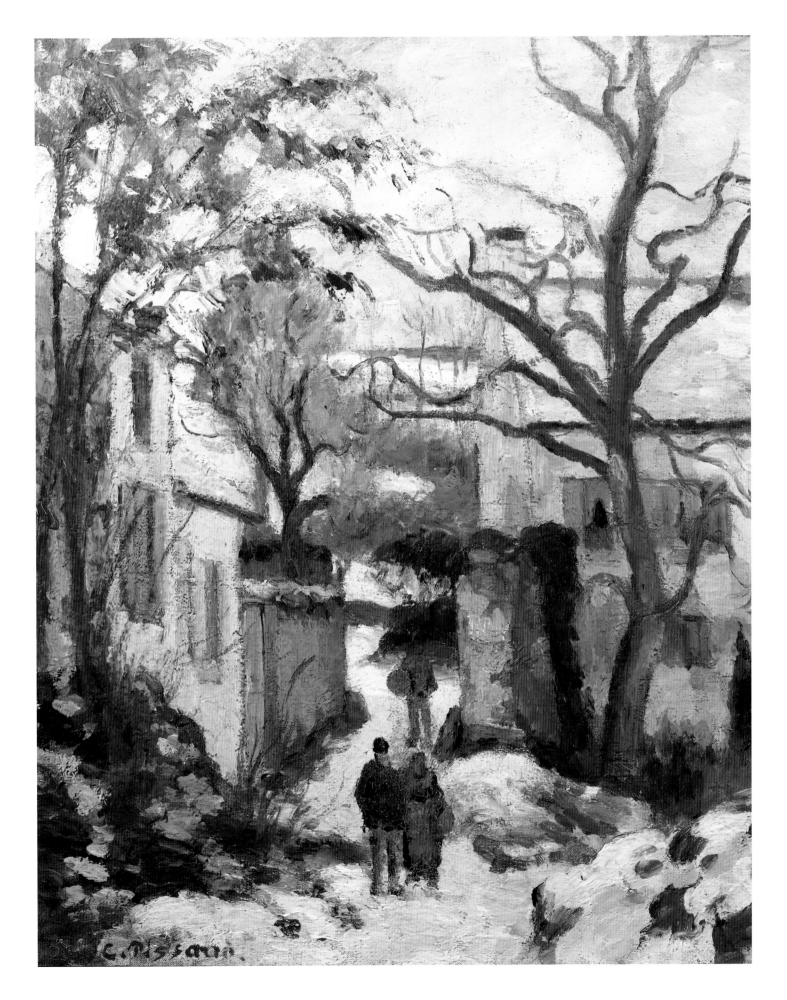

42 *Snow at l'Hermitage, Pontoise*

1874
Private collection

When Pissarro returned to Pontoise in 1872, he resided in the smaller hamlet just northeast of the town, known as l'Hermitage. Within walking distance from his home on the modern rue de l'Hermitage, the houses depicted in the present work were situated on the fond de l'Hermitage, an older, curved road which ran nearly parallel to Pissarro's street. Nestled against a hill, the Côte des Grouettes, the houses in this part of l'Hermitage dated to the seventeenth or eighteenth century. These low, rural dwellings, with their weathered roofs, few windows, and beige façades which blend with the landscape, stand in stark contrast to the modern, orange-yellow château with its commanding view which emerges from the hillside in the upper right corner of the composition.

Richard Brettell has identified this building as the Château des Mathurins, the summer home of Maria Desraimes and her sisters.[1] A radical feminist author and accomplished playwright, Desraimes was also, like Pissarro, ardent in her political ideology. Although a member of the bourgeoisie, and thus outside of the Pissarros' usual circle which primarily included artists, writers, and dealers, Desraimes was a close friend to the Pissarros and opened her home to them. In a rare occurrence, Pissarro, a socialist thinker who consistently omitted the châteaux of Pontoise from his works, would, two years later, depict Desraimes' private garden, creating one of the most unusual paintings in his œuvre, one that closely approaches Monet in both technique and subject matter.[2]

Pissarro had first depicted the Château des Mathurins in the autumn of 1873, in *Hillside in l'Hermitage, Pontoise* (fig. 1). He returned to paint *Snow at l'Hermitage, Pontoise*

the following winter, most likely in December, when Paris and its suburbs experienced their first major snowfall of the season.[3] In setting up his easel at precisely the same site, Pissarro thus created a pairing in which temporal effects on a particular landscape became the primary subject. It was a theme he had begun to work with in Louveciennes and which would recur throughout his career, as it did in the œuvres of both Monet and Sisley.

In *Snow at l'Hermitage, Pontoise*, Pissarro situated himself slightly to the left and further away from the houses than in the earlier painting. Such a position allowed him to extend the structure adjacent to the house on the left and to make visible the roof of the château. This angle, furthermore, enabled Pissarro to reserve more of the composition for the lilac-colored sky, inherently more dramatic than on an autumn afternoon. A thin layer of snow blankets the once lush, green garden, neatly divided into squares in *Hillside in l'Hermitage, Pontoise*. Thickly applied pigment which conveys the brickwork of the rural dwellings in the earlier painting is, in the later work, instead reserved for the accumulated and currently falling snow. The figure of a peasant stands in the immediate foreground of the earlier painting. His back bent from years of labor, his placement and posture recall the worker in *Rabbit Warren at Pontoise, Snow* (cat. 44).

Snow at l'Hermitage, Pontoise, originally titled *Neige. Coteaux de l'Hermitage (Pontoise)*, was among the works that Pissarro contributed to the second Impressionist exhibition. Here, hanging alongside Monet's *Camille Monet in Japanese Costume* and Degas' *Portraits in an Office (New Orleans)*, however, it went unnoticed by the critics.[4] Although in general Pissarro may have been considered the least successful of the nineteen exhibitors in the 1876 show, Philippe Burty, writing for *The Academy*, referred to him as 'the great high-priest of the Intransigeants, a man of sober masculine talent.'[5]

LPS

1. Camille Pissarro, *Hillside in l'Hermitage, Pontoise*, 1873, oil on canvas, 24 x 28¾ in. (61 x 73 cm), Musée d'Orsay, Paris.

1. Brettell, 1990, 41.
2. See Pissarro's *The Mathurins Garden, Pontoise*, 1876, The Nelson-Atkins Museum of Art (P&V349) in relation to Monet's *The Artist's House in Argenteuil*, 1873, The Art Institute of Chicago (W284).
3. See 'Winter Weather Chronology.'
4. Monet, *Camille Monet in Japanese Costume*, 1876, Museum of Fine Arts, Boston (W387); Degas, *Portraits in an Office (New Orleans)*, 1873, Musée Municipale de Pau, France, in Philippe Brame and Théodore Reff, *Degas et son œuvre*, New York and London, 1984, no. 320.
5. Philippe Burty, 'Fine Art: The Exhibition of the 'Intransigeants,' in *The Academy* (15 April 1876), 363–64.

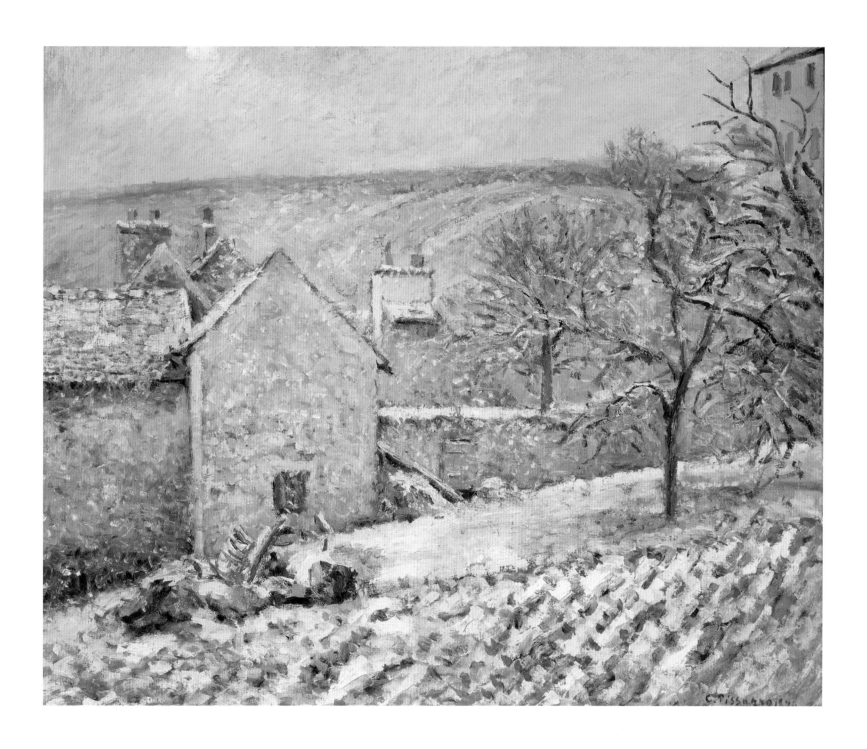

43 Snow Effect at l'Hermitage, Pontoise

1875
Private collection

This work, painted in the winter of 1875, was painted close to Pissarro's home at the time, at 26, rue de l'Hermitage.[1] Pissarro was particularly drawn to the hamlet of l'Hermitage near Pontoise, and lived there for most of his time in the area. Unlike some of the more rural areas in and around Pontoise, l'Hermitage was a relatively crowded place located just north of the larger town. It was also rather small, with many houses and buildings tucked into the valley and on the hillsides.[2] In his paintings of his beloved home, Pissarro celebrated the human presence in the local landscape, as he always included buildings or figures in these works.

Although he left Auvers for the south of France in early 1874, Paul Cézanne continued to visit his close friend Pissarro on a regular basis for the next eight years. Both artists greatly admired each other, and during this period they often worked together, and consistently inspired each other. In 1875, for example, during one of Cézanne's visits to the Pontoise area, he and Pissarro painted with palette knives in their compositions.

Snow Effect at l'Hermitage, Pontoise was partially painted with a palette knife,[3] and clearly shows the influence of Cézanne's technique of the time. Unlike some of Pissarro's *effet de neige* paintings from this period that include small, delicate brushstrokes and emphasize the unique atmosphere and light after a snowstorm, this work is energized with broad, powerful brushstrokes that provide a strong, graphic quality in the landscape and the buildings beyond. Pissarro reduces the untouched ground beneath the large tree in the foreground and the melted patches of snow beyond into almost pure rectangular forms. In addition, Pissarro adventurously plays with the perspective of the architecture in the background, as he depicts both the front and side of the snow-capped building at the left at the same time. Several of the buildings in the background, as well as the hillside to the left, seem to merge into each other without much delineation, causing the planes to flatten.[4]

KR

1. Sotheby's London, auction catalogue, 4 April 1989, 9.
2. Brettell, 1990, 101.
3. Shikes and Harper, 1980, 127.
4. Ibid., 127–28.

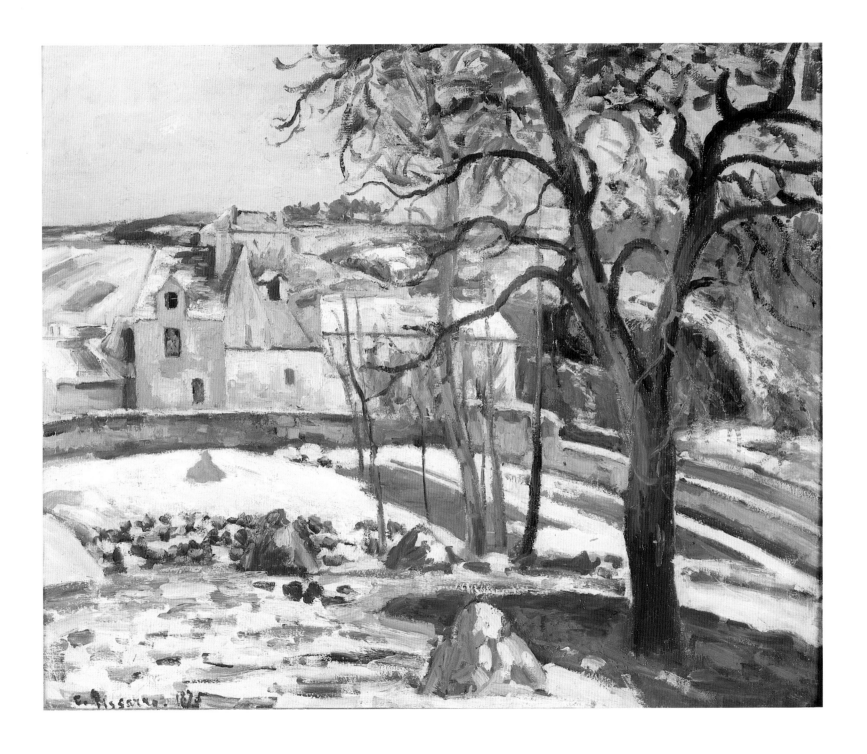

PISSARRO

44 *Rabbit Warren at Pontoise, Snow*

1879
The Art Institute of Chicago
Gift of Marshall Field

In 1866 Pissarro and his growing family first settled in Pontoise, on the river Oise northwest of Paris, at that time approximately an hour and a half from the capital by train. Pontoise offered Pissarro a suburban landscape and a place to paint where no other recognized master had done so before him. Following a brief visit here with Pissarro, Paul Cézanne settled in neighboring Auvers in 1872. The two artists painted together frequently during Cézanne's two-year stay, and again during a number of Cézanne's extended visits in the later 1870s and early 1880s. Gauguin, too, regularly visited Pissarro in Pontoise, beginning in the summer of 1879.

Pissarro painted *Rabbit Warren at Pontoise, Snow* during the unusually snowy and frigidly cold winter of 1879. He may have painted it while indoors, viewing this scene from the window of his house on a small path now called the chemin du Général Belger.[1] From this vantage point atop a hill, rooftops rendered in blues, grays, and whites are visible in the distant town. In the middle distance, the tightly-packed houses of l'Hermitage emerge from the overgrown foliage. Pissarro enlivened the palette of predominant yellows, blues, greens, and whites by adding accents of red to render the houses' chimneys. The bare brown branches of the trees anchor the composition on the left and extend into the ice-blue sky streaked with light yellows and whites.

As Richard Brettell has aptly noted, Pissarro tended to treat his Pontoise peasants as staffage figures who, 'crouching into pictorial niches created by bending branches and the curved silhouettes of hillsides,' convey a sense of scale.[2] The peasant in *Rabbit Warren at Pontoise, Snow* indeed assumes such a role. His figure is barely visible among the trees and vegetation as he gathers wood in the right foreground. He is painted in much the same manner and with the same tonalities as the trees and stucco buildings, and as a result nearly recedes into his surroundings. Leaning slightly forward, his back forms a gentle curve which echoes the hilly terrain in the foreground.

Within this one painting, Pissarro's handling of the paint varies from thin and smooth in the sky, to uncharacteristically thick and roughly applied in the foreground. The less highly finished, heavily textured foreground, in this instance, is appropriate for the work's unpleasant subject matter. As suggested by the painting's title, though not clearly delineated, a pack of rabbits huddle in their snow-covered warren on a cold winter's day. Since their earliest days at Pontoise, Julie Pissarro raised chickens and rabbits to feed the family in order to ease their often distressed circumstances. The warren referred to in the painting's title may have, therefore, belonged to the Pissarro family.

LPS

1. Brettell et al., 1984, 190.
2. Brettell, 1990, 131.

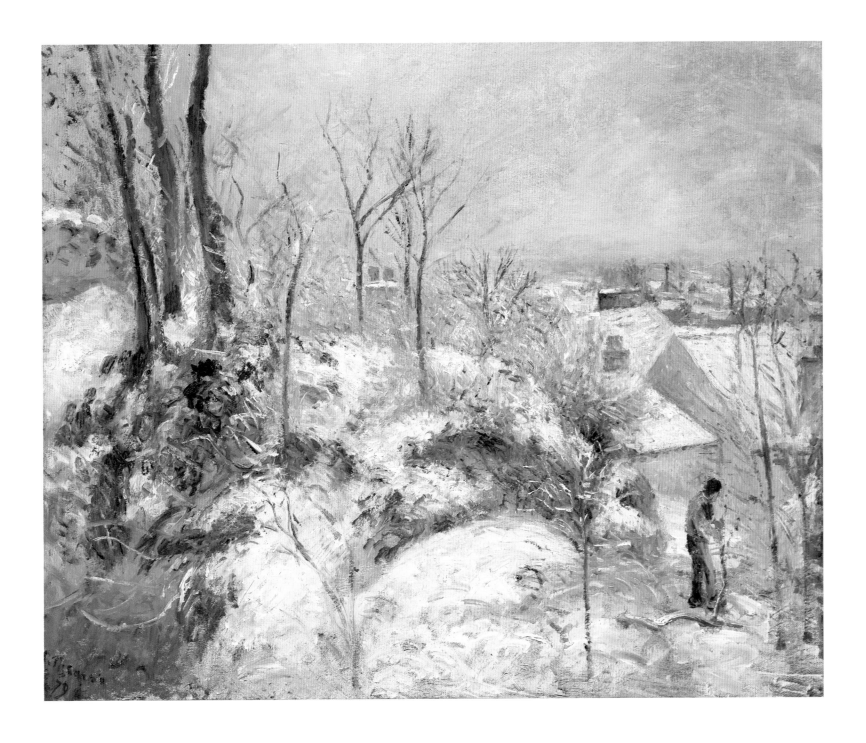

45 *Snow Effect at Eragny, Road to Gisors*

1885
Private collection

In 1882, Pissarro and his family left Pontoise after having spent ten productive and fulfilling years there. Pissarro regretted the move, and, after a brief stay in the village of Osny, he settled in Eragny for the rest of his life. He described his feelings about leaving Pontoise in a letter dated 18 September 1882 to his friend Monet who was considering his own move to Pontoise:

> I have to leave Pontoise much to my regret, as I cannot find a house there that is well located and reasonably priced. It is much to my regret, because it seemed to me that Pontoise suited me from every point of view; but I think that you will manage to find what you are looking for better than I, since you can afford a higher rent.[1]

In April of 1884 Pissarro and his large family moved to Eragny, which was located three kilometers from the town of Gisors. Gisors was attractive to Pissarro as inspiration for his paintings because it had three streams, winding streets, a castle in ruins, a cathedral, and it was a market town.[2] It was, however, further away from Paris than Pontoise, and Pissarro had fewer artists and friends visit him at this more isolated location.

Snow Effect at Eragny, Road to Gisors was painted in the winter of 1885. In this work, Pissarro looks back to his *effet de neige* compositions painted during the winter of 1869–70, with the use of a perspective road view that leads the viewer's eye back to the horizon line in the distance. His brushwork and palette have changed dramatically in fifteen years, however, with great intensity in the strokes of paint that enliven the canvas, particularly in the lavender and yellow sky. The solidity of the red building on the left side of the snow-covered roadway contrasts greatly with the amorphous quality of the snow. Pissarro used a wide variety of colors to serve as highlights in the snow, including shades of green, gray, peach, orange, and plum. He also produced a larger version of this scene[3] from the same location that is remarkably similar in composition and differs only in the addition of several figures in the road.

The energetic brushwork that is evident in this painting looks forward to the next period in Pissarro's career. In the fall of 1885, Pissarro met the artists Paul Signac and Georges Seurat who were both working in a new style of modern painting known as Pointillism or Neo-Impressionism. Pissarro was always open to new influences on his work, and he was quickly inspired by the Neo-Impressionists' views on color theory and the use of complementary colors in painting. For the next four years Pissarro devoted himself to working in this innovative, analytical style.

KR

1. Letter to Monet, 18 September 1882, in Bailly-Herzberg, 1980–91, vol. 1, 165.
2. Shikes and Harper, 1980, 195.
3. P&V656.

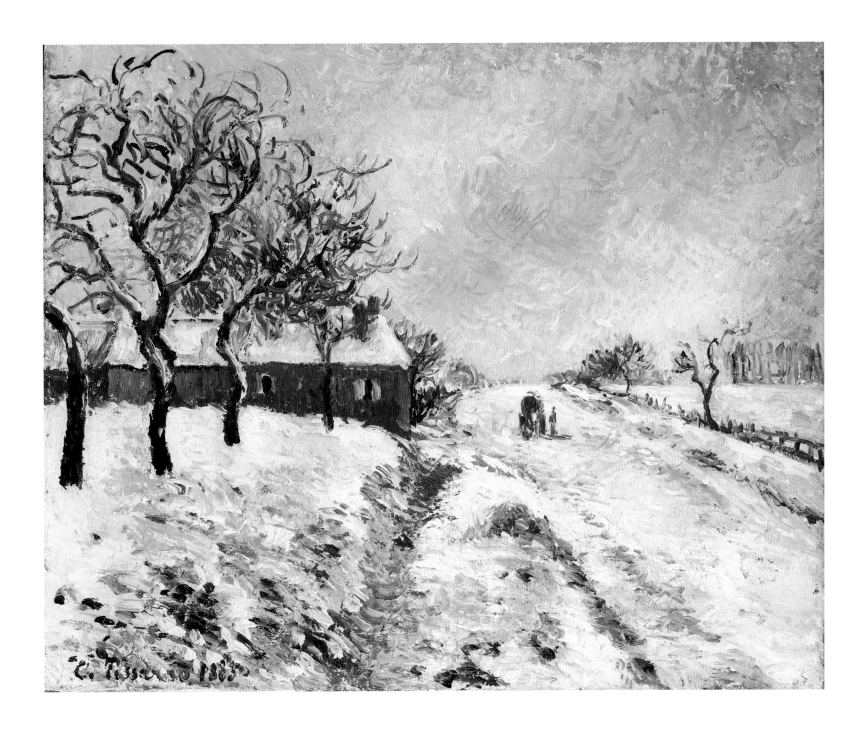

46 *Snowy Landscape. Eragny, Evening*

1894
Ordrupgaard, Copenhagen

Pissarro's four-year experimental period of painting in a Neo-Impressionist manner had ended by the summer of 1890. After an unprofitable year selling his paintings, he began to feel that he had lost his audience entirely during the late 1880s, and was worried that he could not regain the moderate success that he had achieved before his experimentation. By October 1891, his luck began to change, and his new paintings, which were brighter in color and in an Impressionist style, began to sell well. The Parisian dealer Durand-Ruel hosted Pissarro's first extensive retrospective at his gallery in early 1892, and with the extremely positive reaction from both critics and collectors, his financial struggles were finally over.[1] In the summer of 1892, Pissarro was able to buy, with the help of the more financially successful Monet, the house in Eragny where he and his family had been living for the past eight years.

1. Camille Pissarro, *Snow Scene at Eragny*, 1884, oil on canvas, 18 x 21¾ in. (46 x 55 cm), Fine Arts Museums of San Francisco, Gift of Renée M. Bransten to the California Palace of the Legion of Honor.

Plagued with eye troubles since the 1880s, Pissarro had a succession of operations and tried numerous treatments that often forced him to paint indoors or not at all. In the summer of 1893 he converted the barn on his property into a studio where he could paint in any type of weather. At first Pissarro was a bit worried about how the studio would affect his work:

> The studio is splendid, but I often say to myself: what is the good of a studio? Once I painted no matter where; in all seasons, in the worst heat, on rainy days, in the most frightful cold, I found it possible to work with enthusiasm….Will I be able to work in these new surroundings? Surely my painting will be affected; my art is going to put on gloves, I will become official, deuce take it!…This is a serious moment, I shall have to watch myself and try not to fall![2]

Pissarro soon overcame his fears regarding the use of his studio and its affect on his art, and it proved to be exceedingly helpful to him during the last years of his life. *Snowy Landscape. Eragny, Evening* depicts the view of the town of Bazincourt at sunset on a cold winter day, a site that he painted on numerous occasions upon moving to Eragny in 1884 (fig. 1). The warmth from the sun, which emanates from the horizon near the center of the composition, fills the entire canvas with the dazzling color of dusk on a snowy day. The composition is divided into three horizontal bands: the sky, the town, and the snow-covered ground, and Pissarro draws upon his experiments in Neo-Impressionism with his incredibly bright palette and forceful, thick brushwork. *Snowy Landscape. Eragny, Evening* is one of a group of *effet de neige* landscapes Pissarro produced during the winter of 1894 that provide alternating views of neighboring fields, trees, and vistas from the artist's studio.[3]

KR

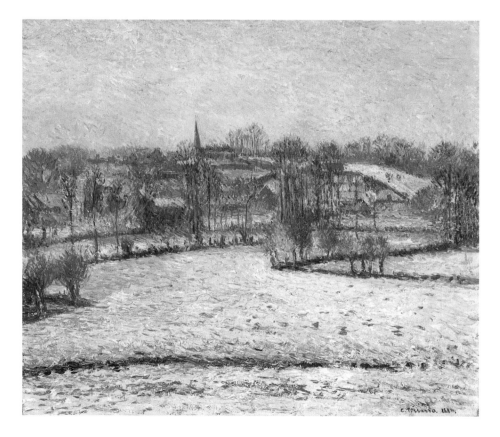

1. Shikes and Harper, 1980, 258–60.
2. Quoted in Rewald, 1981, 273.
3. See P&V867, 868, 870–872.

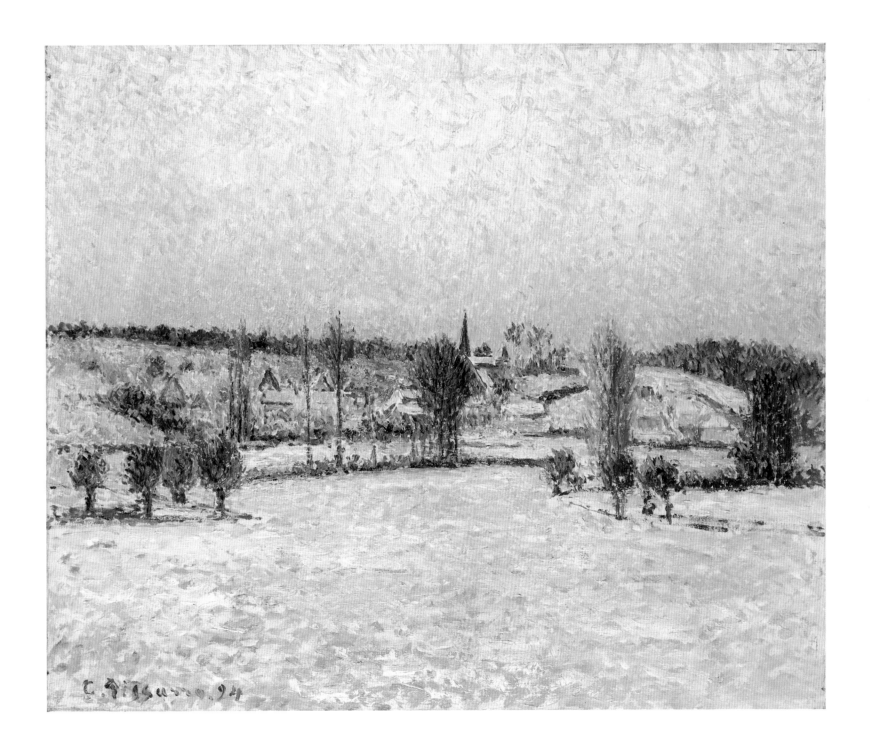

C. Pissarro. 94

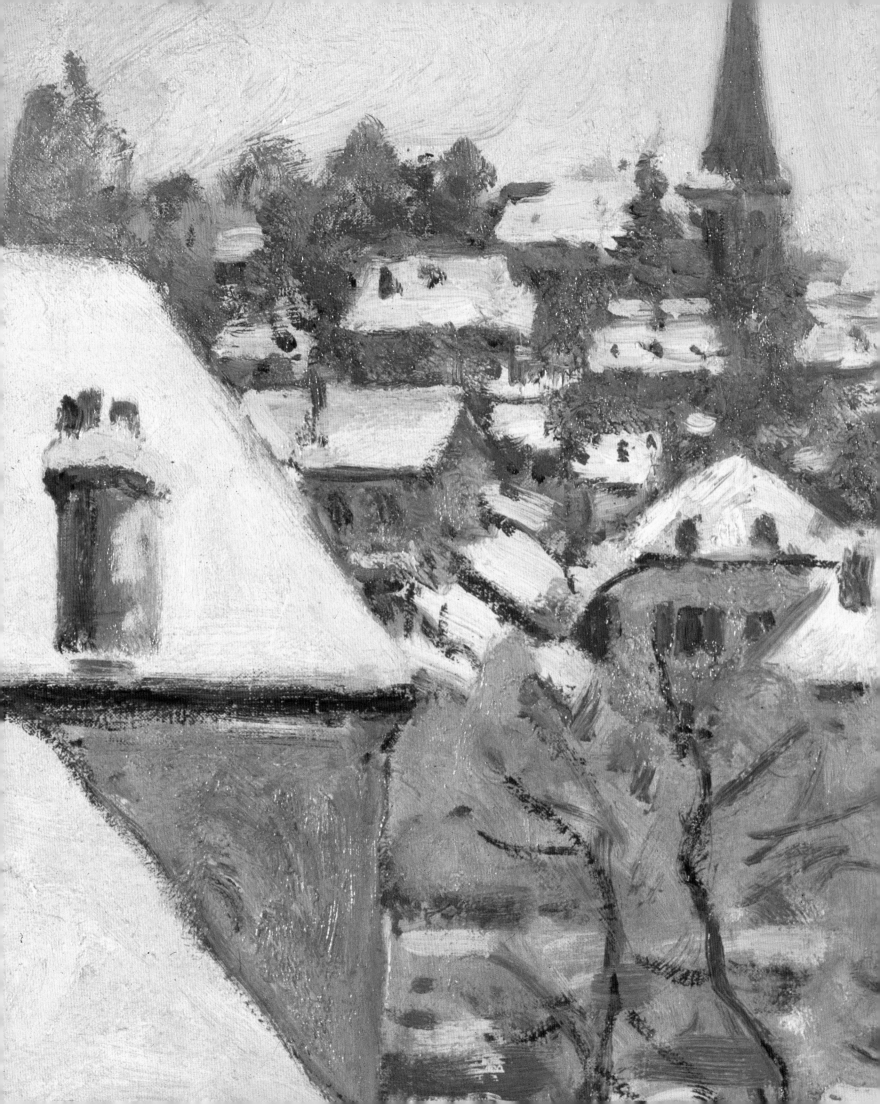

Sisley

Alfred Sisley was born in Paris on 30 October 1839. His parents, both of British descent, had moved to Paris with their three eldest children in the late 1830s. At the age of eighteen he left for London to study commerce, but instead developed a passion for art. In 1859 he returned to his disappointed, business-minded father in Paris, and soon began attending the atelier of Swiss painter Charles Gleyre. There he met Renoir in November 1861 and Monet and Bazille in 1862.

In 1866 Sisley gained his first acceptance to the annual Salon with *Village Street at Marlotte, near Fontainebleau,* and *Women Going to the Woods: Landscape,* both of which he had painted earlier that year on an excursion to the Forest of Fontainebleau with Renoir.[1] These early paintings reflect the Barbizon tradition of Corot, Daubigny, and Rousseau, as well as the bold paint handling of Courbet. Furthermore, the integration of figures with the landscape and the interest in the changing effects of the sky pay homage to Constable, whose landscapes Sisley would have certainly seen during his stay in London.

During the 1860s Sisley painted in and around Paris, in the Forest of Fontainebleau, in the woods at Saint-Cloud, and in Honfleur. In 1871, in search of a home for his mistress, Eugénie Lescouezec, and their two children, Sisley moved from Paris to Louveciennes.[2] The move to a small village just outside Paris also satisfied Sisley's desire to paint views of rural and suburban life, while remaining close to the Seine. That winter he painted his first *effet de neige, Rue de Voisins, Louveciennes: First Snow.*[3]

In 1872 Sisley joined Monet at Argenteuil, where the two artists painted side-by-side. Two years later he participated in the first Impressionist exhibition, to which he contributed six works.[4] That summer, at the invitation of opera singer Jean-Baptiste Faure, he returned to England, where he stayed at Hampton Court and focused on similar motifs as those he had been painting at home.

Sisley returned to France in October. That winter he moved from Louveciennes to nearby Marly-le-Roi, his home for the next two-and-a-half years. Here he painted river life along the Seine, including the dramatic series depicting the floods at Port-Marly in 1876. He also worked on nearly twenty paintings of the watering-place at Marly in various weather conditions, one of which, an *effet de neige,* he included in the first Impressionist exhibition (see cat. 51) and was his first such *effet* to be exhibited.

During the appallingly cold winter of 1879–80, Sisley painted the snow-covered villages of Louveciennes and Marly in earnest. Later that winter, he moved to Veneux-Nadon. In the summer of 1881 he made his third journey to England, where he planned to paint along the picturesque coast of Alum Bay on the Isle of Wight. His canvases from France never arrived, however, and too poor to buy more, Sisley returned to France without having completed any new work. In 1882 he moved from Veneux-Nadon to the town of Moret. The following year he rented a house in Les Sablons, a village of farmhouses, cottages, and barns, just outside of Moret-sur-Loing, the town in which he would settle in 1889.

In 1885, hoping to increase sales and minimize the expense of materials, Sisley began work on a series of landscapes executed in pastel. At about this time, he became preoccupied with the idea of working in series in general. Also in the mid-1880s, he began experiencing health problems; his trips to Paris became increasingly difficult and he saw his colleagues less and less frequently.

Sisley spent three months in England in 1897, painting along the Welsh coast. During this trip he also married Eugénie, his mistress of thirty years. He eventually became so preoccupied with his wife's failing health, as well as his own, however, that he did not paint after 1897. Eugénie died on 8 October 1898. Three-and-a-half months later, on 29 January 1899, Sisley died at his home in Moret of cancer of the throat.

1. D3, 4.
2. Sisley's son Pierre was born on 17 June 1867 and his daughter Jeanne on 29 January 1869. Sisley married Eugénie (1834–98) in 1897.
3. D18.
4. Sisley participated in four of the eight exhibitions, in 1874, 1876, 1877, and 1882.

Alfred Sisley, *Winter in Louveciennes* (detail cat. 55), 1876, oil on canvas, 23¼ x 28¾ in. (59.2 x 73 cm), Staatsgalerie Stuttgart.

47 *The Frost*

1872
Private collection

Sisley began to paint *effets de neige* a few years after his colleagues had started to explore the subject in their works. Monet, for example, painted his first snowscape in Honfleur in 1865 (see cat. 1), but Sisley did not follow suit until the winter of 1871–72 with one example, *Rue de Voisins, Louveciennes: First Snow,* from the Museum of Fine Arts, Boston.[1] During the winter of 1872, however, his interest in the motifs available in the coldest season of the year did increase. According to François Daulte,[2] he executed five compositions during the winter of 1872–73, including this painting. Sisley continued to find inspiration outdoors in the winter for the rest of the decade, producing over forty snowscapes in the 1870s.

In the fall of 1871, Sisley moved with his family from Paris to the small hamlet of Voisins, located next to Louveciennes.[3] This painting, which is signed and dated 1872, may have been painted in the countryside near his new home. The scene is bathed in the bright light of a crisp winter day, and the ground is covered, in parts, by a thin layer of frost. Unlike many other Impressionist snowscapes, this painting features a clear blue sky without any threat of future precipitation. The left side of the foreground is in shadow, while the frost on the right side of the scene has melted in the bright sun. Sisley has used a varied palette, with shades of blue, green, peach, and mauve for the frost on the ground below the wall. A lone figure, probably a laborer or traveler, stands on the other side of an old stone wall with a bag on his back as he surveys the landscape before him. There is a small building—peach colored with a red-brown roof—that Sisley shows as just peaking over the edge of the wall in the background near the center of the composition.

KR

1. D18. Although Daulte dates this work as the winter of 1870, Mary Anne Stevens has suggested the slightly later date of the winter of 1871–72, just after Sisley moved to Louveciennes. See Stevens, 1992, no. 10, 102.
2. D45, 52, 53, 55, 56.
3. Stevens, 1992, 262.

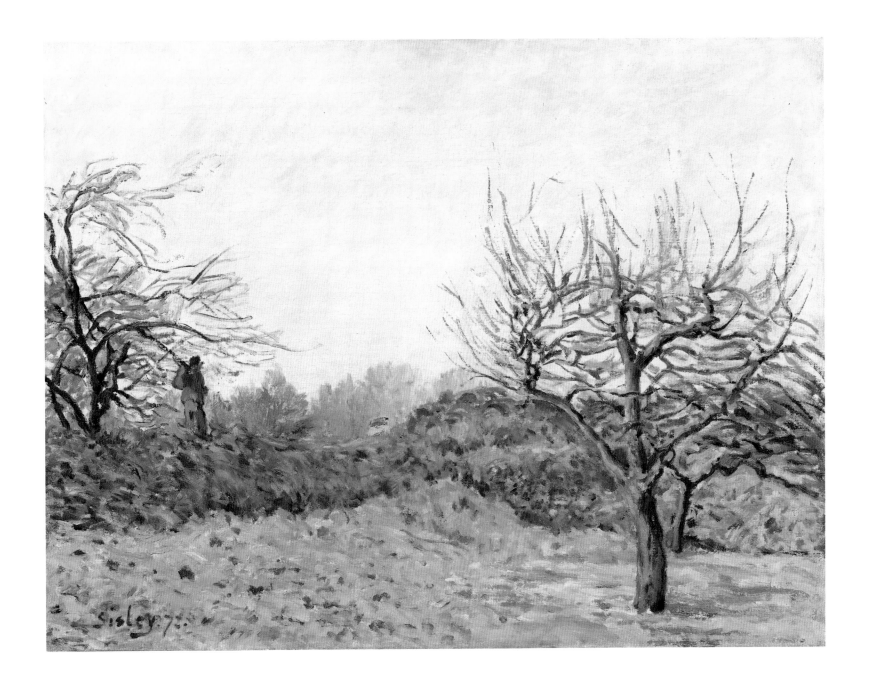

48 *Snow at Louveciennes*

1873
Private collection

This painting was produced during the winter of 1873, perhaps during the first half of February when there was a marked period of snow in the region.[1] Although he did not embrace the subject matter available in *effet de neige* paintings as early as his colleagues Monet and Pissarro, by 1873 Sisley was producing snowscapes on a regular basis. Between 1873 and 1875, for example, he painted over fifteen compositions in winter that explored the unique quality of the light and atmosphere after a snowstorm.[2]

In *Snow at Louveciennes*, a moderate amount of snow has already fallen on the village, and the gray, heavy sky threatens to produce more on this wintry day. Despite the inclement weather, the villagers have continued with their daily routine, as can be seen in the numerous tracks in the snow. Sisley has chosen a site in the village where the road diverges into two directions, and a couple walks arm in arm on the path to the right. Dark brown tracks in the snow, produced by a horse and carriage, follow the path to the left where more houses are located. The inclusion of the garden fence on the left of the composition provides a strong structure for the painting and adds balance to the organic quality of the snow in the road.

The subtle palette of this painting is quite typical for Sisley in the early 1870s. With the exception of the salmon and blue-green used on the house at the left side of the composition, he has limited the palette to gray, brown, blue, tan, white, and pink. One of the most interesting aspects of this picture is Sisley's use of an underdrawing that is visible in certain areas under the thin paint layer. Before painting this *en-plein-air* view of Louveciennes, Sisley first blocked out the composition with charcoal. He did not, however, always adhere to his original concept for the painting, as there are several locations where the black medium can be seen, and the top layer of paint does not correspond to the marks below (see, for example, the underdrawing in the middle of the road in the center of the composition). One can clearly see, however, that some of the houses on the left side of the composition have been fully out-lined in charcoal.

KR

1. See 'Winter Weather Chronology.'
2. D104–108, 145–150, 152–157.

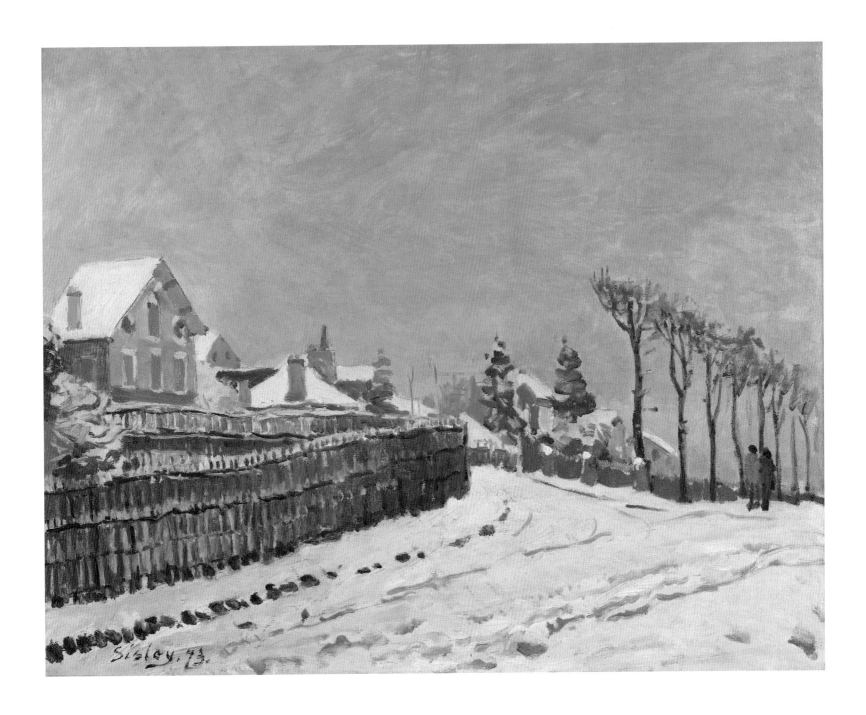

49 *Snow at Louveciennes*

1874
The Phillips Collection, Washington, D.C.

Sisley once wrote, '[T]he spectator should be led along the road that the painter indicates to him, and from the first be made to notice what the artist himself has felt. Every picture shows a spot with which the artist himself has fallen in love.'[1] Indeed, in *Snow at Louveciennes*, the viewer is literally led down a road, directed by the artist, and appreciative of his richly observed scene of falling snow in a quiet village.

The road has been identified as the chemin de l'Etarché, a small path bordering Louveciennes and Voisins. From his home on 2, rue de la Princesse, Sisley would have seen this view of the pathway, just before it bends toward the left. Sisley painted the pathway, a site with which he had 'fallen in love,' on at least four occasions (see cat. 56). One year earlier, in fact, he painted it in a strikingly similar view, though in the midst of a gentle rainfall on a spring or summer day (fig. 1). For this work, *Garden at Louveciennes*, Sisley set up his easel slightly further away from the bend in the road and just to the left of where he would return to paint *Snow at Louveciennes*.

1. Alfred Sisley, *Garden at Louveciennes,* 1873, oil on canvas, 25½ x 18 in. (65 x 46 cm), whereabouts unknown.

Sisley included the motif of a woman carrying an umbrella in both paintings and placed them at identical locations, just as the brown fence curves to follow the road. As they shelter themselves from different forms of precipitation, the two women travel in opposite directions. The aproned figure approaching the viewer in the winter scene dons a gray umbrella, keeps her hand warmly tucked into her pocket, and wears grays and browns. Like her equivalent clad in shades of brown and light blue in *Garden at Louveciennes*, she is appropriately dressed not only for the weather but for her landscape.

Snow at Louveciennes is cohesively arranged and tightly structured. The beholder follows the foreshortened path to the rust-colored square in the wall, which acts as an enclosure to both the composition and the home behind. Its shape and coloration direct the eye upward, where two dormer windows emerge from the now white slanted roof. The ledges above each window echo the strong horizontal lines of the snow-covered wall that runs along the right side of the path. The emphatic horizontals are countered by elongated, thickly painted trees that extend beyond the canvas in the upper right corner of the composition. In a playful ordering of diagonals, the slopes of the roofs on each of the three visible houses repeat one another, as they do the angles which create the criss-cross within the blue-green gate, and even the tilt of the umbrella. In this patterning of verticals, horizontals, and diagonals, Sisley has emphasized the distinct contrast between the geometric man-made homes, gate, and border wall and nature's amorphic curves and bends.

Duncan Phillips purchased *Snow at Louveciennes* in 1923. Although he had already bought Sisley's *Rainy Day—Moret* in 1920 and *The Banks of the Seine* in 1921, Phillips eventually sold and traded the latter works.[2] In 1923 *Snow at Louveciennes* entered Phillips' newly founded public collection, then called The Phillips Memorial Gallery. Phillips considered Sisley to be a 'man of genius' and a 'landscape painter of the first rank' who was 'a man of more delicate sensibility than Monet and Pissarro. His nature was simpler and his mind less preoccupied with theory.'[3] Of *Snow at Louveciennes* he wrote that 'its hush of snowflakes falling over roofs and garden walls, is a lyric of winter, enchanting both in its mood and in its tonality of tenderly transcribed "values."'[4]

LPS

1. Undated letter to an unidentified friend, quoted in Robert Goldwater and Marco Treves, ed., *Artists on Art*, New York, 1905, 309.
2. D71, 657.
3. Duncan Phillips, *A Collection in the Making*, New York, 1926, 32–33.
4. Ibid.

50 *Snow Effect at Argenteuil*

1874
Private collection, courtesy of Pyms Gallery, London

The location depicted in this work proves problematic. As MaryAnne Stevens has noted, with two apparent exceptions, Sisley was working in Argenteuil only in 1872, when he stayed with Monet who had moved there in 1871.[1] Of the two paintings that record Sisley in Argenteuil at a later date, one is signed and dated 1873, and the other, *Boats on the Seine at Argenteuil*, has been dated to 1874.[2] The title of the latter work, however, as well as its calm-looking waters and bright sunlit atmosphere, preclude it from being painted during that winter.

The presumed location of the present work, furthermore, has not always been included in its title. When it belonged to Henri Canonne, for instance, the painting was known as *Neige aux Environs de Paris*.[3] When exhibited in 1931, its title became even more generalized: *La Route—Effet de Neige*.[4] Given the problematic date and the lack of recognizable buildings or landscape markers, we may never with great certainty determine the precise location represented in this painting. It is probable, however, that Sisley, taking a short trip from his residence in Louveciennes, could have visited Monet, then living in Argenteuil, during the winter of 1874.

In *Snow Effect at Argenteuil* a clear, bright blue sky offers no imminent threat of additional snowfall. As opposed to the dramatic, heavy skies in the contemporaneous *Snow at Louveciennes* (cat. 49) and *The Watering Place at Marly with Hoarfrost* (cat. 52), only five small white clouds float in the sky. The only hazard this sky presents is to the snow, which has already begun to thaw in small patches on either side of the snow-covered path. The textured surface of the snow, highlighted with blues and purples, reveals that it has endured brisk winds.

Four small figures travel the snowy path that extends from the foreground to the background, along the left of the painting. A woman dressed in gray and lavender walks alongside a man wearing blue and lavender, and a smaller male figure, in matching wardrobe, walks slightly ahead. Another man, dressed in brown, has passed

beyond, headed in the opposite direction. The blues, lavenders, and browns of the figures' clothing are echoed in the surrounding trees and sky as well as in the reflection of the clear blue sky on the snow-covered ground and the purple trim of the pale yellow house which borders the path.

Snow Effect at Argenteuil is a clearly structured work, based on a layering of diagonals, each of which ultimately leads to the solitary house in the center background. First, Sisley dramatically divided the composition in two, again on a diagonal, separating right from left with an imposing triangular shadow of bluish lavender in the foreground. Within each half of the painting a further division occurs, creating a total of four distinct diagonal areas: the road and fenced-in field to the far left, the looming shadow, the snow-covered hill on a gentle slope to the right of center, and a dark patch of trees anchoring the right side of the painting.

The vast triangular shadow suggests the sun's position to be to the left of the painting and somewhat behind the painter, whose easel must have been placed within the shade. The shadow's density (no lightened areas in the snow are visible to suggest light beaming through) and near-perfect geometric shape further imply that it has been produced by a house or some other type of building. Like Pissarro, who tended to denote a structure outside of the frame by the motif of its shadow (cat. 36), Sisley employed this motif to create the structure of the composition.

LPS

1. Stevens, 1992, 104.
2. D79, D112
3. Arsène Alexandre, *La Collection Canonne*, Paris 1930, illus. between 52 and 53.
4. *Exhibition of French Art 1200–1900*, exh. cat. London: Royal Academy of Arts, January–March 1932, no. 504.

51 *The Watering Place at Marly*

1875
The National Gallery, London

During the winter of 1874–75 Sisley settled at 2, avenue de l'Abreuvoir in the village of Marly-le-Roi. That year he chose the nearby watering place as the central motif in at least eight paintings, and in 1876 he returned to the site to paint at least two additional canvases (see cat. 52). Like Monet, though to a lesser extent, Sisley clearly found inspiration in painting one motif viewed at various angles, at different times of the day, or as it might be affected by different weather conditions. Before he left for Sèvres in 1877, the watering place figured prominently in nearly twenty of his paintings.

Sisley painted this version of the Marly watering place from the place de l'Abreuvoir, looking southeast toward Louveciennes up the côte du Cœur-Volant. The surface of the sunken pond, conveyed by broad sweeps of gray and white in the immediate foreground, has frozen, with the exception of a darkened area on the right where water flows from an outlet in the pond's surrounding wall. On the other side of the heavily snow-covered road (which intersects with the côte du Cœur-Volant to form the place de l'Abreuvoir) stands the buttressed wall of the parc de Marly. Five diminutive figures, rapidly rendered in short strokes of gray, travel the roads; the technique suggests their own hurried movements, while their slight size emphasizes the immensity of the walls surrounding the watering place and the park. Tall, skeletal trees line the côte du Cœur-Volant on either side. Within the walls of the parc de Marly stand shorter trees with fuller foliage.

In its composition, *The Watering Place at Marly* corresponds to another work that Sisley painted of the pond during the winter of 1875, *Watering Place at Marly-Le-Roi: Snow.*[1] In both paintings, the watering place is viewed in the immediate foreground with the enclosing

walls of the parc de Marly just beyond. A dominant feature in both works is also a snow-covered, centrally positioned road leading uphill, which provides a vertical emphasis to the composition and counterbalances the strong horizontals of the pond and its stone wall. In the latter work, however, Sisley slightly altered his location, thus replacing the côte du Cœur-Volant with the avenue des Combattants.

In technique, the two works again share similarities. Both are thinly painted and make use of the pinkish-beige ground color of the canvas throughout their compositions. In The National Gallery painting, however, the pinkish-beige ground is not only more visible but also more dramatically revealed, particularly in the upper third of the canvas, where it beautifully illuminates the winter sky, otherwise conveyed by thin strokes of light blue and white tinged with dashes of orange.

Although The National Gallery painting is a less finished work than *The Watering Place at Marly-Le-Roi: Snow*, Sisley signed and dated it and submitted it to the second Impressionist exhibition. It was among nine canvases he sent to the show, and all of them received generally favorable reviews. Sisley's paintings hung alongside fifteen works by Renoir and one Monet in the second room of the exhibition, called the Grand Salon.[2] In addition to one other *effet de neige* and an *effet de gelée* by Sisley, the final room of the exhibition included four *effets de neige* by Pissarro.

LPS

1. D154.
2. Hollis Clayson, 'A Failed Attempt,' in Moffett et al., 1986, 146.

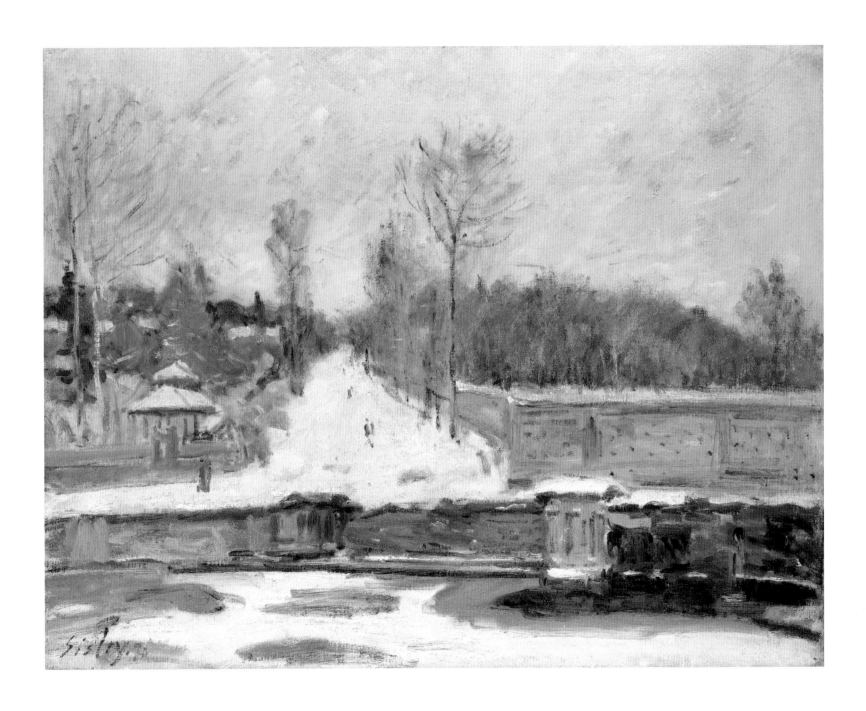

52 *The Watering Place at Marly with Hoarfrost*

1876
Virginia Museum of Fine Arts, Richmond, Virginia
Collection of Mr. and Mrs. Paul Mellon

The watering place at Marly was constructed during the seventeenth century as part of a larger hydraulic system that supplied water to the fountains and pools at the Château de Marly, Louis XIV's country retreat. As part of the king's royal complex, it belonged to the same system as the Marly aqueduct and the Machine de Marly, both of which, like the watering place, Sisley painted on several occasions (see cat. 51). By the mid-nineteenth century the château and its environs served as mere remnants of courtly life enjoyed more than one hundred years earlier. The buildings and grounds had been destroyed during the revolution, and by the time of Sisley's arrival, the reservoir of the once-glamorous château functioned as an area in which to wash clothes and a pond from which horses might drink. Sisley recorded the former activity during the summer of 1875.[1]

Sisley was fascinated by the mundane reality of a place, even more so when it had once enjoyed a prestigious identity. Thus the watering place at Marly, like the Machine de Marly or Hampton Court Palace, provided him with an ideal subject matter. In *The Watering Place at Marly with Hoarfrost* he seems to completely deny the former greatness of the pond and its

surroundings, granting it, in fact, less than half of the composition. In two canvases painted during the previous winter Sisley similarly relegated the pond to a relatively small area to the left of the canvas (fig. 1).[2]

All three canvases were painted along the côte du Cœur-Volant looking toward the northwest, where the avenue de l'Abreuvoir extends into the distance. From this vantage point Sisley captured the panoramic view of the serpentine road bordered by brightly lit buildings and wooden posts that encircle the pond. The ramp by which horses entered the water can be seen on the far left of the middle ground. In the present work, two small figures darkly dressed walk along the icy road in the center of the composition.

The road itself, beneath a layer of hard frost, is tinged with blues, purples, oranges, yellows, and light grays, reflections of the shade and sunlight in the calm winter sky. The icy surface of the water reflects the yellow of the nearby houses, which are rendered in the same yellows, oranges, and blues as the sky, road, and water. The upper half of the composition is dedicated to the depiction of the light blue winter sky lightly streaked with peach. As in the two canvases from 1875, the road and sky, rather than the titled pond, dominate the composition.

The point of view from along the côte du Cœur-Volant in *The Watering Place at Marly with Hoarfrost* offers a directly reverse view from that in the earlier *Watering Place at Marly* (cat. 51). In their composition, the two works are also diametrically opposite. In the present painting, the horizontal format is emphasized by the low vantage point and the great expanse of sky, while in The National Gallery work Sisley seems to have relished in the balance of verticals and horizontals. Furthermore, the monochromatic pinks, beiges, browns, and gray-blues of the earlier work contrast with the more spectral palette that characterizes the 1876 painting. Both paintings, however, are thinly painted and build upon a pinkish-beige ground, thus enhancing the effect of warm sunlight that infuses the heavy winter sky.

LPS

1. Alfred Sisley, *Watering Place at Marly*, 1875, oil on canvas, 15½ x 22¼ in. (39.5 x 56.2 cm), The Art Institute of Chicago, Gift of Mrs. Clive Runnells, 1971.875.

1. D172.
2. D157, 169.

53 *Winter in Marly, Snow Effect*

1876
Private collection, courtesy of Galerie Schmit, Paris

The theme of working along the quays of the Seine, in contrast to the quintessential Impressionist images of the leisurely bourgeois enjoying its promenades, is one that Pissarro had begun to explore in the late 1860s (see cat. 61, fig. 1). Sisley embraced the theme early in his career as well, depicting the barges along the Seine and along the Canal Saint-Martin while still living in Paris in 1870.[1] In *Winter in Marly, Snow Effect,* Sisley turned to the local barges and river boats at Port-Marly, where during the previous summer he had immortalized workers dredging the river in *The Seine at Port-Marly: Heaps of Sand* and *The Sand Bank.*[2]

The top half of the composition of *Winter in Marly, Snow Effect* is given over to a wide expanse of sky, dramatic and overcast, with variegated tones of pink, white, ochre, and blue, which reappear on the surface of the icy green Seine and the snow-covered quay. The brushwork in the sky appears thin and angular in relation to the thicker, more painterly brushstrokes Sisley applied to define the snow, river, houses, and trees. In a letter written five years later to one of his patrons, Georges Charpentier, Sisley would explain:

> Although the landscape painter must always be the master of his brush and his subject, the manner of painting must be capable of expressing the emotions of the artist. You see I am in favor of differing techniques within the same picture….I think I am right, especially when it is a question of light.[3]

Along the right edge of the river extend two series of wooden barrels. Beside the nearest row, a man reaches toward the mane of his horse. In the center of the painting, to the left of an overturned boat with its bottom beneath a layer of snow, stands a wooden sawhorse. A row of brightly colored buildings, with their light pink, ochre, and blue facades, frame the composition on the right. A yellow building capped by a gray mansard roof provided Sisley with a focus for the composition based on a one-point perspective.

Winter in Marly, Snow Effect is closely related to another work in which Sisley again painted barges along the Seine in Marly in winter. In *Port-Marly in the Snow,* presumably painted the same winter, Sisley once more positioned himself along the quay facing the yellow mansard-roofed building, though with a slightly altered orientation.[4] This latter work reflects a position nearer to the water and just to the right of the overturned boat. As a result, the bluish-gray barge in *Winter in Marly, Snow Effect* assumes a central location in *Port-Marly in the Snow,* and the canvas is more evenly divided between sky and ground. In the latter work Sisley has given greater emphasis to the activity on the river, and a thaw has begun to render the winter ground visible.

Sisley painted *Winter in Marly, Snow Effect* in 1876, when snow and bitter cold caused a number of deaths in Paris during the first month of the year.[5] In general, that year was particularly devastating for residents of the city and suburbs, with freezing temperatures and snowfall followed by extensive flooding during the spring and fall. That year, however, Sisley worked extensively out-of-doors in the inclement weather, painting at least thirteen *effets de neige* and seven of the swelling Seine.[6]

LPS

1. *Barges,* 1870, Musée de Dieppe, D14, and *The Canal Saint-Martin,* 1870, Musée d'Orsay, D16.
2. D176, 177.
3. Richard Nathanson, ed., 'Introduction,' in *Alfred Sisley,* exh. cat. London: David Carritt Limited, 1981, 6.
4. *Port-Marly in the Snow,* 1875. Not in Daulte; reproduced ibid., no. 9.
5. See 'Winter Weather Chronology.'
6. D194–198, 216, 236–241, 243–250.

54 *Snow Effect at Louveciennes*

1876

Fondation Rau pour le Tiers-Monde, Zurich

While living in Marly-le-Roi during the winter of 1876, Sisley produced a large number of *effet de neige* compositions that include views of Marly and nearby Louveciennes. This group of works range from picturesque village snowscapes to views of the frozen Seine, and contain some of Sisley's most assured and successful winter compositions.

Snow Effect at Louveciennes was produced after a significant snowfall, and because of its marked view from above, appears to have been painted from a window. In the immediate foreground is an enclosed garden containing two bare trees covered with snow, their branches reaching out across most of the composition. The garden wall gently curves along almost the entire length of the painting, and provides it with a strong anchor. Snow-covered houses are dotted throughout the landscape, and provide a sense of rural peace and serenity. Beyond the garden on the right there is a path through the snow with several villagers who walk to and from their daily errands.

This painting has an interesting provenance. It was originally owned by Sisley's colleague Pierre-Auguste Renoir who later sold it to Durand-Ruel in 1892. Sisley painted another version of this composition from the same window, also titled *Snow Effect at Louveciennes*,[1] but with the view shifted slightly to the left. Both paintings have the same dimensions (19¾ x 24 in./50 x 61 cm), and provide a wonderful example of the Impressionists' interest in depicting the subtle changes in light and atmosphere from moment to moment in their landscape paintings. The works are remarkably similar in palette and composition to an earlier painting by one of Sisley's colleagues. In 1872, Pissarro was commissioned to paint a series of four large-scale paintings of the four seasons, and produced the winter composition first while still living in Louveciennes (fig. 1).[2] Although the scale of the Sisley and Pissarro works are somewhat different, it seems highly possible that Sisley was influenced by Pissarro's quintessential view of winter. Both works are painted from above, providing a panoramic view, both have similar use of tan, gray, and white, and both feature enclosed gardens in the foreground. Unlike the Pissarro painting, however, *Snow Effect at Louveciennes* includes a beautiful group of blue-gray trees in the distance that harmonize with the warm tones of the houses and the wall, and the subtle shades of white, tan, and blue in the snow.

KR

1. Camille Pissarro, *Winter*, 1872, oil on canvas, 21⅞ x 51⅞ in. (55.5 x 131.6 cm), Private collection, photograph courtesy Christie's Images, New York.

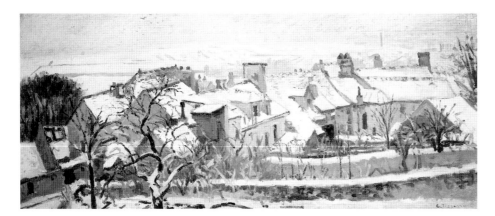

1. D195.
2. See P&V186.

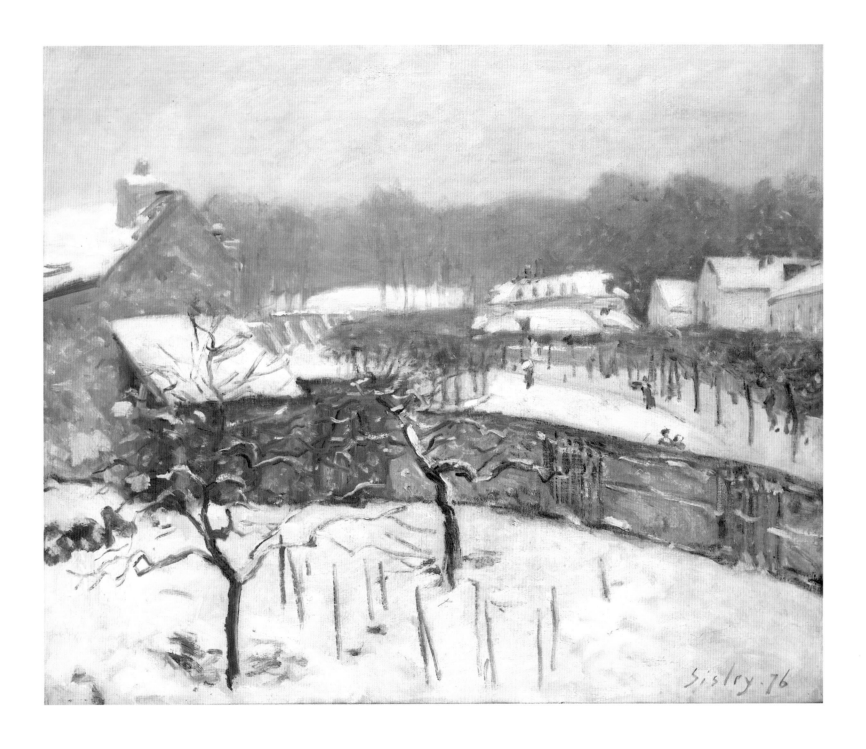

55 *Winter in Louveciennes*

1876
Staatsgalerie Stuttgart

Comfortably settled in Marly-le-Roi during the winter of 1876, Sisley spent his first winter in five years outside of Louveciennes. He often returned to the neighboring village, however, to explore its appearance beneath the effects of freshly fallen snow. His works from this period in Louveciennes may be characterized by their dominant tones of gentle ochres, pale blues, and whites.

As in *Snow Effect at Louveciennes* (cat. 54), the high vantage point of the present work suggests that Sisley may have painted it from a window. In the immediate foreground are three male figures wearing dark clothing and black caps. Two of the men appear to converse as they approach the stone wall, while the third, with arms folded, has turned away. The wall, capped by a layer of snow, links the two stone houses which anchor the composition on the left and right in the foreground. The serpentine curve of the wall, in turn, links the foreground to the background, where Louveciennes, quiet beneath a fresh snowfall, emerges in the distance.

Snow-covered roofs punctuated by chimney-tops sit nestled between poplars on either side. The distant trees, having retained some of their foliage, are rendered in bluish-grays with touches of dark green. In the middle ground, bare trees, their branches obscured by mist and snow, are more loosely defined with lighter dabs of gray, blue, and white. The town is dominated by the church spire which soars above the rooftops and, as a result, becomes the focal point of the composition. Just over the spire the dramatic winter sky, rendered in pale blues, ochres, and whites, brightens, enhancing the church's prominence. Sisley's brushstrokes, which are here clearly visible, seem to radiate from this point as well.

Winter in Louveciennes was originally purchased by Erwin Davis. A self-made, cunning, if disreputable businessman, in the 1860s he rapidly earned and lost his fortune in mining investments. He re-established himself in Europe, where he regained his riches and eventually sought the artistic advice of Julian Alden Weir, who acted as his agent in Paris after 1880. Davis' private collection, with its emphasis on Barbizon, French Romantic, Realist, and Impressionist landscapes ultimately grew to include over four hundred paintings. In 1899, three years before his death, he returned sixteen paintings by Sisley to Durand-Ruel and another seventeen by Monet.

LPS

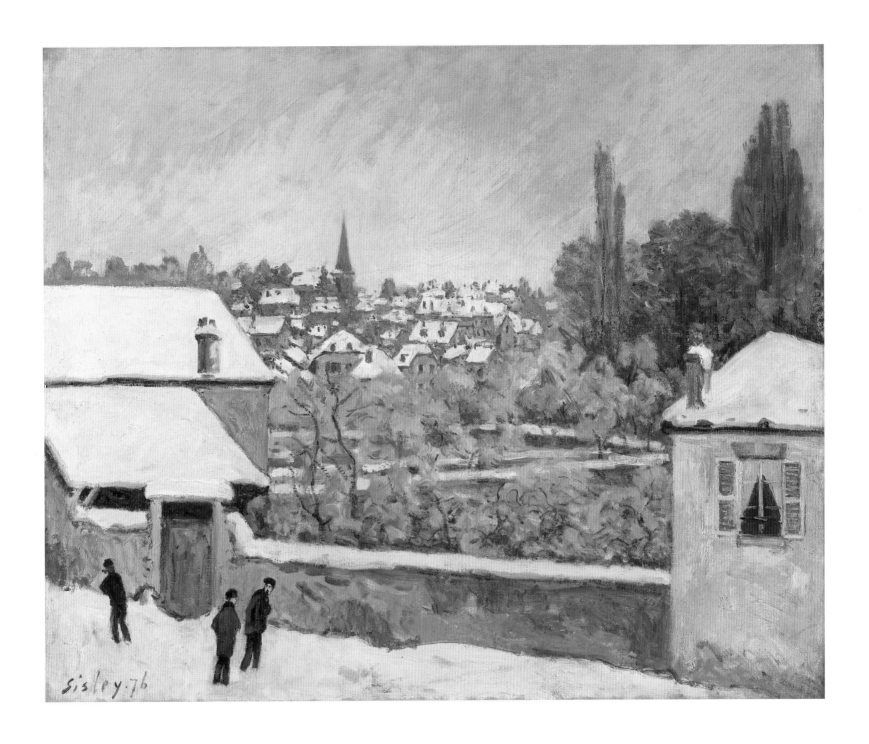

56 *Snow at Louveciennes*

1878
Musée d'Orsay, Paris
Bequest of Comte Isaac de Camondo

Sisley first painted the chemin de l'Etarché blanketed by snow during the winter of 1874 (cat. 49), when he lived on the adjacent rue de la Princesse. By the time he returned to the site to paint the present work, four years had passed and Sisley had resettled in nearby Marly-le-Roi. Displeased with his uncertain financial situation, he had withdrawn from the Impressionist exhibitions, and, instead, sought official acceptance via the Salon. Also within the four intervening years, Sisley had dramatically altered his style.

This most significant modification is reflected in the brushwork, where he replaced shorter, more tightly controlled touches of color with longer, more undulant brushstrokes. Such an approach reveals a more rapid execution and creates a more dynamic composition, which is appropriate for this image of a blustering snowfall. The looser brushwork and vigorous composition, however, result in a less tightly structured work than that in The Phillips Collection (cat. 49). It at once reduces the substantiality which characterizes the houses and bordering walls, and dilutes the impact of the contrapositive relationship between horizontals and verticals, geometrics and amorphics.

Sisley's palette, too, became cooler. In place of the lighter browns and roses of The Phillips Collection work, the later painting is composed of a more monochromatic palette of blues and grays. Painted on an ochre ground, the sky appears heavier and more ominous than that in the earlier work, for which Sisley used a warmer rose-colored ground.

Although Sisley painted both works along the chemin de l'Etarché, and populated each with a solitary female figure crossing the snowy path, he turned his point of view, to paint different ends of the path in each. Whereas in the earlier painting he focused on the area just before the path deviates to the left, in this version of *Snow at Louveciennes* he painted the path at a more southern point, beyond the bend, and faced the different direction.[1]

The houses that remain visible in the distance through the snowstorm stand along the rue de la Grande Fontaine. They appear in another of Sisley's paintings of 1874, *Corner of the Village of Voisins* in the Musée d'Orsay.[2] In this, a signed and dated work completed either in the spring or summer, Sisley positioned himself farther away from the homes in the present work so that a barn-like structure anchors the right side of the composition.

In Sisley's lifetime, *Snow at Louveciennes* was purchased by Count Armand Doria (Armand-François-Paul Desfriches), a wealthy landowner and mayor of the village of Orrouy in northern France. He frequently opened his doors to artists and often visited their homes as well. He purchased his first Impressionist painting in 1874—Cézanne's *The House of the Hanged Man, Auvers*, and eventually owned four paintings by Sisley, including his *First Frost*, from 1876.[3] Following his death in 1896, Doria's collection of nearly forty Impressionist paintings was sold in Paris. The present work was then purchased by the renowned author Georges Feydeau.

LPS

1. Stevens, 1992, 180.
2. D142.
3. Cézanne, *The House of the Hanged Man, Auvers*, Rewald, 1996, no. 202; D249.

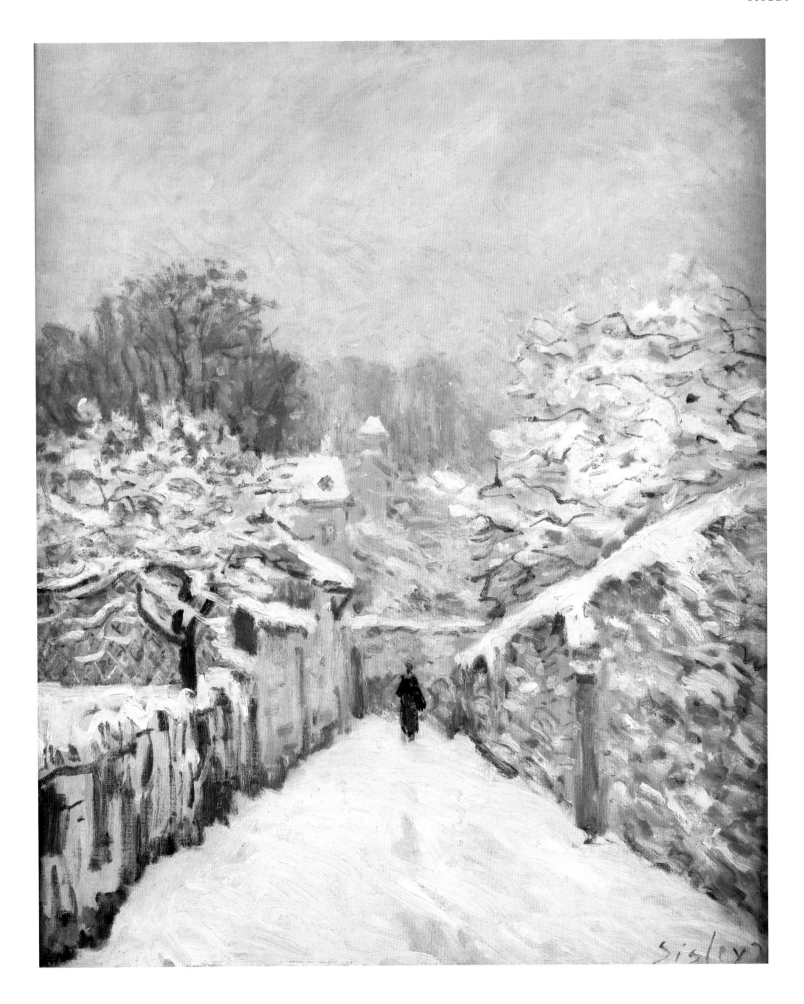

57 *Rue Eugène Moussoir at Moret: Winter*

1891
The Metropolitan Museum of Art, New York
Bequest of Ralph Friedman, 1992

After having spent five years in Marly-le-Roi and Sèvres, in 1880 Sisley moved to Veneux-Nadon, located near Moret-sur Loing.[1] As Gustave Geffroy later wrote regarding this relocation, 'Sisley…had found his country…the fringes of the Forest of Fontainebleau, the small towns strung out along the banks of the Seine and the Loing: Moret, Saint-Mammès, and the rest….'[2] Sisley moved to Moret-sur-Loing in 1882, and was to remain in the region for the rest of his life. As his style matured, he continued to experiment with different types of brushwork, and new, brighter colors in his palette.

Moret was a town that seemed to continually inspire Sisley, both when he lived in nearby Veneux-Nadon and Les Sablons for brief periods in the 1880s, and when he settled there for the rest of his life in 1889. He described the town in a letter to Monet on 31 August 1881: 'It's not a bad part of the world, rather a chocolate-box land-scape…Moret is two hours away from Paris, with plenty of houses to rent…Market once a week, very pretty church, some quite picturesque views…'[3] Much like Pissarro in Pontoise and Monet in Argenteuil, Sisley fully documented the entire town of Moret with his views of the church, the river, its bridge, and its many streets.

Rue Eugène Moussoir at Moret: Winter was painted in the winter of 1891, at the same time, perhaps, that his great friend Monet was producing his series of grain-stacks in the snow (see cats. 23–26). It depicts a view of the rue Eugène Moussoir, a well-known road in the town, that is bordered by the wall of the village hospital on the right. Although approximately twenty years had passed since his first *effet de neige* composition, Sisley has used the familiar compositional device of the off-center perspectival road view to add structure to the painting. In fact, the composition seems so reminiscent of some of his earlier paintings that when this work was put up for sale in 1963, it was misidentified as a view of Louveciennes from 1872.[4]

Unlike his snowscapes from the early to mid-1870s, Sisley's palette in this painting is no longer restrained or subtle. Instead he celebrates the beauty of winter with a wide variety of colors. The cold, heavily overcast sky, which is blue-gray with a hint of lavender, dominates more than half of the composition. At the horizon line, one can see the brilliant color of a spectacular sunset peaking through the clouds that will soon dramatically change the landscape. The pile of snow that lines the road next to the hospital wall seems to reflect the luminosity of the sunset with Sisley's addition of yellow and pink. Unlike some of his earlier snowscapes that generally feature only one or two figures, this painting includes a large group of villagers who walk in two separate pathways that have been made in the aftermath of the significant snowfall.

KR

1. Stevens, 1992, 267.
2. Geffroy, 1923, 19, quoted in Stevens, 1992, 183.
3. See 'Sisley,' in *Bulletin des expositions*, Galerie d'Art Braun, Paris, 30 January–18 February 1933, 7, quoted in Stevens, 1992, 184.
4. Sotheby's London, sale catalogue, 23 October 1963, 45, as *Effet de neige à Louveciennes*, as painted c. 1872. Courtesy of The Metropolitan Museum of Art curatorial files.

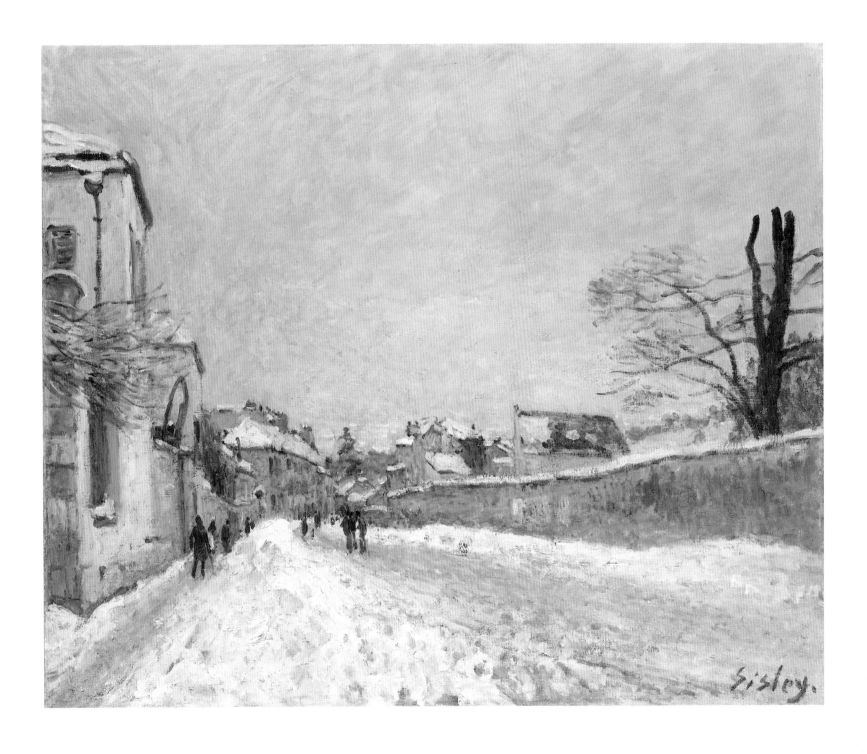

Caillebotte

Gustave Caillebotte was born in Paris on 19 August 1848, the first of three sons born to Martial Caillebotte, Sr. and Céleste Daufresne.[1] He grew up living in luxurious homes in the city and country, built by his father, whose family had been established in the textile business since the eighteenth century. Caillebotte received his bachelor's diploma in law in 1868 and in 1870 was licensed to practice, although he never did. That same year he was drafted into the Garde Mobile de la Seine.

After the Franco-Prussian War, he traveled extensively and in 1872 began attending the atelier of established Salon painter Léon Bonnat. Under Bonnat's sponsorship, Caillebotte entered the Ecole des Beaux-Arts, in 1873.[2] His paintings from this period reflect an academic approach, in both subject matter and technique, yet in 1875 his first and only entry to the Salon was rejected, and in 1876 Caillebotte left the Ecole.

That year he accepted the invitation of Renoir and Rouart to exhibit in the second Impressionist exhibition. Later in 1876 his younger brother René died at the age of twenty-six. Fearing his own premature death, Caillebotte drafted a will soon after, at the age of twenty-eight.

Having received a considerable inheritance upon his father's death three years earlier, Caillebotte had not only been free to paint at leisure but had begun to accumulate an extensive collection of works by his new Impressionist colleagues. His will provided them with money for the next Impressionist exhibition and called for his newly formed collection to hang in the Musée du Luxembourg and later the Louvre. Although he lived to see all eight Impressionist exhibitions, he did not participate in each.[3] He did, however, continue to provide his promised financial support to the Impressionists' cause, by organizing their exhibitions, periodically lending money to individual members of the group, and by purchasing their paintings.

Caillebotte spent the 1870s, his most productive years, painting in the fourth floor studio of his parents' home on rue de Miromesnil in Paris and then in his home on boulevard Haussmann. He found his subjects on the city's boulevards, its vistas viewed from upper floor windows, and the atypical Impressionist setting of the urban interior. It was during the middle years of the decade that he painted his first *effet de neige*, and in 1878 purchased his first by Monet, *The Church at Vétheuil, Snow*.[4]

After selling the family home in Paris and the country house in Yerres following the deaths of their parents, in 1881 Caillebotte and his brother purchased property at Petit Gennevilliers, on the banks of the Seine across from Argenteuil.[5] In 1888 this property became Caillebotte's primary residence, the same year in which he was elected town councilman. Although living in the suburbs, he maintained close contact with Paris and with his colleagues, becoming the godfather of Renoir's first son, Pierre, in 1885, and in July 1892 witnessing Monet's marriage to Alice Hoschedé. Once settled in Petit Gennevilliers he developed a passion for gardening, a hobby mutually shared by Monet, whose consultation Caillebotte often sought. He included the garden and its often exotic contents in several of his paintings from Petit Gennevilliers. He died of an apparent stroke in his home here on 21 February 1894, at the age of forty-five. As the executor of Caillebotte's will, Renoir oversaw his bequest of forty works, chosen from an original group of approximately sixty, to the capital's museum devoted to contemporary painting, the Musée du Luxembourg.

1. Martial Caillebotte Sr. was twice widowed and had one son from a previous marriage.
2. The exact dates of Caillebotte's travels and his studies with Bonnat are not known. Anne Distel has proposed that he began frequenting Bonnat's studios in 1871 so that by 1873, when he entered the Ecole, he would have received approximately two years of formal instruction. See Distel, 'Birth of an Impressionist,' in Varnedoe et al., 1994, 30.
3. Caillebotte exhibited with the Impressionists in 1876, 1877, 1879, 1880, and 1882.
4. W506. The following year he bought Monet's *Frost*, W555.
5. Martial Caillebotte died 24 December 1874 and Céleste on 20 October 1878. The home on rue de Miromesnil was sold 11 March 1879 and, although the exact date of sale is not known for the Yerres property, the new owner, Pierre Ferdinand Dubois, took possession in 1881. See Anne Distel, in Varnedoe et al., 1994, 314.

Gustave Caillebotte, *View of Rooftops (Snow)* (detail cat. 58), c. 1878, oil on canvas, 25¼ x 32¼in. (64 x 82 cm), Musée d'Orsay, Paris, Gift of Martial Caillebotte.

58 *View of Rooftops (Snow)*

c. 1878
Musée d'Orsay, Paris
Gift of Martial Caillebotte

Although Caillebotte began his painting career with an emphasis on figures in interiors, by 1877 he had started to shift his focus from interior scenes to outdoor subjects. He often favored unorthodox points of view, and his striking compositions tend to have a dramatic spatial orientation, plunging into depth or displaying abrupt effects of foreshortening. To some degree his work suggests his awareness of photography as well as Japanese prints, both of which frequently introduce bold perspectives or unexpected vantage points.

Unlike many of the Impressionists, Caillebotte lived in Paris through the 1870s and many of his paintings of these years take aspects of the city as a subject. His interest in a plunging perspective found a perfect opportunity in the new boulevards of Haussmann's design in Paris. However, in this painting, rather than looking down from a window into the street below, he chose to look out across the roofs of Paris. So absorbed was he by this unusual subject that he painted several rooftop views in 1878. One of these works, *View of Roofs, Paris*, is signed and dated 1878 and has been identified as being painted from a precise location on the rue de Clichy in Montmartre, from the studio of a friend, the artist Edouard Dessommes.[1]

Two of Caillebotte's rooftop views are *effets de neige* (see also cat. 59), and they might both have been painted in December of 1878 which was 'much colder and received more precipitation than usual. A large proportion of this water fell in the form of snow.'[2] But once the similarity of viewpoint is granted, the differences between the two works are strikingly apparent. The somewhat larger painting in the Musée d'Orsay appears the more finished of the two and displays a delicate palette of dark lavender, blue-gray, and green; brick-red chimney pots set off the passages of white that run throughout the painting. As opposed to the marching sentinels of vertical chimneys in the other smaller work, here Caillebotte has chosen a view that includes the mansard roofs and dormer windows that immediately evoke Paris. This is one of two views of rooftops that Caillebotte exhibited in the fourth Impressionist exhibition held in Paris in the spring of 1879. He exhibited twenty-five works. Both views of Paris roofs were well received.[3]

Unprecedented in Caillebotte's œuvre, his views looking across the rooftops of Paris suggest the possibility of his awareness of Pissarro's *Winter* (1872), in the series of four seasons, commissioned by the successful businessman Achille Arosa.[4] Given Caillebotte's own position in society as a businessman as well as an artist, he might well have been invited to see Pissarro's series of paintings installed in the Arosa house. Pissarro's rendering of winter offers an unusual view, different from the other three seasons in the cycle, looking across the snowy rooftops of Pontoise.

Caillebotte's *View of Rooftops (Snow)* was included in a retrospective exhibition at the Galerie Durand-Ruel a few months after the artist's death in 1894, and was presented to the Musée du Luxembourg by his brother, Martial Caillebotte, that same year.

EER

1. Berhaut, 1994, no. 97.
2. See 'Winter Weather Chronology'.
3. See Moffett et al., 1986, 273.
4. See Katherine Rothkopf, 'Camille Pissarro: A Dedicated Painter of Winter,' fig. 4.

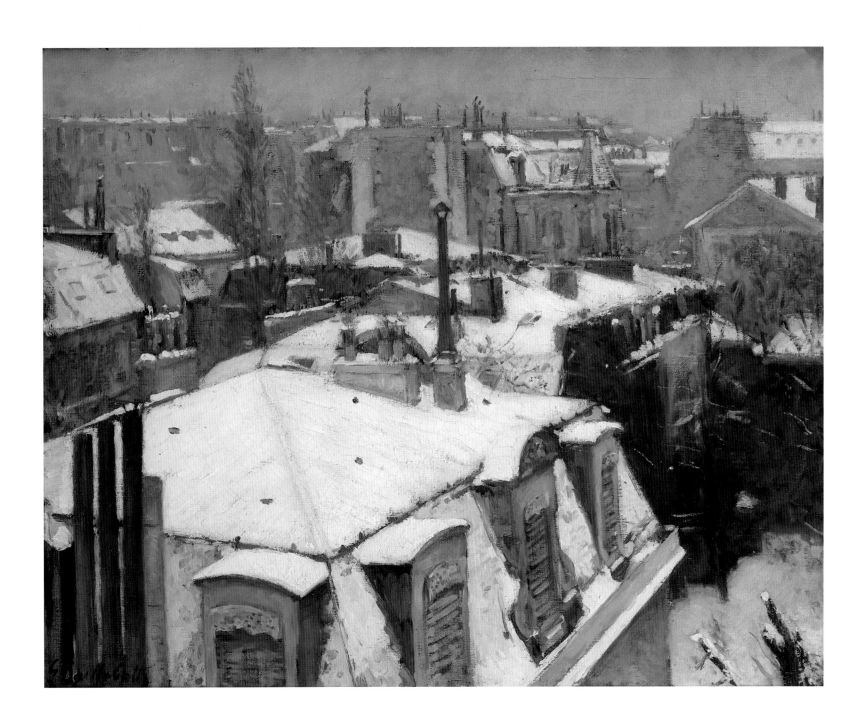

59 *Rooftops in the Snow*

1878
Fondation Rau pour le Tiers-Monde, Zurich

Caillebotte did not sign or date *Rooftops in the Snow*, nor did he exhibit it during his lifetime. Its provenance, furthermore, does not provide specific information which might assist in the dating of this work. Berhaut has attributed the painting to 1878, placing it within a series of rooftop views that Caillebotte painted that year, two of which were exhibited in the fourth Impressionist exhibition in 1879 and which, therefore, must have been painted before the exhibition opened on 10 April 1879 (see cat. 58).[1] Caillebotte would more likely have been provided with the opportunity to paint such images in the first few months of 1879 rather than in the warmer, less snowy winter of 1878. The present work, however, having been excluded from exhibition prior to this century, may have been completed later in 1879, when snow accumulation nearly paralyzed Paris and its outlying areas.[2]

Rooftops in the Snow is typical of Caillebotte's style in the late 1870s. In it he retained the plunging perspective, by this time the artist's hallmark, and somber palette of his earlier works, yet by 1878 he had adopted what was clearly a looser, more Impressionistic technique in comparison to the paintings which date from the middle of the decade. Caillebotte's brushwork is broader, bolder, and his pigments more thickly applied than earlier, perhaps the result of his close affiliation with the Impressionists which began the previous year. Dense, curved brushwork in the sky alternates with long, individual strokes used for the houses and their rooftops. Passages of white snow on the rooftops, applied with a loaded dry brush, create a lively surface pattern.

Rooftops in the Snow is one of several works by Caillebotte in which he painted a view of the city from a dramatically high vantage point or through a window. In the second Impressionist exhibition, his *Young Man at His Window* received generally favorable criticism, and was acknowledged for its charming originality.[3] To the fourth group exhibition the following year, he contributed three more scenes of Paris viewed from high above the city.[4]

The specific subject of *Rooftops in the Snow*, however, what Rodolphe Rapetti has termed the 'absence of the urban picturesque,' is not a typical image in Caillebotte's œuvre, nor in the Impressionist œuvre in general.[5] Sprawling boulevards, picturesque buildings with richly observed architectural details, fashionably dressed men and women, have here been replaced by blackened chimneys and smokestacks, rust-colored buildings without windows or inviting facades, and only puffs of smoke swirling from chimneys and merging with the gray, overcast sky to provide any sign of human presence. As if to complete his expression of this relatively gritty subject, Caillebotte painted *Rooftops in the Snow* on cardboard rather than canvas. The board is clearly visible throughout the painting, most obviously in the rooftops.

LPS

1. Berhaut, 1994, no. 95.
2. See 'Winter Weather Chronology.'
3. Berhaut, 1994, no. 32. For contemporary reviews see 'The Second Exhibition,' in Berson, 1996.
4. Cat. 58; Berhaut, 1994, nos. 96, 97, and 100.
5. See Rodolphe Rapetti, 'Paris Seen from a Window,' in Varnedoe et al., 1994, 143.

60 *Boulevard Haussmann, Snow*

c. 1880–81
Private collection

In 1879 Caillebotte settled into his new home at 31, boulevard Haussmann, where he and his younger brother Martial occupied a fourth-floor apartment in what is today the Société Générale Building. Soon after, he painted *Boulevard Haussmann, Snow*, which features a view of the grand boulevard at the intersection of rue Scribe, as seen from Caillebotte's balcony. He would continue to paint the city viewed from his private quarters high above, frequently including the cast iron grille as a major decorative element.[1] In *A Balcony in Paris*, a painting that dates to about the same time as the present work, Caillebotte depicted the same scene, though with a slightly altered viewpoint in which the balcony comprises the lower half of the composition and the viewer is nearer to the buildings along the rue Scribe (fig. 1). In a highly original work of 1880, he dedicated an entire canvas to the decorative grillework of the balcony itself.[2]

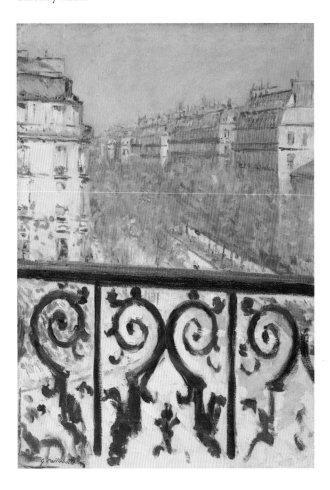

1. Gustave Caillebotte, *A Balcony in Paris*, c. 1880–81, oil on canvas, 21¾ x 15 in. (55 x 38 cm), Courtesy Paul Rosenberg & Co., New York.

As Kirk Varnedoe has discussed, the balcony gained prominence in Parisian architectural construction during the Second Empire, at first for primarily practical reasons.[3] Baron Georges Haussmann, under the administration of Napoleon III, led the way in redesigning the capital, replacing its cramped, maze-like city streets with expansive, glamorously designed boulevards. With the widening of the city's streets, the amount of land on which to erect buildings was naturally greatly reduced, and drastic increases in real estate prices ensued. Large inner courts that had once been the center of domestic life, then, were sacrificed in order to maximize the amount of interior space. The balcony became a favored architectural element for providing a domestic outdoor space. This resulted in a new visual focus on the outer life of the street in place of the inner family life, and concurrently reflected contemporaneous sociological trends.

Caillebotte's technique in this painting is as thoroughly modern as his subject. When compared to *Rooftops in the Snow* (cat. 59), for instance, the handling of the paint is more fluid and the forms less tightly defined. In the foreground, a deep layer of freshly fallen snow resting upon the ledge of the balcony is conveyed through short, thickly applied strokes of whites, blues, and ochres. In contrast, areas of exposed bare canvas remain visible between the grillework and the murky, ochre sky.

All that is not in the immediate foreground is obscured by the overcast light of the stormy day. Quickly painted trees with branches leaning inward toward the boulevard suggest a strong gust. In this blustering weather, a few horse-drawn carriages and pedestrians hasten along the snowy boulevard, rendered in mere dashes of gray and black in a style reminiscent of Monet's *Boulevard des Capucines* (cat. 8). The building facades are sketchily painted as well, though in the fore-ground Caillebotte painted them with slightly more precision, even adorning the nearest building along the right with brightly colored windows. In the distance, the buildings fade into obscurity, invisible beneath the blue-gray winter haze.

LPS

1. See Berhaut, 1994, nos. 137, 138, 140, 145–49, 151.
2. Ibid., no. 147.
3. Varnedoe et al., 1994, 140, 215, n. 1.

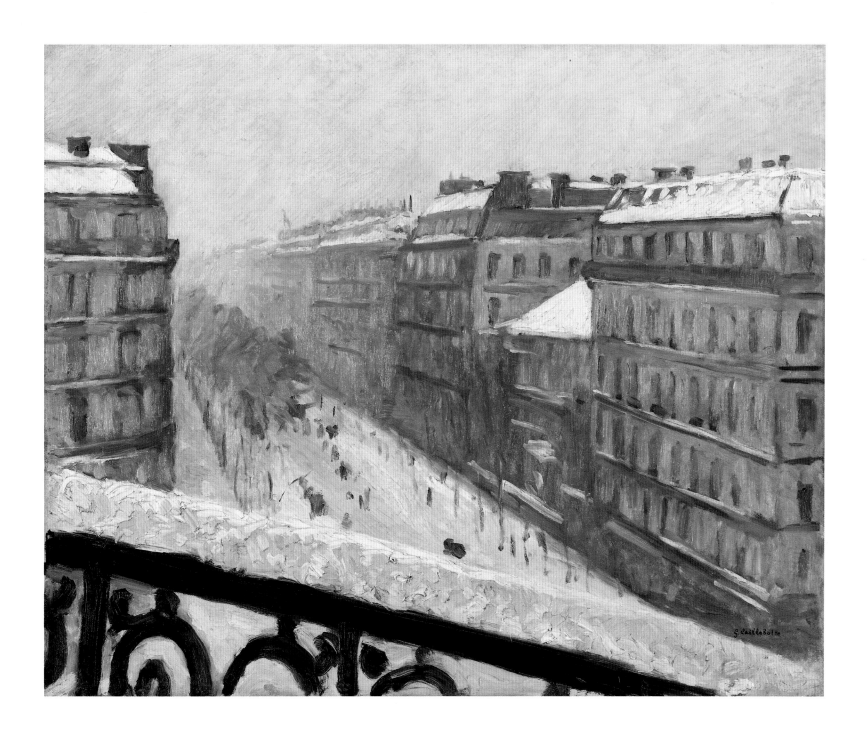

Gauguin

Paul Gauguin was born in Paris on 7 June 1848, the second child and first son of Pierre Guillaume Clovis Gauguin, an editor of the *National*, and his wife Aline Marie Chazal. In August of the following year the Gauguin family set sail for Peru. Two months later, Gauguin's father died of a ruptured aneurysm, leaving his wife and children to live with a relative in Lima. Seven years later the family returned to France and settled in Orléans.

In 1865, at the age of seventeen, Gauguin enlisted as an officer's candidate in the merchant marine, and sailed to Rio de Janeiro that year and the next. As the second lieutenant aboard the *Chili*, in 1867 he traveled around the world. In 1868 he joined the military as a third-class sailor and was involved with the capture of four German ships during the Franco-Prussian War. After the war, with assistance from longtime family friend Gustave Arosa, he found a position as a stockbroker. Ironically, it may have been Arosa, a financier, photographer, and collector of contemporary art, who first exposed Gauguin to art and collectors at about this time. Through Arosa Gauguin was also introduced to Mette Gad, whom he married in 1873. By this time he had begun painting on a part-time basis, without receiving any formal instruction.

In 1876 he debuted at the Paris Salon, with the landscape *The Woods at Viroflay (Seine and Oise)*.[1] After 1876, however, Gauguin either decided not to submit to the Salon or, like his future colleagues, was repeatedly rejected by its juries.[2] In 1877 he began studying with the sculptor Jules Bouillot, also his landlord. Two years later, when, at the last-minute invitation of Degas and Pissarro, he participated in the fourth Impressionist exhibition, he contributed not a painting but a marble bust of his eldest son, the only sculpture in the exhibition. He also lent three works by Pissarro to the show from his personal collection. Represented by paintings, pastels, and sculptures, Gauguin participated in the four remaining group exhibitions.

In the fifth Impressionist exhibition, Gauguin exhibited a marble bust and seven paintings, at least three of which were painted in the environs of Pontoise with Pissarro, whom he often visited, and one of which was an *effet de neige*.[3] When Pissarro traveled to Rouen four years later, Gauguin followed him in search of a new job and a lower cost of living. By this time the stock market had collapsed, Gauguin's personal stocks had followed, and he listed himself as an *artiste-peintre* on his fifth child's birth certificate. In 1885, he settled in Copenhagen with his wife's family but, discouraged by local criticism of his work, he returned to Paris later that year.

Desiring a retreat from the distractions of Paris, and in search of a life of simplicity and unchanging tranquility, Gauguin moved to Pont-Aven in Brittany in July 1886. The following April he set sail for Panama and, from there, Martinique, in hope of finding a more exotic landscape and primitive lifestyle. He returned to France in November 1887 and in October 1888 visited van Gogh in Arles. The visit ended abruptly, however, following a violent disagreement with the latter, and upon his return north, Gauguin divided his time between Paris and Pont-Aven. Eventually seeking a more serene and deserted landscape, he settled in the smaller fishing village of Le Pouldu. By this time, in 1889, he had severed his ties with the Impressionists as well as the younger generation of Neo-Impressionists, and considered himself a Synthetist.

Ever pursuant of a primitive lifestyle in an exotic setting, and seeking to establish a 'studio of the Tropics,' Gauguin left for Tahiti in 1891.[4] He spent just over two years abroad, painting scenes of daily life and creating fantastical images based on Polynesian tales before returning to France. He remained in France for nearly two years before making his final departure to Tahiti on 3 July 1895. In the years that followed, in addition to producing an enormous artistic œuvre, Gauguin edited and wrote for the satirical journal *Les Guêpes* and, for a brief period, designed and printed another, *Le Sourire*. In 1901 he moved to the even more remote island of Hivaoa in the Marquesas. By this time he had often begun feeling too ill or too weak to paint, and began working on his book of memoirs, *Avant et après*. Following years of discomfort and illness, including a series of heart attacks, Gauguin died on the island of Hivaoa in the Marquesas on 8 May 1903 at the age of fifty-four.

Paul Gauguin, *Winter Landscape, Snow Effect* (detail cat. 62), 1888, oil on canvas, 28½ x 36¼ in. (72.5 x 92 cm), Göteborg Museum of Art, Göteborg, Sweden.

1. Wildenstein, 1964, no. 12.
2. The exact reason why Gauguin never again exhibited at the Salon is not known. See Brettell et al., *The Art of Paul Gauguin*, exh. cat. Washington, D.C.: National Gallery of Art, 1988, 11.
3. Wildenstein, 1964, no. 37.
4. See Bengt Danielsson, *Gauguin à Tahiti et aux îles Marquises*, Papeete, 1975, 17–36, and John Rewald, *Post-Impressionism: From van Gogh to Gauguin*, New York, 1978, 410–18.

61 *The Seine at the Pont d'Iéna, Snowy Weather*

1875
Musée d'Orsay, Paris
Bequest of Paul Jamot

In January 1875 Gauguin moved to 54, rue de Chaillot, not far from the Pont d'Iéna. He painted *The Seine at the Pont d'Iéna, Snowy Weather* that winter, looking northeast, toward the Place de la Concorde. To his left stood the magnificent Chaillot Palace and the Trocadero, to his right lay the Champ de Mars where, twelve years later, the Eiffel Tower would be erected at its north-western end. The Pont d'Iéna was originally built to commemorate the French defeat of the Prussian army at Iéna in 1806, and was conceived as part of a larger scheme by Napoleon, who planned to install his son, the King of Rome, in the bordering Chaillot Palace. The bridge, therefore, was endowed with historical connotations with which Gauguin's contemporaries would have readily identified. In much the same vein as Sisley was working in his contemporaneous paintings of Hampton Court or the Marly Aqueduct (see cats. 51 and 52), Gauguin here recalls the former glory of the Empire but does so in a painting thoroughly modern in both imagery and technique.

In *The Seine at the Pont d'Iéna, Snowy Weather*, Gauguin adopted the everyday subject matter embraced by the Impressionists. Moored barges line the quays on either side of the Seine, recalling Pissarro's 1871 and 1872 paintings of the Seine at Port-Marly (fig. 1). The clear juxtaposition of leisure and labor readily apparent in the images of strolling figures along the quays and the laborers aboard the barges in Pissarro's works, however, is lacking in Gauguin's painting. In contrast, *The Seine at the Pont d'Iéna* is at once less populous and the role of the figures along the quays more ambiguous—they are dressed in dark clothing and walk along the snow-covered ground on what is clearly a frosty day, though not cold enough to freeze the river.

The Pont d'Iéna spans the distant horizon. Thick white puffs of smoke from a barge passing just beneath its arches merge with the sky, to which Gauguin dedicated three-quarters of the painting. Dramatically rendered, the stormy sky is tinged with areas of white and light pink. These variegated tones reappear as reflections upon the snow-covered earth as well as upon the river, whose waters, in turn, range from dark blue to a light green-gray.

Gauguin painted *The Seine at the Pont d'Iéna, Snowy Weather* soon after he had been introduced to Pissarro by longtime family friend and successful businessman Gustave Arosa in 1874.[1] By this time, Pissarro and his Impressionist colleagues had been accepted and rejected by the Salon jury and had established their own forum for exhibiting their works. Gauguin, in comparison, had only been painting for a couple of years and had yet to exhibit his work publicly—he took that step the following year, by exhibiting in the Salon of 1876.

The Seine at the Pont d'Iéna, Snowy Weather, one of Gauguin's earliest works, reveals his early, individual approach to painting in the emphasis on linearity and his tonal, rather than broken, application of color. He had not yet exhibited with the Impressionists, though he would join them three years later. At this early stage in his career, however, he clearly shared their interest in conveying temporal effects and recognized the potential for exploring the effects of light and shade on snow-covered landscapes.

LPS

1. Camille Pissarro, *The Seine at Port-Marly*, 1872, oil on canvas, 18 x 22 in. (46 x 55.8 cm), Staatsgalerie Stuttgart.

1. Just before her death in 1867, Gauguin's mother had appointed Arosa her son's legal guardian. Arosa, a collector of contemporary art, had begun to acquire Pissarro's work in the early 1870s. Gauguin, who lent two paintings and one fan by Pissarro from his personal collection to the fourth Impressionist exhibition, had begun forming a collection by 1878, in which Pissarro was well represented.

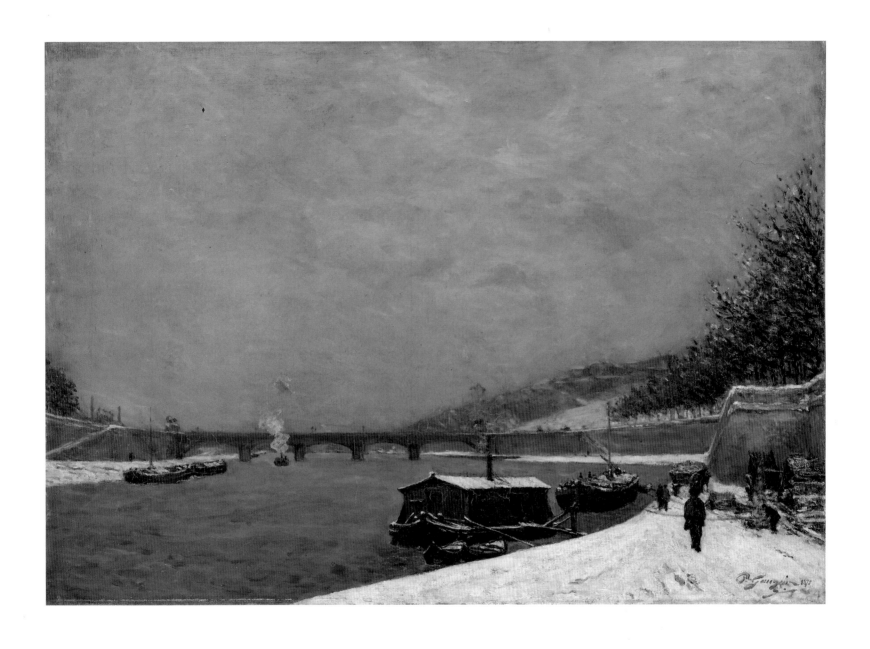

62 *Winter Landscape, Snow Effect*

1888
Göteborg Museum of Art, Göteborg, Sweden

Gauguin painted this work in Brittany two years after his first visit to Pont-Aven in 1886. While in Brittany in February 1888, he began to evolve a new style that moved away from Impressionism called Synthetism. That year he wrote to Emile Schuffenecker, 'A word of advice, do not copy nature too closely. Art is an abstraction; derive it from nature while dreaming in front of it and think more of the creation which will result.'[1]

In *Winter Landscape, Snow Effect* Gauguin explores a composition typical of many of his Brittany landscapes with a high horizon and generalized volumes in which contour, pattern, and rhythm are emphasized. A field of snow in the foreground rises up to almost meet the bottom edges of the steeply pitched roofs of the farm buildings in the middle ground. Behind the buildings a hillside covered in snow carries the eye upward to a pale blue sky. A row of spindly bare-branched trees creates a recession into the distance on the left and a single, fatter and more gnarled trunk serves to mark the edge of the foreground field on the right. The division of the hillside into cultivated fields bordered by walls echoes the angular geometries of the rooftops and walls of the farm buildings. No creature disturbs the quality of hushed stillness that pervades this scene.

The snow appears to be melting on some of the roofs, and both sky and snow exhibit a palette delicately flecked with lavender-blue and aqua that suggests the chilly light of daybreak. These short bruskstrokes of color that are also present elsewhere in the paintings reveal the artist's Impressionist beginnings, while the composition anticipates the bold arrangement of shapes that characterize subsequent work. In the left foreground a concentration of arching brushstrokes that do not correspond to those in the rest of the work suggests that the artist may have decided to alter this passage of the painting, perhaps eliminating a person or animal from the original composition. The result could be interpreted as a bush laden with snow. The work is thinly painted overall, especially in the lower third of the painting and at the top. On the left, the stand of six trees, possibly poplars, appears to be added last with a barely loaded brush in short quick strokes. Delicately suggested, these trees with their bare branches suggest the frailty and vulnerability of every living thing in the damp and freezing winter weather.

Signed and dated 1888, this work was presumably painted soon after the artist's arrival in Pont-Aven in February, since the end of the year saw him returning to Paris from his intense and sometimes turbulent stay with Vincent van Gogh in Arles. One of very few snow-scapes in Gauguin's œuvre, this painting anticipates the subject and composition of *Breton Village in the Snow* of 1894 (cat. 63).

EER

1. Letter to Emile Schuffenecker, 1888, quoted in *Impressionist and Post-Impressionist Masterpieces: The Courtauld Collection*, New Haven and London, 1987, cat. 39.

GAUGUIN *63* *Breton Village in the Snow*

1894
Musée d'Orsay, Paris

Although left unsigned and undated by Gauguin, this painting was probably begun in Brittany in November or December of 1894. Gauguin spent approximately nine months in Brittany from April to December of that year before his final departure for Tahiti. It is recorded that there were several snowfalls in the region in November and December.[1] By the time he painted this scene, Gauguin had spent a first sojourn in Tahiti from 1891 to 1893. On his second and last departure in 1895 for the South Pacific, he took this painting with him. Since it was found unfinished on his easel at the time of his death, the painting was long thought to be the artist's last work.[2]

Gauguin first exhibited with the Impressionists in the fourth Impressionist exhibition of 1879 (although his work was not cited in the catalogue).[3] The following year, 1880, he showed eight works including an *effet de neige* in the fifth Impressionist exhibition. Beginning in the summer of 1879, he had been a regular visitor to Pissarro in Pontoise, and it may be this artist's dedication to snowscapes that encouraged Gauguin to try his hand at conveying the special quality of light on the snow.

Although similar in composition to his *Winter Landscape, Snow Effect* of 1888 (cat. 62), Gauguin's painting of 1894 reflects his stylistic development in the intervening years. The bold composition with a high horizon and strong contrast of snow against the dark chimneys and facades of the buildings, convey the muffled stillness of the village deep in snow at the end of the day.

This particular view of the village bears a striking resemblance to the scene described in another painting probably from the same date, *Christmas Night*, in the Josefowitz Collection.[4] Here too a hillside fills the top left portion of the painting, the steep roofs of the houses covered in snow occupy the middle ground, and the steeple of the church rises at the center of the composition and is suggested beyond the edge of the painting. While *Christmas Night* shows peasants with a pair of bulls in profile looking toward a relief of the Descent from the Cross, *Breton Village in the Snow* appears to be a peaceful scene undisturbed by any human presence. X-radiography and infrared reflecto-graphy, however, suggest that the work once included an animal in profile in the left foreground and a figure in the right foreground, standing just to the left of the stand of trees.[5] Not entirely dependent on direct observation of nature, the artist's palette includes a range of colors in the snow that correspond to the mixture of warm and cool tonalities in the evening sky.

EER

1. According to l'Institut National Météorologique, cited in 'l'Histoire du tableau,' Archives of the Musée d'Orsay, Paris.
2. See Victor Segalen, preface, *Hommage à Gauguin pour les Lettres à Daniel de Monfreid*, 43, Archives of the Musée d'Orsay, Paris.
3. Moffett et al., 1986, 271.
4. Wildenstein, 1964, no. 519.
5. My thanks to Anne Roquebert, Laboratoire des Musées de France.

Exhibition Checklist and Catalogue
Compiled by Lisa Portnoy Stein

1 Monet
A Cart on the Snowy Road at Honfleur
La charrette, route sous la neige à Honfleur avec la ferme Saint-Siméon
1865
Oil on canvas, 25½ x 36½ in. (65 x 92.5 cm)
Signed lower left: *Claude Monet*
Musée d'Orsay, Paris, Bequest of Comte Isaac de Camondo

PROVENANCE
Purchased from Mme. F. Barrey, Le Havre, by Durand-Ruel, 9 October, 1889 and sold 23 October to the Abbé Gauguin (*Effet de neige*); sale, collection of M.G. [abbé Gauguin], Hôtel Drouot, Paris, 6 May 1901, no. 5; Comte Isaac de Camondo, Paris; bequeathed in 1908, Musée du Louvre, Paris, 1911; transferred to the Musée du Jeu de Paume, Paris 1947; transferred in 1986 to the Musée d'Orsay, Paris (RF 2011).

EXHIBITIONS
Paris 1931, no. 2; *Chefs-d'œuvre impressionistes* (temporary exhibition of the Jeu de Paume collections), Paris, Musée de l'Orangerie, 1956; Paris 1980, no. 10.

REFERENCES
P. Lalo, 'La collection Camondo,' *Le Temps* (4 August 1911), p. 4; P. Leprieur and L. Demonts, 'Peintures, pastels, acquarelles et dessins du XIXe siècle,' in *Musée nationale du Louvre. Catalogue de la Collection Isaac de Camondo*, Paris, 1914, pp. 13 (illus.), 14; P. Jamot, 'La collection Camondo au Louvre,' *Gazette des Beaux-Arts* (July 1914), p. 56; P. Leprieur and L. Demonts, 'Peintures, pastels, acquarelles et dessins du XIXe siècle,' in *Musée nationale du Louvre. Catalogue de la Collection Isaac de Camondo*, Paris, 2nd ed., 1922, no. 179; Geffroy, 1922, p. 223; G. Brière, *Musée national du Louvre. Catalogue des peintures exposées dans les galeries*, Paris, 1924, p. 189; R. Koechlin, 'Claude Monet,' *Arts et Décoration* (February 1927), p. 35; R. Régamy, 'Formation de Claude Monet,' *Gazette des Beaux-Arts* (February 1927), p. 70; P. Jamot, 'L'Art français en Norvège,' *La Renaissance de l'art française* (February 1929), p. 87, pl. 67; Adhémar et al., 1947, no. 140; Reuterswärd, 1948, p. 280; M. Rostand, *Quelques amateurs de l'époque impressionniste* (unedited thesis from the Ecole du Louvre), Paris, 1955, p. 356; Champa, 1973, pp. 14–15, fig. 19 (*Snowscape, Honfleur*); Adhémar and Dreyfus-Bruhl, 1958, no. 225; M. Sérullaz, *Encyclopédie de l'Impressionnisme*, Paris, 1974, p. 132 (illus.); Wildenstein, 1974, I, no. 50, pp. 138, 139 and 1991, V, p. 22; A. Distel, 'La Donation Hélène et Victor Lyon,' *Revue du Louvre*, vol. 5/6 (1978), pp. 397 (illus.), 398; J.-P. Crespelle, *Monet*, Paris, 1986, pp. 44, 45 (illus.); Rosenblum, 1989, p. 236 (illus.); Compin et al., 1990, vol. 2, p. 329 (illus.); Spate, 1992, pp. 43, 44 (illus.); W50.

2 Monet
Road by Saint-Siméon Farm in Winter
La route de la ferme Saint-Siméon en hiver
1867
Oil on canvas, 19 x 25 in. (49 x 65 cm)
Signed lower left: *Claude Monet*
Mrs. Alex Lewyt
Washington only

PROVENANCE
(?) Sent to Monet in Le Havre by Bazille in the winter of 1868–69, at Monet's request; Jean-Baptiste Faure, Paris; sale, collection of Mme. L. [Laurent], Hôtel Drouot, Paris, 11 February 1903, no. 9; Galerie Durand-Ruel, Paris; Galerie Paul Rosenberg, Paris, 1903; Jean Dollfus and the Zygomalas Collection, Paris, c. 1911; Galerie Paul Rosenberg, Paris, c. 1926; Georges Martin, Paris; Sam Salz, New York, c. 1951; Mr. and Mrs. Alexander M. Lewyt, United States, c. 1957.

EXHIBITIONS
Impressionists, London, Grafton Galleries, 1906, no. 91; *Rétrospective d'art français*, Amsterdam, Musée d'Etat (Rijksmuseum), 3 July–3 October 1926, no. 73; *Claude Monet*, Paris, Galerie Durand-Ruel, 6–19 January 1928, no. 2; *Claude Monet*, Berlin, Galerie Thannhauser, 15 February–March 1928, no. 10; Paris 1931, no. 3; *French Art 1200–1900*, Royal Academy of Arts, Burlington House, January–March 1932, no. 465; Saint Louis and Minneapolis 1957, no. 12; New York 1969, no. 2; Chicago 1975, no. 21; New York 1976, no. 3; Paris and New York 1994–95, no. 139.

REFERENCES
C. Mauclair, *Claude Monet*, Paris-London, 1927, p. 61, pl. 11; Rewald, 1961, p. 179 (illus.); G. Poulain, *Bazille et ses amis*, Paris, 1932, p. 70; Champa, 1973, pp. 14–15, 46, fig. 18; Wildenstein, 1974, I, no. 81, pp. 156, 157, 426 (ltr. 45), 444 (P.J. no. 13), and 1991, V, p. 22; W81.

3 Monet
The Magpie
La Pie
1869
Oil on canvas, 35 x 51 in. (89 x 130 cm)
Signed lower right: *Claude Monet*
Musée d'Orsay, Paris
Washington only

PROVENANCE
Axel Carlander, Göteborg, 1918 (*Le Verger*); Thor Carlander; Galerie Durand-Ruel, Paris, 1941; Société Guerlain, Paris, 1946; acquired in 1984 by the Musée d'Orsay, Paris (R.F. 1984-164).

EXHIBITIONS
Fransk Konst, Christiania, Stockholm, Nationalmuseum, Göteborg, Kunstmuseum, 1918; *Claude Monet*, Zurich, Kunsthaus, 10 May–15 June 1952, no. 19, Paris, Galerie des Beaux-Arts, 19 June–17 July 1952, no. 14, The Hague, 1952, no. 16; *Chefs-d'œuvre du XIXe siècle français*, Rome, Palazzo delle Esposizioni, February–March 1955, no. 76; Edinburgh and London 1957, no. 18; *Claude Monet*, Paris, Galerie Durand-Ruel, 22 May–30 September 1959, no. 7 (*Environs de Honfleur, Effet de neige*, 1870); *Claude Monet*, Paris, Galerie Durand-Ruel, 24 January–28 February 1970, no. 5; Paris 1980, no. 22; *Anciens et Nouveaux: Choix d'œuvres acquises par l'Etat ou avec sa participation de 1981 à 1985*, Paris, Grand Palais, 5 November 1985–3 February 1986, no. 131; *De Manet à Matisse: Sept ans d'enrichissement*, Paris, Musée d'Orsay, 12 November 1990–10 March 1991, unnumbered entry, p. 71 (illus.); Paris and New York 1994–95, no. 144; Chicago 1995, no. 17.

REFERENCES
Seitz, 1960, pp. 76, 77 (illus.); Wildenstein, 1974, I, no. 133, pp. 178, 179, 425–426 (ltr. 44), and 1991, V, p. 23; Isaacson, 1978, pp. 17, 70 (illus.), 200; Gordon and Forge, 1983, pp. 39 (illus.), 40; Stuckey, 1985, pp. 40, 49 (illus.); J.-P. Crespelle, *Monet*, Paris, 1986, pp. 60, 61 (illus.); House, 1986, pp. 136, 245, pl. 168; Rosenblum, 1989, p. 236 (illus.); Compin et al., 1990, vol. 2, p. 337 (illus.); Spate, 1992, pp. 56, 59, 62 (illus.), 67, 213; Alphant, 1993, pp. 171, 178, 179 (illus.), 183, 311; M. Kimmelman, 'Eclectic Monet Bathed in Chicago's Ballyhoo,' *The New York Times* (24 July 1995), pp. C9–C11 (illus.); Tucker, 1995, pp. 40, 41 (illus.); W133; Koja, 1996, p. 23 (illus.).

4 Monet
The Red Cape
La Capeline rouge
1869–70 or 1871
Oil on canvas, 39 x 31½ in. (99 x 79.8 cm)
Signed lower right: *Claude Monet*
The Cleveland Museum of Art, Bequest of Leonard C. Hanna, Jr., 1958.39

PROVENANCE
Michel Monet, Giverny; Edward Molyneux, Paris. c. 1939; Carroll Carstairs, New York; Leonard C. Hanna Jr., Cleveland, 1948; bequeathed in 1958 to The Cleveland Museum of Art, Cleveland, Ohio (58–39).

EXHIBITIONS
Paris 1931, no. 6; *Claude Monet de 1865 à 1888*, Paris, Galerie Durand-Ruel, November–December 1935, no. 16; *Five Centuries of History Mirrored in Five Centuries of French Art*, New York, World's Fair, 1939, no. 360; New York 1945, no. 26; New York and Los Angeles 1960, no. 13; Chicago 1975, no. 26; Paris 1980, no. 25; Chicago 1995, no. 25.

REFERENCES
Dewhurst, 1904, p. 36 (illus.); Geffroy, 1922, p. 140,

pl. 24; Reuterswärd, 1948, pp. 51 (illus.), 279; Seitz, 1960, pp. 20, 22 (illus.); Rewald, 1961, p. 251 (illus.); J. Isaacson, *Monet: Le Déjeuner sur l'herbe*, New York, 1972, fig. 1; Y. Inoue and S. Takashima, *Monet et L'Impressionisme*, Paris, 1972, pl. 33; Champa, 1973, pp. 28–29, 31, fig. 40; *Handbook of the Cleveland Museum of Art*, Cleveland, 1973, p. 216 (illus.); Wildenstein, 1974, I, no. 257, pp. 222, 223; J. House, *Monet*, New York, 1977, no. 18; J. House 'The New Monet Catalogue,' *The Burlington Magazine*, CXX, no. 907 (October 1978), p. 680; Stuckey, 1985, pp. 75 (illus.), 310; Tucker, 1995, pp. 66, 67 (illus.); W257.

5 Monet

Road at Louveciennes—Snow Effect
Route à Louveciennes, effet de neige
1869–70
Oil on canvas, 22 x 25¾ in. (55.8 x 65.4 cm)
Signed lower left: *Claude Monet*
Private collection, Chicago, Illinois
Washington only

PROVENANCE

(?) Purchased from Monet by Michael Lévy, 1873 (*Effet de neige, Louveciennes*); Berend, Paris; Galerie Durand-Ruel, Paris and New York 1912, until 1930; sold to M. Knoedler & Co., New York, January 1930, until 1941; Mrs. Richard N. Ryan, New York, September 1941, until 1986; sale, Parke Bernet, New York, 9 October 1968, no. 2; E. V. Thaw & Co., New York, until 1971.

EXHIBITIONS

Monet, New York, Galerie Durand-Ruel, 1–16 February 1914, no. 6; *Tableaux Durand-Ruel*, Chicago, Auditorium Hotel, February 1915; *Tableaux Durand-Ruel*, Boston, Brooks Reed Gallery, October–November 1915; *Monet*, New York, Durand-Ruel Gallery, 9–23 December 1916, no. 1; *Tableaux Durand-Ruel*, Boston, Brooks Reed Gallery, March 1917; *Paintings by Modern French Masters*, Worcester, Art Museum, 2–30 December 1917, no. 6; New York, Century Club, March 1921; *Tableaux Durand-Ruel*, Saint Louis, Noonan-Kocian Art Gallery, June–July 1925; Philadelphia, McClees Gallery, March–April 1926; *Monet Memorial Exhibition*, Baltimore, Baltimore Museum of Art, September–October 1927, unnumbered entry; *Claude Monet Retrospective*, New York, Durand-Ruel Gallery, 8–29 January 1927, no. 4; *Memorial Exhibition of the Works of Claude Monet*, Philadelphia, The Art Club, 4–23 April 1927, no. 24; Saint Louis and Minneapolis 1957, no. 23; New York and Los Angeles 1960, no. 16; Chicago 1975, no. 23; Los Angeles, Chicago, Paris 1984–85, no. 15; Paris and New York 1994–95, no. 149.

REFERENCES

G. Geffroy, 'Claude Monet,' *L'Art et les artistes*, no. 11 (1920), p. 67 (illus.); A. Alexandre, *Claude Monet*,

Paris, 1921, pl. 21; L. Werth, *Claude Monet*, Paris, 1928, pl. 16; Reuterswärd, 1948, p. 84 (illus.); Rewald, 1961, p. 212 (illus.); Wildenstein, 1974, I, no. 147, pp. 184, 185, and 1991, V, p. 24; J. House, *Monet*, New York, 1977, no. 7; Isaacson, 1978, p. 76 (illus.), 201; Gordon and Forge, 1983, pp. 130 (illus.), 131, 133, 136; Pissarro, 1993, pp. 16, 62 (illus.); W147.

6 Monet

Road to Louveciennes, Melting Snow, Sunset
Route à Louveciennes, neige fondante, soleil couchant
1869–70
Oil on canvas, 16 x 21 in. (40 x 54 cm)
Signed lower right: *Claude Monet*
Collection of Mr. and Mrs. Herbert L. Lucas
San Francisco only

PROVENANCE

Purchased from Monet by Michael Lévy, 1873 (*Effet de neige, Louveciennes*); B. Mancini, Paris; Boussod, Valadon & Cie., Paris, 1888; Gustave Goupy, Paris, 1888; sale, collection of G. Goupy, Hôtel Drouot, Paris, 30 March 1898, no. 27 (Georges Petit); private collection, France.

EXHIBITIONS

Monet-Rodin, Paris, Galerie Georges Petit, June–July 1889, no. 8; *From Monet to Matisse: French Art in Southern California Collections*, Los Angeles, County Museum of Art, 9 June–11 August 1991, unnumbered entry, p. 50 (illus.).

REFERENCES

J. A., 'Beaux Arts, Exposition à la galerie Georges Petit,' *Art et critique* (29 June 1889), p. 76; Wildenstein, 1974, I, no. 148, and 1991, V, p. 24; Gordon and Forge, 1983, p. 128 (illus.); W148.

7 Monet

Thaw in Argenteuil
Le Dégel
1873
Oil on canvas, 21 x 28½ in. (55 x 73 cm)
Signed lower right: *Claude Monet*
Senator and Mrs. John D. Rockefeller IV

PROVENANCE

Purchased from Monet, February 1873, by Durand-Ruel; Boussod, Valadon & Cie., Paris, 1888; Jean-Baptiste Faure, Paris, 1894; Galerie Durand-Ruel, Paris, 1907; Miethke, Vienna, 1910; Baron Kohner, Budapest, c. 1911; Galerie Durand-Ruel, Paris, c. 1945; sale, Sotheby's, London, 29 April 1964, no. 31; Arthur Tooth & Sons Ltd., London.

EXHIBITIONS

Exposition des œuvres de Cl. Monet, Paris, Galerie Durand-Ruel, 1–25 March 1883, no. 36; *Dix Marines d'Antibes de M. Cl. Monet*, Paris, Boussod, Valadon & Cie., June–July 1888, unnumbered entry; *Monet*,

London, Goupil & Cie., April–May 1889, no. XIV; *Dix-sept tableaux de Cl. Monet de la collection Faure*, Paris, Galerie Durand-Ruel, 19–31 March 1906, no. 8; *Monet-Manet, collection Faure*, Berlin, Galerie Paul Cassirer, September–October 1906, Stuttgart, December 1906, Munich, January 1907, no. 27; (?) *XI. Jahrgang. VI. Ausstellung*, Berlin, Galerie Paul Cassirer, Winter 1909, no. 4; *Monet–Manet*, Vienna, Miethke, May 1910, no. 16; *Cl. Monet*, London, Arthur Tooth & Sons Ltd., 13 April–6 May 1939, no. 10; New York 1945, no. 18.

REFERENCES

Ch. Bertall, 'Exposition des Impressionists rue Le Pelletier,' *Le Soir* (15 April 1876) p. 3; Eaque [P. Robert], 'Claude Monet,' *Le Journal des Arts* (6 July 1888), p. 3; H. Haberfeld, 'Die französischen Bilder der Sammlung Kohner,' *Der Cicerone* (1 August 1911), p. 579 (illus.); F. Fels, 'Claude Monet–Portrait,' *Nouvelle Revue Française-Français Nouveaux*, no. 22 (1925), p. 37 (illus.); Wildenstein, 1974, I, no. 255, pp. 222, 223; Tucker, 1982, pp. 38, 39 (illus.), 40; W255.

8 Monet

Boulevard des Capucines
Le Boulevard des Capucines
1873–74
Oil on canvas, 31⅝ x 23¾ in. (80.4 x 60.3 cm)
Signed lower right: *Claude Monet*
The Nelson-Atkins Museum of Art, Kansas City, Missouri (Purchase: The Kenneth A. and Helen F. Spencer Foundation Acquisition Fund)

PROVENANCE

Purchased from Monet by the painter Ch. Meixmron de Dombasle, Nancy, 1875 (one of five canvases); Madame Meixmoron de Dombasle, Dienay; Galerie Bernheim-Jeune, Paris, 1919; Alex. Reid, London, 1919; E.R. Workman, London, c. 1924; Mr. and Mrs. Marshall Field III, New York, c. 1945; purchased from Mrs. Marshall Field IV, 1972, through the Spencer Foundation Acquisition Fund by The Nelson-Atkins Museum of Art, Kansas City, Missouri (F. 72–35).

EXHIBITIONS

Première Exposition de Peinture du Société Anonyme, Paris, 35, boulevard des Capucines, 15 April–15 May 1874, no. 97; *Peintres de l'école française du XIXe siècle*, Paris, M. Knoedler & Co., 1924, no. 42 (*Les Grands Boulevards*); New York 1945, no. 17; *Great French Paintings*, Chicago, The Art Institute, January– February 1955, no. 26; *Four Masters of Impressionism*, New York, Acquavella Galleries, 24 October–30 November 1968, no. 10; *Centenaire de l'Impressionisme*, Paris, Grand Palais, 21 September –24 November 1974, no. 30; Chicago 1975, no. 36; Washington and San Francisco 1986, no. 7; Tokyo, Nagoya, Hiroshima 1994, no. 19; Chicago 1995, no. 39.

REFERENCES

Ch. Cournault, 'Le Salon de Nancy,' *L'Art* 21 (1880), p. 309; M. Elder, *A Giverny chez Claude Monet*, Paris, 1924, pl. 17; Reuterswärd, 1948, pp. 70, 71 (illus.), 281; Seitz, 1960 (illus. frontispiece), p. 92; Rewald, 1961, p. 321 (illus.); Wildenstein, 1974, I, no. 293, pp. 240, 241; M. and G. Blunden, *Impressionists and Impressionism*, Geneva, 1980, pp. 136 (illus.), 137; Tucker, 1982, pp. 163, 172 (illus.); Gordon and Forge, 1983, pp. 68–69, 70, 72 (illus.); P. H. Tucker, 'The First Impressionist Exhibition and Monet's *Impression: Sunrise*: A Tale of Timing, Commerce, and Patriotism,' *Art History* 7 (December 1984), pp. 469–70; Rewald and Weitzenhoffer, 1984, p. 109 (illus.); J. Rewald, *Studies in Impressionism*, New York, 1986, pl. V (illus.); Alphant, 1993, pp. 282, 288, 289, 468; M. Gerstein, *Impressionism: Selections from Five American Museums*, New York, 1993, no. 49; K. Varnedoe et al., 1995, pp. 142, 143 (illus.); W293; Koja, 1996, pl. V, pp. 27, 29 (illus.).

9 Monet

Snow at Argenteuil
Neige à Argenteuil
c. 1874
Oil on canvas, 21½ x 29 in. (54.6 x 73.8 cm)
Signed lower left: *Claude Monet*
Museum of Fine Arts, Boston, Bequest of Anna Perkins Rogers

PROVENANCE

Purchased from Monet by Durand-Ruel, c. 1876 and sold to Anna Perkins Rogers, Boston, June 1890; donated in 1921 to the Museum of Fine Arts, Boston, Massachusetts (21.1329).

EXHIBITIONS

(?) *4e exposition de peinture*, Paris, 28 avenue de l'Opéra, 10 April–11 May 1879, no. 159 (lent by Galerie Durand-Ruel); Boston 1892, no. 19; *Monet*, Boston, Saint Botolph Club, 6–29 February 1899, no. 6; *Old Masters*, Boston, Copley Hall, 1903, no. 8; Boston 1905, no. 6; *Monet*, Boston, Museum of Fine Arts, August 1911, no. 38; Boston 1927, no. 3; *Golden Gate International Exhibition*, San Francisco, Palace of Fine Arts, 1940, no. 286; *Loan Exhibition of Paintings and Prints since 1860,* Wellesley, Wellesley College Art Museum, 8–25 May 1947, unnumbered entry; Boston, Symphony Hall, 1949; Boston, Lincoln House; Edinburgh and London 1957, no. 41; New York 1976, no. 22; *Monet Unveiled: A New Look at Boston's Paintings*, 22 November 1977–29 January 1978, no. 6; *Monet in Massachusetts*, Williamstown, Sterling and Francine Clark Art Institute, 8 June–6 October 1985, unnumbered entry; *Monet and his Contemporaries: Masterpieces from the Museum of Fine Arts Boston*, Tokyo, Bunkamura Museum, 17 October 1992–17 January 1993, Kobe, The Hyogo Prefectural Museum of Modern Art, 23 January–21 March 1993, no. 22; Chicago 1995, no. 43.

REFERENCES

Reuterswärd, 1948, p. 282; Seitz, 1960, pp. 29, 100, 101 (illus.); Wildenstein, 1974, I, no. 348, pp. 262, 263, and 1991, V, p. 29; Tucker, 1982, pp. 48 (illus.), 49; Gordon and Forge, 1983, pp. 64 (illus.), 65, 84; Stuckey, 1985, pp. 58 (illus.), 104; House, 1986, p. 167, pl. 203; W348.

10 Monet

View of Argenteuil—Snow
Vue d'Argenteuil, neige
c. 1874
Oil on canvas, 21½ x 25⅝ in. (54.6 x 65.1 cm)
Signed lower left: *Claude Monet*
The Nelson-Atkins Museum of Art, Kansas City, Missouri (Gift of the Laura Nelson Kirkwood Residual Trust)

PROVENANCE

(?) Purchased from Monet by Durand-Ruel, c. 1876; Galerie Durand-Ruel, c. 1891; sold to William Rockhill Nelson, 1896; Laura Kirkwood, née Nelson; Gift of the Laura Nelson Kirkwood Residual Trust, to The Nelson-Atkins Museum of Art, Kansas City, Missouri (44.41/3).

EXHIBITIONS

The Hague, Cercle artistique, September–November 1893; *36e exposition des Beaux-Arts*, Ghent, Musée de Ghent, 1 September–28 October 1895; *Claude Monet*, Liège, Salle Saint Georges, 13 March–10 May 1992, no. 5.

REFERENCES

Wildenstein, 1974, I, no. 358, pp. 266, 267, and 1991, V, p. 29; Isaacson, 1978, pp. 97 (illus.), 207; W358.

11 Monet

Boulevard Saint-Denis, Argenteuil, in Winter
Effet de neige, Argenteuil (boulevard Saint-Denis)
1875
Oil on canvas, 24 x 32⅛ in. (60.9 x 81.5 cm)
Signed and dated lower right: *Claude Monet 75*
Museum of Fine Arts, Boston, Gift of Richard Saltonstall

PROVENANCE

Purchased from Henri Kapferer, Paris, by Durand-Ruel, 17 July 1888; sold to G. Foxcroft Cole for Peter C. Brooks, Boston, 25 September 1890; Mr. and Mrs. Richard M. Saltonstall, Boston, c. 1927 by inheritance; R. Saltonstall, Boston; donated in 1978 to the Museum of Fine Arts, Boston, Gift of Richard Saltonstall (1978.633).

EXHIBITIONS

Boston 1892, no. 3; Boston 1927, no. 62; *European and American Impressionism: Crosscurrents*, Boston, Museum of Fine Arts, 19 February–17 May 1992, no catalogue; *Monet and his Contemporaries: Masterpieces from the Museum of Fine Arts, Boston*, Tokyo, Bunkamara Museum, 17 October 1992–17 January 1993, Kobe, The Hygo Prefectural Museum of Modern Art, 23 January–21 March 1993, no. 24; London and Boston 1995–96, no. 78.

REFERENCES

Tucker, 1982, pp. 52, 54 (illus.); Stuckey, 1985, p. 81 (illus.); Wildenstein, 1991, V, pp. 6, 7, no. 1998; W357a.

12 Monet

Train in the Snow at Argenteuil
Train dans la neige à Argenteuil
1875
Oil on canvas, 23⅝ x 32 in. (60 x 81.3 cm)
Signed lower center-left: *Claude Monet*
Mr. and Mrs. Stephen A. Schwarzman
Washington only

PROVENANCE

Alexander J. Cassatt, Philadelphia, c. 1893; Plunkett Stewart, Wynnwood (PA) (by descent); Mrs. William Potter Wear, Philadelphia (by descent); Richard L. Feigen & Co., New York; Mr. and Mrs. Herbert Klapper; sale, Christie's, New York, 13 November 1996, no. 25.

EXHIBITIONS

World's Columbian Exposition, Chicago, 1 May–30 October 1893, no. 3021; *Artists of the Modern French School*, Philadelphia, Pennsylvania Academy of Art, 1920, no. 92; St. Louis and Minneapolis 1957, no. 22; *The Discerning Eye: Radcliffe Collectors Exhibition*, Cambridge, Fogg Art Museum, 9 October–24 November 1974, no. 70; Chicago 1995, no. 44.

REFERENCES

M. de Fels, *La vie de Claude Monet*, Paris, 1929, p. 236; Wildenstein, 1974, I, no. 360, pp. 268, 269; T.J. Clark, *The Painting of Modern Life: Paris in the Art of Manet and His Followers*, London, 1984, p. 190, pl. XVI (illus.); W360.

13 Monet

Lavacourt in Winter
Lavacourt, l'hiver
1879
Oil on canvas, 20 x 26 in. (50.8 x 66 cm)
Signed lower left: *Claude Monet*
Private collection

PROVENANCE

Purchased from Monet by Vayson, January 1879; Boussod, Valadon & Cie., Paris, 1890; Cyrus J. Lawrence, New York, 1891; sale, collection of C.J.

Lawrence, New York, The American Art Association, 21–22 January 1910, no. 67; Mr. and Mrs. Cooper Schieffelin, New York; sale, The Estate of Frances Schieffelin, Christie's, New York, 12 May 1987, no. 34.

EXHIBITIONS
Unknown.

REFERENCES
Wildenstein, 1974, I, no. 514, pp. 336, 337, and 1991, V, p. 33; W514.

14 Monet
Road to Vétheuil, Snow Effect
La Route de Vétheuil, effet de neige
1879
Oil on canvas, 24 x 32⅛ in. (60.9 x 81.6 cm)
Signed and dated lower left: *Claude Monet 79*
Museum of Fine Arts, St. Petersburg, Florida, extended anonymous loan
Washington only

PROVENANCE
Purchased from Monet by Luquet, April 1880 (*La Route de La Roche, effet de neige*); (?) sale, Hôtel Drouot, Paris, 14 December 1882, no. 47 (Curel for Durand-Ruel); Galerie Durand-Ruel, c. 1890; Miss E.H. Henderson, New Orleans, 1913; private collection.

EXHIBITIONS
(?) *7e exposition des artistes indépendants*, Paris, 251, rue Saint-Honoré, March 1882, no. 68 or 72; Hamburg, 14 March–30 April 1895; *Monet and Renoir*, New York, Durand-Ruel Gallery, April 1900, no. 8; *Monet*, New York, Durand-Ruel Gallery, 11–25 February 1902, no. 6; *Opening Season 1905–1906*, Toledo (OH), Museum of Art, 1905–1906, no. 44; *Monet*, New York, Durand-Ruel Gallery, 26 January–14 February 1907, no. 12; *Paintings by the French Impressionists*, Buffalo, The Albright-Knox Art Gallery, 31 October–8 December 1907, no. 54; *International Exhibition of Modern Art*, New York, Armory of the 69th Regiment, 15 February–15 March 1913, Chicago, The Art Institute, 24 March–16 April 1913, Boston, Copley Hall, 28 April–14 May 1913, no. 495; *Early Masters of Modern Art*, New Orleans, Isaac Delgado Museum of Art, November–December 1959, no. 30 (*Effet de neige, Giverny*); *A Celebrated New Orleans Collection*, New York, M. Knoedler & Co., 9 May–30 June 1961, no. 30; *The Armory Show 50th Anniversary Exhibition*, Utica (NY), Munson-Williams Proctor Institute, 17 February–31 March 1963, New York, Armory of the 69th Regiment, 6–28 April 1963, no. 198; *New Orleans Collects: Early Masters of Modern Art*, New Orleans, Isaac Delgado Museum of Art, 2 November–15 December 1968, no. 25; *Claude Monet*, Vienna, Österreichische Galerie im Belvedere, 14 March–16 June 1996, no. 30.

REFERENCES
Geffroy, 1922, p. 145 (illus.); W. Seitz, 'Five Paintings by Monet,' *Pharos* 11, nos. 3, 4 (December 1973), pp. 50–57, p. 52 (illus.); Wildenstein, 1974, I, no. 508, pp. 334, 335, and 1991, V, p. 33; W508.

15 Monet
Road into Vétheuil in Winter
La Route à Vétheuil, l'hiver
1879
Oil on canvas, 20½ x 28 in. (52.5 x 71.5 cm)
Signed lower left: *Claude Monet*
Göteborg Museum of Art, Göteborg, Sweden

PROVENANCE
(?) Purchased from Monet by Petit, Bernheim & Montaignac, December 1899; Ballaciano; Bernheim-Jeune & Cie., Paris, 1904; Galerie Paul Cassirer, Berlin, 1905; Bernheim-Jeune & Cie., Paris, 1910; Galerie Durand-Ruel, Paris, 1910; Galerie Paul Rosenberg, Paris, 1912; donated in 1923 by the director, Gustaf Werner, to the Göteborg Konstmuseum, Göteborg, Sweden (736).

EXHIBITIONS
Claude Monet, Madrid, Museo español de Arte Contemporaneo, 29 April–30 June 1986, no. 24; *Claude Monet*, Liège, Salle Saint Georges, 13 March–10 May 1992, no. 8; *Claude Monet*, Göteborg, Göteborg Museum of Art, 11 October 1997–6 January 1998.

REFERENCES
Reuterswärd, 1948, pp. 118 (illus.), 283; Seitz, 1960, pp. 29, 32 (illus.); Wildenstein, 1974, I, no. 510, pp. 334, 335, and 1991, V, p. 33; W510.

16 Monet
Winter on the Seine, Lavacourt
Hiver sur la Seine, Lavacourt
1879–80
Oil on canvas, 23½ x 39¼ in. (60 x 100 cm)
Signed lower right: *Claude Monet*
Private collection

PROVENANCE
(?) Purchased from Monet by Isaac Montaignac, Paris, May 1899; sold to Bernheim-Jeune & Cie., Paris, December 1899; Bernheim-Jeune & Cie., Paris, 1919; sale, Drouot-Montaigne, Paris, 15 June 1990, no. 36 (withdrawn); sale, Sotheby's, London, 27 November 1995, no. 6.

EXHIBITIONS
XVIII Biennale Internazionale d'Arte, Mostra individuale retrospettiva Claude Monet, Venice, March 1932, no. 12.

REFERENCES
G. Bernheim-Jeune, *L'Art moderne et quelques aspects de l'art d'autrefois*, II, Paris, 1919, pl. 88; Wildenstein, 1974, I, no. 558, pp. 356, 357, and 1991, V, p. 34; Alphant, 1993, p. 312; W558.

17 Monet
Winter Sun, Lavacourt
Soleil d'hiver, Lavacourt
1879–80
Oil on canvas, 21½ x 31⅞ in. (55 x 81 cm)
Signed lower right : *Claude Monet*
Le Havre, Musée des Beaux-Arts André Malraux

PROVENANCE
Portier, Paris; Eugène Blot, Paris, c. 1885; sale, collection of E. Blot, Hôtel Drouot, Paris, 9–10 May 1900, no. 114; Baron Blanquet de Fulde, Paris; sale, collection of Baron Blanquet de Fulde, Hôtel Drouot, Paris, 27 May 1905, no. 39; Charles-Auguste Marande, Le Havre; bequest of C.-A. Marande to the Musée des Beaux-Arts André Malraux, Le Havre, 1936.

EXHIBITIONS
De Corot à nos jours au Musée du Havre, Paris, Musée nationale d'Art Moderne, December 1953–January 1954, no. 79; *Impressionistes et Précurseurs*, Brive, Musée de Brive, 1 June–15 July 1955, La Rochelle, Musée de La Rochelle, August 1955, Angoulême, September 1955, Rennes, October–November 1955, no. 20; *La Neige et les Peintres*, Annecy, Palais de l'Isle, Summer 1957, no. 32; *La découverte de la lumière des Primitifs aux Impressionistes*, Bordeaux, Galerie des Beaux-Arts, 20 May–31 July 1959, no. 249; *Peintures impressionistes des musées français*, Leningrad, The Hermitage Museum, Moscow, Pushkin Museum, 1970–71, no. 60; *Los Impressionistas franceses*, Madrid, Museo español de Arte contemporaneo, 1971, no. 49; *1874: Naissance de l'Impressionisme*, Bordeaux, Galerie des Beaux-Arts, 3 May–1 September 1974, no. 105; *Exposition impressioniste*, Seoul, Musée national, 1976; Paris 1980, no. 75.

REFERENCES
R. Arnould, *Collections du Musée des Beaux-Arts de la Ville du Havre, Peinture, Ecole Française de la fin du XIXe siècle à 1952*, Paris, 1957, p. 44; Vergnet, Ruiz, Laclotte, *Petits et grands musées de France*, Paris, 1962, p. 245; Wildenstein, 1974, I, no. 557, pp. 356, 357 (illus.); W557.

18 Monet
The Breakup of the Ice at Lavacourt
La Débâcle à Lavacourt
1880
Oil on canvas, 18 x 32 in. (46 x 81.5 cm)
Signed and dated lower left: *Claude Monet 80*
Private collection

PROVENANCE
Alex. Reid and Lefevre, London; Mr. J.C.W. Sawbridge Erle-Drax, Great Britain, 1933.

EXHIBITIONS

Edinburgh and London 1957, no. 56; New York and Los Angeles 1960, no. 25.

REFERENCES

Wildenstein, 1974, I, no. 563, pp. 358, 359; W563.

19 Monet

The Breakup of the Ice
La Débâcle
1880
Oil on canvas, 23¾ x 39⅜ in. (60.3 x 99.9 cm)
Signed and dated lower right: *Claude Monet 80*
University of Michigan Museum of Art, Acquired through the generosity of Mr. Russell B. Stearns (LSA 1916) and his wife, Andrée B. Stearns, Dedham, Massachusetts
Washington only

PROVENANCE

(?) Purchased from Monet by Durand-Ruel in February or May 1881; William H. Fuller, New York, c. 1891; sale, collection of W. H. Fuller, The American Art Association, New York, 12–13 March 1903, no. 147; Durand-Ruel Gallery, New York; Arthur B. Emmons, Newport (RI), 1907; sale, collection of A. B. Emmons, Plaza Hotel, New York, 14–15 January 1920, no. 26; acquired by Durand-Ruel Gallery for the Museum of Fine Arts, Boston (20.163); Sam Salz, New York; M. Knoedler & Co., New York; sale, Parke Bernet, New York, 31 October 1962, no. 20; Mr. and Mrs. Arnold S. Askin, United States, c. 1968; acquired in 1976 from Mr. and Mrs. Russell B. Stearns by The University of Michigan Museum of Art, Ann Arbor, Michigan (1976/2.134).

EXHIBITIONS

Monet, New York, Union League Club, February 1891, no. 53; (?) *Monet*, New York, The Lotos Club, January 1899, no. 15; Boston 1927, no. 5; New York 1976, no. 35.

REFERENCES

P.H. 'L'exposition de Monet,' in *L'Art dans les Deux Mondes* (28 February 1891), p. 173; 'W.H. Fuller's Monet Sold,' *The Sun* (14 March 1903); 'Une vente française à New York,' *Bulletin de la vie artistique* (1 December 1919), p. 15 (illus.); P. Forthuny, 'Des prix considérables,' *Bulletin de la vie artistique* (15 February 1920), p. 179; *Bulletin of the Museum of Fine Arts*, Boston (February 1920), p. 10 (illus.); *Museum of Fine Arts: Catalogue of Paintings*, Boston, 1921, p. 130, no. 359; Reuterswärd, 1948, p. 282; Wildenstein, 1974, I, no. 565, pp. 358, 359, and 1991, V, p. 34; W565.

20 Monet

The Breakup of the Ice
La Débâcle
1880–81
Oil on canvas, 24 x 39⅜ in. (61 x 100 cm)
Signed and dated lower right: *1881 Claude Monet*
Private collection

PROVENANCE

Wohler, Switzerland; Wildenstein & Co., New York; Mr. and Mrs. H. Leslie Hoffman, United States, 1959; Hoffman Foundation; sale, Sotheby's, New York, 11 May 1993, no. 25.

EXHIBITIONS

Unknown.

REFERENCES

Wildenstein, 1974, I, no. 570, pp. 113 (color pl.), 360, 361; W570.

21 Monet

Sunset on the Seine in Winter
Coucher de soleil sur la Seine, l'hiver
1880
Oil on canvas, 23½ x 31½ in. (60 x 80 cm)
Signed and dated lower left: *Claude Monet 80*
Private collection, Japan

PROVENANCE

Desmond Fitzgerald, Boston, c. 1892; sale, collection of D. Fitzgerald, The American Art Association, New York, 21–22 April 1927, no. 91; Mrs. Edwin S. Webster, Boston, c. 1957; Stein, United States, c. 1972; Acquavella Galleries, New York.

EXHIBITIONS

Monet-Rodin, Paris, Georges Petit, June–July 1889, no. 45; Boston 1892, no. 17; *Monet*, Boston, St. Botolph Club, 6–9 February 1899, no. 22; Boston 1905, no. 25; *Monet*, Boston, Museum of Fine Arts, August 1911, no. 4; Saint Louis and Minneapolis 1957, no. 39; New York 1976, no. 36; Tokyo, Nagoya, Hiroshima 1994, no. 31; Chicago 1995, no. 57.

REFERENCES

Wildenstein, 1974, I, no. 574, pp. 362, 363; Spate, 1992, p. 145 (illus.); W574.

22 Monet

Frost
Le Givre
1885
Oil on canvas, 23½ x 31⅝ in. (60 x 80 cm)
Signed lower left: *Claude Monet*
Private collection, Dallas, Texas
Washington only

PROVENANCE

Michel Monet, Giverny; Jean-Pierre Hoschedé,

Giverny; Giraudon, Lyon, 1963; Wildenstein & Co.

EXHIBITIONS

(?) *Centenaire de Claude Monet*, Paris, Galerie André Weil, 30 January–21 February 1940, no. 17; *Claude Monet*, Zurich, Kunsthaus, 10 May–15 June 1952, no. 97, The Hague 1952, no. 75; *Impressionist and Modern Masters in Dallas, Monet to Mondrian*, Dallas, Museum of Art, 3 September–22 October 1989, no. 67; *Monet: A Turning Point*, Dallas, Museum of Art, 29 March–17 May 1998, no catalogue.

REFERENCES

Wildenstein, 1979, II, pp. 37, 152, 153, no. 964; Tucker, 1995, p. 122 (illus.); W964.

23 Monet

Stack of Wheat (Snow Effect, Overcast Day)
Meule, effet de neige, temps couvert
1891
Oil on canvas, 30 x 36½ in. (66 x 93 cm)
Signed and dated lower right: *Monet 91*
The Art Institute of Chicago, Mr. and Mrs. Martin A. Ryerson Collection, 1933.1155
Washington only

PROVENANCE

Purchased from Monet by Durand-Ruel, May 1891; Martin A. Ryerson, Chicago, 1893; bequeathed in 1933 to The Art Institute of Chicago, Mr. and Mrs. Martin A. Ryerson Collection, Chicago, Illinois (1933.1155).

EXHIBITIONS

Paris 1891, no. 9; *Inaugural Exhibition*, Minneapolis Institute of Arts, 7 January–7 February 1915, no. 255; *A Century of Progress: Exhibition of Paintings and Sculpture*, Chicago, The Art Institute, 1 June–1 November 1934, no. 218; *Masterpieces of European and American Art*, Decatur (IL), Art Center, March 1945, Springfield (IL), April–May 1945, no. 12; Chicago, Remington Rand, April 1952; University of Chicago, November–December 1952; *Claude Monet*, Chicago, The Art Institute, 1–30 April 1957; Chicago 1975, no. 86; Los Angeles, Chicago, Paris 1984–85, no. 111; Tokyo, Fukuoka, Kyoto 1985–86, no. 57; *Ot Delakrua do Matissa*, Leningrad, The Hermitage Museum, 15 March–16 May 1988, Moscow, Pushkin Museum of Fine Arts, 30 May–30 July 1988, no. 30; Boston, Chicago, London 1990, no. 25; Chicago 1995, no. 99.

REFERENCES

Geffroy, 1922, p. 189; M.C., 'Monets in the Art Institute,' *Bulletin of The Art Institute of Chicago* (February 1925), p. 20; G. Slocombe, 'Giver of Light,' *Coronet*, 3, no. 5 (March 1938), pp. 19–28, p. 23 (illus.); Reuterswärd, 1948, p. 286; *Paintings at the Art Institute*, 1960, p. 230; P. Marandel, 'Monet in Chicago,' *The Art Gallery Magazine*, XVII, no. 6

(March 1975), pp. 47–50; Wildenstein, 1979, III, no. 1281, pp. 142, 143; Gordon and Forge, 1983, p. 160 (illus.); Brettell, 1984, p. 6, pl. 5, fig. 9; J. House, *Claude Monet: Painter of Light*, exh. cat. Auckland: City Art Gallery, 1985, p. 211, fig. 11; Stuckey, 1985, p. 163 (illus.); Moffett et al., 1986, pp. 64, 66 (illus.); W1281.

24 Monet
Stack of Wheat
La Meule
1891
Oil on canvas, 25½ x 36¼ in. (65.6 x 92 cm)
Signed and dated lower left: *Claude Monet 91*
The Art Institute of Chicago, Restricted gift of the Searle Family Trust; Major Acquisitions Centennial Endowment; through prior acquisitions of the Mr. and Mrs. Martin A. Ryerson and Potter Palmer Collections; through prior bequest of Jerome Friedman, 1983.29

PROVENANCE
(?) Bought from Monet by I. Montaignac, May 1899; sale, collection of Potter Palmer, Parke Bernet, New York, 16 March 1944, no. 46; The Art Insitute of Chicago, acquired in 1983 as a Restricted Gift of the Searle Family Trust, Major Acquisitions Centennial Endowment, through prior acquisitions of the Mr. and Mrs. Martin A. Ryerson and Potter Palmer collections; through prior bequest of Jerome Friedman (1983.92).

EXHIBITIONS
Los Angeles, Chicago, Paris 1984–85, no. 106; Tokyo, Fukuoka, Kyoto, 1985–86, no. 57; Boston, Chicago, London 1990, no. 27; Chicago 1995, no. 101.

REFERENCES
Wildenstein, 1979, III, no. 1283, pp. 142, 143, and 1991, V, p. 47; Gordon and Forge, 1983, p. 161 (illus.); 'French Paintings Acquired by the Art Institute of Chicago,' *The Burlington Magazine* (July 1984), pp. 463, 464 (illus.); Brettell, 1984, pp. 2, 6, fig. 11; Koja, 1996, p. 31 (illus.); W1283.

25 Monet
Grainstacks: Snow Effect
Meules, effet de gelée blanche
1891
Oil on canvas, 25½ x 35⅞ in. (65 x 91 cm)
Signed and dated lower left: *Claude Monet 91*
National Gallery of Scotland

PROVENANCE
Purchased from Monet by Boussod, Valadon & Cie., Paris, July 1891; sold to Jules Chavasse, Sète, 1898; Galerie Durand-Ruel, Paris, 1898; Sir A. Chester Beatty, Dublin, 1929; Arthur Tooth & Sons Ltd., London, 1960; Sir Alexander Maitland, Edinburgh,

1960; bequeathed in 1965 to the National Gallery of Scotland, Edinburgh (2283).

EXHIBITIONS
Paris 1891, no. 7; *Monet, Manet, Renoir, et Cézanne*, Weimar, March 1904, no. 11; *Pictures by Boudin, Manet, Pissarro, Cézanne, Monet, Renoir, Degas, Morisot, Sisley*, London, Grafton Galleries, January–February 1905, no. 153; *Modern French Paintings*, Manchester, Art Gallery, Winter 1907–1908, no. 81; *Claude Monet*, Paris, Galerie Durand-Ruel, 6–19 January 1927, no. 62; Edinburgh and London 1957, no. 92; *Claude Monet*, Madrid, Museo Español de Arte Contemporáneo, 29 April–30 June 1986, no. 68; Boston, Chicago, London 1990, no. 21; *Monet to Matisse*, Edinburgh, National Gallery of Scotland, 11 August–23 October 1994, no. 239.

REFERENCES
J. Rewald, ' Theo Van Gogh, Goupil and the Impressionists,' *Gazette des Beaux-Arts*, annexe I, (January–February 1973), p. 101; Wildenstein, 1979, III, no. 1277, pp. 140, 141; G. Seiberling, *Monet's Series*, Ph.D. diss., Yale University, New York and London, 1981, pp. 96, 358, fig. 11; Rewald and Weitzenhoffer, 1984, p. 149 (illus.); Stuckey, 1985, pp. 162, 165, 190 (illus.); House, 1986, pp. 191, 199, pl. 254; W1277.

26 Monet
Stacks of Wheat (Sunset, Snow Effect)
Meules, effet de neige, soleil couchant
1891
Oil on canvas, 25¾ x 39½ in. (65.3 x 100.4 cm)
Signed and dated lower right: *Claude Monet 91*
The Art Institute of Chicago, Mr. and Mrs. Potter Palmer Collection, 1922.431
Washington only

PROVENANCE
Bought from Monet by Durand-Ruel, July 1891; sold by Durand-Ruel to Potter Palmer, Chicago, 8 July 1891, no. 848; bequeathed to The Art Institute of Chicago, 1922 (1922.431).

EXHIBITIONS
Paris 1891, no. 13; Boston 1905, no. 84; *Paintings from the Collection of Mrs. Potter Palmer*, Chicago, The Art Institute, August 1910, no. 36; *Picture of the Month* (organized by the American Confederation of Arts) Poughkeepsie, Vassar College, November 1954, La Jolla, Art Center, December 1954, Charleston, Gibbes Art Gallery, January 1955, Columbus (GA), Museum of Arts and Crafts, February 1955, Seattle, Charles and Emma Frye Free Public Art Museum, March 1955, Louisville, The J.B. Speed Art Museum, April 1955, Berea (KY), Berea College Art Department, May 1955, no. 4 (illus.); *Claude Monet*, Chicago, The Art Institute, 1–30 April 1957; New York and Los Angeles 1960, no. 52; *Color and Field:*

Abstract Painting in the Sixties and its Backgrounds, Buffalo, The Albright-Knox Art Gallery, 15 September–1 November 1970; Dayton, Dayton Art Institute, 15 November 1970–8 January 1971, Cleveland, The Cleveland Museum of Art, 4 February–28 March 1971, no. 14; Chicago 1975, no. 87 (illus.); New York and St. Louis 1978, no. 13 (illus.); *The Best of Fifty*, Cincinnati, The Taft Museum, 22 March–8 May 1977, unnumbered entry; Los Angeles, Chicago, Paris 1984–85, no. 112; *The Art of the Edge: European Frames 1300–1900*, Chicago, The Art Institute, 17 October–14 December 1986, hors catalogue; Boston, Chicago, London 1990, no. 22; Chicago 1995, no. 96.

REFERENCES
'Claude Monet Exhibit Opens,' *Boston Post* (15 March 1905); M.C., 'Monet's in the Art Institute,' *Bulletin of the Art Institute of Chicago*, 19 (February 1925), p. 20; *Handbook of The Art Institute*, Chicago, 1932, p. 164: Reuterswärd, 1948, p. 286; Wildenstein, 1979, III, no. 1278, pp. 140, 141; Brettell, 1984, pp. 4–21, p. 6, pl. 3, fig. 13; R. Brettell, 'Monet's Haystacks,' in *Post-Impressionists*, The Art Institute of Chicago, vol. 3, 1987, p. 37 (illus.); Spate, 1992, pp. 213, 215 (illus.); G. Keyes, 'Claude Monet's *Grainstack, Sun in the Mist*,' *Arts*, The Minneapolis Institute of Arts (1993), p. 7 (illus.); W1278.

27 Monet
Ice Floes
La Débâcle
1893
Oil on canvas, 26 x 39½ in. (66 x 100.4 cm)
Signed and dated lower right: *Claude Monet 93*
The Metropolitan Museum of Art, New York, Bequest of Mrs. H.O. Havemeyer, 1929, The H.O. Havemeyer Collection (29.100.108).

PROVENANCE
Bought from Monet by Galerie Durand-Ruel with I. Montaignac, Paris, 3 February 1897; sold to Mr. and Mrs. H.O. Havemeyer, New York, 3 February 1897; Mrs. H.O. Havemeyer, 1907–29; bequeathed to the Metropolitan Museum of Art, New York, 1929 (29.100.108).

EXHIBITIONS
The H.O. Havemeyer Collection, New York, The Metropolitan Museum of Art, 10 March–2 November 1930, no. 87; New York 1969, no. 32; New York and St. Louis 1978, no. 23; *Splendid Legacy: The Havemeyer Collection*, New York, The Metropolitan Museum of Art, 27 March–20 June 1993, no. 408.

REFERENCES
M. de Fels, *La Vie de Claude Monet*, Paris, 1929, p. 234; 'The Exhibition of the H.O. Havemeyer Collection,' *Bulletin of the Metropolitan Museum of Art XXV*, no. 3 (March 1930), p. 56; *The H.O.*

Havemeyer Collection: A Catalogue of Paintings, Prints, Sculpture and Objects of Art, Portland, 1931, pp. 158f., (illus.) (*Landscape—Les Glaçons*, as given to H.O. Havemeyer by Monet); S. Gwynn, *Claude Monet and his Garden*, New York, 1934, p. 168; Reuterswärd, 1948, p. 282; *The H.O. Havemeyer Collection: The Metropolitan Museum of Art*, 2nd ed., New York, 1958, p. 31, no. 174; C. Sterling and M. Salinger, *French Paintings: A Catalogue of the Collection of The Metropolitan Museum of Art*, III, New York, 1967, p. 138 (illus.); D. Cooper, 'The Monets in the Metropolitan Museum of Art,' *Metropolitan Museum Journal*, 3 (1970), p. 295, fig. 16, pp. 304–305; S. Cotté, *Monet*, 1974, Paris, p. 46, pl. 16; R. Huyghe, *La Relève du Réel, impressionisme, symbolisme*, Paris, 1974, p. 120 (illus.); Wildenstein, 1979, II, p. 294 (P. J. no. 95), III, no. 1335, pp. 160, 161, 292, 293 (ltrs. 1354, 1355, 1357, 1361, 1364); M. Grayson, 'Monet's Houses of Parliament: Toward nostalgia and a new reality,' *Pharos* 16, no. 1 (May 1979), pp. 3–10, p. 9 (illus.); F. Weitzenhoffer, 'The Creation of the Havemeyer Collection, 1875–1900,' Ph.D. diss., The City University of New York, 1982, University Microfilms International, Ann Arbor (MI), pp. 266f., fig. 92; G. Clemenceau et al., *Claude Monet au temps de Giverny*, exh. cat. Paris: Centre Culturel du Marais, 1983, pp. 96 (illus.), 309, fig. 51; Rewald and Weitzenhoffer, 1984, p. 250 (illus.); House, 1986, pp. 27, 57, 65, 69, 100, 128, 148, 173 (illus.), 174, 233, 238; F. Weitzenhoffer, *The Havemeyers: Impressionism Comes to America*, New York, 1986, pp. 117, 257, pl. 75; S.Z. Levine, *Monet, Narcissus, and Self-Reflection: The Modernist Myth of the Self*, Chicago, 1994, pp. 169–70, 171, 304, fig. 86; W1335.

28 Monet

Floating Ice at Bennecourt
Les Glaçons, Bennecourt
1893
Oil on canvas, 25½ x 39⅜ in. (64.8 x 100 cm)
Signed and dated lower right: *Claude Monet 93*
Waterhouse Collection

PROVENANCE
Purchased from Monet by Boussod, Valadon & Cie., Paris, 1 December 1893, lot no. 23239 (sold for 6,000 francs; *Glaçons Effet Rose*); Henri Vever, Paris, 2 December 1893 (purchased for 8,000 francs); sale, collection of H. Vever, Galerie Georges Petit, Paris, 1–2 February 1897, lot 82 (sold for 12,600 francs); Galerie Montaignac, Paris (sold half-share in the painting to Galerie Durand-Ruel, Paris, 3 February 1897 and repurchased it to regain full ownership, 23 September 1897); Henry Osborne Havemeyer, New York, 23 September 1897; Mrs. H.O. Havemeyer, New York, 1907–1929; Horace Havemeyer, New York, 1929–56; Mrs. Horace (Doris Dick) Havemeyer, New York, 1956–82; sale, The Estate of Doris D.

Havemeyer, Sotheby Parke Bernet, New York, 18 May 1983, lot 13.

EXHIBITIONS
Monet, Paris, Galerie Durand-Ruel, 1895, no. 40; Boston, Chicago, London 1990 no. 45; *Splendid Legacy: The Havemayer Collection*, New York, The Metropolitan Museum of Art, 27 March–20 June 1993, no. 409; *Seattle Collects: Paintings*, Seattle, Seattle Art Museum, 22 May–7 September 1997, no catalogue.

REFERENCES
Thiébault-Sisson, 'L'exposition de Claude Monet,' *Le Temp* (12 May 1895); T. Natanson, 'Exposition: M. Claude Monet,' *La Revue Blanche* (1 June 1895), p. 521; Th. Duret, *Histoire des peintres impressionistes*, Paris, 1906, p. 58 (illus.); F. Fels, *Propos d'artistes*, Paris, 1925, p. 211; *The H.O. Havemeyer Collection: Paintings, Prints, Sculpture and Objects of Art*, Portland, 1931, p. 419; Venturi, 1939, pp. 357–59; Wildenstein, 1979, II, p. 294 (P. J. no. 96), III, no. 1336, pp. 160, 161, 286, 287, 293 (ltrs. 1294, 1302, 1364), and 1991, V. p. 49; F. Weitzenhoffer, 'The Creation of the Havemeyer Collection, 1875–1900,' Ph.D. diss., The City University of New York, 1982, pp. 267, 280f., n. 29, fig. 93; F. Weitzenhoffer, *The Havemeyers: Impressionism Comes to America*, New York, 1986, p. 117, pl. 75 (illus.); Tucker, 1989, pp. 168, 170 (illus.), 212; S. Sproccati, *Monet*, Milan and Paris, 1992, p. 216; W1336.

29 Monet

Morning Haze
Matin brumeaux, débâcle
1894
Oil on canvas, 25⅞ x 39½ in. (65.6 x 100.3 cm)
Signed and dated lower right: *Claude Monet 94*
Philadelphia Museum of Art, Bequest of Mrs. Frank Graham Thomson

PROVENANCE
(?) Purchased from Monet by Isaac Montaignac, 1899 (*Glaçons*); Miss Anne Thomson, Philadelphia, c. 1920; Mrs. Frank Graham Thomson; bequeathed in 1961 to The Philadelphia Museum of Art, Pennsylvania (1961–48–2).

EXHIBITIONS
Exhibition of Paintings and Drawings by Representative Modern Artists, Philadelphia, Pennsylvania Academy of Fine Arts, 17 April–9 May 1920, no. 166; Boston, Chicago, London 1990, no. 46; *Claude Monet*, Vienna, Österreichische Galerie im Belvedere, 14 March–16 June 1996, no. 57.

REFERENCES
Wildenstein, 1979, III, no. 1338, pp. 162, 163, and 1991, V, p. 49; Tucker, 1989, pp. 168, 171 (illus.), 212; W544.

30 Monet

Ice Floes on the Seine near Bennecourt
Débâcle, la Seine près Bennecourt
1893
Oil on canvas, 25⅝ x 39⅜ in. (65.1 x 100 cm)
Private collection, courtesy James Roundell Ltd.

PROVENANCE
(?) Bought directly from the artist by Petit, Bernheim and Montaignac, Paris, December 1899 (*Glaçons*); Galerie Georges Petit, Paris; William H. Fuller, New York; sale, collection of W.H. Fuller, American Art Association, New York, 12 March 1903, lot 144; Mrs. Florence Macy Sutton, New York; sale, collection of Mrs. James F. Sutton, Plaza Hotel, New York, 16 January 1917, lot 142; bought by Durand-Ruel Gallery, New York; Harris Whittemore; sale, H. Whittemore, Parke Bernet, New York, 19 May 1948, lot 86; bought by Wildenstein & Co., New York; Dr. Ralph André Kling, 1959; Galeria Theo, Madrid, c. 1968; Marlborough Fine Art, London, December 1973; sale, Christie's, London, 30 November 1992, no. 19.

EXHIBITIONS
Monet, New York, Lotos Club, January 1899, no. 15; Boston 1905, no. 63; New York 1945, no. 34; The Hague 1952, no. 43; *Selected European Masters of the 19th and 20th Centuries*, London, Marlborough Fine Art, Summer 1973, no. 48.

REFERENCES
'W. H. Fuller's Monets sold,' *The Sun*, New York (14 March 1903); 'Cl. Monet exhibit opens,' *Boston Post*, (15 March 1905); H. Huth, 'Impressionism comes to America,' *Gazette des Beaux-Arts* (April 1946), p. 246; Reuterswärd, 1948, p. 282; Wildenstein, 1979, III, no. 1339, pp. 162, 163, and 1991, V, p. 49; W1339.

31 Renoir

Skaters in the Bois de Boulogne
Les patineurs à Longchamp
1868
Oil on canvas, 28⅜ x 35⅜ in. (72.1 x 89.9 cm)
Signed and dated lower left: *A. Renoir 68*
From the collection of William I. Koch

PROVENANCE
Ambroise Vollard, Paris; Marquess of Northampton, Warwick; Richard L. Feigen & Co., New York; sale, Sotheby's, London, 26–27 June 1978, no. 717.

EXHIBITIONS
Renoir, London, Hayward Gallery, 30 January–21 April 1985, Paris, Galeries Nationales du Grand Palais, 14 May–2 September 1985, Boston, Museum of Fine Arts, 9 October 1985–5 January 1986, no. 7; *A Personal Gathering: Paintings and Sculpture from the Collection of William I. Koch*, Wichita, Wichita Art Museum, 11 February–19 May 1996, no. 30.

REFERENCES

A. Vollard, *Tableaux, Pastels & Dessins de Pierre-Auguste Renoir*, vol. I, Paris, 1918, p. 5, no. 18; A. Vollard, *La Vie et l'Œuvre de Pierre-Auguste Renoir*, Paris, 1919, p. 48; A. Vollard, *Renoir*, Paris, 1920, p. 51; A. Vollard, *Renoir: An Intimate Record*, trans. H.L. Van Doren and R.T. Weaver, 1925, pp. 51–52; J. Meier-Graefe, *Renoir*, Leipzig, 1929, p. 20, no. 8 (illus.); W. Gaunt, *Renoir*, London, 1942, pl. 4; G. Oeri, *Kunstwerke des 19. Jahrhunderts aus dem Basler Privatbesitz*, Basel, 1944, pl. 43; M. Drucker, *Renoir*, Paris, 1944, p. 193, no. 11; J. Rewald, *The History of Impressionism*, New York, 1946, p. 167 (illus.); G. Bazin, *L'Epoque Impressioniste*, Paris, 1947, pl. 16; P. Courthion, *Paris d'Autrefois de Foucquet à Daumier*, Geneva, 1957, p. 118 (illus.); M. Gilbert, *Le Bois de Boulogne*, Paris, 1958, p. 145 (illus.); D. Cooper, 'Renoir, Lise and the Le Cœur Family: A Study of Renoir's Early Development,' *The Burlington Magazine* (May, September–October 1959), p. 168; F. Daulte, *Renoir*, Milan, 1972, p. 75 (illus.); E. Fezzi, *L'opera completa di Renoir, nel periodo impressionista 1869–1883*, Milan, 1972, no. 28 (illus.); Champa, 1973, pp. 57–58. fig. 78; Rewald, 1973, p. 191 (illus.); K. Wheldon, *Renoir and his Art*, London, 1975, pl. 25; B. Ehrlich White, *Renoir, His Life, Art, and Letters*, New York, 1984, p. 26 (illus.); R. Herbert, *Impressionism, Art, Leisure, and Parisian Society*, New Haven and London, 1988, pp. 147–49.

32 Pissarro

The Versailles Road at Louveciennes (Snow)
La Route de Versailles à Louveciennes
1869
Oil on canvas, 15⅛ x 18¼ in. (38.4 x 46.3 cm)
Signed lower left: *C. Pissarro*
The Walters Art Gallery, Baltimore

PROVENANCE

(?) Purchased from the artist by Pierre Firmin ('Père') Martin, Paris; purchased from Martin by George A. Lucas, Paris, 7 January 1870; bequest to the Maryland Institute through Henry Walters, executor of George A. Lucas, 1909/10; purchased from the Maryland Institute by The Walters Art Gallery, Baltimore, 1996.

EXHIBITIONS

The George A. Lucas Collection of the Maryland Institute, Baltimore Museum of Art, 12 October–21 November 1965, no. 223; London, Paris, Boston 1980–81, no. 13; *Camille Pissarro Retrospective*, Tokyo, Isetan Museum of Art, 9 March–9 April 1984, Fukuoka, Fukuoka Art Museum, 25 April–20 May 1984, Kyoto, Municipal Museum of Art, 26 May–1 July 1984, no. 11; Paris and New York 1994, no. 162.

REFERENCES

L.M. Randall, ed., *The Diary of George A. Lucas: An American Agent in Paris, 1857–1909*, Princeton, 1979, vol. 1, fig. 102, vol. 2, p. 313; Lloyd, 1981, p. 43; Brettell et al., 1984, pp. 80, 90, fig. 14; Brettell, 1990, p. 215, n. 25.

33 Pissarro

Road, Winter Sun and Snow
Route de Versailles, Soleil d'hiver et neige
c. 1869–70
Oil on canvas, 18 x 21¾ in. (46 x 55.3 cm)
Signed lower left: *C. Pissarro*
Carmen Thyssen-Bornemisza Collection

PROVENANCE

Thiolliet Collection, Lyon; sale, Lyon, 21 December 1937, lot 42; Captain Edward Molyneux, Paris; Wildenstein & Co., New York; Mrs. Lucy Smith Battson, Los Angeles, 22 October 1957; sale, Sotheby's, New York, 3 November 1993, lot 5.

EXHIBITIONS

From Canaletto to Kandinsky: Masterworks from the Carmen Thyssen-Bornemisza Collection, Madrid, Thyssen-Bornemisza Museum, 20 March–8 September 1996, no. 57; *Del vedutismo a las primeras vanguardias, Obras Maestras de la colección Carmen Thyssen-Bornemisza*, Bilbao, Museo del Bellas Artes, 5 May–13 July 1997, no. 35; *Masterworks from the Carmen Thyssen-Bornemisza Collection*, Lugano, Villa Favorita, 5 September–2 November 1997, no. 79.

REFERENCES

P&V136; *Sotheby's Art at Auction: The Art Market Review, 1993–94*, New York, 1994, p. 98 (illus.).

34 Pissarro

Fox Hill, Upper Norwood
Lower Norwood, Londres, effet de neige[1]
c. 1870
Oil on canvas, 14 x 18 in. (35.3 x 45.7 cm)
Signed and dated lower right: *C. Pissarro 70*
The National Gallery, London

PROVENANCE

Galerie Paul Rosenberg, Paris; A.J. McNeill Reid; bought by Lefevre for Reid in 1932; sold to Mrs. Israel Sieff, 1932; bought back from Mrs. Sieff, October 1947; sold to Viscount Radcliffe, 1947; presented by the Viscount and Viscountess Radcliffe to The National Gallery, London, 1964.

EXHIBITIONS

Rétrospective Camille Pissarro, Paris, Galerie Monzi et Joyant, January– February 1914, no. 78; *French Pictures*, Glasgow, McLellan Galleries, January 1920; Dundee, Lamb's Hotel, October 1920, no. 38; *Important Pictures by 19th Century French Masters*, London, Lefevre Gallery, May–June 1924, no. 38; *Un siècle de peinture française*, Glasgow, McLellan Galleries, May 1927, no. 25; *Exhibition of oil paintings by Camille Pissarro*, London, Tate Gallery, 27 June–10 October 1931, no. 27, Birmingham, Birmingham Art Gallery, October–November 1931, no. 20, Nottingham, Castle Art Gallery, November–December 1931, Stockport, War Memorial Building, January 1932, no. 33, Sheffield, Mappin Art Gallery, February–March 1932, no. 32; *Delacroix to Dufy*, London, Lefevre Gallery, June–July 1946, no. 40; *Gli Impressionisti*, Venice, XXIV Biennale, 1948, no. 17; Piccadilly 1949–50, no. 235; Cardiff 1960 no. 31; *The Impressionists in London*, London, Hayward Gallery, 3 January–11 March 1973, no. 31.

REFERENCES

P&V105; K. Clark, *Landscape into Art*, New York, 1976, pl. 99; M. Reid, 'Camille Pissarro: Three Paintings of London of 1871: What do they represent?' *The Burlington Magazine* 119 (April 1977), pp. 253–261; J. House, 'New Material on Monet and Pissarro in London in 1870–71,' *The Burlington Magazine* 120 (October 1978), pp. 636–642; Shikes and Harper, 1980, pp. 89–90 (illus.); M. Reid, *Pissarro*, London, 1993, pp. 60, 61 (illus.).

1. Although the French title provided in P&V identifies this site as Lower Norwood, further research has confirmed that the view in this painting is indeed of Upper Norwood.

35 Pissarro

Snow at Louveciennes
Louveciennes (effet de neige)
c. 1871–72
Oil on cradled panel, 12¾ x 18¾ in. (32.3 x 47.5 cm)
Signed lower right: *C. Pissarro*
The Art Institute of Chicago, Mr. and Mrs. Lewis Larned Coburn Memorial Endowment, 1973.673

PROVENANCE

Paul Rosenberg & Co., New York; The Art Institute of Chicago, Mr. and Mrs. L.L. Coburn Memorial Endowment (1973.673).

EXHIBITIONS

Unknown.

REFERENCES

Lloyd, 1981, p. 42 (illus.).

36 Pissarro

Louveciennes
Louveciennes
1872
Oil on canvas, 18⅛ x 21¾ in. (46 x 55 cm)
Signed and dated lower right: *Pissarro 1872*
Museum Folkwang Essen
Washington only

PROVENANCE

Private collection, Washington; Wildenstein & Co., New York; Barbara Hutton, United States; Fine Arts Associates, New York, 1959; Galerie Wilhelm Grosshennig, Düsseldorf; Lefevre Gallery, London, 1960; Paul Rosenberg & Co., New York, 1964; Marianne Feilchenfeldt, Zurich, 1965; Museum Folkwang Essen, acquired from Marianne Feilchenfeldt, 1966.

EXHIBITIONS

Nineteenth- and Twentieth-Century French Paintings, London, Lefevre Gallery, March–April 1960, no. 25; *Impressionist Paintings*, New York, Paul Rosenberg & Co., 1964, no. 19; *Meisterwerke des Museum Folkwang Essen*, Okayama, The Okayama Prefectural Museum of Art, 5 April–19 May 1996, Sapporo, Hokkaido Museum of Modern Art, 21 June–28 July 1996, Hakodate, Hakodate Museum of Art, 4 August–8 September 1996, Nagoya, Nagoya City Art Museum, 15 September–27 October 1996, Tokyo, Tobu Museum of Art, 2 November 1996–19 January 1997, Kumamoto, Kumamoto Prefectural Museum of Art, 14 February–23 March 1997, Chiba, Chiba City Museum of Art, 29 April–15 June 1997, no. 60.

REFERENCES

J. Rewald, *Pissarro*, New York, 1963, no. 7; J. Rewald, *Camille Pissarro*, Köln, 1963, p. 78 (illus.); P. Vogt, 'Museum Folkwang Essen,' *Wallraf-Richartz-Jahrbuch* 29 (1967), p. 374; P. Vogt, 'Neuerwerbungen 1966–67,' in *Mitteilungen des Museum Folkwang Essen*, vol. 1, 1967, p. 7; J. Held, ed., *Katalog der Gemälde des 19. Jahrhunderts*, Museum Folkwang Essen, 1971, no. 350; *Kunstkalender 'Impressionismus,'* Brönner-Verlag, 1977 (illus.); *Lesebuch für bayerische Hauptschulen*, Braunschweig, 1978, p. 189; *Kunstkalender 'Deutsche Sparkasse,'* 1978 (illus.); Lloyd, 1981, p. 52; M. Reid, *Pissarro*, London, 1993, pp. 68, 69 (illus.).

37 Pissarro

Street in Pontoise, Winter
Rue de la Citadelle, Pontoise
1873
Oil on canvas, 21¼ x 29 in. (53.9 x 73.6 cm)
Signed and dated lower right: *C. Pissarro 1873*
Private collection

PROVENANCE

Galerie Durand-Ruel, Paris and New York (*La Route*); Cyrus J. Lawrence, New York; sale, collection of C.J. Lawrence, American Art Galleries, New York, 21–22 January 1910, lot 69; Mrs. Charles B. Alexander, New York; Mr. and Mrs. Sheldon Whitehouse, New York (inherited from Mrs. Whitehouse's mother, Mrs. Alexander, 1935); Wildenstein & Co., New York, 1965; Mrs. Florence Gould, before 1970; sale, Sotheby's, New York, 24 April 1985, lot 38.

EXHIBITIONS

Die Ile-de-France und ihre Maler, Berlin, Staatliche Museen, 29 September–24 November 1963, no. 14; *100 Years of Impressionism*, New York, Wildenstein & Co., 2 April–9 May 1970, no. 19.

REFERENCES

L. Venturi, *Cézanne: Son Art, Son Œuvre*, Paris, 1936, vol. 1, no. 137; P&V201 (*L'Hiver à Pontoise*—not illus.); L. Reidemeister, *Auf den Spuren der Maler der Ile de France*, Berlin, 1963, p. 54 (illus.); Rewald, 1973, p. 294 (illus.); U. Perucchi-Petri, 'War Cézanne Impressioniste?' *Du* (September 1975), p. 58 (illus.); J. Rewald, *Cézanne: A Biography*, New York, 1986, p. 97 (illus.); Pissarro, 1993, pp. 115, 122 (illus.); Rewald, 1996, vol. 1, p. 149 (illus.).

38 Pissarro

Piette's House at Montfoucault
La Maison de Piette à Montfoucault
1874
Oil on canvas, 18¹⁄₁₆ x 26⅝ in. (45.9 x 67.6 cm)
Signed and dated lower left: *C. Pissarro 1874*
Sterling and Francine Clark Art Institute, Williamstown, Massachusetts

PROVENANCE

Ambroise Vollard, Paris; E. Bignou, Paris; Sam Salz, New York; Durand-Ruel, New York; R.S. Clark Collection, acquired 1941 from Durand-Ruel, New York; Sterling and Francine Clark Art Institute, Williamstown, Massachusetts, 1955.

EXHIBITIONS

Milestones in French painting, London, Alex. Reid and Lefevre, June 1939, no. 25; *The Art of Camille Pissarro in Retrospect*, New York, Durand-Ruel Gallery, 24 March–15 April 1941, no. 12; *French Paintings of the Nineteenth Century*, Williamstown, Clark Art Institute, Summer 1956, no. S-2; London, Paris, Boston, 1980–81, no. 37; *Camille Pissarro: Impressionism, Landscape and Rural Labor*, Birmingham, City Museum and Art Gallery, 8 March–22 April 1990, Glasgow, Burrell Collection, 4 May–17 June 1990, no. 16.

REFERENCES

P&V287; G. Jedlicka, *Pissarro*, Bern, 1950, pl. 17; *French Paintings of the Nineteenth Century*, Clark Art Institute, Williamstown, 1963, no. 96; *List of Paintings in the Sterling and Francine Clark Art Institute*, Williamstown, 1972, p. 78; Shikes and Harper, 1980, p. 122; Pissarro, 1993, p. 139 (illus.).

39 Pissarro

Snow at Montfoucault
Neige à Montfoucault
1874
Oil on canvas, 21⅜ x 25½ in. (54.3 x 65 cm)
Signed and dated lower left: *C. Pissarro 1874*
Lord and Lady Ridley-Tree

PROVENANCE

Eugène Blot, Paris; Etienne Bignou, Paris; Georges Bernheim, Paris; sale, 7 June 1935, lot 72 (*Le chemin de la ferme, en hiver, temps de neige*); Dr. Brocq, Paris; Marlborough Fine Arts Ltd., London; Marlborough-Gerson Gallery, London; Mr. and Mrs. Josef Rosensaft, New York; sale, Sotheby Parke Bernet, New York, 17 March 1976, lot 32; Cynthia Wood; Wood-Claeyssens Foundation, Santa Barbara; sale, Sotheby's, New York, 11 May 1993, lot 4.

EXHIBITIONS

Centenaire de la Naissance de Camille Pissarro, Paris, Musée de l'Orangerie, February–March 1930, no. 27; *A Great Period of French Painting*, London, Marlborough Fine Art Ltd., June–July 1963, no. 25; *New York Collects*, New York, The Metropolitan Museum of Art, 3 July–2 September 1968, no. 163; *Santa Barbara Collects—Impressions of France*, Santa Barbara, Santa Barbara Museum of Art, 29 January–19 April 1998, no. 50.

REFERENCES

P&V284.

40 Pissarro

Farm at Montfoucault, Snow Effect
Ferme à Montfoucault; effet de neige
1876
Oil on canvas, 21¼ x 25½ in. (54 x 65 cm)
Signed and dated lower left: *C. Pissarro 1876*
The Visitors of the Ashmolean Museum, Oxford
Washington only

PROVENANCE

Lucien Pissarro, London; presented by the Pissarro family to the Ashmolean Museum, Oxford, 1951.

EXHIBITIONS

Rétrospective Camille Pissarro, Paris, Galerie Manzi et Joyant, January–February 1914, no. 53; *Memorial Exhibition of the Works of Camille Pissarro*, London, Leicester Galleries, May 1920, no. 57; *Peintures par Sisley, Renoir, Pissarro, Monet, Boudin, Cassatt*, London, Leicester Galleries, April–May 1936, no. 5; *Pissarro*, London, Matthiesen Gallery, 1956, no. 8; Cardiff 1960, no. 35; *Camille Pissarro*, Tokyo, Isetan Museum of Art, 9 March–9 April 1984, Fukuoka, Fukuoka Art Museum, 25 April–20 May 1984, Kyoto, Municipal Museum of Art, 26 May–1 July 1984, no. 22; *Camille Pissarro: Impressionism, Landscape and*

Rural Labor, Birmingham, City Museum and Art Gallery, 8 March–22 April 1990, Glasgow, Burrell Collection, 4 May–17 June 1990, no. 17.

REFERENCES
P&V283; A. Thorold and K. Erickson, *Camille Pissarro and his Family: The Pissarro Collection in the Ashmolean Museum*, Oxford, 1993, no. 6.

41 Pissarro
The Road to l'Hermitage in the Snow
Chemin de l'Hermitage, Pontoise, sous la neige
c. 1874
Oil on canvas, 18¼ x 15⅜ in. (46 x 38 cm)
Signed lower left: *C. Pissarro*
Private collection, Cambridge, Massachusetts

PROVENANCE
Bruno and Paul Cassirer Gallery, Berlin; Mrs. Hedwig Cassirer (distant cousin of B. and P. Cassirer); inherited by H. Cassirer's daughter, Mrs. Anne Marie Cassirer; inherited by A.M. Cassirer's daughter, Mrs. Marianne Lowenberg Davis; E.V. Thaw Gallery, New York.

EXHIBITIONS
Camille Pissarro: Impressionist Innovator, Jerusalem, The Israel Museum, 11 October 1994–9 January 1995, New York, The Jewish Museum, 26 February–16 July 1995, no. 47.

REFERENCES
J. Rewald, *Cézanne: A Biography*, New York, 1986, p. 102 (illus.); Rewald, 1996, vol. 1, pp. 161–62 (illus.).

42 Pissarro
Snow at l'Hermitage, Pontoise
Effet de neige à l'Hermitage à Pontoise
1874
Oil on canvas, 21½ x 25¾ in. (54.5 x 65.5 cm)
Signed and dated lower right: *C. Pissarro 1874*
Private collection

PROVENANCE
J.B. Faure Collection, France; Mme. L. Ferrey; Comte de Lainsecq, Paris.

EXHIBITIONS
2e exposition de peinture, Paris, 11 rue Le Peletier, April 1876, no. 200; *Exposition de l'œuvre de Camille Pissarro*, Paris, Galerie Durand-Ruel, 7–30 April 1904, no. 30; *Camille Pissarro*, New York, Wildenstein & Co., 25 March–1 May 1965, no. 23; Los Angeles, Chicago, Paris 1984–85, no. 64.

REFERENCES
Vente de Mme. L. Ferrey, Paris, Galerie Georges Petit, 18 April 1921, opposite p. 40 (*L'Hiver à Auvers-sur-Oise*); *Vente de M. le Comte de X…(Lainsecq)*, Hôtel Drouot, Paris, 6 April 1922, p. 19, no. 15 (*L'Hiver à*

Auvers-sur-Oise); P&V238; Moffett et al., 1986, p. 156 (illus.).

43 Pissarro
Snow Effect at l'Hermitage, Pontoise
Effet de neige à l'Hermitage, Pontoise
1875
Oil on canvas, 21¼ x 25 in. (54 x 65 cm)
Signed and dated lower left: *C. Pissarro 1875*
Private collection

PROVENANCE
Estate of the artist; Georges Pissarro; Galerie Bernheim-Jeune, Paris, 25 September 1905; sale, Sotheby's, London, 3 December 1975, lot 27; Irene Albert, Switzerland; sale, Sotheby's, London, 4 April 1989, no. 9.

EXHIBITIONS
Aberdeen, on loan to the Art Gallery and Museum, 1979–1985; *Impressionist and Post-Impressionist Works from a British Collection*, Hamilton (NY), The Picker Art Gallery at Colgate University, March–May 1986, Austin (TX), Archer M. Huntington Art Gallery at The University of Texas, September–November 1986, Palm Beach, The Society of the Four Arts, 9 January–8 February 1987, Norwich, Castle Museum, 1987, no. 37.

REFERENCES
P&V297; Shikes and Harper, 1980, p. 127; Brettell, 1990, pp. 99, 113, 117 (illus.).

44 Pissarro
Rabbit Warren at Pontoise, Snow
La Garenne à Pontoise, effet de neige
1879
Oil on canvas, 23⁵⁄₁₆ x 28⁷⁄₁₆ in. (59.2 x 72.3 cm)
Signed and dated lower left: *C. Pissarro 79*
The Art Institute of Chicago, Gift of Marshall Field, 1964.200

PROVENANCE
Mme. Pissarro; Galerie Bernheim-Jeune, Paris; Galerie Durand-Ruel, Paris (bought from Bernheim-Jeune & Cie., 9 August 1918); private collection, Paris; The Art Institute of Chicago, Gift of Marshall Field (inv. 1964.200).

EXHIBITIONS
Exposition Camille Pissarro, Paris, Galerie Durand-Ruel, February 1892, no. 11; *Exposition de Tableaux de Monet, Pissarro, Renoir, et Sisley*, Paris, Galerie Durand-Ruel, April 1899, no. 43; *The Artist looks at the Landscape*, Chicago, The Art Institute, 22 June–25 August 1974, no catalogue; London, Paris, Boston 1980–81, no. 51; Los Angeles, Chicago, Paris 1984–85, no. 68; Tokyo, Fukuoka, Kyoto 1985–86, no. 27; London and Boston 1995–96, no. 92.

REFERENCES
P&V478; *Catalogue of The Art Institute of Chicago*, Chicago, 1961, p. 358B; *The Art Institute of Chicago Annual Report*, 1963–64, p. 19; R. Shiff, 'Seeing Cézanne,' *Critical Inquiry* iv (1978), p. 803, no. 85; Pissarro, 1993, pp. 115, 125 (illus.).

45 Pissarro
Snow Effect at Eragny, Road to Gisors
Effet de neige à Eragny, la route de Gisors
1885
Oil on canvas, 13⅛ x 16⅛ in. (33.5 x 41 cm)
Signed and dated lower left: *C. Pissarro 1885*
Private collection

PROVENANCE
Dr. Störï; sale, Kunstsalon Zürich, 26 November 1927; Hans Wirth, Siebnen; private collection.

EXHIBITIONS
Unknown.

REFERENCES
Unknown.

46 Pissarro
Snowy Landscape. Eragny, Evening
Effet de neige à Eragny, soir
1894
Oil on canvas, 21½ x 25½ in. (54.5 x 65 cm)
Signed and dated lower left: *C. Pissarro 94*
Ordrupgaard, Copenhagen

PROVENANCE
Wilhelm Hansen, Copenhagen, 1916; Ordrupgaard, Copenhagen.

EXHIBITIONS
Französische Kunst des XIX und XX Jahrhanderts, Zurich, Kunsthaus, May–June 1917, no. 151; *French Masterpieces from the Ordrupgaard Collection in Copenhagen*, Tokyo, Nihonbashi Takashimaya, 3 August–29 August 1989, Yokohama, Yokohama Takashimaya, 7 September–26 September 1989, Toyohashi, Toyohashi City Art Museum, 27 October–26 November 1989, Kyoto, Kyoto Takashimaya, 27 December 1989–23 January 1990, no. 37.

REFERENCES
K. Madsen, *Malerisamlingen Ordrupgaard: Wilhelm Hansen's Samling. Malerier, Akvareller, Pasterller, Tegninger af franske Kunstnere*, Copenhagen, 1918, no. 57; P&V869; H. Leth, *Om et par billeder på Ordrupgaard. i: Aarstiderne*, III, Copenhagen, 1943, pp. 12, 13 (illus.); L. Swane, *Etatsråd Wilhelm Hansen og hustru Henny Hansens malerisamling. Katalog over kunstværkerne på Ordrupgård*, Copenhagen, 1954, no. 88; H. Rostrup, *Franske malerier i Ordrupgaard-samlingen. Udgivet at Foreningen Fransk Kunst i*

anledning af 40-årsdagen for den stiftelse, Copenhagen, 1958, no. 88; H. Rostrup, *Catalogue of the Works of Art in The Ordrupgaard Collection*, Copenhagen, 1966, no. 88; H. Rostrup, *Etatsraad Wilhelm Hansen og hustru Henny Hansens malerisamling. Fortegnelse over kunstværkerne på Ordrupgaard*, Copenhagen, 1973, no. 88; A. Stabell, *Catalogue of the Ordrupgaard Collection*, Copenhagen, 1982, no. 86 (rev. M. Wivel, 1992); H. Leth, *Camille Pissarro: Om et par billeder på Ordrupgaard. Se selv. Tekster om billedkunst udvalgt og med en indledning af Henning Jørgensen*, Copenhagen, 1991, pp. 69–76, p. 73 (illus.); M. Asmussen, *Wilhelm Hansen's Original French Collection at Ordrupgaard*, Copenhagen, 1993, pp. 206–207, no. 57; M. Wivel, *Ordrupgaard: Selected Works*, Copenhagen, 1993, no. 42 (illus.).

47 Sisley

The Frost
Le Givre (Gelée blanche)
1872
Oil on canvas, 18⅛ x 22¼ in. (46 x 56.5 cm)
Signed and dated lower left: *Sisley 72*
Private collection
San Francisco only

PROVENANCE
Bought from Sisley by Durand-Ruel, 27 February 1873; sold to Jules Strauss, Paris, 10 February 1900; sale, collection of J. Strauss, Hôtel Drouot, Paris, 3 May 1902, no. 64 (sold for 6700 francs); second sale, collection of Jules Strauss, Galerie Georges Petit, Paris, 15 December 1932, no. 81 (sold for 31,000 francs).

EXHIBITIONS
Exposition Centennale de l'art français: Exposition universelle, Grand Palais des Champs-Elysées, May–November 1900, no. 617; *Alfred Sisley*, Galerie Georges Petit, 14 May–7 June 1917, no. 74; *Tableaux de Sisley*, Paris, Galerie Durand-Ruel, 22 February–13 March 1930, no. 2; *Sisley*, Paris, Galerie Braun, January–February 1933, no. 1; *Important XIX & XX Century Works of Art*, London, Lefevre Gallery (Alex. Reid and Lefevre Ltd.), 1–18 December 1997, no. 21.

REFERENCES
D53.

48 Sisley

Snow at Louveciennes
Neige à Louveciennes
1873
Oil on canvas, 20⅛ x 26 in. (51.1 x 66 cm)
Signed and dated lower left: *Sisley 73*
Private collection

PROVENANCE
Paul Durand-Ruel, Paris; Galerie Durand-Ruel, Paris, 25 August 1891; Jules Strauss, Paris, 10 February 1900; sale, collection of J. Strauss, Hôtel Drouot, Paris, 3 May 1902, no. 69 (sold for 8,000 francs); M. Mounier, Paris; Georges Hoentschel, Paris; Etienne Bignou, Paris; Alphonse Morhange, Paris; sale, Sotheby's, London, 28 June 1961, lot 88; Max Kaganovitch, Paris.

EXHIBITIONS
Tableaux de Sisley, Paris, Galerie Durand-Ruel, 22 February–3 May 1902, no. 13; *La Peinture française de Manet à nos Jours*, Warsaw, Musée Nationale, February–March 1937, no. 37; Piccadilly 1949–50, no. 230; Cardiff 1960, no. 46.

REFERENCES
D104.

49 Sisley

Snow at Louveciennes
Jardin à Louveciennes—Effet de neige
1874
Oil on canvas, 22 x 18 in. (55.9 x 45.7 cm)
Signed and dated lower right: *Sisley 74*
The Phillips Collection, Washington, D.C.

PROVENANCE
Paul Rosenberg & Co., Paris and New York; Duncan Phillips, Washington, D.C., 1923; The Phillips Collection, Washington, D.C., 1923

EXHIBITIONS[1]
Exposition d'une cinquantaine d'œuvres de Sisley, Paris, Paul Rosenberg & Co., 7–24 November 1904, no. 37; *Exposition d'Œuvres de Grands Maîtres du Dix-Neuvième Siècle*, Paris, Paul Rosenberg & Co., 3 May–3 June 1922, no. 89 (*La Rouelle—Effet de Neige*); *Paintings by Alfred Sisley*, London, The Independent Gallery, November–December 1927; *Exhibition of French Painting of the 19th and 20th Centuries*, Cambridge, Fogg Art Museum, 6 March–6 April 1929, no. 85 (*Snow Scene*); *Alfred Sisley Centennial*, New York, Durand-Ruel Gallery, 2–21 October 1939; New York, Levy Galleries, February 1940; *The Age of Impressionism and Objective Realism*, The Detroit Institute of Arts, 3 May–2 June 1940, no. 41; *Masters of Art from 1790 to 1950*, Pomona, Art Building (presented by the Los Angeles County Fair), 15 September–1 October 1950, unnumbered entry; *100 Years of French Painting*, Pasadena, Art Institute, 16 October–22 November 1950, unnumbered entry; *Die Welt des Impressionismus*, Schaffhausen, Museum zu Allerheiligen, 29 June–29 September 1963, hors catalogue; *Loan Exhibition: Sisley*, New York, Wildenstein & Co., 27 October–3 December 1966, no. 18 (*Jardin à Louveciennes, effet de neige*);

Impressionists in 1877, Memphis, The Dixon Gallery and Gardens, 4 December 1977–8 January 1978, no. 28; *The Phillips Collection in the Making: 1920–1930*, Washington, The Phillips Collection, 5 May–10 June 1979, Memphis, Brooks Memorial Art Gallery, 14 July–22 August 1979, Omaha, Joslyn Art Museum, 15 September–28 October 1979, Dayton Art Institute, 17 November–30 December 1979, Coral Gables, Metropolitan Museum and Art Center, 19 January–2 March 1980, Tulsa, The Philbrook Art Museum, 22 March–4 May 1980, San Antonio, Marion Koogler McNay Art Institute, 24 May–6 July 1980, Portland Art Museum (OR), 26 July–31 August 1980, Santa Ana, The Bowers Museum, 20 September–2 November 1980, The Allentown Art Museum, 22 November 1980–4 January 1981, no. 32; *Impressionism and the Modern Vision: Master Paintings From The Phillips Collection*, The Fine Arts Museums of San Francisco, 4 July–1 November 1981, Dallas Museum of Fine Arts, 22 November 1981–16 February 1982, The Minneapolis Institute of Arts, 14 March–30 May 1982, Atlanta, The High Museum of Art, 24 June–5 September 1982, Oklahoma City, Oklahoma Art Center, 17 October 1982–9 January 1983, no. 69; *Impressionism and the Modern Vision: Master Paintings from The Phillips Collection*, Tokyo, The Nihonbashi Takashimaya Art Galleries, 25 August–4 October 1983, Nara Prefectural Museum of Art, 9 October–13 November 1983, no. 31; *Paintings and Drawings from The Phillips Collection*, New York, IBM Gallery of Science and Art, 9 December 1983–21 January 1984, no. 91; *French Masterpieces from The Phillips Collection: Impressionism and Post-Impressionism*, Louisville, J.B. Speed Art Museum, 19 February–8 April 1984, no. 15; *Rétrospective Alfred Sisley*, Tokyo, Isetan Museum of Art, 15 March–15 April 1985, Fukuoka Art Museum, 20 April–20 May 1985, Nara Prefectural Musem, 25 May–30 June 1985, no. 12; *Old Masters—New Visions: El Greco to Rothko from The Phillips Collection*, Canberra, Australian National Gallery, 3 October–6 December 1987, Perth, Art Gallery of Western Australia, 22 December 1987–21 February 1988, Adelaide, Art Gallery of South Australia, 4 March–1 May 1988, unnumbered entry; *Master Paintings from The Phillips Collection, Washington*, London, The Hayward Gallery, 19 May–14 August 1988, Frankfurt, Schirn Kunsthalle, 27 August–6 November 1988, Madrid, Centro de Arte Reina Sofia, 30 November 1988–16 February 1989, no. 17 (*Neige à Louveciennes*); London, Paris, Baltimore 1992–93, no. 31 (*The Chemin de l'Etarché, Louveciennes, under Snow*).

REFERENCES
R. Fry, 'French Art of the Nineteenth Century—Paris,' *The Burlington Magazine* 40 (June 1922), p. 276 (illus.); F.N. Prige, 'The Phillips Memorial Gallery,' *The Studio* (October 1924), p. 18 (illus.); R. Fry, 'Sisley at the Independent Gallery,' *Nation and*

Athenaeum (3 December 1927), p. 276 (illus.); J. Rewald, *The History of Impressionism*, New York, 1946, p. 241 (illus.); D. Phillips, *The Phillips Collection: A Museum of Modern Art and its Sources*, 1952, p. 93; L. Venturi, *De Manet à Lautrec*, Paris, 1953, p. 115, fig. 84; D146; H. Kramer, 'The Impressionist Eye,' *New York Times Magazine* (7 January 1968), pp. 28 (illus.), 29–30; Rewald, 1973, p. 289 (illus.); R. Cogniat, *Sisley*, New York, 1978, pp. 24 (illus.), 59; R. Shone, *Sisley*, Oxford, 1979, pl. 27; M. and G. Blunden, *Impressionists and Impressionism*, Geneva, 1980, pp. 116 (illus.), 117; Lassaigne and Gache-Patin, 1983, pp. 82, 84 (illus.); Denis et al., 1984, p. 102; Y. Inui and T. Kashiwa, *Sisley*, in *Les peintres impressionistes* 7, Tokyo, 1987, no. 14; L. de Nanteuil, 'Impressionist avant tout,' *Connaissance des Arts*, numéro spécial (1992), pp. 10 (illus.), 19; R. Cogniat, *Sisley*, Lichtenstein, 1992, pp. 37, 39 (illus.); Shone, 1992, pp. 94, 98 (illus.).

1. From 1926 to 1986 *Snow at Louveciennes* was included in at least six exhibitions at The Phillips Collection. Although they were accompanied by publications, in general these exhibitions did not travel. Complete information is available in the archives of The Phillips Collection.

 In the interest of abbreviating this extensive exhibition history, city names have been deleted if they are included in the title of the museum or gallery in which the painting was exhibited.

50 Sisley

Snow Effect at Argenteuil
Effet de neige à Argenteuil
1874
Oil on canvas, 21¼ x 25⅝ in. (54 x 65 cm)
Signed and dated lower left: *Sisley 74*
Private collection, courtesy of Pyms Gallery, London

PROVENANCE
François Depeaux, Rouen; sale, collection of F. Depeaux, Galerie Georges Petit, Paris, 31 May 1906, lot 59 (sold for 16,000 francs); Maurice Barrett-Décap, Biarritz; sale, Hôtel Drouot, Paris, 12 December 1929, lot 13; Henri Canonne, Paris.

EXHIBITIONS
Exposition d'œuvres importantes de grands maîtres du dix-neuvième siècle, Paris, Galerie Paul Rosenberg, 18 May–27 June 1931, no. 76; *Exhibition of French Art 1200–1900*, London, Royal Academy of Arts, January–March 1932, no. 504.

REFERENCES
A. Alexandre, 'La Collection Canonne,' *La Renaissance* (1930), p. 88; A. Alexandre, *La Collection Canonne*, Paris, 1930, illus. between pp. 52 and 53; D147.

51 Sisley

The Watering Place at Marly
L'Abreuvoir de Marly-le-Roi
1875
Oil on canvas, 19½ x 25¾ in. (49.5 x 65.4 cm)
Signed and dated lower left: *Sisley 75*
The National Gallery, London

PROVENANCE
(?) 'Père' Martin, Paris; François Depeaux, Paris; *Vente de Tableaux modernes, Collection d'un amateur* (Depeaux Sale), Hôtel Drouot, Paris, 25 April 1901, lot 48 (sold for 6,600 francs); Georges Hoentschel, Paris, with Paul Rosenberg, Paris; The Independent Gallery, London; Trustees of the Courtauld Fund for The Tate Gallery, London; transferred to The National Gallery, London, 1961.

EXHIBITIONS
2e Exposition de la Société Anonyme des Artistes Peintres, Sculpteurs, Graveurs, Paris, 11, rue Peletier, April 1876, no. 240; *P.-A. Besnard, J.-C. Cazin, C. Monet, A. Sisley, F. Thaulow, E. Chapelet*, Paris, Galerie Georges Petit, 16 February–8 March 1899, no. 78; *Première Exposition au Profit de la Société des Amis du Luxembourg*, Paris, Hôtel de la Curiosité et des Beaux-Arts, March 1924, no. 248; *Samuel Courtauld Memorial Exhibition*, London, Tate Gallery, May–September 1948, no. 76; *Rétrospective Alfred Sisley*, Tokyo, Isetan Museum of Art, Fukuoka, Fukuoka Art Museum, Nara, Nara Prefectural Museum, 7 March–30 June 1985, no. 17; Washington and San Francisco 1986, no. 37; London and Boston 1995–96, no. 79.

REFERENCES
G. Geffroy, *Sisley*, Paris, 1923, p. 23; G. Geffroy, *Sisley*, Paris, 1927, p. 24; J. Rothenstein, *100 Modern Foreign Pictures in the Tate Gallery*, London, 1949, pl. 49 (illus.); D. Cooper, *The Courtauld Collection*, London, 1954, no. 74, pl 45 (illus.); R.R. Tatlock, 'The Courtauld Trust,' *The Burlington Magazine* 48 (February 1956), p. 56 (illus.); R. Alley, *Tate Gallery: Foreign Paintings, Drawings and Sculpture*, London, 1959, pp. 248–49, pl. 52a (illus.); D152; M. Davies, *French School—Early 19th Century, Impressionists, Post-Impressionists, etc.*, 2nd ed., London, National Gallery Catalogues, 1970, no. 4138; *Illustrated General Catalogue*, The National Gallery, London, 1973, no. 4138 (illus.); Lassaigne and Gache-Patin, 1983, pp. 98, 99 (illus.); Denis et al., 112 (illus.); D. Bomford et al., *Art in the Making: Impressionism*, London, 1990, pp. 148, 149 (illus.); R. Shone, 1992, pp. 85, 87 (illus.), 96.

52 Sisley

The Watering Place at Marly with Hoarfrost
L'Abreuvoir à Marly — Gelée blanche
1876
Oil on canvas, 14⅞ x 21⅝ in. (37.8 x 54.9 cm)
Signed and dated lower right: *Sisley 76*
Virginia Museum of Fine Arts, Richmond, Virginia, Collection of Mr. and Mrs. Paul Mellon

PROVENANCE
François Depeaux, Rouen; sale, collection of F. Depeaux, Galerie Georges Petit, Paris, 31 May–1 June 1906, no. 57; bought by Durand-Ruel (for 8,000 francs); Galerie Durand-Ruel, Paris; sold to Galerie Paul Cassirer, 17 November 1913; Paul Cassirer, Berlin; sold by Cassirer to Dr. Curt Hirschland, Essen; Wildenstein & Co., New York; Mrs. Hirschland, New York; Mr. and Mrs. Paul Mellon; Virginia Museum of Fine Arts, Richmond, Collection of Mr. and Mrs. Paul Mellon.

EXHIBITIONS
French Paintings from the Collections of Mr. and Mrs. Paul Mellon and Mrs. Mellon Bruce, Washington, D.C., National Gallery of Art, 17 March–1 May 1966, no. 76; London, Paris, Baltimore, 1992–93, no. 42.

REFERENCES
Denis et al., 1984, p. 107 (illus.); J. P. Munk, 'Sisley's landskaber fra Marly,' *Meddelelser fra Ny Carlsberg Glyptotek*, Copenhagen, 1991, pp. 73–74, n. 20; Shone, 1992, pp. 85, 87 (illus.), 96.

53 Sisley

Winter in Marly, Snow Effect
Hiver à Marly, Effet de neige
1876
Oil on canvas, 18⅛ x 22¼ in. (46 x 56.5 cm)
Signed lower left: *Sisley*
Private collection, courtesy of Galerie Schmit, Paris

PROVENANCE
Ferdinand Bing, Paris; G. Bing, Paris; sale, collection of G. Bing, Hôtel Drouot, Paris, 9 June 1927 (sold for 34,100 francs); Wildenstein & Co., New York; Lord Sandwich, London.

EXHIBITIONS
Exposition Sisley, Galerie Paul Rosenberg, Paris, 7–24 November 1904, no. 4; *El impressionismo francés en las coleccíones argentinas*, Museo Nacional de Bellas Artes, Buenos-Aires, September–October 1962, no. 72.

REFERENCES
H.R. Wilenski, 'The Sisley Compromise,' *Apollo* (January 1928), p. 73 (illus.); D198; J.J. Levêque, *Les Années Impressionistes*, Paris, 1990, p. 311 (illus.); R. Cogniat, *Sisley*, Lichtenstein, 1992, p. 77 (illus.).

54 Sisley

Snow Effect at Louveciennes
Effet de neige à Louveciennes
1876
Oil on canvas, 19¾ x 24 in. (50 x 61 cm)
Signed and dated lower right: *Sisley 76*
Fondation Rau pour le Tiers-Monde, Zurich

PROVENANCE
Pierre-Auguste Renoir, Paris; Galerie Durand-Ruel, Paris, purchased from Renoir 25 June 1892; Collection Gardin, Paris, purchased from Durand-Ruel 9 December 1893; sale, Palais Galliéra, 17 June 1970, lot L; Marianne Feilchenfeldt, Zurich 1971/72; Fondation Rau pour le Tiers-Monde, Zurich, GR 1.154.

EXHIBITIONS
Manet to Gauguin: Masterpieces from Swiss Private Collections, Tokyo, The Sezon Museum of Art, 21 October 1995–21 January 1996, Nagoya, Matsuzakaya Museum of Art, 3 February–12 March 1996, no. 57.

REFERENCES
Stevens, 1992, p. 158.

55 Sisley

Winter in Louveciennes
L'Hiver à Louveciennes
1876
Oil on canvas, 23¼ x 28¾ in. (59.2 x 73 cm)
Signed and dated lower left: *Sisley 76*
Staatsgalerie Stuttgart

PROVENANCE
Galerie Durand-Ruel; Erwin Davis, New York; Durand-Ruel Gallery, New York, 14 April 1899; Martha A. Alford, New York; Miss Elen B. Alford, New York, 16 December 1916; sale, Parke-Bernet, New York, 1962; Marlborough Fine Art Ltd., London; purchased by the Staatsgalerie Stuttgart, 1963.

EXHIBITIONS
A Journey into the Universe of Art, London, Fischer Fine Art Ltd., June–July 1972, unnumbered entry.

REFERENCES
D194; *Katalog der Staatsgalerie Stuttgart. Neue Meister*, Stuttgart, 1968, p. 171, fig. 29; C. von Holst, *Malerei und Plastik des 19 Jahrhunderts. Staatsgalerie Stuttgart*, Stuttgart-Bad Cannstatt, 1982, p. 146f.

56 Sisley

Snow at Louveciennes
La neige à Louveciennes (Yvelines)
1878
Oil on canvas, 24 x 19⅞ in. (61 x 50.5 cm)
Signed and dated lower right: *Sisley 78*
Musée d'Orsay, Paris, Bequest of Comte Isaac de Camondo

PROVENANCE
Comte Armand Doria, Paris; sale, collection of Comte Armand Doria, Galerie Georges Petit, Paris, 4–5 May 1899, no. 223 (sold for 6,050 francs); Georges Feydeau, Paris; sale, collection of Georges Feydeau, Hôtel Drouot, Paris, 4 April 1903, no. 42 (sold for 11,100 francs); Comte Isaac de Camondo, Paris; bequest of Comte Isaac de Camondo to the Musée du Louvre, 1908; transferred to the Musée du Jeu de Paume, Paris, 1947; transferred to the Musée d'Orsay, Paris, 1986 (R.F. 2022).

EXHIBITIONS
Le Paysage français de Poussin aux impressionistes, Tarbes, Musée municipal, August–September 1956, no. 26; *De Renoir à Vuillard*, Louveciennes, Musée Promenade de Marly-le-Roi-Louveciennes, 22 March–24 June 1984, no. 39; *Louveciennes, de Sisley à nos jours*, Louveciennes, Musée Promenade de Marly-le-Roi-Louveciennes, 6 April–30 June 1991, p. 2 (illus.); London, Paris, Baltimore 1992–93, no. 46.

REFERENCES
Catalogue de la Collection Isaac de Camondo, Paris, n.d., no. 203 (illus.); G. Besson, *Sisley*, Paris, n.d., pl. 14; P. Jamot, *La Peinture au Musée du Louvre, école française, XIXe siècle*, III, Paris, 1928, pp. 98–99, pl. 82; Adhémar et al., 1947, no. 277; J.-L. Vaudoyer, *Les Impressionistes de Manet à Cézanne*, Paris, 1955, pl. 35; Adhémar and Dreyfus-Bruhl, 1958, no. 414; G. Bazin, *Trésors de l'Impressionisme au Louvre*, Paris, 1958, pp. 188, 189 (illus.); J. Ribault-Ménétière, 'Sur les Impressionistes,' *Journal de l'Amateur d'Art* (10 July 1958), p. 7; D282; R. Shone, *Sisley*, Oxford, 1979, pl. 26 (illus.); Lassaigne and Gache-Patin, 1983, p. 28 (illus.); C. Lloyd, *Alfred Sisley Retrospective*, exh. cat., Tokyo, 1985, fig. 2; Rosenblum, 1989, p. 306 (illus.); Compin et al., 1990, 2, p. 431 (illus.); L. de Nanteuil, 'Impressioniste avant tout,' *Connaissance des Arts*, numéro spécial (1992), pp. 20, 67 (illus.); Shone, 1992, pp. 2 (illus.), 120-21 (illus.).

57 Sisley

Rue Eugène Moussoir at Moret: Winter
Une Rue à Moret en hiver
1891
Oil on canvas, 18⅜ x 22¼ in. (46.7 x 56.5 cm)
Signed lower right: *Sisley*
The Metropolitan Museum of Art, New York, bequest of Ralph Friedman, 1992 (1992.366)

PROVENANCE
Baron Blanquet de Fulde, Paris; *Vente de collection de M. le Baron Blanquet de Fulde*, Hôtel Drouot, Paris, 12 March 1900 (sold for 6,900 francs); M. Foinard, Paris; Maurice Goldfiel, Paris; *Sale of the Collection of M. Goldfiel and Others*, (*Effet de neige à Louveciennes*, painted c. 1872), 23 October 1963, no. 45 (illus.); purchased by M.G.B. Bernier (for $56,000); Wildenstein & Co., New York, April 1965; Ralph Friedman, January 1966; The Metropolitan Museum of Art, New York, bequest of Ralph Friedman, 1992 (1992.366).

EXHIBITIONS
Sisley, Wildenstein & Co., New York, 27 October–3 December 1966, no. 23 (*Scène de village*, 1875); *Sisley, Master Impressionist*,[1] Baltimore, Walters Art Gallery, hors catalogue.

REFERENCES
D780; 'From Delacroix to Picasso: Paintings to be sold at Sotheby's,' *Illustrated London News* vol. 243, no. 6479 (5 October 1963), p. 519 (illus.); 'Recent Acquisitions: A Selection,' *The Metropolitan Museum of Art Bulletin*, New York, 1992–93, p. 54.

1. This is the title listed in the files of The Metropolitan Museum of Art. Elsewhere in this catalogue, the title of the exhibition is cited as London, Paris, Baltimore 1992–93.

58 Caillebotte

View of Rooftops (Snow)
Toits sous la neige
c. 1878
Oil on canvas, 25¼ x 32¼ in. (64 x 82 cm)
Signed lower left: *G. Caillebotte*
Musée d'Orsay, Paris, Gift of Martial Caillebotte

PROVENANCE
M.K., Paris, 1879; Martial Caillebotte; given from the Caillebotte family to the State, 1894; entered Musée du Luxembourg, Paris, 1896; Musée du Louvre, Paris, 1929; transferred to the Musée du Jeu de Paume, Paris, 1947; Musée d'Orsay, Paris, 1986 (R.F. 876).

EXHIBITIONS
4e exposition de peinture, Paris, 28, avenue de l'Opéra, 10 April–11 May 1879, no. 12 (*Vue de toits. Effet de neige*, 'Appartient à M. K.'); *Exposition rétrospective des œuvres de Gustave Caillebotte*, Paris, Galerie Durand-Ruel, 4–16 June 1894, no. 17; *La Neige et les peintres*, Annecy, Palais de l'Isle, Summer 1957, no. 9; *Caillebotte et ses amis impressionistes*, Chartres, Musée de Chartres, 28 June–5 September 1965, no. 7; *Gustave Caillebotte: A Retrospective Exhibition*, Houston, The Museum of Fine Arts, 22 October 1976–2 January 1977, New York, The Brooklyn Museum, 12 February–24 April 1977, no. 42; Washington and San Francisco 1986, no. 68; *Gustave Caillebotte: Urban Impressionist*, Paris, Grand Palais,

16 September 1994–9 January 1995, Chicago, The Art Institute, 15 February–28 May 1995, no. 60; Copenhagen 1996, no. 59.

REFERENCES
F.C. de Syène, 'Salon de 1879,' *L'Artiste* (May 1879); 'Les Dons au musée du Luxembourg,' *Le journal des artistes* (22 July 1894); G. Denoinville, 'L'Annexe du musée du Luxembourg,' *Le journal des artistes* (9 February 1896); L. Bénédite, *Le musée du Luxembourg. Les Peintures*, Paris, 1912, p. 30, no. 87; L. Bénédite, *Le Musée du Luxembourg, Peintures, Ecole française*, Paris, 1924, p. 30, no. 76; Adhémar et al., 1947, no. 26; M. Berhaut, *La Vie et l'œuvre de Gustave Caillebotte*, Paris, 1951, no. 60; P. Guth, 'Il était un collectionneur de neige,' *Connaissance des arts* (December 1955), p. 82 (illus.); Adhémar and Dreyfus–Bruhl, 1958, no. 16; C. Sterling and H. Adhémar, *Musée national du Louvre. Peintures, Ecole française, XIXe siècle*, Paris, 1958, I, p. 12, no. 152, pl. XL (illus.); H. Adhémar and A. Dayez, *Musée du Louvre. Musée du Jeu de Paume*, Paris, 1973, p. 139, p. 15 (illus.); Berhaut, 1978, no. 107 (illus.); H. Adhémar and A. Dayez–Distel, *Musée du Louvre, Musée du Jeu de Paume*, Paris, 1979, pp. 19, 152; G. Bazin, *L'Univers impressioniste*, Paris, 1982, p. 66 (illus.); *Catalogue sommaire illustré des peintures du musée du Louvre et du musée d'Orsay. Ecole française*, III, Paris, 1986, p. 93 (illus.); Varnedoe, 1987, no. 29 (illus.); K. Adler, *Unknown Impressionists*, Oxford, 1988, p. 76, pl. 69 (illus.); M. J. de Balanda, *Gustave Caillebotte*, Lausanne, 1988, p. 92, pl. 93 (illus.); P. Vaisse, 'Paris République (1871–1914),' *L'Histoire de Paris par la peinture*, Paris, 1988, p. 326 (illus.); R. Brettell et al., *The Art of Paul Gauguin*, exh. cat. Washington, D.C.: National Gallery of Art, 1988, pp. 315–16, (illus.); Rosenblum, 1989, p. 325 (illus.); Compin et al., 1990, vol. 1, p. 82 (illus.); G. Bazin, *Les impressionistes au musée d'Orsay*, Paris, 1990, p. 74 (illus.); J.-J. Levêque, *Les Années impressionistes, 1870–1889*, Paris, 1990, p. 371 (illus.); P. Wittmer, *Caillebotte and His Garden at Yerres*, New York, 1991, pp. 300, 301 (illus.); Berhaut, 1994, no. 96.

59 Caillebotte
Rooftops in the Snow
Toits sous la neige, Paris
1878
Oil on cardboard, 23⅝ x 28½ in. (60 x 72.4 cm)
Unsigned
Fondation Rau pour le Tiers-Monde, Zurich

PROVENANCE
Nat Leeb, Paris; sale, Sotheby's, London, 1 July 1970, lot 57; sale, Sotheby's, London, 2 December 1971, lot 28 (illus.); Fondation Rau pour le Tiers-Monde, Zurich, GR 1.517.

EXHIBITIONS
Copenhagen 1996, no. 58.

REFERENCES
Berhaut, 1978, no. 108, and 1994, no. 95.

60 Caillebotte
Boulevard Haussmann, Snow
Boulevard Haussmann, effet de neige
1880–81
Oil on canvas, 25½ x 32⅜ in. (65 x 82 cm)
Stamped lower right: *G. Caillebotte*
Private collection

PROVENANCE
Family of the artist.

EXHIBITIONS
Caillebotte et ses amis impressionistes, Chartres, musée de Chartres, 28 June–5 September 1965, no. 9; *Gustave Caillebotte 1848–1894*, London, Wildenstein & Co. Ltd., 15 June–16 July 1966, no. 14; *Gustave Caillebotte: A Retrospective Exhibition*, Houston, The Museum of Fine Arts, 22 October 1976–2 January 1977, New York, The Brooklyn Museum, 12 February–24 April 1977, no. 56; *Gustave Caillebotte*, Marcq-en-Barœl, Fondation Septentrion, 16 September 1982–23 January 1983, no. 24; *Gustave Caillebotte: Urban Impressionist*, Paris, Grand Palais, 16 September 1994–9 January 1995, Chicago, The Art Institute, 15 February–28 May 1995, no. 70.

REFERENCES
M. Wykes-Joyce, 'Maecenas at Work: Gustave Caillebotte,' *Arts Review* (11 June 1966), p. 269; Berhaut, 1978, no. 333 (illus.); Varnedoe, 1987, p. 152, fig. 45b; J. Milner, *Atelier d'artistes. Paris, capitale des arts à la fin du XIXe siècle*, Paris, 1990, pp. 114–116, pl. 115; Berhaut, 1994, no. 180.

61 Gauguin
The Seine at the Pont d'Iéna, Snowy Weather
La Seine au pont d'Iéna - Temps de neige 1875
Oil on canvas, 25¼ x 36¼ in. (65 x 92.5 cm)
Signed and dated lower right: *P. Gauguin 1875*
Musée d'Orsay, Paris, Bequest of Paul Jamot

PROVENANCE
(?) Mme. Uribe Héléna; anonymous sale, Hôtel Drouot, Paris, 28 May 1892, no. 39; bought 11 October 1893 by Vollard from Boussod et Valadon; sold to Bernheim, 27 December 1898; sale, collection of Ch. V, Hôtel Drouot, Paris, 9 February 1906, no. 31; sale, collection of Albert Bernier, 23 November 1910, no. 16; purchased by P. Jamot; bequest of Jamot to the Louvre, 1941; transferred to the Musée du Jeu de Paume, Paris, 1947; Musée d'Orsay, Paris, 1986 (R. F. 1941–27).

EXHIBITIONS
Les Etapes de l'Art Contemporain, Paris, Galerie des Beaux-Arts, 1933, no. 46; *Gauguin, ses amis, l'école de Pont-Aven*, Paris, Galerie des Beaux-Arts, 1934, no. 46; *Gauguin*, New York, Wildenstein & Co., 20 March–18 April 1936, no. 1 (*Snow Scene on the Seine*); *Gauguin*, Cambridge, Fogg Art Museum, 1936, no. 1; *Paysages de 1400 à 1900*, Paris, Galerie Séligmann, June–July 1938, no. 109; *Views of Paris*, New York, M. Knoedler & Co., 9–28 January 1939, no. 35; *Gauguin*, Liège, 1939; *Donation Jamot*, Paris, Musée de l'Orangerie, 1941, no. 60; *New Acquisitions by the Louvre*, Paris, Musée du Louvre, 1945, no. 85; *Peintures et sculptures impressioniste*, Paris, Musée du Jeu de Paume, 1947, no. 89; *Gauguin*, Paris, Musée de l'Orangerie, 1949, no. 1; *Gauguin*, Basle, Kunstmuseum, 1949, no. 1; *Gauguin*, Lausanne, Musée Cantonal, 1950, no. 31; *Paul Gauguin: His Place in the Meeting of East and West*, Houston, Museum of Fine Arts, 1954, no. 2; *Paysage français de Poussin aux Impressionistes*, Tarbes, Musée municipal, August–September 1956, no. 25; *Gauguin*, Munich, Haus der Kunst, 1960, no. 4; *Paul Gauguin*, Vienna, Österreichische Galerie im Oberen Belvedere, 1960, no. 1; *Paris vu par les maîtres de Corot à Utrillo*, Paris, Musée Carnavalet, March–May 1961, no. 33; *Peinture impressioniste dans les musées français*, Leningrad, The Hermitage Museum, Moscow, The Pushkin Museum, 1970–71, no. 2; Copenhagen 1996, no. 67.

REFERENCES
J. Rewald, 'Paysage de Paris de Corot à Utrillo,' *Renaissance de l'art Français* (January–February 1937), p. 31; Rewald, 1938, p. 59 (illus.); P. Gauguin, *Lettres à sa femme et ses amis*, Paris, 1946, p. 249; Adhémar et al., 1947, no. 89; J. René, *Gauguin*, Paris, 1948, pl. 1 (illus.); L. Van Dovski, *Gauguin*, Paris, 1950, no. 3, p. 338; R. Goldwater, *Gauguin*, Paris, 1957, p. 28 (illus.); G. Bazin and H. Adhémar, *Musée National du Louvre, Catalogue des peintures impressionistes*, Paris, 1958, no. 128, p. 66; C. Sterling and H. Adhémar, *La Peinture au Musée du Louvre—Ecole française XIXe siècle*, II, Paris, 1959, no. 897 (illus.); Rewald, 1961, p. 409; 'Gauguin e il gruppo di Pont-Aven,' in *L'Arte Moderna*, I, 1962, p. 204 (illus.); Wildenstein, 1964, no. 13; M. Carra, *Gauguin et le Groupe de Pont Aven*, Milan, 1967, p. 204 (illus.); F. Cachin, *Gauguin*, Paris, 1968, pp. 41, 42 (illus.); T. Nishimara, *Gauguin*, Tokyo, 1972, p. 125 (illus.); J. Rewald, 'Théo Van Gogh, Goupil and the Impressionists,' *Gazette des Beaux-Arts* LXXXI (February 1973), pp. 83, 84 (illus.); S. Alexandrian, 'La Peinture Impressioniste de A à Z,' *Le Monde des grands musées*, no. 5 (January/February 1974), Paris, p. 33 (illus.); M. Ikida, *The Book of Great Masters*, 1977, Tokyo, no. 15 (illus.); G.M. Sugana, *Tout l'œuvre peint de Gauguin*, Paris, 1981, no. 3; Brettell et al., 1984, pp. 110, 112 (illus.); F. Cachin, *Gauguin*, Paris,

1988, p. 17 (illus.); Rosenblum, 1989, p. 496 (illus.); Compin et al., 1990, vol. 1, p. 203 (illus.); P. Vance, *Gauguin*, London, 1991, pp. 44, 45 (illus.).

62 Gauguin

Winter Landscape, Snow Effect
Effet de neige
1888
Oil on canvas, 28½ x 36¼ in. (72.5 x 92 cm)
Signed and dated lower right: *P. Gauguin 88*
Göteborg Museum of Art, Göteborg, Sweden

PROVENANCE
Gauguin Sale, 23 February 1891, Hôtel Drouot, Paris, no. 18 (*Effet de neige*; sold for 240 francs); Pontus Furstenburg, Paris; bequest of Pontus Furstenburg, 1902 to the Göteborg Museum of Art, Göteborg, Sweden.

EXHIBITIONS
Cézanne till Picasso, Stockholm, Liljevalchs Konsthall, Moderna Museets Vänner, September 1954, no. 138; *Gauguin and the Pont-Aven Group*, London, Tate Gallery, January–February 1966, no. 6.

REFERENCES
Rewald, 1938, p. 158 (illus.); Wildenstein, 1964, no. 248.

63 Gauguin

Breton Village in the Snow
Village breton sous la neige
1894
Oil on canvas, 24½ x 34¼ in. (62 x 87 cm)
Unsigned
Musée d'Orsay, Paris

PROVENANCE
Posthumous sale of works remaining in the artist's studio; Papeete, 1903; Victor Ségalen; Dr. Fouquiau (second husband of Mme. Ségalen); Mme. Joly-Ségalen; acquired by the Musée du Louvre, 1952; transferred to the Musée du Jeu de Paume, Paris, 1957; transferred to the Musée d'Orsay, Paris, 1986 (R.F. 1958–12).

EXHIBITIONS
Paysage de Bretagne à M. Ségalen, Paris, Galerie Druet, 1923, no. 29; *Gauguin*, Paris, Association Paris-Amérique Latine, 1926, no. 20; *Biennale*, Venice, Palazzo dell'esposizione 1928, no. 7; *La Bretagne*, Paris, Galerie le Sylve, 1934, no. 105; *La vie ardente de Gauguin*, Paris, Gazette des Beaux-Arts, 1936, no. 128; *Daniel de Monfreid et son ami Gauguin*, Paris, Galerie Charpentier, 1938, no. 163; *La peinture française au XIXe siècle*, Belgrade, Musée du Prince Paul, March–April 1939, no. 54; *French and British Contemporary Art*, Adelaide, National Art Gallery, 1939, no. 41; *Gauguin et ses amis*, Paris, Galerie Kléber, 1949, no. 43; *Gauguin*, Paris, Musée de l'Orangerie, 1949, no. 61; Piccadilly 1949–50, no. 285; *Centenaire de Victor Ségalen*, Paris, Musée Cernuschi, 1978–79, no. 22; *Cent ans, Gauguin à Pont-Aven*, Pont-Aven, Musée de Pont-Aven, 28 June–30 September 1986, no. 30.

REFERENCES
V. Ségalen, 'Gauguin dans son dernier décor,' *Mercure de France* (June 1904) pp. 679–85; V. Ségalen, 'Hommage à Gauguin,' in *Lettres de Paul Gauguin à Georges-Daniel de Monfreid*, Paris, 1918, pp. 68–69; Ch. Chassé, *Gauguin et le groupe de Pont-Aven*, Paris, 1921, pp. 89–90; J. de Rotonchamp, *Paul Gauguin*, Paris, 1925, p. 221; A. Alexandre, *Paul Gauguin: sa vie et le sens de son œuvre*, Paris, 1930, pp. 251–52; Rewald, 1938, p. 159 (illus.); E. Bernard, *Souvenirs inédits sur Gauguin*, Paris, 1941, p. 7; B. Dorival, ed., *Les Peintres célèbres*, Geneva, 1948, p. 301; P. Gauguin, *Lettres à Daniel de Monfreid*, introduction by V. Ségalen, Paris, 1950, pp. 43–44; L. Van Dovski, *Gauguin*, Paris, 1950, p. 355, no. 400; R. Rey, 'Dernier décor de la demeure de Gauguin,' *Revue des Arts* (1953), pp. 115–21; Adhémar and Dreyfus-Bruhl, 1958, no. 137; H. Adhémar and C. Sterling, *Musée National du Louvre, Peintures, Ecole Française XIXème siècle*, II, 1959, no. 908; R. Huyghe, *Gauguin*, 1959, p. 92 (illus.); Wildenstein, 1964, no. 525; G. M. Sugana, *Tout l'œuvre peint de Gauguin*, Milan, 1981, no. 351; M. Prather and C. F. Stuckey, *Gauguin: A Retrospective*, exh. cat. Washington D.C.: National Gallery of Art, 1987, pp. 267 (illus.), 342; M. Hoog, *Gauguin, sa vie, son œuvre*, Paris, 1987, pp. 227 (illus.), 231, 297; F. Cachin, *Gauguin*, Paris, 1988, p. 204 (illus.); Rosenblum, 1989, p. 507 (illus.); Compin et al., 1990, vol. 2, pp. 204, 205 (illus.).

Winter Weather Chronology

December 1864 through January 1893[1]

Selected and compiled by Eliza E. Rathbone
Translations by Lisa Portnoy Stein

1864

DECEMBER
1 Snow from eleven to noon, a dreary and cold day.

1865

JANUARY
3 Continuous haze, with snow a good part of the day.

4 A beautiful morning with a little frost; thaw for the rest of the day.

17 A day of sudden showers, snow, sleet.

18 Dreary, misty, a small amount of snow toward three o'clock.

22 A dreadful day, cold, rain and snow which covered the ground.

29 A rather heavy frost, beautiful in the morning.

30 Snow during the night and in the morning, then it rained; the sky was full of clouds for the rest of the day.

FEBRUARY
9 Sudden storms of snow and sleet, bitter winds all day long.

12 Dreary weather, cloudy sky, small snowfall during the day.

16 Thick hoarfrost, a beautiful morning.

20 A heavy snow storm in the morning, the rest of the day rather calm, but extremely cold.

21 Cold, damp, cloudy, frequent showers of light snow.

26 Thick hoarfrost, a wonderful morning.

MARCH
8 Heavy snowfall from two to three o'clock, cold and variable weather.

9 Dreary, cold, a little rain, snow at night.

14 A very cold day, heavy snow in the morning, hazy sky, cloudy the remainder of the day.

22 Beautiful morning, some more strong and sudden bursts of snow from three o'clock in the afternoon.

23 Beautiful in the morning, more sudden bursts of snow beginning at two-thirty.

24 Same type of day with sudden bursts [of snow].

26 Rainy morning, two strong bursts of snow after five o' clock in the evening, bitter winds.

27 A very cold day, more strong bursts of snow particularly at four o'clock in the afternoon.

Extracted from the 'Journal Météorologique,' in *Annuaire de la Société Météorologique de France*, tome 14, 1866, 21–22.

1. Most of the research for this chronology was done by Alexandra Ames in New York and Sylvie Péharpré in Paris. It includes every description of significant snowfall between 1865 and 1893 that the research produced.

1867

JANUARY
2 Water from snow in the rain gauge, cloudy day; at six o'clock in the evening, a small amount of snow rapidly fell to the ground.

3 Dreary, cold, snow from three to five o'clock.

5 Rather clear, a little sun, snow on the ground and rooftops.

17 Nearly 2 centimeters of snow on the ground and on the roofs.

20 Fine weather, the snow is still on the ground, icy winds.

DECEMBER
In the last days of December 1867, a period of very intense cold began abruptly: it led to a freezing of the Seine; in Paris the river stayed frozen for eleven consecutive days.

Extracted from the 'Journal Météorologique,' in *Annuaire de la Société Météorologique de France*, tome 16, 1868, 29, 122.

On 3 December, snow began to fall heavily. On 5 December,…as early as seven o'clock in the morning, the roofs were disappearing, the streets were obstructed, and the entire countryside had disappeared under a deep layer of snow.

'Faits divers,' *Le Temps*, 17 décembre 1867.

1868

JANUARY
Although the thermometer suggests an easing of the temperature, it is still severely cold. The surface of the ice covering the Seine has, as of yesterday, acquired enough strength to support the number of curious onlookers who are adventurous enough to cross the river…this morning, a rather serious accident occurred near the Pont des Arts. But, after making some inquiries, it turned out that there were only some cold baths taken here and there, without any further consequences. In any case, the police are now opposed to permitting pedestrians out onto the ice.

In the departments, the cold continues. The Loire is frozen in different places; the Rhône, despite the speed of its current, has stopped moving, the Meuse, the Garonne, and others are also frozen.

Throughout Provence, there are signs of the most severe cold accompanied by heavy snowfall.

Yesterday, only a small amount of snow fell in Paris. However, it fell in such a way to make it very difficult for cars to move in the hilly areas. The authorities removed the ice and snow, but this operation does not seem to have been conducted as diligently as possible.

'Le Temps,' 5 janvier 1868.

The low temperatures returned last night, putting an end to yesterday's improved conditions. The snow mostly fell fine and dense, whipping into pedestrians' faces. All the uphill streets have become very difficult for cars; higher up they are nearly impassable. We saw nine horses barely able to pull a cart-load which ordinarily two would have been able to draw.

The same cold-spell is making itself felt in the departments. In Rouen and Le Havre, the thermometer has fallen from 2 to 6 and 7 degrees below zero, accompanied by snow.

The Rhône is filled with enormous ice floes which cover half of it, giving the river the impression of being a glacier. In Nantes it was 10 degrees.

[I]n Bordeaux, the same persistent cold and heavy snowfall, as well as in Marseille, Toulouse, and Toulon. Everywhere, rivers and streams are frozen, and people are skating on them, quite a rare pleasure in the Midi. Provence fears for its olive trees. Around Nice there is snow, and in Nice itself the thermometer remained at 7 degrees below zero.

'Faits divers,' *Le Temps*, 7 janvier 1868.

1869

DECEMBER

1 Snow all day long, beginning with a few small dust-like flakes, followed by a heavy snowfall and later hail, finally ending with large flakes.

3 A few small snowflakes fell in the late afternoon followed by a very fine but heavy snowfall which ended by ten o'clock that night.

4 Heavy snowfall in the form of small, fine flakes just after midnight; less heavy later in the morning though it continued to fall, ending by seven o'clock in the evening.

24 Snowfall which melted just after midnight, very fine in the afternoon, a bit of snow during the night.

27 Very fine snowflakes just after midnight, becoming heavier later in the morning, nearly stopping by early in the day.

28 Snow fell for a moment during the afternoon.

29 A little snow in the morning.

Extracted and paraphrased from *Le Bulletin de l'Observatoire Météorologique Central de Montsouris.*[2]

We are in the heart of winter. Since last week the thermometer has shown us that happy skaters may soon take to the lake. And the snow, the first to fall this winter, white, silent and slow, has covered Paris in a brilliant shroud. The first snow always has a bizarre effect: when we see the flakes fall without landing, some on a diagonal, others straight down, others across, and flutter uncertainly from place to place without stopping, we are always astonished to feel our hearts tighten, and we return home quickly to huddle in front of the fire, this poor substitute for the sun.

When Paris is all white, the city becomes dreary; none of its noises are heard, the horses walk timidly, the cars are silent, and the buses no longer have the sound of iron which those who are accustomed to it can no longer do without. We see the passers-by spin about, like quick shadows, warmly wrapped, without exchanging a word. Everyone comes and goes, and the noises outdoors are muffled by the blanket of snow; you could say that it is like a mechanical city whose citizens slide by, silent and hurried. The snow slowly falls from a sky the color of lead, and all its men and women who walk by as if they were on wheels give the rue Lafitte the allure of a German ballad.

'Chronique,' *Le Journal Illustré*, 12 décembre 1869, 394.

2. In most cases precise times have been omitted from the French text extracted from *Le Bulletin de l'Observatoire Météorologique Central de Montsouris.*

P. Blanchard, *A Train stopped by the snow between Macon and Culoz*, from *L'Illustration*, March 1870, Collection Viollet, Paris.

A. Lancon Smeeton, *Siege of Paris: Burial of the dead...*, from *L'Illustration*, 17 December 1870, 396–97, The New York Public Library.

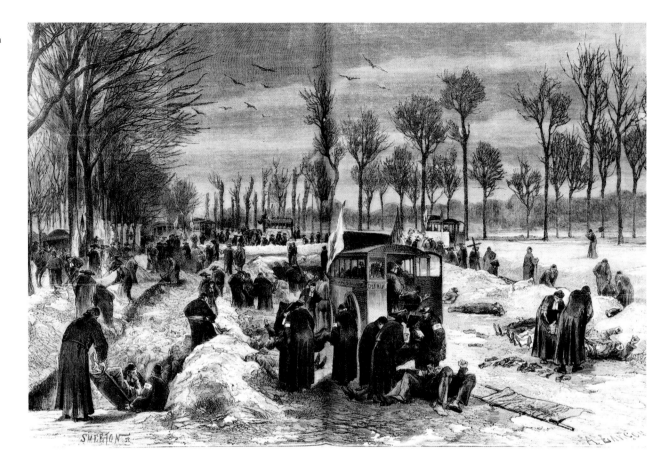

1870

JANUARY

24 Snow fell in small flakes in the form of stars.

25 A small amount of extremely fine snow fell.

FEBRUARY

9 Snow began to fall at 8:30 in the morning and soon after fell heavily in large flakes; it formed a slightly thick layer on the ground and ended just after nine o'clock in the morning.

12 Light snow began to fall during the night and fell heavily but in extremely small flakes.

13 Snow fell as it had during the previous evening and became heavier throughout the morning; it stopped snowing by seven o'clock in the morning.

18 Extremely fine, granular snow in the morning which continued until early afternoon.

19 Some snow early in the morning, becoming very fine and then stopping by one o'clock in the afternoon.

21 Rain mixed with snow at noon, then just snow.

22 Some recently fallen snow on the ground noticed early in the morning.

24 Very fine but heavy snowfall at seven o'clock in the morning, followed by a few but very large snowflakes.

Extracted and paraphrased from *Le Bulletin de l'Observatoire Météorologique Central de Montsouris.*

DECEMBER

From 7 to 9 December we had snow which stayed on the ground: the thawing rains began on 12 December....

Extracted from G. Lemoine and E. Belgrand, 'Résumé des observations centralisées par le service hydrométrique du bassin de la Seine pendant les années 1871 et 1872,' in *Annuaire de la Société Météorologique de France*, tome 22, 1874, 31.

6 Still very cold, 20 degrees at night, and our soldiers sleep in the snow! Our troops are cruelly housed at Châteauroux in a contaminated factory, exposed to the wind....Each night there are about twenty whose feet are frozen or who never wake up. Literally dead from the cold! How wretched, and it is like this everywhere! Before they are allowed to die, they are forced to suffer agonizing torture.

12 Thaw. After so much snow, it is an ocean of mud. Another bed for our soldiers.

19 It is cold again.

22 Cold, snow and frost, in other words, torture or death for those who are not sheltered.

25 The snow falls in torrents.

27 It is getting colder.

31 Still freezing cold.

1871

JANUARY

8 Snowstorm.

9 Thick snow, white, crystallized, wonderful. The trees, the bushes, the smallest brushwood are bouquets of diamonds….The snow is always so beautiful.

George Sand, *Journal d'un voyageur pendant la guerre*. Paris, 1871.

During the month of January 1871…a large amount of water fell in the form of snow….

FEBRUARY

Most noteworthy were the rains from 4 to 12 February which, aided by the snow still on the ground, produced a flood which reached Paris, at the Pont d'Austerlitz….

Extracted from G. Lemoine and E. Belgrand, 'Résumé des observations centralisées par le service hydrométrique du bassin de la Seine pendant les années 1871 et 1872,' in *Annuaire de la Société Météorologique de France*, tome 22, 1874, 31–32.

NOVEMBER

29 Snow from nine o'clock in the morning in the form of small needles.
30 Fine rain mixed with snow and hail during the night.

Extracted and paraphrased from *Le Bulletin de l'Observatoire Métérologique Central de Montsouris.*

DECEMBER

Snow was already observed during the month of November 1871. It fell frequently during the first half of December, but nowhere did it attain considerable depth…on the most elevated peaks of Morvan, on the Haut Follin, for example, the snow stayed during the entire month of December without anyone noticing little more than some mist that was barely measurable….[U]ntil 22 December there was still a lot of snow in the forest. On the other hand,…near Honfleur, in November and December there was not a single day of snow.

Extracted from G. Lemoine and E. Belgrand, 'Résumé des observations centralisée par le service hydrométrique du bassin de la Seine pendant les années 1871 et 1872,' in *Annuaire de la Société Météorologique de France*, tome 22, 1874, 40.

1 Rain…still mixed with snow, all morning long.

3 Snow in the afternoon….It fell very heavily at four o'clock that afternoon.

6 Rain mixed with snow at noon.

7 A strong snowfall in the afternoon which stopped by nine o'clock that night; it began to fall again at ten o'clock.

8 Average height of snowfall: 15 to 18 cm. Noon…in assessing the 12 cm, the average height of snow on the ground, it was found that 19 mm of the water fell in the form of snow during the day on 7 December.

10 Slight snowfall in the early morning.

Extracted and paraphrased from *Le Bulletin de l'Observatoire Métérologique Central de Montsouris.*

1873

FEBRUARY

6 It is snowing, raining, windy, hailing, and in the midst of this fine weather, a completely undignified couple (they had been bickering all night) were fighting in the basin of a fountain.

9 It snowed during the night, this morning, and this afternoon.

12 Paris flounders in the fallen snow. It is no time to put even a German outdoors.

La Presse Illustrée, 15 février 1873, 2.

In the first half of the month of February, from 30 January to 9 February, for instance, precipitation fell rather uniquely in the form of snow. In the largest part of the basin, this snow melted as it fell, or very soon after.

The amount of snow that fell on the span along the basin of the Seine, from 30 January to 9 February, was quite normal: it corresponds to an elevation of water of about 20 millimeters.

Extracted from G. Lemoine, 'Résumé des observations centralisées par le service hydrométrique du bassin de la Seine pendant l'année 1873,' in *Annuaire de la Société Météorologique de France*, tome 23, 1875, 19.

1874

MARCH

10 A little snow during the afternoon.

11 Snow from 4:30 in the afternoon; there were 2 centimeters on the ground.

12 A little snow after 3:30 in the afternoon.

'Journal Météorologique,' in *Annuaire de la Société Météorologique de France*, tome 23, 1875, 88.

DECEMBER

Finally, the snow is here, real snow, that we haven't seen for many years.

I know very well that people will write to me from Jura, Puy-de-Dôme, from the Haute-Loire, the Creuze, the Corrèze, from Cantal, Dauphiné, and the Pyrenees: 'What? For several years you haven't seen snow?'

My God, yes, it is true. It so happens that very often the snow in Paris isn't real snow.

It is not, however, fine white powder (would you wish to always be young and beautiful?), scattered on the roofs, trees, and statues. Nor is it the avalanche of small pieces of paper which fall from above, at the Ambigu, the Castellano theater, or at the Porte Saint-Martin. No: it is very much that of Father Winter, crystalline and immaculate snow, one thousand times whiter than white ermine and the tie of a perfect notary. But!…

But, when this snow falls on Paris, it habitually produces two or three disagreeable phenomena. It enters into the smoky atmosphere of the great city; it becomes covered by black molecules; this is from the snow on the chimneys, which then creates a slushy mess.

This snow. Thank God, this snow is as beautiful, as pure as that in the Alps.

All day long on Wednesday, [snow] fell in large flakes. In the early part of the day, the water-carriers, going to the fountain, had it up to their ankles. In the street and on the sidewalks, thanks to municipal sweeping, which has replaced private sweeping, paths have not yet been made, and this time, at least, the ruts, made by the cautious movement of cars, are white tracks, traced in a large layer of sugar candy.

This creates such joy for the Parisians who came from the mountains. The snow reminds them of winters in their homelands. Their eyes half-closed, as in dreams that one pursues while still wide awake, they catch a glimpse rather than look at the forest of black chimneys capped with white. It is the forest of fir trees transported to Paris by the wave of the Imagination fairy's wand. Sparrows fly back and forth, worried, troubled, perhaps hungry, in front of window panes gray with steam.

'Chronique de sept jours,' *Le Presse Illustré*, 19 décembre 1874.

Well, winter has burst upon us this week, in all its rigor. Deep snow has covered Paris for three days; and Paris, under snow, has lost three quarters of its charm

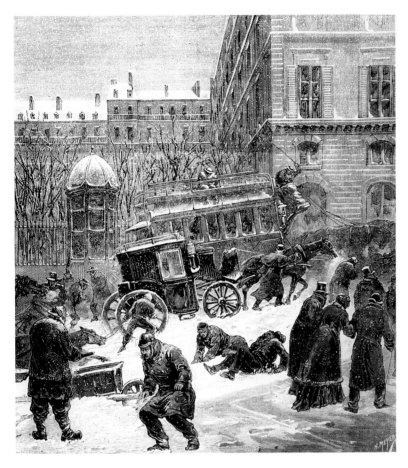

H. Meyer, *Paris: The Slope of the rue des Martyrs during the last snowstorm*, from *Le Journal Illustré*, 23 January 1876, front page, Collection Viollet, Paris.

and activity. Life congeals in its streets, like blood in a frozen corpse; snow-bound cars don't go anywhere; buses are experiencing unheard of problems getting out of the slush formed by dirt blended with snow.

'Chronique de la Semaine,' *Le Journal Illustré*, 27 décembre 1874, 410.

1875

JANUARY
December 1874 was colder than average, January 1875 was warm and rainy; February was cold and had a little bit of snow.

Nearly all the precipitation that has fallen has been snow, but it has not attained any great depth.

NOVEMBER
The month ends, in its last ten days, with cold that, in the Haut-Morvan, reached -7 degrees, and -3 degrees in the outskirts of Paris. The small amount of precipitation that has fallen during this time is all in the form of snow, but even in the Haute-Marne, from Chaumont to Vassy, it only adds up to a few centimeters on the ground.

DECEMBER
The characteristics of the end of November continue in the first half of

December: it becomes colder and colder, the sky is almost always cloudy, and the small amount of water which falls is in the form of snow. Its depth, moreover, is very limited on the banks of the Morvan, at Pannetière, there is not more than 10 centimeters of snow on the ground.

Extracted from G. Lemoine and E. Belgrand, 'Résumé des observations centralisées par le service hydrométrique du bassin de la Seine pendant l'année 1875,' in *Annuaire de la Société Météorologique de France*, tome 25, 1877, 16, 19, 30.

1876

JANUARY
Winter, which faded away during the first week of the year, has again taken possession of the calendar these past few days. More biting and icier than ever, it blew down small huts, and happiness disappeared as if in a dream, leaving the field free for the serious things of reality.

It is icy, it is snowing; one might be authorized to say that it is a wolf-like time, for a herd of these ferocious carnivores has appeared, of that one can be assured, at the gates of Paris, between Argenteuil and Enghien....

Returning to the rigors of winter, we do not doubt it appears as if the intense cold has been reserved for the end of January. The prophets of the almanac are dismal, and whatever the case, many people have already died of the cold in Paris last week.

It is terrible that, in the foremost city of the world, the most generous, the most charitable, one could still die of cold or hunger.

'Chronique de la Semaine,' *Le Journal Illustré*, 16 janvier 1876, 18.

We are now happily in a total thaw; but what a week of snow and ice!...Paris, as a matter of fact, has been until now, relatively spared. Telegraphs have been sent, each day, with news of unbelievable cold that has raged in the Midi; snow obstructing the roads, stopping the trains, rolling in downright avalanches in the Auvergne and Cévannes valleys; but we haven't remained less isolated nor forgotten by winter.

Well, we have now received our share, and we haven't lost anything for waiting.

Montélimart, of the renowned nougat, hasn't run out of snowflakes; the coasts of Perpignan haven't stopped experiencing their cold winds; there remains a thin coating of ice sufficient enough to coat our footpaths and sidewalks.

All that came to us quickly, all at once, and the appearance of Paris completely changed from one night to the next day. I will naturally not count the broken arms and legs, the sprains, nor the twisted ankles provoked by this offensive bout of ice....

It is in the streets around Montmartre, on the rue des Martyrs in particular, that difficulties in movement have been especially hard. I do not believe Bonaparte had more misfortune crossing the Saint Bernard with his troops, than the bus drivers who pull up their cars by the horses at the Place Pigalle. The pedestrians, in these difficult areas, have great difficulty in keeping upright; the unhappy horses, for every two steps forward, take three steps backward.

'Chronique de la Semaine,' *Le Journal Illustré*, 23 janvier 1876, 26.

1878

DECEMBER
The month of December 1878...was much colder and received more precipitation than usual. A large proportion of this water fell in the form of snow which, toward 19 December, in the areas of the Côte-d'Or and the Haute-Marne reached from 15 to 30 centimeters in depth.

Extracted from E. Renou, 'Note sur l'hiver de 1880–Hiver 1878-79,' in *Annuaire de la Société Météorologique de France*, tome 28, 1880, 260.

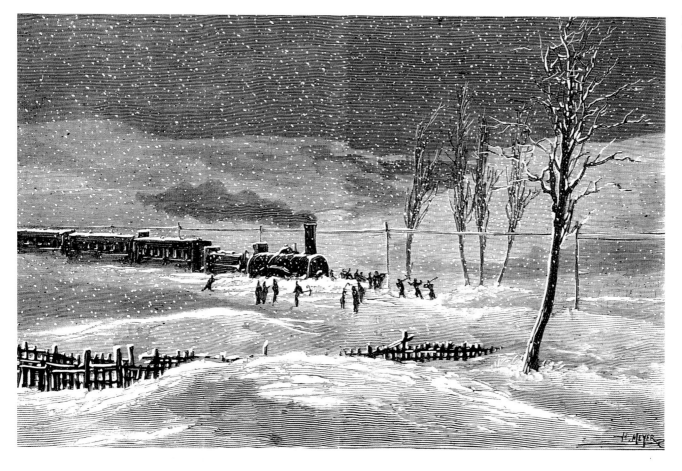

H. Meyer, *Trains stopped by the snow,* Winter 1879, Collection Viollet, Paris.

FAR LEFT
M. Férat, *Paris in the snow, the approach to the Senate: Luxembourg Palace,* from *Le Monde Illustré,* 13 December 1879, front page, The New York Public Library.

LEFT
A. Edelfelt, Ch. Baude, *A Parisian: A view taken on the Boulevard des Italiens,* from *L'Illustration,* 20 December 1879, front page, The New York Public Library.

1879

JANUARY

The rains from 1 to 5 January were the only significant ones during the month. The ice returned around 6 January to high areas, and it hardly stopped until around 23 January; for the lower areas, it was interrupted on 15 and 16 January. In this interval, snow, more or less mixed with rain, fell several times....

Extracted from G. Lemoine, 'Résumé des observations centralisées par le Service hydrométrique de la Seine, pendant l'année 1879,' in *Annuaire de la Société Météorologique de France*, tome 28, 1880, 261–62.

The environs of Paris have managed to escape the disasters that one might have feared could surpass those that caused the floods of 1872.

Unfortunately, all threats of danger have not disappeared: the enormous quantities of snow that fell for many days over two-thirds of France, brought with it a new flood, so at this time, the Seine and its tributaries have not yet returned to their normal height. The persistent cold, however, gives us some hope that these expectations will not be realized.

'Les Inondations. — La Neige,' *Le Journal Illustré*, 19 janvier 1879, 19.

NOVEMBER

Winter truly began in November 1879 and brought the same characteristics as the two following months. There was less precipitation than average:...in the area above the basin, a large amount of this water fell in the form of snow. The average temperature for the month was about 3 degrees lower than average; it has already been bitterly cold.

Extracted from G. Lemoine, 'Résumé des observations centralisées par le Service hydrométrique de la Seine, pendant l'année 1879,' in *Annuaire de la Société Météorologique de France*, tome 28, 1880, 273.

Successive snowfalls. — Snow had already fallen in elevated areas of the basin from 20 to 22 November and it wasn't completely washed away by the rainfall of 22 to 24 of November. In the first days of December, the snowfall began again and lasted until about 9 December; but it was especially heavy from 3 to 5 December; for three or four days communications were interrupted nearly everywhere.

DECEMBER

In the high area of the basin, the snow began around the evening of 3 December; in the lower area it was only detected toward the morning of 4 December and became especially heavy during the night from 4 to 5 December. The snowfall was accompanied by violent winds from 3 to 5 December; the night of 3 to 4 December, or that of 4 to 5 December, according to the stations, there were storms sometimes accompanied by lightning which caused damage; it is these snowstorms which are preserved so sharply in one's memory when one has seen even a diminutive of it in the country and the mountains.

Extracted from G. Lemoine, 'Résumé des observations centralisées par le Service hydrométrique de la Seine pendant l'année 1879,' in *Annuaire de la Société Météorologique de France*, tome 28, 1880, 290.

The month of December 1879 was one of the coldest we have had in a long time....At the same time, it was relatively dry; despite the large amount of snow that we had, the total depth was less than average....

Snow fell during the first ten days of the month, but particularly from 3 to 5 December; at this time nearly everywhere there were frightful snowstorms and

M. Férat, *The New Look of Paris: The Seine between the Louvre and the Institute,* from *Le Monde Illustré,* 20 December 1879, 396–97, The New York Public Library.

Eug. Bumand, Ch. Baude, *Winter in Paris: Unloading the carts of snow in the Seine, View of the Pont-Neuf,* from *L'Illustration,* 27 December 1879, 404, The New York Public Library.

Riou, *Piles of Snow on the Seine at the Pont Saint-Michel,* from *L'Illustration,* 27 December 1879, 408, The New York Public Library.

communications remained suspended almost everywhere for two to three days.

Depth of the snow on the ground. — In December 1879, in the general area of the basin of the Seine, the snow was about 30 centimeters in height.

> Extracted from G. Lemoine, 'Résumé des observations centralisées par le Service hydrométrique de la Seine, pendant l'année 1879,' in *Annuaire de la Société Météorologique de France,* tome 28, 1880, 274, 296.

Charcoal Pits Outside

With the truly Siberian-like temperatures which have overcome us for more than two weeks, several people have proposed to do as they do in Russia, and as was done in France during the winter of 1789, in other words, establish *charcoal-pits* outside for passers-by; the town council of Paris is eager to put this excellent measure into action.…

These *charcoal-pits* are, for the moment, the actual province of the police, messengers, drivers, and all of the people who, by profession, are forced to remain outside and whose feet and hands are half-frozen.

View of the Seine

The foreigner arriving in Paris right now would not recognize our beautiful capital, lost under its shroud of white snow, and he would think he had been transported to the banks of the Neva. Thanks to the Siberian-like temperatures that we have been enduring since the beginning of the month, it is colder here than in Astrakhan and more hazy than Liverpool. We are no longer in Paris, but deep in Russia.

The illusion is made even more complete, when, from the height of our office balcony, we contemplate the magnificent panorama of the Seine and the Louvre with its white hoarfrost ornamentation, an image that M. Férat has reproduced in this volume with his characteristic spirit and accuracy.

At the end, the magnificent Renaissance facade of the Louvre, whose chamfers covered with snow stand out strongly in relief against the background of an overcast winter sky. Farther away, and hardly blurred in the haze, the spire of Sainte Chapelle and the dome of the Institute. The greenish waves of the Seine, where not long ago the passenger ferries moved about and goods were transported, are now covered with a thick layer of ice, on which numerous workers move around, using axes to strike the sides of boats attached to the banks. The impression is most curious—you would think you were witnessing a winter scene in the North Pole. On the quays, rare passers-by walk swiftly with their collars turned up covering their ears, some sleighs glide silently on the hardened snow of the embankment, transporting us to the quays of the Neva.

'Le Froid à Paris,' *Le Monde Illustré*, 20 décembre 1879, 394.

Having begun early, winter was especially emphasized on Sunday, 29 November, by its first heavy snowfall, followed, on Thursday, 4 December, by a squall, a true storm, that again covered the ground, in the cities as well as in the countryside, with a layer of snow nearly one foot deep. In twenty-four hours, Paris was completely transformed. It was no longer Paris, it was Saint Petersburg, Tobolsk, Haparanda. And the Parisian who recognized it, who would still recognize it in this strange environment, for him it is as if little has changed. He, so slim, so elegant, who treads so delicately on the asphalt along the boulevard, do you see him today, as seen by our draftsman, and as he shows us, with an otter cap on his head, formidable shoes on his feet, completely wrapped in furs to which he must resort, shapeless, under the heap of clothing by which he makes himself a defence against the enemy?

'Nos Gravures, L'hiver à Paris,' *L'Illustration*, 20 décembre 1879.

The accumulation of snow in the streets of Paris has become, for its residents as well as for its government, a subject of serious trouble, and we cannot recall having ever seen as great a quantity of snow accumulation in so little time and which has persisted for nearly one month. In most of the provincial cities, and even in capitals such as London and Brussels, the city councils are more or less waiting for a chance thaw to spare them the trouble of clearing the public ways. In Paris, the people, more difficult to please—often the most difficult to please—are continually urging their town councillors to restore flowing traffic. This operation, which may appear simple on the surface, requires, however, putting into action a considerable amount of personnel and an expense which will probably add up to more than two million francs. It has been estimated that the amount of snow which has fallen on Paris is about fifteen million cubic meters, and there is no need to dwell on this to make it clear what a truly gigantic operation it will be to completely remove this enormous mass. The city found recourse in the most simple system: carrying it off in carts.

The snow loaded into the carts is brought to the quays, but principally to the bridges. There the cart is unloaded by using a weight-machine [see-saw] and the workers, armed with pickaxes and large shovels, throw the snow and ice over the parapet. In ordinary circumstances, the fall of the ice at such a height would be sufficient enough to smash the frozen layer along the Seine; but this year that layer is so deep that at certain points, such as at the Pont Saint-Michel, the conical mountain of snow has accumulated and even risen to the vault of the bridges without making the ice break….At the location on the Seine, which is represented in one of our prints, between the Pont-Neuf and the Pont Saint-Michel, the sight of the frozen Seine is quite curious; the ice floes accumulate there one on top of the other and have formed a surface that is no longer flat, but hilly and uneven, which truly gives an impression of the immense glaciers that are so admired in the Alps.

'L'Hiver à Paris,' *L'Illustration*, 27 décembre 1879, 407.

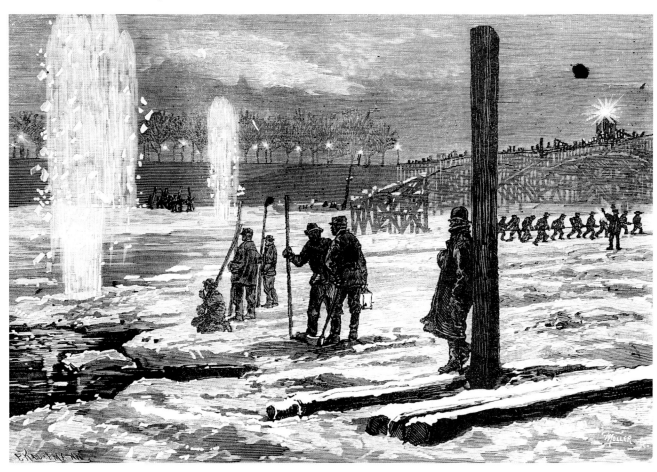

M. Kauffmann, *Paris in the Snow: Breaking the Ice with Dynamite at the Pont des Invalides*, from *Le Monde Illustré*, 3 January 1880, 4, The New York Public Library.

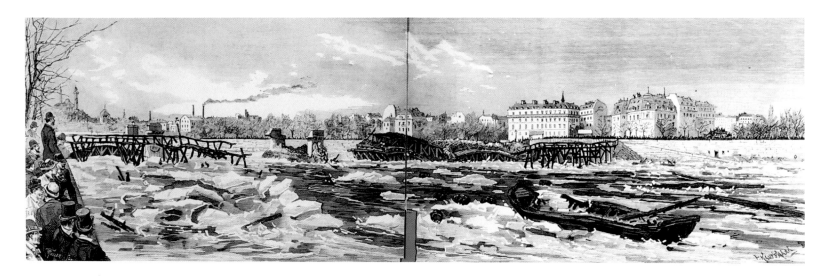

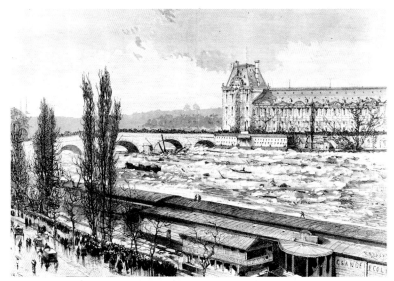

M. Kauffmann, *Paris: The great Débâcle of the Seine of 3 January. The state of the bridge and the foot-bridge from the Invalides at 2 o'clock in the afternoon,* from *Le Monde Illustré,* 10 January 1880, 24–25, The New York Public Library.

LEFT
M. Scott, *Paris: The great Débâcle of 3 January. View of the Seine from above the Pont Royal, at 11 o'clock in the morning,* from *Le Monde Illustré,* 10 January 1880, 28, The New York Public Library.

BELOW LEFT
The Débâcle of the Seine. The footbridge and the Pont des Invalides washed away, January 1880, Collection Viollet, Paris.

BELOW RIGHT
Riou, *The Débâcle of the Seine at Asnières. View taken from the Island of the Grande Jatte,* from *L'Illustration,* 10 January 1880, 36, The New York Public Library.

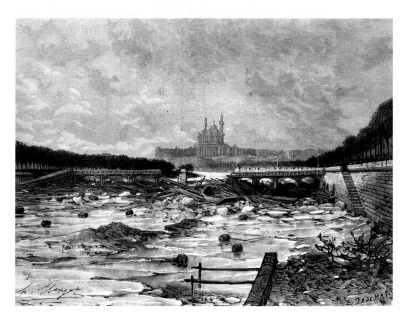

1880

JANUARY
First day of the year
…[D]espite the gray sky, the snow in the streets, the pathways have survived and this New Year's gift, it seems, is to begin a new era and a future in which we will have more luck than we have had in the past.

Echoes of Paris
The Temperature. — Since Sunday, the day on which the worst weather and the rise in the temperature reached France, movement is occurring rapidly in the Channel and is increasing in intensity. The sea is swollen everywhere and hurricanes furrow the coastlines.

The temperature continues to rise in Western Europe.…

Miscellaneous news
The Thaw. — The slowness with which the break-up of ice is occurring and the activity which presides over the work of breaking the ice on the Seine almost gives cause for the bad joke that we heard told yesterday quite seriously:

'Don't worry, the ice is breaking apart and then there won't be any more ice floes. Certainly yesterday they could have cleared the ice with the help of some dynamite, on the part of the river between the Concorde and Solférino bridges. This job, one must admit, would become more dangerous minute by minute.… '

The thaw has revealed the ruin caused by the cold in parks and gardens, particularly of those perennially leafy bushes which should be protected from the harshness of winter.…

It is also feared that the great exotic trees such as the Eucalyptus, Judas, and Polownias didn't have the strength to endure the exceptional severity of this winter, and the gardeners—like everyone—will be trying to save them for a long time.

Le Figaro, 1 janvier 1880.

Miscellaneous News
The Break up of Ice and the Swelling of the Seine. — These two catastrophes unleashed themselves yesterday with a violence which seems to have surpassed all expectations.

Toward the end of the evening, the level of the Seine rose to alarming proportions and even exceeded the height predicted by hydrometric stations.…

At 6:20 the second part of the break-up occurred. Seven successive explosions, which were heard throughout Paris, took place in the space of ten minutes.

The ice began to break apart from the Pont-Neuf to the Pont Solférino, and an extraordinarily rapid current caused a true avalanche.

At 6:45, this enormous mass, tumbling relentlessly, carried away the foundations of the Pont des Invalides, taking eight 'quoits' or trusses from the bridge, and it all collapsed into pieces with a dreadful commotion.

Le Figaro, 3 janvier 1880.

Miscellaneous News
The masses of falling snow blended with organic residues continue to infect, and could be an accessory to a formidable epidemic. All the hygienists agree on this point and typhoid fever, the result of poisons produced by their decomposition, has already been discovered in several areas.…

H. Meyer, *View of the boulevard Montmartre at one o'clock in the morning during the last snow-storm,* Winter 1881, Collection Viollet, Paris.

The New Snowplow, Winter 1881, Collection Viollet, Paris.

The Pont Saint-Michel has only one passable arch....

The Pont des Arts, where under the arches small waterfalls form, produced by the presence of all of the debris left by boats, is strictly forbidden to pedestrians....

The Parisian suburbs were severely tested by the break-up of ice. We have already described some related events in Billancourt, Saint-Cloud, Suresnes, etc....Neuilly,...Chatou, Bougival, Port-Marly...also experienced many lamentable disasters....

On the Marne, Joinville, Champigny, and La Varenne Saint-Hilaire have equally suffered.

In the latter area, we heard some interesting episodes. At the beginning of the break-up, some enormous forward-projecting blocks of ice literally cut poplars at least forty centimeters around. More debris from the ice, a considerable amount, was thrown to a distance of more than twenty meters and at once covered the banks and paths along the Marne.

Le Figaro, 5 janvier 1880.

The bill to pay for the break-up of ice on the Seine promises to be rather costly.

For the crossing of Paris alone, it appears that the total damages could be valued at about three and a half million.

This number will surprise no one when it is realized that forty-two boats of full tonnage have been sunk or destroyed by the break-up and the flood—some of these boats were worth fifteen to twenty thousand francs—and that the losses caused by the double catastrophe of the gangway and Pont des Invalides will add up to four or five thousand francs.

Le Figaro, 12 janvier 1880.

NOVEMBER

The winter of 1880 is one of the most inclement ever experienced in Paris. To begin with, the month of November was colder than usual, as the average temperature at the Parc de Saint-Maur, 3.3 degrees, is 2.4 degrees below normal in the countryside. The second half of the month was especially cold; there were thirteen icy days with temperatures of -6.5 degrees on 16 November and -6.7 degrees on 28 November. Since the last days of the month, the daily averages were very low, and this atmospheric condition continued until the last days of December....The ice lasted from 26 November to 28 December, thus for thirty three days; it is very nearly the maximum number of consecutive icy days in the environs of Paris.

Extracted from E. Renou, 'Note sur l'hiver de 1880,' in *Annuaire de la Société Météorologique de France*, tome 28, 1880, 43.

1890

NOVEMBER/DECEMBER

This winter will be inscribed among the most memorable winters, as much for its precocity as for its severity. It began on 26 November [when] the thermometer suddenly fell to a low of -2.3 degrees without rising above -8 degrees, and gave us a temperature, like today, on average of -1.6 degrees. The next day it fell to a low of -7.1 degrees and the day after, on 28 November, to -15, which it has not since surpassed. This was the beginning of a persistent and severe cold spell.

As for the ice, since 26 November until the day on which we write these words (13 January), there have been forty-five days of ice, and only three days of thawing out (19, 20, and 21 December)....One can only find, since 1757, three Decembers as cold: those of 1829, 1840, and 1879.

1891

JANUARY

After a cold December, such as we have just seen, the thaw came on 31 December at eleven o'clock in the morning, but lasted only briefly. The Seine drifted considerably again that day; on 1 January, the ice had nearly all melted. There was a slight return of the cold on 2 January (from 6.3 degrees to 2.2 degrees), and on 3 January (from 0.4 degrees to 4.4 degrees); during the evening of 5 January the cold returned.

The Seine, whose temperature has been hovering near zero degrees for more than one month, began to drift again on 7 January; on 10 January the ice floes, all but welded to one another, progressed extremely slowly. On 11 January the river was frozen along all of its crossings in Paris and only along two-thirds of its width were currents visible, as the ice floes moved to the middle of the Seine; during the night between 11 and 12 January the river was completely frozen....

The morning of 12 January the river was still, and throughout the day the curious ran to the banks to look at a spectacle such as Parisians have not seen in eleven years....

During our century, the Seine has completely frozen in Paris on the following dates: January 1803, December 1812, January 1820, January 1823, December—January 1829–30, January 1838, December 1840, January 1854, January 1865, December 1867, December 1871, December 1879, and January 1891.

'L'hiver de 1890-91,' *L'Illustration*, 17 janvier 1891, 51.

1892

FEBRUARY

The snow made its first significant appearance of the winter in Paris on 16 February, at seven o'clock in the morning. It fell in abundance until noon, and stopped for a while only to begin again that evening. This snow didn't melt immediately afterward as it had earlier in the day, due to the colder temperatures, and a thick layer of snow covered the ground.

The snowfall didn't only hit Paris; it also fell the same day in the departments. In the evening, a large amount of snow re-covered the city of Le Mans and its neighboring areas. The ground was soaked by a heavy downpour which had taken place earlier; the blanket of snow, however, didn't take long to become very deep.

Snow was recorded, moreover, in Laval, Châlons-sur-Marne, Château-Thierry, Laon, Sens, Saint-Malo, Granville, Longuyon, Lille, Dijon, Grenoble, Périgueux, and Bordeaux. In Le Havre the snow fell all day long on 16 February, from seven o'clock in the morning. The temperature dropped considerably. The semaphore thermometer read 9 degrees below zero.

Extracted from 'La neige à Paris et dans les départements,' in *Annuaire de la Société Météorologique de France*, tome 40, 1892, 101.

DECEMBER

The temperature everywhere was notably colder during the last week of 1892....The persistent cold during these many successive days has allowed numerous ice skaters to 'christen' the ice on the skating circle in the Bois de Boulogne. Ice skating also began at just about the same time in the rest of the country.

1893

JANUARY

Since the beginning of the new year, the temperature has been very low in all regions of France. At Avignon, on 2 January, due to north winds, the thermometer fell to 8 degrees below zero....On 4 January snow fell in Paris....

From 8 to 12 January the temperature rose again in Paris and reached a few degrees above zero, on average two to three degrees. But by 12 January it became cold again only to be broken on 14 January and then to return with even more intensity.

Extracted from 'Le froid,' in *Annuaire de la Société Météorologique de France*, tome 41, 1893, 131.

Frequently Cited Bibliographic References

Adhémar et al., 1947
Adhémar, Hélène, et al. *Catalogue des Peintures et Sculptures—Exposition au Musée de l'Impressionisme.* Paris, 1947.

Adhémar and Dreyfus-Bruhl, 1958
Adhémar, Hélène, and M. Dreyfus-Bruhl. *Catalogue des Peintures, Pastels, Sculptures impressionistes.* Paris, 1958.

Alphant, 1993
Alphant, Marianne. *Claude Monet, une vie dans la paysage.* Paris, 1993.

Bailly-Herzberg, 1980–91
Bailly-Herzberg, Janine, ed. *Correspondance de Camille Pissarro.* 5 vols. Paris, 1980–91.

Berhaut, 1978
Berhaut, Marie. *Gustave Caillebotte, sa vie et son œuvre. Catalogue raisonné des peintures et pastels.* Paris, 1978.

Berhaut, 1994
Berhaut, Marie. *Gustave Caillebotte, Catalogue raisonné des peintures et pastels.* Paris, 1994.

Berson, 1996
Berson, Ruth, ed. *The New Painting: Impressionism, 1874–1886—Documentation.* San Francisco, 1996.

Brettell, 1984
Brettell, Richard R. 'Monet's Haystacks Reconsidered,' *The Art Institute of Chicago Museum Studies,* vol. II, no. 2 (Fall 1984), 4–21.

Brettell et al., 1984
Brettell, Richard R., et al. *A Day in the Country,* exh. cat. Los Angeles: Los Angeles County Museum of Art, 1984.

Brettell, 1990
Brettell, Richard R. *Pissarro and Pontoise: The Painter in a Landscape.* New Haven and London, 1990.

Champa, 1973
Champa, Kermit. *Studies in Early Impressionism.* New Haven and London, 1973.

Compin et al., 1990
Compin, Isabelle, et al. *Musée d'Orsay—Catalogue sommaire illustré des peintures,* 2 vols. Paris, 1990.

D
Daulte, François. *Alfred Sisley, Catalogue Raisonné de l'œuvre peint.* Lausanne, 1959.

Denis et al., 1984
Denis, Marie-Amynthe, et al. *De Renoir à Vuillard,* exh. cat. Louveciennes: Musée de Marly-le-Roi, 1984.

Dewhurst, 1904
Dewhurst, Wynford. *Impressionist Painting.* London, 1904.

Distel, 1990
Distel, Anne. *Impressionism: The First Collectors,* trans. Barbara Perroud-Benson. New York, 1990.

Geffroy, 1922
Geffroy, Gustave. *Claude Monet, sa vie, son temps, son œuvre.* Paris, 1922.

Geffroy, 1923
Geffroy, Gustave. *Sisley.* Paris, 1923.

Gordon and Forge, 1983
Gordon, Robert, and Andrew Forge. *Monet.* New York, 1983.

House, 1986
House, John. *Monet: Nature into Art.* New Haven and London, 1986.

Isaacson, 1978
Isaacson, Joel. *Claude Monet: Observation and Reflection.* Oxford and New York, 1978.

Koja, 1996
Koja, Stephen. *Monet,* exh. cat. Vienna: Österreichische Galerie im Belvedere, 1996.

Lassaigne and Gache-Patin, 1983
Lassaigne, Jacques, and Sylvie Gache-Patin. *Sisley.* Paris, 1983.

Lloyd, 1981
Lloyd, Christopher. *Camille Pissarro.* Geneva, 1981.

Lloyd, 1986
Lloyd, Christopher, ed. *Studies on Camille Pissarro.* London and New York, 1986.

Moffett et al., 1986
Moffett, Charles S., et al. *The New Painting: Impressionism 1874–1886,* exh. cat. San Francisco: Fine Arts Museums, 1986.

Pissarro, 1993
Pissarro, Joachim. *Camille Pissarro.* New York, 1993.

P&V
Pissarro, Ludovico Rodo, and Lionello Venturi, *Camille Pissarro: Son Art—Son Oeuvre.* 2 vols. Paris, 1939; 3rd ed. repr. Santa Barbara and Salt Lake City, 1989.

Reuterswärd, 1948
Reuterswärd, Oscar. *Monet: en konstnärshistorik.* Stockholm, 1948.

Rewald, 1938
Rewald, John. *Gauguin.* London, 1938.

Rewald, 1961
Rewald, John. *The History of Impressionism.* 3rd rev. ed. New York, 1961.

Rewald, 1973
Rewald, John. *The History of Impressionism.* 4th rev. ed. New York, 1973.

Rewald, 1981
Rewald, John, ed. *Camille Pissarro: Letters to his Son Lucien.* Santa Barbara and Salt Lake City, 1981.

Rewald, 1986
Rewald, John. *Studies in Post-Impressionism.* New York, 1986.

Rewald, 1996
Rewald, John. *The Paintings of Paul Cézanne: A Catalogue Raisonné.* 2 vols. New York, 1996.

Rewald and Weitzenhoffer, 1984
Rewald, John, and Frances Weitzenhoffer, et al. *Aspects of Monet: A Symposium on the Artist's Life and Times.* New York, 1984.

Rosenblum, 1989
Rosenblum, Robert. *Les Peintures du Musée d'Orsay.* Paris, 1989.

Seitz, 1960
Seitz, William. *Claude Monet.* New York, 1960.

Shikes and Harper, 1980
Shikes, Ralph E., and Paula Harper. *Pissarro: His Life and Work.* New York, 1980.

Shone, 1992
Shone, Richard. *Sisley.* New York, 1992.

Spate, 1992
Spate, Virginia. *Claude Monet: Life and Work.* New York, 1992.

Stevens, 1992
Stevens, MaryAnne, ed. *Alfred Sisley,* exh. cat. London: Royal Academy of Arts, 1992.

Stuckey, 1985
Stuckey, Charles F., ed. *Monet: A Retrospective.* New York, 1985.

Tinterow and Loyrette, 1994
Tinterow, Gary, and Henri Loyrette. *Origins of Impressionism,* exh. cat. New York: The Metropolitan Museum of Art, 1994.

Tucker, 1982
Tucker, Paul Hayes. *Monet at Argenteuil.* New Haven and London, 1982.

Tucker, 1989
Tucker, Paul Hayes. *Monet in the '90s, The Series Paintings,* exh. cat. Boston: Museum of Fine Arts, 1989.

Tucker, 1995
Tucker, Paul Hayes. *Claude Monet: Life and Art.* New Haven and London, 1995.

Varnedoe, 1987
Varnedoe, J. Kirk. *Gustave Caillebotte.* New Haven and London, 1987.

Varnedoe et al., 1994
Varnedoe, J. Kirk, et al. *Gustave Caillebotte: Urban Impressionist,* exh. cat. Chicago: The Art Institute, 1994.

Venturi, 1939
Venturi, Lionello. *Les Archives de l'Impressionisme.* 2 vols. Paris and New York, 1939.

White, 1996
White, Barbara Ehrlich. *Impressionists Side by Side.* New York, 1996.

Wildenstein, 1974
Wildenstein, Daniel. *Monet, vie et œuvre.* Volume I. Lausanne-Paris, 1974.

Wildenstein, 1979
Wildenstein, Daniel. *Monet, vie et œuvre.* Volumes II and III. Lausanne-Paris, 1979.

Wildenstein, 1991
Wildenstein, Daniel. *Monet, vie et œuvre.* Volume V. Lausanne-Paris, 1991.

W
Wildenstein, Daniel. *Claude Monet: Biographie et catalogue raisonné.* 4 volumes, Paris-Lausanne, 1996.

Wildenstein, 1964
Wildenstein, Georges. *Gauguin,* ed. Raymond Cogniat and Daniel Wildenstein. Paris, 1964.

Frequently Cited Exhibitions

Paris 1891
Monet, Paris, Galerie Durand-Ruel, 4–16 May 1891.

Boston 1892
Monet, Boston, St. Botolph Club, 28 March–9 April 1892.

Boston 1905
Monet-Rodin, Boston, Copley Hall, March 1905.

Boston 1927
Claude Monet Memorial Exhibition, Boston, Museum of Fine Arts,
January–February 1927.

Paris 1931
Claude Monet, Paris, Musée de l'Orangerie, June–July 1931.

Piccadilly 1949–50
Landscape in French Art, Piccadilly, Royal Academy of Arts, 10 December 1949–
5 March 1950.

The Hague 1952
Claude Monet, The Hague, Gemeentemuseum Vans-Gravenhage, 24 July–
22 September 1952.

Edinburgh and London 1957
Claude Monet, Edinburgh, Royal Scottish Academy, 18 August–7 September
1957, London, Tate Gallery, 26 September–3 November 1957.

Saint Louis and Minneapolis 1957
Claude Monet, Saint Louis, City Art Museum, 25 September–22 October,
Minneapolis, The Minneapolis Institute of Arts, 1 November–1 December 1957.

New York and Los Angeles 1960
Claude Monet: Seasons and Moments, New York, The Museum of Modern
Art, 7 March–14 May 1960, Los Angeles County Museum of Art, 14 June–7
August 1960.

Cardiff 1960
How Impressionism Began, Cardiff, Arts Council (Welsh Committee) and
National Museum of Wales, July–August 1960.

New York 1969
Claude Monet, New York, Richard L. Feigen, 15 October–15 November 1969.

Chicago 1975
Paintings by Monet, Chicago, The Art Institute, 15 March–11 May 1975.

New York 1976
Claude Monet, New York, Acquavella, 27 October–28 November 1976.

New York and St. Louis 1978
Monet's Years at Giverny: Beyond Impressionism, New York, The Metropolitan
Museum of Art, 19 April–9 July 1978, St. Louis, The St. Louis Art Museum,
late July–15 September 1978.

Paris 1980
Hommage à Claude Monet, Paris, Grand Palais, 8 February–5 May 1980.

London, Paris, Boston 1980–81
Pissarro, London, The Hayward Gallery, 30 October 1980–11 January 1981, Paris,
Grand Palais, 30 January–27 April 1981, Boston, Museum of Fine Arts, 19 May–
9 August 1981.

Los Angeles, Chicago, Paris 1984–85
A Day in the Country: Impressionism and the French Landscape, Los Angeles
County Museum of Art, 28 June–16 September 1984, Chicago, The Art Institute,
23 October–6 January 1985, Paris, Grand Palais, 8 February–13 April 1985.

Tokyo, Fukuoka, Kyoto 1985–86
The Impressionist Tradition: Masterpieces from the Art Institute of Chicago, Tokyo,
The Seibu Museum of Art, 18 October–17 December 1985, Fukuoka, Fukuoka
Art Museum, 5 January–2 February 1986, Kyoto, Municipal Museum of Art, 4
March–13 April 1986.

Washington and San Francisco 1986
The New Painting, Washington, National Gallery of Art, 17 January–6 April 1986,
San Francisco, The Fine Arts Museums of San Francisco, 19 April–6 July 1986.

Boston, Chicago, London 1990
Monet in the '90s: The Series Paintings, Boston, Museum of Fine Arts,
7 February–29 April 1990, Chicago, The Art Institute, 19 May–12 August 1990,
London, Royal Academy of Arts, 7 September–9 December 1990.

London, Paris, Baltimore 1992–93
Alfred Sisley, London, Royal Academy of Arts, 3 July–18 October 1992, Paris,
Musée d'Orsay, 28 October 1992–31 January 1993, Baltimore, The Walters Art
Gallery, 14 March–13 June 1993.

Tokyo, Nagoya, Hiroshima 1994
Monet: A Retrospective, Tokyo, Bridgestone Museum of Art, 11 February–7 April
1994, Nagoya, City Art Museum, 16 April–12 June 1994, Hiroshima, Museum of
Art, 18 June–31 July 1994.

Paris and New York 1994–95
Origins of Impressionism, Paris, Grand Palais, 19 April–8 August 1994, New York,
The Metropolitan Museum of Art, 27 September 1994–8 January 1995.

Chicago 1995
Claude Monet 1840–1926, Chicago, The Art Institute, 22 July–26 November 1995.

London and Boston 1995–96
Impressions of France: Monet, Renoir, Pissarro, and their Rivals, London, Hayward
Galllery, 18 May–28 August 1995, Boston, Museum of Fine Arts, 4 October
1995–14 January 1996.

Copenhagen 1996
Impressionists in Town, Copenhagen, Ordrupgaard, 6 September–1 December
1996.

Index

Figures in **bold** refer to illustrations

237

Photographic Credits and Copyrights

Unless otherwise noted, photographs were supplied by the owners of the
works of art listed in the captions. All rights reserved.

Edited by Cherry Lewis
Designed by Andrew Shoolbred
Printed in Italy by Artegrafica S.P.A.